DEVELOPING MOTOR BEHAVIOR IN CHILDREN

A balanced approach to elementary physical education

DEVELOPING MOTOR BEHAVIOR IN CHILDREN

A balanced approach to elementary physical education

Daniel D. Arnheim, D.P.E.

Professor, Director of the Institute for Sensory-Motor Development,
California State University at Long Beach

Robert A. Pestolesi, Ph.D.

Professor, Chairman Men's Physical Education Department,
California State University at Long Beach

With 300 illustrations

The C. V. Mosby Company

Saint Louis 1973

7960707

To my family: Helene, Craig, Karen, and Mark
D. D. A.

To my wife Marillyn and children, Robert, Diane,
Susan, Janet, Thomas, and Carol
R. A. P.

Preface

Physical education is an integral part of the total educational process. All learning is expressed in some motor response. Recently there has been a movement toward the integration of the goals, objectives, and concepts of the classroom curriculum with those of physical education.

This volume is intended to offer the reader a balance between the new and traditional concepts of elementary physical education. We have attempted not to present any one point of view to the exclusion of another. Every effort has been made to blend equally the theoretical and practical aspects concerned with the field of elementary physical education.

Developing Motor Behavior in Children is designed to serve as a college text for classes in elementary physical education and as a guide for classroom teachers as well as physical education specialists in the field. It will also serve as an invaluable resource for all persons concerned with the motor development of children.

Generally, this text is organized to provide an understanding of children and the important part that movement plays in their lives. Specifically, it is divided into four major parts: Foundations, Implementation of the Program, Instructional Approaches, and Activity Progressions. Also provided within the text are Appendixes I, II, III, and IV, containing, respectively, relevant source material in elementary physical education, basic motor ability scale, movement

observation survey, and physical fitness tests.

Part I, Foundations, introduces to the reader the complex area of motor behavior. Focus is placed on aims, goals, and objectives of elementary physical education and the relevance of movement to the total development of the child. Pertinent information is provided for the reader on the process of developing perception and its relationship to motor behavior.

Part II, Implementation of the Program, is designed to give the reader a thorough discussion of the teacher's role in planning and carrying out a program of elementary physical education. Suggestions are provided for the practical application of techniques in teaching and administering of a highly successful program.

Part III, Instructional Approaches, provides current concepts on different instructional methods in physically educating children. It affords theoretical and practical information in the areas of movement education, basic motor development, motor fitness and exercise methods, and modifying instruction in elementary physical education. From Part III the reader should have a basic rationale for including specific movement approaches within the well-integrated program of physical education.

Part IV, Activity Progressions, is concerned with four major activity areas: movement exploration, stunts and self-testing, rhythms and dance, and games and sports. Activities are specifically chosen on the

basis of their value to the individual child. Each activity area is presented in a sequential order, from simple to the more complex. In order that the practitioner can account for each child's progress, behavioral objectives are given for the area of games and sports in three levels. Because children vary considerably in their motor capabilities, we have chosen to present games and sports in three levels rather than by ages. Level 1 represents low-organization activities, level 2 represents moderately organized games and sport lead-up activities, and level 3 consists of highly organized motor activities.

No textbook such as this is solely the effort of the authors. Such an endeavor requires the effort of many persons. We would like to thank those individuals who gave of their time, patience, and energy to make this volume possible. Sincere thanks is given to Mrs. Helene Arnheim, whose invaluable help with the manuscript and outstanding illustrations have made this book both a creative and scholarly achievement. Special appreciation is extended to Mrs. Marillyn Pestolesi, who gave incalculable hours of tireless work in the preparation of this book, and to Miss Susan Pestolesi for her outstanding and dedicated service. Appreciation is also expressed to Mrs. Jane H. Beck, Dr. John McConnell, and Mrs. Kathie McConnell for their invaluable suggestions, and to Lincoln Elementary School and Mr. Phil Shaner, Principal, Paramount School District; John H. Eader School and Ernest H. Gisler, Huntington Beach Elementary School District; and James O. Harper Elementary School, Fountain Valley Elementary School District, for the cooperation of their children and use of facilities.

Daniel D. Arnheim
Robert A. Pestolesi

Contents

I

Foundations

Part I is an introduction to the complex area of motor behavior. Focus is directed on the aims, goals, and objectives of elementary physical education and the importance of movement to the total development of the individual. Pertinent information is provided on the process of developing perception and its relationship to motor behavior.

Chapter 1

The focus

History reveals that the idea of physical education is as old as the human species. In the beginning, primitive man utilized effective motor skills for the sole purpose of survival. The motor skills of running, throwing, and striking were needed to effect the kill and accomplish a successful hunt. Since life was dependent on the successful execution of the hunt, man found it necessary to create better and more efficient methods to accomplish the kill (Fig. 1-1). Man soon discovered that the better-skilled hunters had the most success and were emulated by other hunters in their technique. Trial and error revealed that hunting could become more effective when an implement was introduced into the action. This brought about a greater demand for coordinating the hand and eye to successfully strike the intended object. These basic survival skills were passed down from father to son and perfected as new techniques were discovered. Tribesmen began to challenge each other to contests as each tried to gain the recognition and respect that was found to be a by-product of physical superiority.

Today, as in the past, skilled movement commands respect. Whether it is the skill of a professional athlete or the motor prowess of an elementary school child, the successful accomplishment of motor activities is personally rewarding and highly regarded by all.

WHY PHYSICAL EDUCATION

Physical education is an integral part of the total educational process. Man is designed for a variety of motor responses utilizing both large and small muscles; consequently, he must become aware at an early age of the values and satisfactions that can be derived from physical activity. All learning is expressed in some form of motor response. Although the need for primitive survival skills has greatly diminished and modern medicine has done much to prolong our lives, the need for physical education is greater today than ever before. In this age of large urban centers, automated conveniences, and mass transportation, opportunities for the natural development of motor skills has been greatly limited. The contemporary child has little or no opportunity to climb a big oak tree, throw stones across a river, or challenge a friend to a balancing contest on a rail.

Physical education is concerned with growth, development, and the proper physical maintenance of youth. This can be accomplished through a program of physical activities designed systematically to meet the objectives of physical education for purposes of realizing socially acceptable individual outcomes. Physical education plays an increasingly important role in today's automated society and is a valid and important phase of education. Since its values are im-

3

portant to all students at all levels, it is a necessary part of general education and should be required of every child. The blending of mind and body into a well-rounded individual is best accomplished through specialized programs presented by professional teachers in facilities planned for movement.

In recent times, because of research and concern for the underachiever, there has been a revitalization of bringing together the goals and objectives of the classroom with those of physical education. The physical education program that is conceived, planned, and carried out effectively can aid a child in reaching an optimal level of the cognitive and physical domains. Children gain motoric sophistication by engaging in a great variety of movement experiences. Because of a lack of opportunity, children are increasingly being identified as having perceptual-motor or neurological dysfunctions caused by being deprived of gross and/or fine motor opportunities.

Although there is a need for more research relating success in physical activities to success in the classroom, recent literature indicates that motor development programs encompassing a variety of perceptual-motor activities can serve to help overcome some classroom readiness deficiencies. There is a strong indication based on subjective information from the Institute for Sensory Motor Development in California State University at Long Beach that the confidence achieved on the playing field does much to alleviate fear and frustration in the classroom. A child having sensory-motor deprivation during his early developmental growth stages will often be encumbered throughout life with emotional and motor as well as cognitive problems. Elementary physical education generally should allow for the child to manage his total body and the objects with which he comes in contact (Fig. 1-2). In addition to this, physical education also provides opportunities for the development of healthy social relationships and emotional stability so much needed for living a full and successful life.

Within individual capabilities and limitations, each child should have the opportunity for optimum growth physically, men-

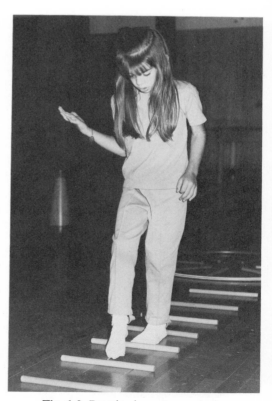

Fig. 1-2. Practice in motor control.

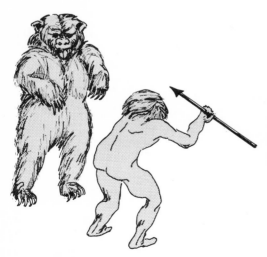

Fig. 1-1. Primitive hunter.

tally, and emotionally. A sound motor development program offers activities geared to the child's maturational and readiness levels as well as providing a wide variety of positive attributes for the individual involved. Some of the attributes derived are motor pattern development, mechanical and postural efficiency, temporal and spacial awareness, body awareness, organic efficiency (which includes physical power, muscular and cardiorespiratory endurance, and flexibility), basic play skills, perceptual motor efficiency, coordination, and agility (Fig. 1-3). Since not all children learn at the same rate or in the same manner, programs involving these factors must be developed on an individual basis (Fig. 1-4). Periodic motor evaluations should be made to assess the maturational level at which each child is functioning. From this information, the teacher can properly select activities suited to the individual child's level of maturity. Other concomitants realized from a well-developed physical education program are self-confidence, safe use of apparatus and playground equipment, self-control, psychosocial development, learning to follow rules, and release from emotional stress.

Fig. 1-3. Children exploring movement capabilities within limited space.

Fig. 1-4. Children exploring movement on modern playground.

Fig. 1-5. Developing team work through group activities.

Development of an aim

Prior to developing a well-organized physical education program, each teacher of physical education must thoroughly understand the proposed aims and desired objectives of physical education. The curriculum in physical education should be evaluated in line with the aims and objectives established leading toward the realization of desired behavioral outcomes. Only in this manner can the activities presented in a balanced program meet the needs of all the children at all levels.

An aim is usually defined as a generalized philosophical statement of purpose. It serves as a guide to the development and selection of general and specific objectives that are more readily attainable. The aim of any discipline is first in the hierarchy of purposes that describe specific subject areas in the total school curriculum. In 1918 the Educational Policies Commission reiterated the purposes of education in American democracy. Of the seven objectives described in educational references,[160] physical education contributed directly to three: health, worthy use of leisure, and ethical character. More recently, the central purposes of education were reduced to four main objectives:

self-realization, civic responsibility, economic efficiency, and human relations.[48] Although one might claim that physical education can contribute in varying degrees to all four, the areas of self-realization and human relations appear to be the most appropriate. The opportunities afforded the individual through the physical education program allow the child to fully realize his personal capabilities as a moving being. It is important that elementary school children understand their strengths and weaknesses in order to develop a positive and accurate self-image. The physical education curriculum also provides for a variety of socially oriented activities. Children learn to interact in group situations in a socially acceptable manner. Playing with others in activities where added stress factors are introduced into the action prepares the child for the dynamic world in which he lives (Fig. 1-5).

Although many professional physical educators have expressed the aim of physical education in a variety of ways, the interpretations of their statements have always shown a great deal of similarity. Nixon and associates state that organized physical education should aim to make the maximum contribution to the optimum development of

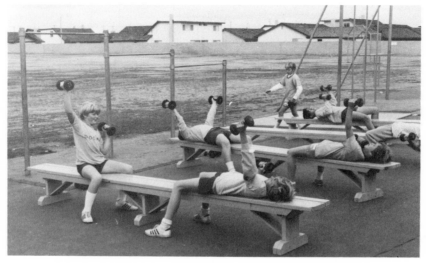

Fig. 1-6. Sixth-grade children participating in weight training unit.

the individual's potentialities in all phases of life, by placing him in an environment as favorable as possible to the promotion of such muscular and related responses or activities that will best contribute to this purpose (Fig. 1-6).[124] LaPorte relates that the ultimate aim of physical education may well be to so develop and educate the individual through the medium of wholesome and interesting physical activities that he will realize his maximum capacities, both physically and mentally, and will learn to use his powers intelligently and cooperatively as a good citizen even under violent emotional stress.[105] Williams determined that physical education should aim to provide skilled leadership and adequate facilities that will afford an opportunity for the individual or group to act in situations that are physically wholesome, mentally stimulating and satisfying, and socially sound.[166] Hetherington states that physical education is that phase of education that is concerned, first, with the organization and leadership of children in big-muscle activities, to gain the development and adjustment inherent in the activities according to social standards, and second, with the control of health and growth conditions naturally associated with the lead-

Fig. 1-7. Developing fine motor skill.

ership of the activities, so that the educational process may go on with or without handicaps (Fig. 1-7).[82] Bookwalter states that an aim of physical education is the optimum development, integration, and adjustment physically, mentally, and socially of the individual through guided instruction and participation in selected total-body

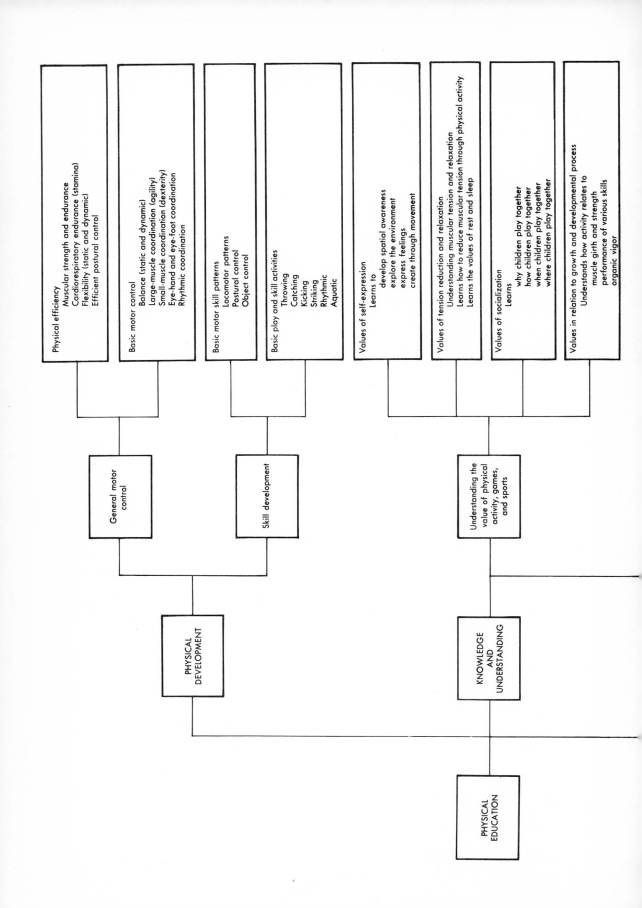

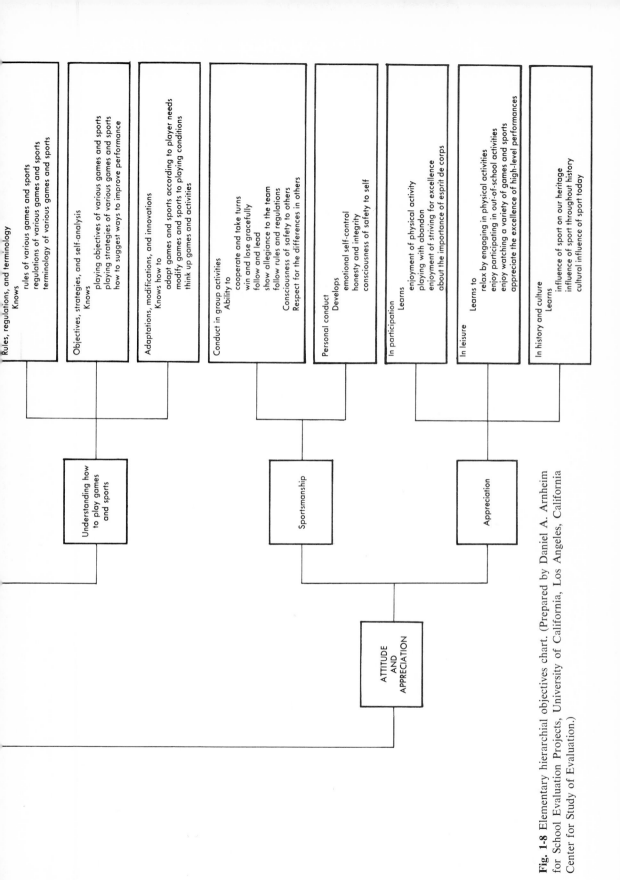

Fig. 1-8 Elementary hierarchial objectives chart. (Prepared by Daniel A. Arnheim for School Evaluation Projects, University of California, Los Angeles, California Center for Study of Evaluation.)

sports and in rhythmic and gymnastic activities conducted according to social and hygienic standards.[17]

We propose that the aim of physical education is to *facilitate the optimum growth and development of each individual through sequential, guided instruction and participation in sports and games, rhythms, and individual activities presented in a balanced manner leading toward the fulfillment of those physical, emotional, and social needs acceptable in today's society.*

The objectives of physical education

An objective might well be defined as a statement of purpose that is more immediate and specific in nature and that is in harmony with the established aim and more likely to be attained. We have described general objectives as including three major areas of physical education: physical de-

velopment, knowledge and understanding, and attitude and appreciation. Fig. 1-8 is presented as a model for a balanced approach to physical education. Each general objective has been divided into two subcategories that are listed as intermediate objectives of physical education.

Physical development. The general objective of physical development has been divided into the intermediate objectives of general motor control and skill development.

General motor control. The objective of general motor control has been further categorized into two specific objectives, one of which is *physical efficiency*. In order to fulfill the program requirements of this objective, activities must be offered that develop muscular strength and endurance, cardiorespiratory endurance, joint flexibility, and efficient postural control (Fig. 1-9). Each child should have the opportunity to

Fig. 1-9. Developing cardiorespiratory endurance.

Fig. 1-10. Jumping with good balance.

become physically efficient so as not to deter the learning process involved in more refined activities.

The second objective is that of *basic motor control.* Children need to develop balance, large-muscle coordination, small-muscle coordination, eye-hand coordination, eye-foot coordination, and rhythmic coordination (Fig. 1-10). The development of these basic motor controls enables the child to successfully participate in sports and game activities. The child who has learned and developed basic motor control has the foundation necessary to learn motor skill patterns necessary for the successful accomplishment and enjoyment of more sophisticated game activities.

Skill development. The intermediate objective of skill development has been divided into the specific objectives of basic motor skill patterns and basic play skills. *Basic motor skill patterns* that should be developed are the various modes of locomotion such as walking, jumping, hopping, skipping, crawling, climbing, rolling, and sliding. The child should also learn adequate postural control for proper stature in a variety of positions.

Children not only must be able to control their own personal movements, but also should be able to develop this control to include objects in activities of throwing,

catching, kicking, striking, pulling, pushing, stopping, and carrying (Fig. 1-11).

The accomplishment of basic motor skill patterns will enable the child then to successfully participate in *basic play skills* involving throwing, catching, kicking, striking, rhythmic, and aquatic activities.

Knowledge and understanding. Understanding the value of physical activity, games, and sports and understanding how to play games and sports are the two intermediate objectives of physical education.

Understanding the value of physical activity, games, and sports. Values of physical activity, games, and sports can be divided into the values of (1) self-expression, (2) tension reduction and relaxation, (3) socialization, and (4) physical activity in growth and development of the individual. In the area of *values of self-expression,* the child should learn to develop spacial awareness in physical activity. Each child should have the opportunity to explore the environment and learn to express his feelings through creative movement. In developing *values of tension reduction and relaxation,* the child should become aware of how to reduce muscular tension through physical activity and should be made aware of the values of rest and sleep. Children should understand why children play together, how they play together, when they play together,

Fig. 1-11. Controlling the body through pushing and pulling activities.

and where they play together. In developing an understanding of these *values of socialization,* children can better accept the variety of programs offered in the elementary school in relation to time and place of participation in each. Every child must understand the *values of physical activity* in relation to the growth and developmental process. He must understand how activity relates to muscle girth and strength, to performance of various skills, and to organic vigor. As these values are presented to the children, activities involving games and sports should take on a new meaning through better understanding of the reasons for play.

Understanding how to play games and sports. The second intermediate objective of understanding how to play games and sports is divided into the following specific objectives: (1) rules, regulations, and terminology, (2) objectives, strategies, and self-analysis, and (3) adaptations, modifications, and innovations. Children should have a thorough understanding of the *rules* of the various games and sports presented. Specific *regulations* in game activities and the *terminology* used in the various games and sports will aid in a more thorough understanding and appreciation of the activities presented. Each child should be made aware of the playing *objectives* of the activity pre-

sented, and should acquire the playing *strategies* needed to experience a successful performance. This process aids in the development of the cognitive aspect of the individual. He should also be taught how to objectively analyze his own performance and suggest ways to improve the level of his participation. To complete the understanding of how to play games and sports, children should be taught how to adapt games and sports according to player needs and should be taught that certain games can be modified in relation to playing conditions and available facilities. Children should also be able to develop their creative ability by designing new games and activities by drawing on their previous experiences. They should be encouraged to investigate their individual motor capabilities and create new movement activities.

Attitude and appreciation. Children learn to enjoy physical activity through successful performance in a variety of game situations (Fig. 1-12). The child also learns to play with complete "carefree" abandon, realizing the full value of physical activity. The child enjoys striving for excellence in physical activities that are within his own capabilities. Greater satisfaction is achieved when the individual performs well in any assigned task. The importance of esprit de corps and

Fig. 1-12. Equipment provides variety in game activities.

its relationship to group success should be stressed. Children can learn to relax by engaging in physical activity as well as learning to enjoy participation in a variety of physical activities. Participation in these activities outside of school is an important outcome of the physical education program. The child may also acquire an enjoyment of games and sports as a spectator and learn to appreciate the excellence that is displayed in high-level athletic performance. Children can be made aware of the role of sport throughout history and should understand the important influence that sport has had on our American heritage. The child can also develop a knowledge and appreciation of contemporary sport as it influences culture and provides an international language respected and appreciated by all nations.

Sportsmanship. Each child should develop the ability to cooperate and take turns and to win and lose gracefully and should learn to follow and lead through a planned program of sportsmanship. Developing allegiance to a team, a knowledge of how to follow rules and regulations, consciousness of safety to others, and respect for the differences in others enhances the development and maturity of the individual. Children can also develop emotional self-control during periods of physical and mental stress and can develop a sense of honesty and integrity while participating in games and be conscious of safety to self and others. However, it must be recognized by teachers that sportsmanship is not inherent in physical education activities but must be planned for and overtly applied by the participant.

RATIONALE FOR THE BALANCED APPROACH TO PHYSICAL EDUCATION

In order to provide interesting, exciting, and meaningful experiences for each child in line with the principles described, we suggest a balanced approach to teaching physical education. *The major purpose of this text is to blend the best* of all physical education philosophies, including the traditional games and sports, sensory-motor, movement ex-

ploration, and biological efficiency concepts of physical education into a well-designed pattern of instruction of developmental movement. Each approach singularly has much to offer toward the achievement of the major objectives of physical education. However, a well-planned combination of all basic methods enhances the ultimate development of the maturing child. The following information is presented to acquaint the teacher with some of the approaches of teaching physical education leading toward the fullfillment of the objectives brought forth in the curriculum model displayed in Fig. 1-8. A more detailed description of each method is given in later chapters. Teachers of elementary school children are afforded an opportunity to develop a personal philosophy of physical education and to construct meaningful programs designed to meet specific individual and group needs, using the suggested methods as a guide.

The traditional program

The traditional approach in physical education aims to achieve the objectives of physical education through the medium of stunts, dance, games, and sports (Fig. 1-13). The successful accomplishment of these activities contributes to the development of physical efficiency as well as to the development of positive attitudes, appreciation, knowledge, and understanding. Activities should be planned on a progressive developmental basis for each grade level. At the completion of the elementary school physical education experience, the child should have participated in a variety of lead-up games and sports that emphasize the fulfillment of the objectives proposed. Most traditional activities are presented on a group basis rather than on an individual basis with personal help being given to the children having the greatest difficulty in learning each skill. It is very important in using this approach that the teacher provide adequate equipment and individually modify activities so that all children have opportunities for full participation in each activity. Games providing activity for a few children at a time should

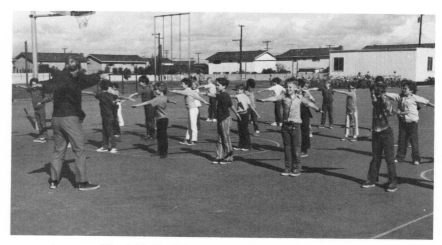

Fig. 1-13. Traditional physical education program.

Fig. 1-14. Solving problems through movement.

be modified in such a manner that a majority of children have opportunities for physical participation.

Children gain leadership experience by being squad leaders or team captains. In the traditional approach, the teacher plays a dominant role, becoming involved in the presentation and demonstration of the game to be learned. This phase of the physical education program is teacher directed and planned to meet the needs of the majority of the children in the class.

Movement education

The movement education approach emphasizes individualized programs of motor development (Fig. 1-14). Through this method children become acutely aware of their physical abilities and learn to use them effectively through a problem-solving technique. One of the salient points of this approach is that there are many correct ways to solve movement problems that are proposed by the teacher. Although some movements and postures may be more efficient or

effective in the solution of the problem, children seldom fail in their attempt.

The technique of discovering how they move enables children to understand their physical capabilities and develop sequential movement patterns from the knowledge acquired. The objectives of physical education are accomplished through a much less structured approach, and failure is kept to a minimum as each child finds his own best solution to the problem at hand. The movement education approach allows each child to increase his own motor ability at his own rate. The established goal for the participant is realistic and attainable, since all goals are developed on an individual basis. The informal atmosphere allows for effective social development, so that often one child communicates his solution to the problem to another child. The teacher plays a less dominant role in the movement education approach and acts more as a guide than as a director. Through this method, the teacher finds time for individual instruction, and the child finds time to create new movement patterns.

Biological efficiency

Biological efficiency is more commonly referred to as physical fitness. This approach should include a basic understanding of exercise physiology for all levels. This method of teaching physical education strives to develop muscular, skeletal, and cardiovascular-respiratory systems of the body. Activities are of a vigorous nature and often include intensive competition between teams or groups of children. The program is directive in nature, and children have fewer planned opportunities for social development.

The program should be planned in such a manner that the children experience the conditioning effect of activities designed to develop the heart, lungs, and muscles (Fig. 1-15). A child should discover that when he runs, his heart beats faster. The teacher should take advantage of this phenomenon and take the time to explain the values of physical conditioning in relation to one's total health. (See Chapter 8.)

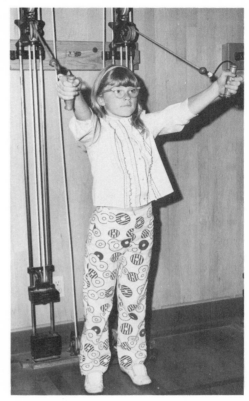

Fig. 1-15. Using equipment to develop muscular strength.

Children should become aware of the values of living a physically active life as early as possible and should begin to plan their own programs of physical conditioning. In today's society, modern conveniences have eliminated much of the physical work involved in our daily activity; therefore, it becomes increasingly important to emphasize this aspect of physical education in a well-balanced program.

The sensory-motor approach

The sensory-motor approach is a task-oriented method of teaching physical education (Fig. 1-16). Mastery of sensory-motor tasks prepares the child for future learning and understanding of the world in which he lives. Sensory-motor tasks should include both gross and fine motor skills. Locomotor patterns, body awareness and body image, balance tasks, tension recognition, and the

Fig. 1-16. Sensory-motor activities.

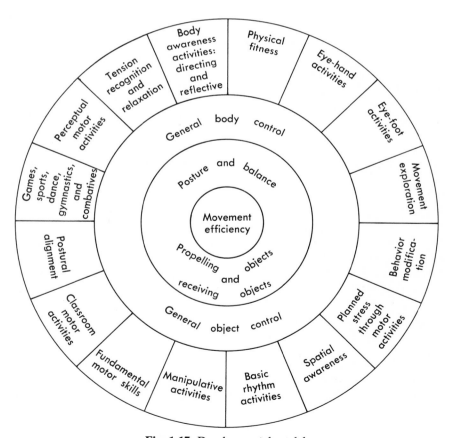

Fig. 1-17. Developmental model.

ability to relax all play a major role in this method of teaching physical education.

The program is teacher directed, with each child developing motor skills based on individual requirements. The program has a success-oriented approach, each activity beginning at a level at which the child can accomplish the skill. Although this phase of the program has greater emphasis at the lower levels or with children having movement difficulties, it should be a planned part of the total physical education program experience. If movement is combined with the child's sense modalities, he develops a positive body awareness and a favorable self-image. (See Chapter 7.)

Children with learning difficulties often are poorly coordinated and have definite perceptual problems. Although there is a paucity of research indicating that improvement in motor development relates to improvement in classroom skills, there are strong indications that success in motor development activities and the achievement of a favorable body image of oneself has some carry-over to success in the classroom.

No longer can one use only the traditional approaches to material presentation and expect the students to establish acceptable attitudes toward living a physically active life. The day is long past when a teacher can present a stereotyped program from a curriculum guide and expect all students to absorb all material presented at the same rate of learning, much less to develop a sound attitude toward physical education, health, and recreation. The physical education curriculum should be a blend of teaching approaches to satisfy the needs and developmental level of each child. Each teacher must attempt to find the best way to present program materials in exciting and meaningful ways. There is no reason why all students cannot achieve a personal satisfaction in physical education as long as the teacher develops the program within each child's individual potential. This can be accomplished only if the teacher takes time to work individually with each student and to develop programs in line with individual needs presented at different rates of learning. The teacher blends the science of learning with the art of teaching. And if this is done, not only should it be enjoyable to the student, but also there should be a tremendous satisfaction for the teacher. The smile on a child's face when a skill is accomplished is rewarding to the teacher who knows that a personal pride and positive self-control are being developed. There is no better arena than that of physical education to afford the child an opportunity to develop to his fullest potential. The total developmental model (Fig. 1-17) graphically displays how each physical education approach and developmental task contributes to the achievement of movement efficiency in a balanced manner.

RECOMMENDED READINGS

Anderson, M., Elliot, M. E., and LaBerge, J.: Play with a purpose, New York, 1966, Harper & Row, Publishers.

Bookwalter, K. W., and Vanderzswaag, H. J.: Foundations and principles of physical education, Philadelphia, 1969, W. B. Saunders Co.

Schurr, E.: Movement experiences for children, Des Moines, Iowa, 1967, Meredith Corporation.

Sweeney, R. T., editor: Selected readings in movement education, Reading, Mass., 1970, Addison-Wesley Publishing Co., Inc.

Williams, J. F.: The principles of physical education, Philadelphia, 1964, W. B. Saunders Co.

Chapter 2

The developing child

Understanding of the primary characteristics of the developing child is necessary before programs designed to affect motor behavior can be logically instituted. It is extremely important that children in physical education have movement experiences suited to their particular maturational level. This chapter provides the reader with the important highlights of human development from conception to puberty to assist teachers in providing a program of motor development.

In this text three terms associated with the changes occurring within human beings will be used: growth, maturation, and development. Growth is defined as the progressive change that occurs in an individual's structure and bodily function as the result of an increase in the size of the cells or an increase in the number of cells. Physical maturation refers to the ultimate limits of anatomical and physiological change as determined by individual genetic characteristics, and development is the process by which maturity is attained.

DEVELOPMENT BEFORE BIRTH

Life in utero is characterized by four basic features: orderly cell division, differentiation, unification, and integration. Following the union of the sperm and ovum, the new life (zygote) rapidly develops or

matures by a predetermined genetic plan progressing through the embryo and fetal stages. The embryonic stage, which lasts from the third to the sixth week, is best described as a period in which the cells begin their *differentiation* into specialized tissues, organs, and organ systems. Cellular differentiation creates, first, an outer layer (ectoderm) that eventually forms the nervous and cutaneous systems; second, a middle layer (mesoderm) forming the tissues of the musculoskeletal, lymphatic, and cardiovascular systems; and third, the inner layer (endoderm) eventually forming the digestive and respiratory systems. Obvious during the embryonic period are a primitive heart, cerebral and optic vesicles, and the development of the musculature (Fig. 2-1).

The unborn human organism is termed a *fetus* when the skeletal system begins to replace its soft cartilaginous skeleton with bony mineral substances. The early fetus is distinguished from the embryonic stage by the presence of rudimentary arms, legs, and essential organs for independent life after birth. This fetal period extends approximately for the last seven months of prenatal life until birth. Rapid, uniform, and progressive growth characterizes the cellular and tissue development during the prenatal stage or gestation period. The new human being gradually unfolds from a mass of

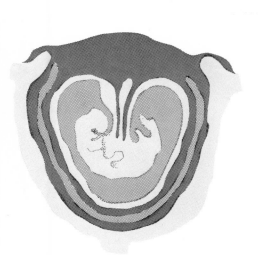

Fig. 2-1. Human embryo.

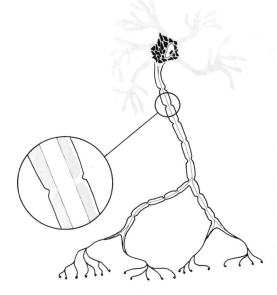

Fig. 2-2. Myelinated nerve.

diffused and undifferentiated cells to a highly organized and interrelated group of organic systems.

DEVELOPMENTAL DIRECTION AND INTEGRATION

The developmental and maturational direction of the new organism, generally, is from head to foot (cephalocaudal) and from the midline of the body outward (proximal-distal). This pattern of development is verified when the fetus within the mother is observed to gain motor control of first the head, back, and arms and, finally, the legs.

During the prenatal stage, motor behavior follows closely the progressive cellular development that is established at conception. The early fetus expresses movement that is arrhythmic and uncoordinated. Gradually an integrating process takes place as motor nerves within the central nervous system become myelinated (Fig. 2-2). The mature motor nerve is often coated with a fatty covering called the myelin sheath that serves as an insulation against the misdirecting of neural impulses.[66] It should be noted that myelinization allows increased speed of muscular reaction, more precise movement,

and increased strength. In keeping with the original biological plan, fetal motor responses mature in a cephalocaudal and proximal-distal direction. With increasing maturity, the neonate (newborn infant) progressively develops from a generalized to a more specific behavior. For example, control of large muscles generally occurs before control of the small muscles. This can be observed as the muscles of the arm mature; first, development of the large muscles of the shoulder and arm occurs followed by fine digital coordination.

Reflex behavior

Reflex patterns become apparent in the early fetus and serve to direct many motor functions throughout life (Fig. 2-3). A reflex may be defined as an involuntary nervous-system response from sensory stimulation that produces a movement or glandular activity.[139] The neonate is normally able to breath, yawn, cough, sneeze, suck, and display many other reflex motor patterns. Reflexes are essential for normal progressive motor development.[85] Florentino describes three progressive levels of reflex development based on postural positioning: *apedal*

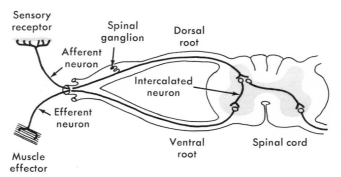

Fig. 2-3. Simple reflex arc.

primary motor control by the primitive reflexes emanating from the spinal cord and brainstem; *quadrupedal* major motor function from the brainstem; and the *bipedal* level, which is regulated by the cortex.[59] As a child develops motorically, his lower levels of reflex behavior become dominated by higher centers within the central nervous system. For example, the newborn infant is controlled mainly by the spinal-level motor reflexes relegating the body positions to those of prone (front lying) and supine (back lying). The newborn infant blinks when a light is directed into his eyes, executes a grasping action with his fingers and toes when pressure is exerted on the palms and soles of his feet, turns his head to one side when his cheek is touched (rooting reflex), sucks when his lips are touched, controls the position of his head when he is pulled upright, and responds to a sudden loss of support or loud noise by raising his arms to the side and extending his legs (Moro or startle reflex). Gradually, through the maturation process, higher nervous center levels dominate, allowing the child to move to the upright posture by progressing through the developmental stages of rolling over, crawling, sitting, and standing.

Mobility

For the most part, the newborn infant is without the ability to conduct purposeful mobility. Body segments move independently of each other. The newborn child creates swimminglike movements with his limbs but fails to direct the body in a purposeful manner. Squirming and twisting actions may turn the infant in circles or produce unintentionally a rolling action to the side. However, not until about 3 months of age is the infant able to fully turn over from back to stomach. The first important event that signals the beginning of purposeful mobility that eventually leads to the upright posture and bipedal locomotion is *crawling* (Fig. 2-4), which occurs at about 2½ months of age in its rudimentary homologous form; the infant crawls, keeping his abdomen continually in contact with a supporting surface by moving, first, both legs and then both arms. Gradually, the more general homologous movements are replaced by the more organized homolateral pattern that is initiated by alternately moving both the arm and leg on the same side of the body in a wriggling fashion. Finally, maturation allows the child to accomplish a cross-pattern crawl that employs the movement of alternating one leg and the opposite arm. Not until around 8 or 9 months does the child acquire enough neuromuscular maturity to attempt to push his body up against the force of gravity into the relatively unstable quadrupedal position in preparation for creeping. Like crawling, creeping (Fig. 2-5) develops from gross homologous movements to homolateral and finally acquisition of the mature cross-limb movement patterns.

The ability to move in the upright posture is one of man's greatest achievements.

Fig. 2-4. Infant preparing to crawl.

Fig. 2-5. Nine-month-old infant creeping.

The infant prepares for independent walking for over 12 months; however, not until many physiological and anatomical features have been acquired is he able to move from the safe four-point position to the very precarious and unstable upright posture (Fig. 2-6). The skill of upright locomotion progresses from the time of the child's first attempts at pulling himself up on the side of the crib to moving around the room holding onto furniture, to walking free of support with feet spread and arms raised for balance, and finally to acquiring an almost adult pattern of walking and running, which is present at approximately 4 years of age (Fig. 2-7). From the basic motor functions of walking and running, emerge such locomotor skill variations as ascending and descending stairs, going up and down ladders, hopping, skipping, galloping, and jumping from and over objects (Table 1). These motor skills will later be used for successfully engaging in the more complex activities of games and sports. (See Chapter 7.)

Fig. 2-6. Two-year-old child walking.

Fig. 2-7. Four-year-old child running.

Table 1. Age at which a given percentage of children perform locomotor skills

	25%	50%	75%	90%
Rolls over	2.3 mo.	2.8 mo.	3.8 mo.	4.7 mo.
Sits without support	4.8 mo.	5.5 mo.	6.5 mo.	7.8 mo.
Walks well	11.3 mo.	12.1 mo.	13.5 mo.	14.3 mo.
Kicks ball forward	15 mo.	20 mo.	22.3 mo.	2 yr.
Pedals trike	21 mo.	23.9 mo.	2.8 yr.	3 yr.
Balances on one foot ten seconds	3 yr.	4.5 yr.	5 yr.	5.9 yr.
Hops on one foot	3 yr.	3.4 yr.	4 yr.	4.9 yr.
Catches bounced ball	3.5 yr.	3.9 yr.	4.9 yr.	5.5 yr.
Heel-to-toe walk	3.3 yr.	3.6 yr.	4.2 yr.	5 yr.

Selected items from the Denver Developmental Screening Test by permission of William K. Frankenburg, M.D., and Josiah B. Dodds, Ph.D., University of Colorado Medical Center.

Vocalization

Communication through purposeful vocalization can be considered as an important outcome of the long period of dependency that the human being must undergo. Simply stated, communication is the transferring of information by some symbolic form from one person to another. Language in the usual sense refers to communication by means of the voice; however, there are nonlinguistic means of human communication utilizing postures, attitudes, gestures, and facial expressions. Vocalization occurs mainly from control of expired air passing through the vocal cords, which are contained within the larynx. Although the

acquiring of motor skill necessary for speech is very important, it is to some people less dramatic than the acquisition of mobility in the upright posture.

As in the development of all motor responses, there is a hierarchy of events leading to the eventual mature speech. Vocal sounds at birth are represented by undifferentiated sounds such as crying, yawning, sneezing, and coughing. Undifferentiated crying is followed at about 3 months of age by differentiated crying, also known as *vital crying,* indicating the baby's response to discomfort such as pain, cold, or hunger. Meaningful sounds such as phonemes or babbling and lallation occur at about 6 months of age.[112] The ability to echo speech sounds appears at about 7 months and is maintained throughout life. Other speech milestones are considered by some observers to be when the child emits "dada" or "mama" type words at about 10 months, when he can name a picture at about 20 months, and when he has the ability to produce simple sentences at about 4 years of age.[64, 112]

Manipulation

Prehension, or the act of seizing an object, is present at birth in the form of the grasping reflex, which may be activated by pressing on the palm of the baby's hand. The thumb at birth is either free or enclosed by the flexed fingers. An essential event emerges by about 2½ months called the *vital release,* which is the combination of grasping and voluntary releasing. Release of the grasp is more difficult to execute than the actual grasp because, characteristically, the flexor muscles are stronger than the extensors. Volitional grasping occurs at about 8 months. However, it is not until about 16 months that the child can oppose the thumb on either hand, and not until around 2 years can a mature thumb opposition be performed bilaterally and simultaneously. Before the infant can utilize volitional prehension to explore his immediate surroundings, he must learn to coordinate the hand and eye. Ultimately, the emergent individual will perform the most difficult of motor functions: writing.

Sensory awareness

The sensory functions of the neonate are at a relatively primitive state. Through variation in experiences and environmental stimulation, the senses of seeing, hearing, feeling, smelling, and tasting are enhanced. The sensory organ receptors are designed to respond to specific stimuli: light, heat and cold, stretching of muscle fibers, pressure on joints, vibrations, and chemical stimulants that differentiate tastes and smells. Working in coordination with the motor system and with each other, the various senses guide and alert the organism to internal or external danger.

Visualization. The newborn child visually responds immediately to lights by moving or twitching the eyelids. This light reflex also may elicit the Moro or startle reflex. There are indications that some colors can be perceived, particularly blue and green.[50] The baby's following of a movement or object with his eyes is apparent when he is only 2 weeks old. At approximately 3 months of age the infant can visually perceive an outline, and at 8 months, he can identify detail as a configuration from a varied background, which is the beginning of figure-ground perception. However, it is not until almost 1½ years that coordinated focusing of the eyes occurs. At this time three visual functions are able to take place simultaneously: the oculomotor system coordinates six pairs of eye muscles in the process of convergence or the simultaneous turning in of the eyes in order to focus on objects at a near point; the thickness of the eye lenses can be muscularly altered; and the eyes can accommodate the incoming light by opening and constricting the pupils. Le Winn equates the child's maturity of visual accommodation and convergence with that of taking the first step, speaking the first word, and opposing the thumb to the index finger.[112] At approximately 2 years of age the child can visually differentiate similar and unlike objects as the brother and the cat or the house and the

car. The child at 4 years of age is often mature enough to make differentiation of shapes, sizes, and varied visual symbols. At 6 years, the young child is often mature enough to accurately see and understand letters and words at a near point.

Wold defines vision as "the comprehension of information that is gathered into the brain through the various sense modalities and the reconstruction of this information into a conceptual image that has meaning. It involves sight, perception, integration and conception."* Vision, therefore, must be considered not as a single process of sight, but in terms of the entire developing human organism. To point up the fact that vision emerges as a totality, Getman and Wold discuss Skeffington's suggested four overlapping and interweaving performance areas in the creation of vision: the antigravity process, the centering process, the identification process, and the speech-audition process (Fig. 2-8).[68, 169]

The *antigravity process* occurs as the result of the infant's struggle to gain mobility in the bipedal position. The righting reflexes initiated by the labyrinths of the inner ear and the muscle receptors of the neck combine with the eyes to coordinate the balance and position awareness. The antigravity process assists the child in answering the questions Who am I? and Where am I?

The *centering process* provides the human organism with "whereness." Through maturation and experience, the child is able to determine where he is in space and to identify where objects are in his surroundings. Before centering can become realized, the child must have the coordinated use of his two eyes. The fusion of the images of the same object perceived by both eyes may be defined as binocularity. Coordinated teaming of both eyes in terms of physical maturation may be considered at the same level of differentiation as cross-pattern locomotion, which indicates that the

two halves of the body are beginning to coordinate reciprocally.

The *identification process* is third in Skeffington's development of vision and provides the "whatness" to life. This process involves all the senses of the human organism to perceive the contrast of the world about him. The various stimuli received from smelling, tasting, feeling, hearing, and seeing are matched together selectively to form a mental concept of what it is.

The fourth and most sophisticated of the visual processes in the development of vision is the *speech-audition* area. Language is the matching of sound and speech in a meaningful manner. Elaboration of speech sounds in the production of words and sentences leads to auditory-visual communication known as visualization or visual imagery; for example, just by listening to specific words or phrases, the listener can imagine seeing colors or picture forms.

Audition. Auditory development begins in the fetal stage as early as 5 weeks. At birth the neonate will respond to noise with

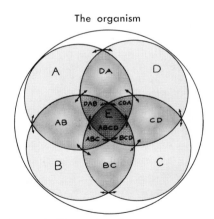

The organism

A: The antigravity process

B: The centering process

C: The identification process

D: The speech-audition process

E: The emergent: vision

Fig. 2-8. The visual processes. (From Getman, G. N.: The visuomotor complex in the acquisition of learning skills. In Learning disorders, vol. 1, Seattle, 1965, Special Child Publications, Inc.)

*Wold, R. M., editor: Visual and perceptual aspects for the achieving and underachieving child, Seattle, 1969, Special Child Publications, Inc.

the Moro reflex pattern. At 3 months, the infant responds more specifically to threatening sounds and appears to be able to focus attention on particular voices and sounds. Between 4 and 5 months, the infant is able to localize a sound by turning his head in the direction of the stimulus. Auditory maturity parallels the development of language.

Tactility. For the maturing human organism to be efficient in its movement it must have tactile competence. Barsch defines tactility as "a system for gaining information from the cutaneous surfaces of the body by means of active or passive contact."* Touching and feeling involve the excitation of not only skin receptors but also the entire motor system. For example, it has been determined that a reflex action is elicited from the 10-week-old fetus when the sole of the foot is stroked. Tactility is, in essence, dependent on the ability to touch, move, and manipulate the environment. Through his tactile ability, the child can discriminate and discern familiar objects held in his hands. This is known as *stereognosis,* a quality very important to the eventual accomplishment of high-level motor tasks. The combination of feeling and movement is known as the *haptic sense.*

Stroking of the baby's skin at birth will elicit various skin reflexes such as the grasping reflex. A baby at approximately 5 months is able to differentiate and react to sensations that are important for its survival, such as pain, wetness, and temperature irregularities. At 13 months the infant can discriminate nonpain stimuli such as roughness or smoothness. At 16 months the young child becomes aware of the third dimension and that all objects are not flat but may have depth. At 2 years the child can feel and determine the difference in shapes of objects such as blocks or balls. However, it is not until approximately 4 years of age that he is able to accurately identify and describe the unique features of objects by their feel alone.

*Barsch, R. H.: Achieving perceptual motor efficiency, vol. 1, Seattle, 1967, Special Child Publications, Inc.

STAGES OF DEVELOPMENT
Early childhood

From birth to age 2 years, physical growth proceeds in much the same proportions as during prenatal development. Directional growth continues from head to foot and from the midline of the body outward. The 2-year-old child has progressed from the primarily reclining posture of a toddler, to moving with relative ease in the upright posture. He walks up and down stairs and runs without falling (Fig. 2-9). He balances on one foot for about 1 second, jumps in place, and pedals a tricycle. His speech has developed from babbling to three-word sentences, and he is able to identify some parts of his body or name a picture. At 2 years of age the young child has emotionally emerged from a period of being completely dependent for his basic needs to that of seeking independence and autonomy.

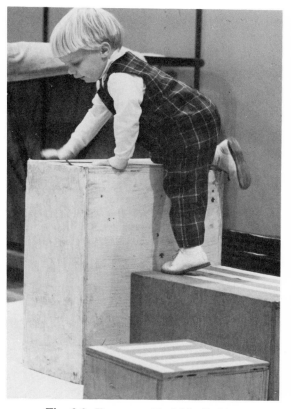

Fig. 2-9. Two-year-old child climbing.

The period from 2 to 6 years of age consists of leveling of the rapid growth characteristics. The single most outstanding attribute of infancy at this time is the increase in height. Leg length increases significantly as compared to trunk length. Espenschade describes the child's body at this time as developing toward a rectilinear and flat configuration.[51] The young child's weight gain can be attributed primarily to the ossification of bones and the presence of increased amounts of muscle tissue. Structural change follows closely the maturation of the motor system. Early childhood is a crucial time for acquiring motor skills basic to later success at play and cognitive development. Children who are denied the opportunities for full motoric experience at this level may be deficient later in activities requiring more complex movement proficiencies.

Social development. *Social competence* progresses in the individual child close in time with the development of motor abilities. The infant, until age 1 year, is mainly in an egocentric world concerned with immediate needs and comfort. The infant's social world is his parents and their approval. As the child becomes mobile and seeks independence from his early recumbent position, he may play side by side with another child, stimulated by the play situation but having no desire to interact. At age 3 or 4 years, the child may include another child in play, reciprocally interacting in some social manner. The 5- or 6-year-old child is ready emotionally to perform in groups of three or more, to abide by simple rules of a game, and to lead or to follow in an atmosphere of cooperation.

General motor control. The gross motor characteristics during early childhood are mainly involved with the development of locomotor skills. At 2 years of age, the child has a balanced walk that is rhythmically executed but not yet automatic. However, he can walk sideways and backward, run, ascend stairs, jump crudely from an elevation with two feet, kick and throw a ball, and attempt to stop a rolling ball.

At 3 years of age the child runs more

efficiently; walks upstairs using alternate feet; walks heel to toe along a line that is 10 feet long; hops one to three steps with both feet; jumps from a height of 18 inches with both feet; ascends and descends ladders, alternating feet; and throws a small ball from 6 to 11 feet.[17]

At four years of age the child runs efficiently, hops four to six steps on one foot, broad jumps 2 to 3 feet and throws a small ball 10 to 11 feet.[17] Although there are wide variations in motor ability among children, most are able to balance on one foot for several seconds, walk forward heel to toe, lace shoes, button clothes, draw a man containing three individual parts, and throw small balls 12 feet or more.

Body awareness becomes apparent when the toddler is able to identify a few large body areas such as the leg or arm. However, it is not obvious until 2 or 3 years of age when the child locates either verbally or by pointing, his "tummy," head, feet, front, back, side, and sometimes the smaller features of face, hands, and feet. It is not until he is about 4 years of age that the child becomes aware of the two sides of his body and totally aware of fingers, toes, and facial features.

Physical education programs in early childhood must be concerned mainly with basic motor pattern development. This will assure that each individual has the opportunity to reach full motoric maturity and develop basic skills essential for later success in games, sports, and cognitive development. Motor development programs provided for the preschool child should be prescriptive and be conducted at each individual's maturational and readiness level. Program offerings should be sequential and progressive in nature, one basic motor skill being constructed on another to eventually form efficient patterns of purposeful movement. (See Chapter 7.) A multisensory approach should be employed by the instructor to provide a wide variety of experiences for the child. Exploration of space is essential in motor development and the position the child takes in that space. Familiarization

Fig. 2-10. Exploring apparatus in a play situation.

by personal exploration of a wide number of objects and apparatus should be made available to the child in play situations (Fig. 2-10). Experiences in handling ropes, Hula-Hoops, climbing apparatus, balance apparatus, rebounding devices, balls, and bean-bags, to name a few, are important to the child's ultimate success in developing motor skills. (See Chapter 6.)

The primary child

By 5 years of age the young child's general motor control has matured to the extent that many patterns of movement are well defined. Locomotor patterns have progressed to the point that the child is able to skip and gallop smoothly, broad jump 2 to 3 feet, climb a high ladder with facility, easily descend stairs in an alternating manner, and engage in game activities (Fig. 2-11).

Fig. 2-11. Five-year-old child running smoothly.

In the primary childhood period also there is a more concise body awareness than in infancy. The 5- or 6-year-old child learns to identify left and right sides of the body, but it is not until he is 7 or 8 years old that laterality is well established. Sidedness is an important factor in the child's growing awareness of himself and how he relates to the space around him. At age 5 years the child realizes where he is in relation to other objects, at age 6 he can relate objects in terms of his left and right side, and at age 7 or 8 he identifies the left and right sides of other objects or persons.

Dynamic balance of the child has progressed to the point that he is able to walk a 10-foot walking board all the way to the end without stepping off, and static balance, to the point that he can maintain balance on one foot for 5 or more seconds (Fig. 2-12). Basic skills necessary for successful play are usually apparent in an unrefined form. Skills such as throwing, catching, striking, and kicking require coordination between the

eyes and limbs and appear early in motor development but mature slowly. At age 5 years the child can catch a bounced large playground ball, throw a large ball over 10 feet, strike a tennis ball on a string in side-arm fashion, and kick a playground ball that is rolling toward him slowly (Figs. 2-13 and 2-14).

Generally speaking, the sixth year of life is one of consolidation in the area of motor behavior. The child has acquired many basic patterns of movement, and then is the time to channel these into some functional and purposeful activities.

Middle childhood

Middle childhood, for descriptive purposes in this text, consists of the growth and development period from 6 through 8 years of age. This is a period in which previously acquired motor traits (characteristics) become more established into individualized movement behaviors. Characteristically, the child's rapid growth since conception slows down and becomes more stabilized, as depicted in the Meredith Growth Chart for girls and boys (Fig. 2-15). The child is more efficient and expends less energy in executing motor tasks. Having a backlog of movement experiences, the child is able to solve novel movement problems. This re-

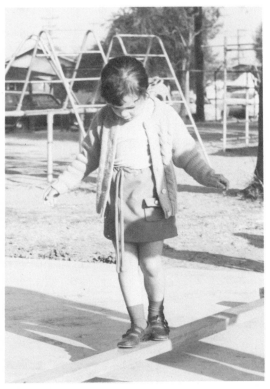

Fig. 2-12. Five-year-old child walking on a balance beam.

Fig. 2-13. Five-year-old child catching a ball.

Fig. 2-14. Five-year-old child jumping.

quires the ability to conduct motor planning and indicates the presence of neurological integration.

Physical education during this period should be directed at helping a child acquire as many movement experiences as possible. Every opportunity should be provided for exploring the environment through the major senses. Movement education (see Chapter 6) is provided for the major purpose of acquiring full sensory-motor awareness concepts of time and space and to integrate unique motor patterns into creative expression. This is a time when children respond very well to the learning of elementary stunts and self-testing activities. Varied gymnastic challenges provide the young performer with opportunities for increased

physical efficiency, particularly in the realm of strength and muscular control (Fig. 2-16). Games and relays at this level are geared to the needs and readiness level of each participant. Play activities for middle childhood should emphasize accuracy of movement, efficiency in gross and fine motor control, and more complex rules and regulations with concomitant values of sportsmanship and fair play. Rhythmic activities are essential during this period, requiring responses that are necessary for intentional and purposeful movement behavior.

Late childhood

Late childhood extends from 9 to approximately 12 years of age, or to the period of *pubescence*. The last stage of childhood is marked by the perfecting of skills acquired earlier. Many activities engaged in by adults will be emulated by children during this period. Skillful play becomes increasingly important to peer social acceptance. A child lacking in motor abilities may be relegated to marginal or less desirable social roles. The late childhood period is still characterized by slow, uniform growth as is the middle period. Physical efficiency factors of strength, flexibility, and endurance continue to increase along with abilities in complex movements (Fig. 2-17). It is commonly understood that infants and children may vary widely in their growth and development and still be considered in the normal range. This is particularly true of sexual maturity during adolescence. The *prepubescent* period is the immature period just before pubescence and is characterized by lack of reproductive functioning but with certain apparent body changes taking place. During the prepubescent period the child may show a weight and height increase with rapid development of strength, with the secondary sex characteristic of pubic hair being present. The age at which adolescence is reached is between 12½ and 14½ years for girls and 14 and 15½ for boys. Early-maturing boys and girls are larger in late childhood and reach their maximum growth in a relatively short period of time, whereas late maturers,

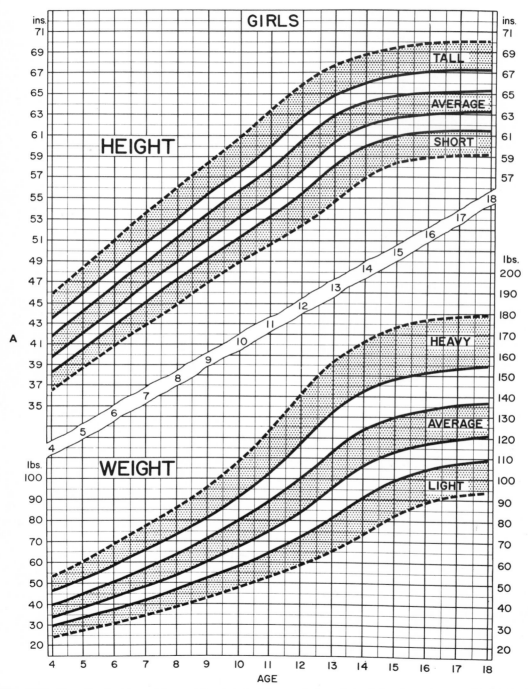

Fig. 2-15. Growth of girls and boys. (Reprinted with permission of the Joint Committee on Health Problems in Education of the National Education Association and the American Medical Association.)

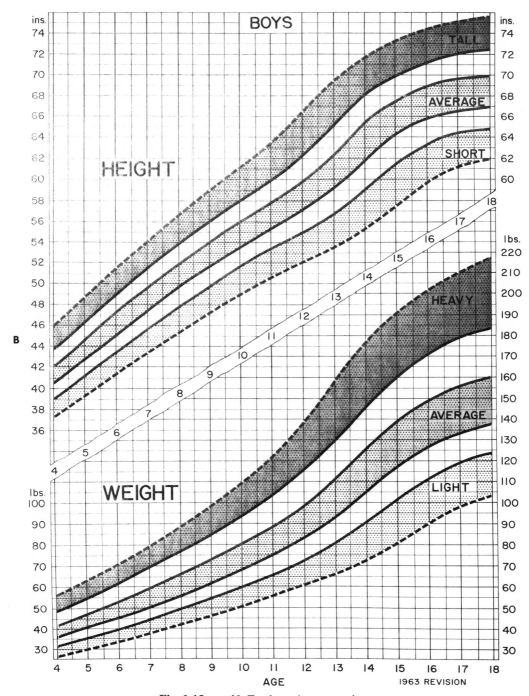

Fig. 2-15, cont'd. For legend see opposite page.

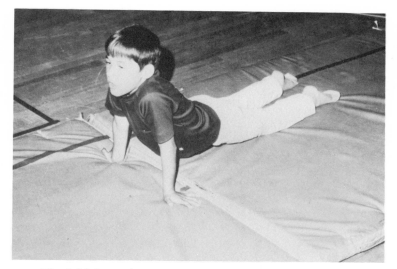

Fig. 2-16. Increasing arm strength by performing the seal walk.

Fig. 2-17. Free-form play.

who generally are small, reach full maturity slower and over a longer period of time.

The older child should have the opportunity to participate in a good physical education program. Such a program should promote maximum movement proficiency in a wide variety of activities. If the child has had a sound progressive motor development regime since infancy, he can be instructed in specific high-level movement skills. The most important program areas at this level are elementary gymnastics, including mat and apparatus stunts; contests involving the basic motor skill patterns of locomotion, posture, and object control; as well as the basic play skills of throwing, catching, striking, and kicking. Children should be taught the skills necessary for engaging in track events as well as games such as baseball, tennis, soccer, football, hockey, and basketball. Self-expression and socialization through dance must be available. Although physical efficiency is considered and striven for throughout the entire elementary physical education program, it should be specifically included as physical fitness exercises at the late childhood level. During this period, emphasis is given to physical fitness particularly in areas of strength, joint flexibility, endurance, and relaxation. (See Chapter 8).

MOTOR DEVELOPMENT THROUGH PLAY

Play is a general term often applied to any form of activity that is undirected, spontaneous, or engaged in randomly. All persons play in some setting before reaching maturity. Various reasons have been given by social scientists for why people play. In

Fig. 2-18. Developing socially through play. (Photo by Linda Brundage.)

essence, four main theories have been proposed to explain man's need for play: energy drainage, recreation-relaxation, phylogeny, and social interaction. Many think that play is mainly a means of expending energies that have built up and must be expressed in some form of large-muscle activity. Others believe that the individual has to be refreshed by a change of pace; consequently, playing games revitalizes and aids in recovering lost energy. Some theorists contend that man plays instinctively and needs to relive some primitive movements through play. Other theorists contend that because man is basically gregarious and social, play is a means of developing skills of "getting along with people." It might be speculated that all these theories contain some elements of truth; however, whatever theory scientists hold about play, they all agree it is necessary for normal growth and development. Without adequate opportunity for play, the individual will be unable to reach a full maturational potential.

Many of the movement patterns established in childhood are carried over to be expressed later as adult motor behavior. While playing, the child develops neuromuscular coordination and strength and has the opportunity to interact socially with other children (Fig. 2-18). Mild stresses imposed on the body through muscular action encourage its growth. Miniature life situations or problems are identified, solved, and retained for future use. Many adult values and attitudes toward life are deeply rooted in the play experiences of childhood. Children at play manifest their own particular maturational energy levels; for example, the immature infant's play activity is random, fleeting, and nonspecific and a great deal of energy is expended with little task accomplishment, whereas the older and more mature child's play is less random, and more is accomplished with greater efficiency and less energy expended.

The play environment is extremely important to the developing child. Ideally,

Fig. 2-19. Playing creatively.

nature provides all the ingredients for play that are required for developing to full maturity. Large expanses to run across, rocks to jump from, hills to struggle up, trees to climb, and stones to throw provide a setting beautifully suited to the growing child. However, urbanization has eliminated the fields to play in, concrete and asphalt have replaced the rolling hills, and signs are everywhere indicating, "keep off" or "don't." A child is seldom allowed to run free because of the safety factors involved. The confines of television watching are often more attractive than the activities of running and playing. If a child is to have full occasion to play in today's world, an artificial environment must be created for him. The world of home, park, and school should provide the opportunity for children of all ages to gain those experiences necessary for efficient locomotion, balance, and control of various objects (Fig. 2-19).[71]

RECOMMENDED READINGS

Cratty, B. J.: Perceptual motor and educational processes, Springfield, Ill., 1969, Charles C Thomas, Publisher.

Espenschade, A., and Eckert, H.: Motor development, Columbus, Ohio, 1967, Charles E. Merrill Publishing Co.

Florentino, M. R.: Reflex testing methods for evaluating C.N.S. development, Springfield, Ill., 1963, Charles C Thomas, Publisher.

Foundations and practices in perceptual motor learning—a quest for understanding, Washington, D. C., 1971, American Association for Health, Physical Education, and Recreation.

Gesell, A., and Amatruda, C. S.: Developmental diagnosis, New York, 1947, Harper & Brothers.

Le Winn, E. B.: Human neurological organization, Springfield, Ill., 1969, Charles C Thomas, Publisher.

O'Donnell, P. A.: Motor and haptic learning, San Rafael, Calif., 1969, Dimensions Publishing Co.

Piaget, J.: The origins of intelligence in children, New York, 1936, New York University Press.

Wickstrom, R. L.: Fundamental motor patterns, Philadelphia, 1970, Lea & Febiger.

Chapter 3

Perceptual-motor development

Current curriculum trends in education and particularly in physical education are encompassing programs designed to alter and, hopefully, favorably change the perceptual-motor behavior of children. These have been variously titled *Movement education, educational gymnastics, movement exploration,* and *perceptual-motor development* programs. Although often different in their application and approach, these programs are basically concerned with helping the child as a learner. In this discussion the terms "sensory-motor" and "perceptual-motor" will be considered as synonymous. On the other hand, movement education, although containing sensory-motor components, will be considered as being on a higher and more complex level in the development of motor behavior. The perceptual-motor process is simply defined as the management of information coming to the individual through the senses, the processing of the information, and then the reacting in terms of overt motor behavior (Fig. 3-1). Although stated simply, in reality the perceptual-motor process is extremely complex, requiring many interrelationships of abilities on the part of the processor. Sensory information is first recognized, discriminated, and selectively carried through nerve pathways to various levels of the brain. The initial reception of information is conducted through the primary channels of sight, hear-ing, feeling, and proprioception. Sensory information must then be processed for current or future use. All information is compared, integrated, and stored within the brain on the basis of previous experience of the individual. Information is expressed as a constant source of covert feedback impulse that then provides a continual means for adjusting to current or future motor behavior.

Perception cannot be separated from cognition; they must be considered as inseparable, dependent, and reciprocal. To have a thought, a person must receive and perceive hundreds on thousands of impulses from external and/or internal stimuli. From the time of conception the individual is perceiving and reacting to his environment.[13] Barsch, considering perception as the economy of the intellect, states: "It [perception] becomes a way of having experiences on a continuing basis without having to repeat them. As you perceive, it takes less and less of the original experience to recall the total experience to you."*

A breakdown at any point along the perceptual chain of events can lead to dysfunction of any one or all of the processes, for example, difficulty in information retrieval,

*Barsch, R. H.: Enriching perception and cognition, vol. 2, Seattle, 1968, Special Child Publications, Inc.

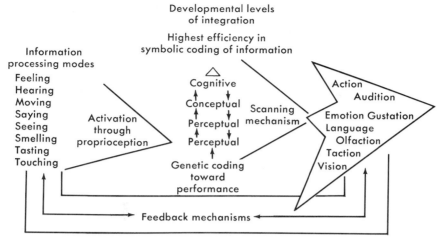

Fig. 3-1. Conceptual model of a functional learning system. (From Sheldon R. Rappaport, Effective Educational Systems, Inc., Onancock, Va.)

an inability to differentiate stimuli, or faulty movement behavior. In physical education, the performing child with perceptual-motor dysfunction may be considered awkward or clumsy while on the playground. The same child may or may not be able to cope with the many discrete symbols or fine motor coordinations required of him in the classroom. (See Chapter 9.)

FACTORS IN PERCEPTUAL-MOTOR TRAINING

Most educational programs that today base their approach on enhancing the perceptual-motor process are for the most part empirical. Seefeldt contends that most of the perceptual-motor systems in vogue today utilize, to some extent, recapitulation of early motor patterns, cerebral dominance, the intensity of training, and the effect of environmental stimulation on the developing child.[146]

Many classroom and physical education curriculums today depend heavily on the precepts of sequential development. As discussed in Chapter 2, maturation basically follows an orderly sequence of events that is characteristic of all human beings and yet unique for each person. In observing his orderly development, man has created labels to identify human milestones and ages. The emergent human organism is carefully plotted, scheduled, and staged in reference to what may be considered a normal chronology of sequential development.[67, 130, 137] Children who fall outside a normal pattern of development are thought to be atypical. Many theorists believe that skipping or inadequately experiencing developmental steps will produce harmful consequences.[146] Because of this belief, many educational and clinical programs have the child experience specific missed developmental events. Experimental data at this time fails to concur with this point of view. There is little evidence that experiencing skipped events directly helps children to become better learners; however, there are indications that children having a lack of proficiency in specific motor skills may benefit indirectly from the developmental sequence approach. Such concomitants as increased self-confidence, better interest in school, and a positive self-concept are but a few benefits that could arise from a sequenced developmental program.

Cerebral dominance

Neurological organization, cerebral dominance, and laterality have all played a direct or indirect role in many programs designed to improve sensory- or perceptual-motor

functioning. Some professionals in this area contend that mixed, latent, or undetermined preference for parts on one side of the body, primarily the eye, ear, hand, and foot, is predictive of or a causative factor in poor classroom achievement and motor skill.[41] Current data do not substantiate that having cross-hemispheric cerebral control will produce a more or less proficient learner.[33] However, there are indications among some exceptional children who have mental deficiencies and/or perceptual-motor dysfunctions of a higher percent of mixed dominance and left-handedness than among normal children.[8, 51] It is generally conceded that a deficit in the integration of the two halves of the brain may ultimately result in a lack of internal lateral awareness (laterality) of the body, which in turn, may prevent the development of a directional or spatial awareness, a quality that is apparent in good motor coordination and symbolic learning.

Postural control

Many perceptual-motor programs stress activities that enhance posture and gross muscle control, with hopes that it will aid individuals in their cognitive development. Some authorities consider sound gross muscle development necessary before the fine muscle control required for near-point activities can be efficiently conducted. The optometrical field stresses the importance of proper postural and large-muscle activities in the development of normal vision and ultimately of skill in learning symbolically. Errors in the perceptual process and learning disabilities have been attributed, in part, to maturational lags, neurological dysfunctions, or lack of experience that may have stemmed from inadequate postural adjustment to the force of gravity.[64, 96] (See Chapter 9.)

Perceptual-motor training in the classroom

Generally speaking, perception is the process of interpreting stimuli through the senses that has been predetermined by past experience. Consequently, perception must be considered as a function that can be learned and modified by varying the environment. Education, therefore, should provide a rich source of different experiences that are designed to enhance the perceptual-motor process (Fig. 3-2). Classroom education as well as physical education can aid the child in accurately interpreting sensations that are emitted by the surroundings. Learning is defined as a "modification of behavior through experience, involving growth as a response to stimulation, and dependent upon the intent or the will to learn, or motivation."* No matter what the age or maturation level of the learner is, learning is accomplished through the sense channels of olfaction, gustation, vision, audi-

*Van Witsen, B.: Perceptual training activities handbook, Columbia University, New York, 1967, Teachers' College Press.

Fig. 3-2. Child increasing development of perceptual-motor process.

tion, tactility, and kinesthesis. A teacher concerned with perceptual-motor development creates maximum experiences through the varied senses.

Visual-motor skills

Vision, discussed in Chapter 2, is highly complex, involving much more than the sharpness of vision. Valett states the educational rationale for vision: "What an individual sees is the result of a psychophysical process which integrates gravitational forces, conceptual ideation, spatial-perceptual orientation, and language functions."* For learning to occur efficiently through vision, the eyes must focus readily on the intended object and function symmetrically. Vision basically means the differentiation of shapes and configurations and remembered sights. In order to be more successful in the classroom, the child must have the ability to translate symbols and reproduce them on paper through the coordinating of fine manipulations and tactility of the hands (Fig. 3-3).

Visual acuity. This refers to the individual's ability to discriminate between symbols within his personal field of vision. Normal visual acuity is considered the ratio of 20/20, or in other words, what the aver-

*Valett, R. E.: The remediation of learning disabilities, Belmont, Calif., 1967, Fearon Publishers.

age person can see at a distance of 20 feet. A child indicating difficulty in seeing details clearly at a distance may squint in an effort to see more distinctly or may prefer near-point indoor activities to outdoor playing. Blurred vision, eye fatigue, headaches, and dizziness are often complaints of children having a defect in visual acuity.

Visual coordination. Visual coordination, or ocular control, is binocularity or the teaming of eyes when reading or pursuing an object in space. Ocular-motor coordination involves the following important functions:

1. *Fixation.* The ability of accurately directing the eyes toward a specific point. Ideally, the child should be able to make rapid visual adjustments or accommodations between near-point and far-point objects.
2. *Visual pursuit.* The ability of accurately tracking objects moving in space (Fig. 3-4).
3. *Convergence.* The turning inward of the two eyes toward the nose as they focus on objects at different distances from the face. The two eyes increasingly turn equally inward as objects become nearer to the viewer.

Coordinated eye movement is essential for success in symbolic learning situations, particularly in reading and writing, as well as

Fig. 3-3. Child developing fine motor control.

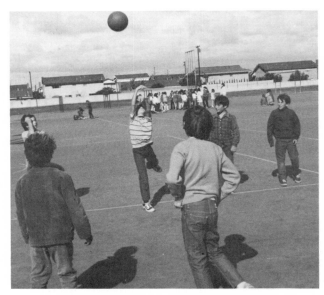

Fig. 3-4. Children pursuing a moving object.

for success on the playground, where object management is so critical in games and sports activities.

Visual-motor and visual form discrimination. These discriminations relate to the recognition of differences in shapes and symbols found in the environment. Children having this ability are able to match or clearly differentiate like and unlike symbols, designs, letters, and eventually words through visual cues. This is a necessary factor before classroom motor skills can be learned. It also refers to three-dimensional forms in space that combine the sensory input of sight and feel. The child is capable of matching solid objects by both seeing and feeling them.

Visual figure-ground discrimination. This is the recognition of meaningful differences in objects with varying foregrounds and backgrounds. This perceptual skill requires the child to be able to concentrate and focus attention on a visual stimulus. Without it, there is an inability to pick out or select pertinent symbols from the environment. Dysfunction in this area is reflected in physical education when a child is unable to catch, bat, strike, or kick a moving object consistently because it is lost in the varied background of sky, trees, and buildings. (See Chapter 9.)

Visual memory. Visual memory or retention relates to the ability to retain and recall accurately visual experiences after a time period has elapsed. Visual memory is determined by how well the child is able to retrieve stored information when provided with a set of visual cues. The capability of translating the process of visual memorization into some motor act such as throwing a ball or writing a letter is known as the combined skill of visual-motor retention. It allows the child to recall learned visual experiences and respond motorically with a logically ordered series of acts.

Visual-motor and hand coordination. This coordination is essential for manipulative tasks. Motor tasks requiring detail or accuracy involve the synchronization of many small muscles of the hand coordinated with the visual apparatus. Such skills as lacing shoes, stringing beads, throwing at a target, and kicking a rolled ball require the synchronization of small and large skeletal muscles along with visual adaptation for their accomplishment (Fig. 3-5).

Visual-motor learning. This refers to the learning of visual-motor skills through

Fig. 3-5. Child lacing for visual-motor control.

a process of repetitively seeing a movement sequence. In many activities, rote memorization is required for visual learning of tasks that are logically ordered and sequenced. For example, spelling and arithmetic as well as serving of a tennis ball require a high degree of visual-motor sequential learning.

The ultimate in seeing is visual-motor integration—the utilization of all the visual-motor skills in a highly sophisticated manner. With visual-motor integration the child is able to solve a multitude of complex visual-motor problems. The child is able to learn and play games and sports that involve a high degree of coordination between eyes, hands, feet, and large and small muscles. The child can play ball-handling games and team sports as well as draw and reproduce accurate symbols with pencil and paper. In addition to the other attributes, a visually well-integrated person is able to produce *eidetic imagery* ("seeing with the mind's eye"). In other words, a participant is able to reproduce within the mind a picture of past movement experiences that is utilized for current and future motor responses. Consequently, the eidetic imagery can serve as a means to mentally practice an activity, thereby helping to eliminate past

errors in a movement sequence skill. Visualization of a task to be performed has definite ramifications for the development of gross and fine muscle activities.

Auditory perceptual-motor skills

Audition, like vision, consists of a number of discrete processes, some of which are auditory acuity, auditory discrimination, auditory-vocal association, auditory memory, auditory sequencing, and auditory integration.

Auditory acuity. This acuity is concerned with the ability to discern auditory stimuli. Two very important factors composing auditory acuity are the ability to attend or listen and the ability to locate sound direction. Acuity is enhanced by activities that encourage identification of sound direction, sound distance, and discrimination between high and low as well as loud and soft sounds.

Auditory-motor discrimination. This process is the distinguishing of the difference between various meaningful sounds. It includes auditory figure-ground discrimination, in which, as in visual figure-ground discrimination, the perceiver is able to pick out specific tones and frequencies from a com-

plex background of sounds.[153] Also, auditory discrimination consists of understanding of spoken words, and the motor capability of matching and duplicating sounds verbally, such as imitating animal noises or producing rhyming words.

Auditory-motor rhythm perception. This involves the recognition of sounds patterned in a predictable and organized series. It consists of identifying tempo and accent rhythm patterns.[153] Rhythm experiences through the auditory mode are essential to the young child in developing temporal and spatial awareness. (See Chapter 8.) Combined with motor responses such as playing a musical instrument, dancing, or singing, auditory rhythm perception provides a medium for self-expression.

Auditory memory and sequencing. Auditory memory is the retaining and recalling of information as the result of the input of auditory stimuli. Children must be able to rapidly retrieve correct information when given an auditory stimulus and to express it by either a verbal or a movement response. Auditory sequencing is a direct extension of auditory memory. The child retains information in a logical order, recalling and expressing in accurate sequential order. Activities like singing songs, telling stories, or carrying out a series of movement instructions require the ability to retain the memory of a sound and then pull it out of the memory bank to relate it to the activity in a meaningful way.

Auditory perception is extremely important to classroom learning. Children who misinterpret sounds or are unable to respond correctly to auditory cues may find difficulty in reading, understanding printed matter, or understanding or responding to verbal directions. The dual abilities of hearing and moving are utilized to a great extent in physical education. The child may move to verbal directions by the teacher, or, he may show the paired response of audition and movement that is stimulated by a rhythmic cadence. A well-planned and well-initated physical education program assists in the integration of the auditory mode in its sensory input and motor output. Through the mediums of elementary rhythms and dance the child can develop the auditory-motor perceptual process. (See Chapter 12.)

Tactile perception

Tactile perception develops early in prenatal development, with receptors of touch highly concentrated in and around the mouth area as well as in the fingers and palms of the hands and soles of the feet. Development of touch progresses in the direction typical of other processes, from head to feet and from the midline outward. Tactile awareness can be developed in

Fig. 3-6. Child manipulating objects without visual assistance.

Fig. 3-5. Child lacing for visual-motor control.

a process of repetitively seeing a movement sequence. In many activities, rote memorization is required for visual learning of tasks that are logically ordered and sequenced. For example, spelling and arithmetic as well as serving of a tennis ball require a high degree of visual-motor sequential learning.

The ultimate in seeing is visual-motor integration—the utilization of all the visual-motor skills in a highly sophisticated manner. With visual-motor integration the child is able to solve a multitude of complex visual-motor problems. The child is able to learn and play games and sports that involve a high degree of coordination between eyes, hands, feet, and large and small muscles. The child can play ball-handling games and team sports as well as draw and reproduce accurate symbols with pencil and paper. In addition to the other attributes, a visually well-integrated person is able to produce *eidetic imagery* ("seeing with the mind's eye"). In other words, a participant is able to reproduce within the mind a picture of past movement experiences that is utilized for current and future motor responses. Consequently, the eidetic imagery can serve as a means to mentally practice an activity, thereby helping to eliminate past

errors in a movement sequence skill. Visualization of a task to be performed has definite ramifications for the development of gross and fine muscle activities.

Auditory perceptual-motor skills

Audition, like vision, consists of a number of discrete processes, some of which are auditory acuity, auditory discrimination, auditory-vocal association, auditory memory, auditory sequencing, and auditory integration.

Auditory acuity. This acuity is concerned with the ability to discern auditory stimuli. Two very important factors composing auditory acuity are the ability to attend or listen and the ability to locate sound direction. Acuity is enhanced by activities that encourage identification of sound direction, sound distance, and discrimination between high and low as well as loud and soft sounds.

Auditory-motor discrimination. This process is the distinguishing of the difference between various meaningful sounds. It includes auditory figure-ground discrimination, in which, as in visual figure-ground discrimination, the perceiver is able to pick out specific tones and frequencies from a com-

plex background of sounds.[153] Also, auditory discrimination consists of understanding of spoken words, and the motor capability of matching and duplicating sounds verbally, such as imitating animal noises or producing rhyming words.

Auditory-motor rhythm perception. This involves the recognition of sounds patterned in a predictable and organized series. It consists of identifying tempo and accent rhythm patterns.[153] Rhythm experiences through the auditory mode are essential to the young child in developing temporal and spatial awareness. (See Chapter 8.) Combined with motor responses such as playing a musical instrument, dancing, or singing, auditory rhythm perception provides a medium for self-expression.

Auditory memory and sequencing. Auditory memory is the retaining and recalling of information as the result of the input of auditory stimuli. Children must be able to rapidly retrieve correct information when given an auditory stimulus and to express it by either a verbal or a movement response. Auditory sequencing is a direct extension of auditory memory. The child retains information in a logical order, recalling and expressing in accurate sequential order. Activities like singing songs, telling stories, or carrying out a series of movement instructions require the ability to retain the memory of a sound and then pull it out of the memory bank to relate it to the activity in a meaningful way.

Auditory perception is extremely important to classroom learning. Children who misinterpret sounds or are unable to respond correctly to auditory cues may find difficulty in reading, understanding printed matter, or understanding or responding to verbal directions. The dual abilities of hearing and moving are utilized to a great extent in physical education. The child may move to verbal directions by the teacher, or, he may show the paired response of audition and movement that is stimulated by a rhythmic cadence. A well-planned and well-initated physical education program assists in the integration of the auditory mode in its sensory input and motor output. Through the mediums of elementary rhythms and dance the child can develop the auditory-motor perceptual process. (See Chapter 12.)

Tactile perception

Tactile perception develops early in prenatal development, with receptors of touch highly concentrated in and around the mouth area as well as in the fingers and palms of the hands and soles of the feet. Development of touch progresses in the direction typical of other processes, from head to feet and from the midline outward. Tactile awareness can be developed in

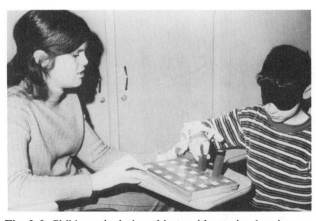

Fig. 3-6. Child manipulating objects without visual assistance.

a progressive manner by experiencing the differences between flat surfaces, such as rough and smooth, hot and cold, sharp and blunt, soft and hard, wet and dry, and sticky and greasy. Identification of shapes usually follows surface discrimination. By feel, the child learns to distinguish between basic geometrical shapes such as circles, squares, rectangles, and other more complicated forms. Later the child has the ability to identify and label a variety of objects without visual assistance, just by feel (Fig. 3-6). The classroom teacher may even go a step further and use the sense of feel in learning letters and numbers. A classroom activity that is both challenging and exciting to children of all ages is the "feely box" game, in which each child is asked to reach into a bag filled with different common objects and identify them by touch.

Physical education can provide a rich source of tactile stimulation for the maturing child. Activities such as swimming, crawling, and rolling allow the child to feel his environment through the entire body. As many varied touch experiences as possible should be provided for the child; for example, he should be allowed to play with bare feet on different textures such as grass, dirt, or surfaces that are flat, rough, or hilly.

Kinesthesis

Kinesthesis is the perception of movement, or the muscle sense. It is the awareness of body movement and its relative position in space. Oxendine attributes three major areas of sensory perception to kinesthesis: awareness of the position of the body segments, precision of movement, and balance and spatial orientation.[128] Kinesthesis is primarily based on the internal stimuli from sense receptors, called proprioceptors, located in muscles, tendons, and joints as well as from the semicircular canals in the inner ear. The proprioceptors provide a continuous feedback of information to determine bodily orientation and muscular tension levels. Because kinesthe-

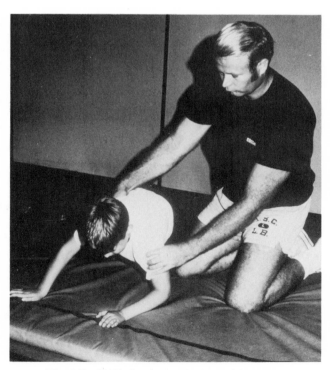

Fig. 3-7. Child developing body position sense.

sis is a complex of many independent and interdependent constituents, it cannot be considered a general trait.[101, 150] Therefore, "body sensation" must be considered a compilation of many specific abilities. Consequently, the more varied movements and positions a child can experience, the more opportunities he has to learn skilled motor behavior (Fig. 3-7).

Balance. Balance, or equilibrium, is highly integrated with kinesthetic awareness and is defined as the state of maintenance of a bodily position. Balance involves a number of neurophysiological functions, such as vision, labyrinthine or vestibular stimulation, neck reflexes, and the tactile sense combined with the very important proprioception. Together with the internal senses of proprioception and the vestibular system, vision provides the individual with external information as to his position in space.

The vestibular apparatus consists of semicircular canals containing a fluid called endolymph. Rotation and gravity are sensed by receptors located at the end of these canals. In general, the vestibular apparatus aids the individual in being aware of postural positions and changes in acceleration and coordinates with visual, tactile, and proprioceptor systems in providing guidance in movement. Without a normal vestibular apparatus, the child will find great difficulty in balancing and rebounding activities.

Sensory-motor integration. Sensory-motor integration is the bringing together of all the elements of perception to form a well-coordinated, functional whole. Chaney and Kephart refer to sensory-motor integration as perceptual-motor matching in which a perceiver utilizes a number of senses to establish identity with the environment.[23] In other words, a child learning the concept of *round* sees it, feels it, and hears the word. All these senses—vision, feel, and audition —coincide to form a constancy of perception. In order for a child to make comparisons and varied responses to his environment, he must have stored a backlog of perceptual experiences. It is essential that a child have in his repertoire a great variety

of perceptual-motor experiences through play and general movement activities. Such a backlog of experiences allows *motor planning* to take place without prior instruction. A motorically well-integrated person can make instantaneous perceptual-motor decisions when he is confronted with unique movement problems.

EDUCATION AND THE PERCEPTUAL-MOTOR PROCESS

A wide variety of perceived responses related to past experiences, accurately interpreted, and properly stored provide the learner with information that can be used for solving current or future motor problems. Each set of adequately stored experiences can be selected and retrieved for use in other motor performances. Consequently, the classroom teacher and the physical education teacher working together should give the child every opportunity for a variety of experiences in movement. The learner must be continually provided with movement problems within his capability to solve. Perception develops as the performer struggles for mastery over each problem. When the task at hand no longer presents a challenge to the learner, the perceptual process fails to be stimulated (Fig. 3-8). To aid the child in perceptual development, the teacher must provide motor problems that are outside the immediate motor repertoire but that are similar to the previously accomplished task. In other words, the learner is perceptually stressed by engaging in a particular unique motor task. (See Chapter 7.) Motivated and challenged by a novel experience, the learner struggles for understanding and mastery.

As is every segment of education, physical education is vitally concerned with improving the learning process and the potential of an individual to learn. It is the intent of perceptual-motor training in physical education to offer the child a repertoire of movement experiences that will raise his level of learning effectiveness. Perceptual-motor efficiency is necessary for success in game skills, and perceptual-motor

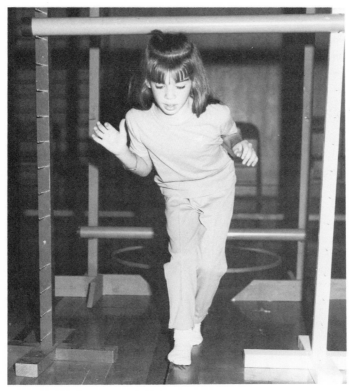

Fig. 3-8. Child struggling for mastery over perceptual problem.

programs are particularly important to the young child. A child lacking a rich background of movement and perceptual experiences may be impaired not only in motor skills but also in his social and emotional development as well. Perceptual-motor deprivation can have lasting adverse affects on the emerging individual. (See Chapter 9.)

Motor development in physical education

In contrast to the "games approach" during early childhood, perceptual-motor training as part of physical education is concerned with the child's developmental requirements. Historically children have been assigned games to play without thought as to their biological maturity or readiness to learn specific skills. We contend that perceptual-motor training cannot be separated from good physical education. It must be considered a necessary approach during early childhood and for older children in need of specific movement intervention because of a maturational lag or neurological dysfunction. Motor development programs designed to enrich the perceptual environment of the young child contain activity opportunities in the large areas of general total-body management, object management, and emotional control. Specifically, a perceptual-motor training program should include logically sequenced task areas utilizing a multisensory approach.

In physical education the sense channels of vision, kinesthesis, and audition are primarily utilized to accomplish motor skills. Seldom are these sense modes used singularly but are interwoven in a complex fashion to accomplish the desired movement. The combined senses of movement and touch, or haptic sense, provide the organism with valuable information from the environment. Certain senses may pre-

dominate, depending on skill requirements. For example, vision may predominate in controlling objects, such as in catching a thrown ball, but kinesthesis cannot be discounted in initiation of the muscle control to actually catch the ball. Kinesthesis may be the important sense in the process of executing large-muscle activities such as bouncing on a trampoline; however, vision is very helpful in maintaining body orientation while a person is suspended in air. Although used less extensively, audition is important in the areas of dance and rhythmic type stunts and gymnastics.

Important in all motor skill development are the perceptual components of general motor control and general motor skill development. In order to attain general motor control, the child must achieve an individual level of physical efficiency in terms of muscular strength, muscular endurance, joint flexibility, and stamina; he must also acquire basic motor control involving coordination in balance, use of large and small muscles, and the combining of eye and hand, and eye and foot. General motor skills are acquired through the learning of movement patterns such as locomotion and regulation of objects and the development of basic play skills such as throwing, catching, striking, and kicking.

Teacher cooperation

The classroom teacher and the physical educator should work together in helping a child to reach full motoric development. Through an understanding of the individual child's needs both inside the classroom and outdoors on the playground, perceptual-motor activities can be provided that will complement one another. For example, a child having spatial difficulties causing a reversal of words or letters may be aided by developing a lateral body awareness in playing activities on the playground. As was mentioned earlier, some children are more movement oriented than others; these children may learn classroom activities by putting themselves more physically into the learning task, for example, by walking through the alphabet or playing

hopscotch games on numbers requiring addition, subtraction, or multiplication.

However, it is an error to conclude that successful engagement in a wide variety of motor activities will automatically produce a more efficient classroom performer or that the motor skills of reading, writing, and arithmetic will suddenly become apparent. Research indicates that perceptual-motor skill is, for the most part, specific and not carried over to other areas of learning automatically. It must be transferred by indicating the relationship to similar activities; for example, the teacher must point out how a physical activity such as hopscotch spelling is like paper and pencil spelling. (See Chapter 7.) Many physical education outcomes may aid the learning process in the classroom. A child may find a great deal of success at play, acquiring self-confidence and a favorable self-concept. Such a child may become happy at school and, consequently, motivated to learn. A successful player is usually more physically efficient, with increased alertness and less fatigue, which increases the ability to engage in classroom motor activities.

RECOMMENDED READINGS

Auxter, D.: Developmental physical training for better motor functioning, experimental edition, Western Pennsylvania Special Education Regional Resource Center, 1969.

Hebb, D.: Organization of behavior, New York, 1949, John Wiley & Sons, Inc.

Perceptual-motor foundations: a multidisciplinary concern. Proceedings of the Perceptual-Motor Symposium sponsored by the Physical Education Division of American Association of Health, Physical Education, and Recreation, Washington, D. C., 1969.

Robb, M. D., et al., editors: Foundations and practices in perceptual motor learning, Washington, D. C., 1971, American Association for Health, Physical Education, and Recreation.

Seefeldt, V.: Perceptual motor skills. In Montoye, H. J.: An introduction to measurement in physical education, vol. 2, Bloomington, Ind., 1970, Indiana University Press, Phi Epsilon Kappa Fraternity.

Valett, R. E.: The remediation of learning disabilities, Palo Alto, Calif., 1967, Fearon Publishers.

Wold, R. M., editor: Visual and perceptual aspects for the achieving and underachieving child, Seattle, 1969, Special Child Publications, Inc.

II

Implementation of the program

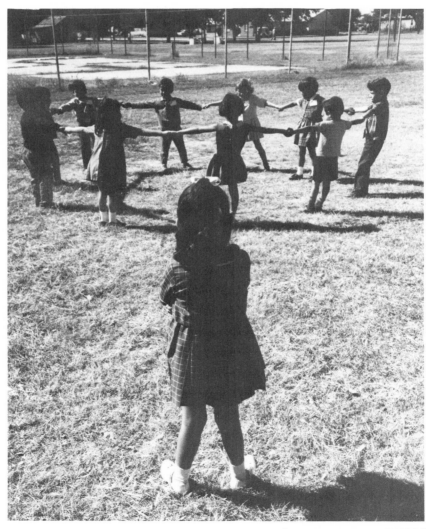

(COURTESY MICHAEL D. SULLIVAN.)

Part II gives a thorough discussion of the teacher's role in planning and implementing a program of elementary physical education. Suggestions are provided for the practical application of techniques in teaching and administering the highly successful program.

Chapter 4

The teacher

Learning occurs more effectively and efficiently when proper guidance and direction are provided. A well-prepared and well-qualified teacher has a great influence on the amount of learning that will take place. The interest of the teacher in his students combined with the knowledge of his field is the foundation for successful experiences in physical education activities. Children are quick to respond to a teacher who sets the example by displaying interest and enthusiasm in the subject matter presented. Teaching is recognized as both an art and a science and as such allows for the development of meaningful learning experiences. The teacher as a leader guides the child along the correct learning paths, the result being desirable behavioral changes. To provide each child with the kind of change in behavior that will enhance his position in society is the role the physical education teacher must play.

Learning to enjoy wholesome physical activity is an identifiable objective of our contemporary society. The teacher who strives for excellence will accomplish this objective through hard work and a desire to be remembered as a good teacher who was successful in his instructional endeavors.

PROFESSIONAL PREPARATION

Elementary school physical education teachers should have a thorough understanding of human movement, child growth and development, and contemporary learning theories and techniques combined with a desire to work with children. An adequate program of professional preparation for elementary physical education teachers should include the following aspects:

1. Instruction and practice in the fundamental game skills commonly taught in the elementary schools
2. Instruction and practice in the fundamental rhythm skills commonly taught in the elementary schools
3. Analysis and practice in fundamental skills, gymnastics, combatives, track and field, and perceptual-motor activities for elementary school children
4. Knowledge of the application of principles of anatomy and physiology to the motor performance of children
5. Proficiency in the techniques of movement exploration as applied to the learning of dance and game activities
6. Knowledge of contemporary methods and techniques applied to the presentation of traditional physical education activities in the elementary school
7. Knowledge of the principles of motor learning as applied to elementary-age children

8. Proficiency in the sensory-motor approach to developing motoric sophistication in children
9. Knowledge of the principles, aims, and objectives of elementary school physical education as related to curriculum development

The physical education specialist and the supervisor of physical education should complete additional course work in preparation for effective leadership in public school physical education programs. Since the teacher of physical education in a self-contained classroom will likely have had no more than one course in physical education in preparation for teaching in this area, much can be accomplished through in-service training programs administered by a specialist or supervisor of physical education. When classroom teachers are responsible for teaching physical education, it is imperative that a plan be developed in which regular leadership and guidance are given by qualified resource people who are experienced in elementary school physical education (Fig. 4-1).

CLASSROOM TEACHER AND PHYSICAL EDUCATION

In a self-contained classroom the teacher has the advantage of being responsible for all subject areas taught. It is much easier for the teacher to coordinate the learnings in the other aspects of the educational program with physical education when he is involved in the total program. It is quite easy for the classroom teacher to determine whether it would be beneficial to teach an American folk dance when the children are studying early American history or more advantageous to present dance as a self-contained unit. Coordinating physical education activities with English, math, and social studies can readily be accomplished when one is responsible for designing the total curriculum of the children involved. However, proper guiding of the learning experiences in the most successful manner demands preparation and understanding of physical education activities. It is also easier to allow for continuity of experiences and to provide for proper emphasis in physical education activities in relation to the total school program.

PHYSICAL EDUCATION SUPERVISOR

Although the supervisor of physical education seldom gets directly involved with the teaching of children, it is his responsibility to work with the teacher in the self-contained classroom or the physical education specialist by helping him to design suc-

Fig. 4-1. Teacher working with child.

cessful curriculum plans, and to act as a resource person in suggesting new and innovative ideas in material presentation. A supervisor of physical education must continue to improve his knowledge of physical education by attending state and national conferences, and he must carry the material back to his colleagues. A supervisor of physical education should continually draw on his personal experiences and share his knowledge and training with the teachers with whom he works. A good supervisor will instill enthusiasm into his teachers and encourage continued development of successful physical education programs.

PHYSICAL EDUCATION SPECIALIST

The physical education specialist should be an involved staff member of the total elementary school program. It is increasingly important for this individual to be aware of the classroom activities of each group of children involved, since coordination between classroom and playground must take place if integration is to be accomplished. The specialist should work closely with the classroom teacher in developing physical education activities. Although the classroom teacher has a greater opportunity to know the children in a variety of situations, it is the responsibility of the physical education specialist to obtain as much knowledge as possible about the children with whom he works. The kinds of behavior exhibited by certain children in the classroom should lead to the development of a physical activity program that will enhance the individual needs of those involved. Since the specialist should have a greater amount of information and ability regarding physical activity programs and their value for the children in the elementary program, it should be his responsibility to act as the voice of the school in matters pertaining to physical education. There should be no one better prepared to interpret what is happening in the physical education class to parents and other interested community participants than the specialist in physical education.

The specialist should have a greater wealth of material and have a greater knowledge of the variety of games and approaches to teaching physical activities than the classroom teacher. This knowledge should aid in the development of programs that are best suited for the various age groups involved. Working with the classroom teacher and sharing ideas regarding the total educational experience is a major responsibility of the physical education specialist (Fig. 4-2).

Attitudes

Children are quick to observe the attitude that a teacher has toward presenting a particular subject to them. It is imperative that the teacher of physical education maintain the attitude that physical education is an important phase of the total educational process. The teacher of elementary physical education finds little difficulty in motivating children in movement activities; however, a lack of teacher interest and the inability to provide exciting and interesting activities through a behavioral approach can turn the physical education period into one of boredom and unhappy experiences. The teacher will have difficulty in helping the children to develop a favorable attitude toward physical education if he himself is not convinced that the activity has worth in the educational program. If all children are able to participate in activities that are fun and that are suited to their individual needs and if they understand the value of that activity to themselves, the teacher of physical education will have provided a safe and challenging environment in which attitudes should develop in a favorable manner.

Humor

The ability to laugh at his own successes and inadequacies is a trait that each teacher of physical education should possess. At the end of a tiring day when his patience has been tried to the breaking point, the teacher with a sense of humor can salvage a potentially damaging situation and turn it into one that is fun for all. In order to make

Fig. 4-2. Physical education specialist introducing a lesson.

Fig. 4-3. Teacher encouraging proper jumping techniques.

teaching a rewarding and satisfying experience for both the teacher and the student, it is necessary to maintain a good sense of humor. The more trying the experience is, the more important it is to laugh. Having fun is one of the greatest motivating factors a teacher can utilize in presenting a successful lesson in physical education.

Enthusiasm

Each teacher should possess a genuine enthusiasm toward physical education activity. The children should observe a behavior that presents physical education as the greatest subject in the school curriculum. A lack of enthusiasm can lead to other faults in developing a successful program, such as failing to prepare adequately for the lesson to be taught and looking at physical education as a "free play" period rather than giving adequate preparation to a subject area that is as important as any other in the curriculum. Enthusiasm is contagious. If the teacher is excited about the day's lesson, the

children will experience a beneficial activity period (Fig. 4-3).

Personality

An enthusiastic personality is one of the prime factors necessary for effective teaching. The impression that a teacher makes on his students is a strong motivating factor toward successes or failures in the learning environment. The individual who is always ready with a kindly smile, is friendly to all, and is empathetic toward the problems of developing children has little difficulty in presenting an effective lesson. Students like a teacher who is consistent, fair, cooperative, and dependable in his educational pursuits.

One of the greatest assets a teacher can have is confidence in his ability to teach physical education. Confidence in a subject area builds a personality that thrives on success. Making excuses for one's inadequacies is a sign of weakness and results in loss of respect from the students involved, making learning difficult.

Appropriate dress, habits of neatness and cleanliness, and a pleasing voice are attractive personality traits.

Each teacher should undertake a program of self-evaluation to determine where improvements can be made in his personality. Evaluation of his personality should be an ongoing process of eliminating the weak points and emphasizing as many of the favorable attributes as possible.

Above all, the teacher should attempt to be himself. Although there is much to be gained by observing a successful teaching performance of another it must be remembered that there are many excellent ways of presenting an effective lesson. The teacher who takes advantage of his own personality will be much more successful and happier than the teacher who emulates another.

The following personality traits are suggestive of favorable teaching behaviors. The children are more receptive to physical education when the teacher:

1. Is enthusiastic in lesson presentations.
2. Gives individual instruction in teaching skills.
3. Is concerned with student enjoyment in class.
4. Has a happy, friendly personality that is reflected during instructions.
5. Encourages students to achieve their best within their own capabilities.
6. Utilizes innovations, ingenuity, and variety in class presentations.
7. Speaks in a voice that is pleasing to the ear and easily understood.
8. Participates in class activities.
9. Is well skilled and demonstrates in class.
10. Exhibits patience and understanding with students facing difficulty in learning a skill.
11. Praises student achievement regardless of level or degree.
12. Develops a class atmosphere in which students are not afraid to make mistakes.
13. Is willing to listen and help students with problems.
14. Provides for total social contact.
15. Is trim and physically fit.

Health

Physical education is a demanding subject to teach. A teacher who lacks strength and stamina will often tend to neglect the physical education period. The teacher who does not maintain an adequate fitness level often uses the physical education period as a chance to rest and recuperate rather than to develop a good sequential program of physical activity for the children. Teaching excellence in physical education requires an enthusiastic approach that involves a certain amount of physical effort. The teacher must arrive at school at a fitness level that is conducive to the development of and participation in active physical education games and sports. The children in the class incur the greatest loss when a low health status is maintained by the teacher.

Creativity

Creating new approaches to physical education is one of the most exciting and

interesting activities for the teacher. To develop creativity the teacher of physical education must have a strong background in the skills and activities to be taught. The greater the knowledge of the subject matter he has, the more opportunities for creativity he will have at hand. In some instances teachers have avoided creative approaches to instruction for fear of receiving criticism from more conservative peers or rigid community groups. However, the teacher too often fails to engage in creative activities because of a lack of knowledge of the subject matter at hand. Creating new activities or new ways of playing games and encouraging the children to do the same can be an exciting phase of physical education.

Creativity cannot be left to chance; it must be planned for and situations must be presented in which children have the opportunity to express themselves in a new and challenging manner. The teacher who listens with an open mind and encourages children to try out their ideas shows a respect for their attempts to do something new and often learns something himself. New ideas or solutions to problems should not be thrown out until the children have had an opportunity to try them. Children can learn by evaluating their own solutions and often

are given too little credit for knowing the difference between success and failure in problem-solving activities. Creativity should be encouraged whenever possible, since it is a way of growth that cannot be duplicated through any other aspect of the school program. Planning situations that encourage creativity should be a part of each program of physical education.

Participation

A question often asked is whether or not a teacher should participate in the physical education activities of the day. Children enjoy having an opportunity to participate in group activities in which the teacher is involved. If a teacher is well skilled, there is an added incentive, since he gains a definite personal respect by being able to successfully execute the skill. Through participation in activities with the children, the teacher becomes a co-worker rather than a director. In most cases, children are quite pleased when this occurs and often put the teacher to the test.

If a teacher is to participate in the activity, he should make sure he is properly dressed for games and sports so that he will not be limited to an observational role. A teacher who participates with the children on

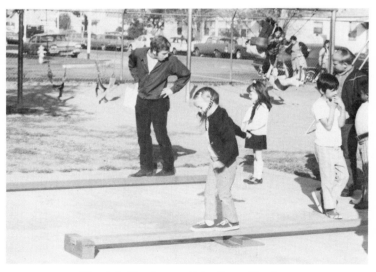

Fig. 4-4. Teacher participating with class.

a regular basis finds that the class response is excellent and that the activity is most enjoyable for teacher and children alike (Fig. 4-4).

Striving for excellence

The teacher of physical education should continually strive to improve the teaching-learning situation in his classes. Sharing problems in class organization and successes in the presentation of materials can be a tremendous aid in developing teaching excellence. The teacher should begin with himself and determine what his greatest needs are in improving the instructional program of physical education. After he determines these needs, he should share them with other individuals on the staff or with the supervisor of physical education and should develop a plan to solve the particular problems involved. The important aspect of this procedure is, first, to identify the problem areas and then to seek ways of solving them. Too often a teacher shows little improvement in the instructional program because of a lack of knowledge of how to present the material in an interesting and exciting manner. Individual and small group meetings should be established from time to time to discuss new techniques in material presentation. Each teacher should strive to reach his fullest potential in developing excellence in teaching. This can be accomplished only if he recognizes the fact that the teaching-learning situation can be improved and that dedication to excellence is necessary for improvement to take place. Successful teaching in physical education is best developed when the teacher:

1. Makes participation in physical education activities an enjoyable experience.
2. Is thoroughly convinced of the values of physical education activities in the school program.
3. Maintains a good sense of humor and is flexible in his approach to teaching physical education.
4. Encourages the children to develop the ability to participate in physical education activities on their own.
5. Requires children to maintain high standards of performance in physical education activities.
6. Encourages the children to evaluate the successes or failures of the activities in which they participate.
7. Allows the children the opportunity to help in the development of the physical education program.
8. Encourages good performances in physical activities by praising the children in successful performances.
9. Evaluates the physical education experience and uses the information gained to develop future programs.

Class organization

Each teacher of physical education should strive to enhance the instructional program by utilizing sound organizational techniques. Provisions should be made to ensure that children have the fullest opportunities for participation in class activities. The following suggestions are offered as guides to successful class organization:

1. A daily program of physical activities is recommended to best serve the needs of the children in elementary schools.
2. The length of the class period should vary according to the purpose of the lesson and the needs of the children involved.
3. Children should be grouped according to size, ability, and activity interests.
4. Activities should be arranged to provide for individual instruction in learning skills.
5. Adequate equipment should be provided to allow for full participation by all class members.
6. The lesson should provide for the development of leadership experiences.
7. The program offered should be in line with the needs and interests of the children participating in the activity.

If adequate time is given to organizing a class for effective teaching, there will be a twofold return of enjoyment and understanding of physical education. The teacher who plans well will realize the full potential of class participation and successful performance in physical education skills.

Guidance

The physical education teacher should be concerned with the total development of an individual and should not limit his role to one of supplying vocational information. When physical education specialists are responsible for program activities, they enjoy distinct guidance advantages that the teachers of other disciplines usually do not experience. The physical education teacher often has contact with the same children for consecutive years. This continued experience along with the informality of the student-teacher relationship allows for a guidance function not available in any other school subject. Since physical education deals with children in movement activities, individual strengths and weaknesses appear more readily than elsewhere in the school. The playground is an excellent laboratory for studying the individual. A child's personality is usually more observable in action situations than in the confines of the traditional classroom. Although the need for personal guidance increases with the age of the child, there is evidence that problems in health and personal social adjustment formerly associated with older children are now prevalent at the elementary level.

Safety

The desire for new experiences, excitement, and adventure and a need for group recognition are identifiable needs of elementary school children. These needs are satisfied by certain vigorous activities involving close contact with others and the introduction of specialized equipment that results in certain risks by the participants. The element of danger in activity is often the motivating factor needed for full participation and enjoyment by certain individuals. Too often the attempted solution to the risk factor is deletion of the activity from the

Fig. 4-5. Spotting children provides safe play environment.

curriculum. This should not be the case. With proper class organization and a definite safety plan, activities such as touch football, wrestling, tumbling, and swimming can be safe and enjoyable for all. When planning for a safe play environment, the teacher should apply the following principles:

1. Employ qualified personnel to teach physical education.
2. Provide for adequate protective equipment when needed.
3. Insist on the strict enforcement of rules during play.
4. Provide suitable play areas properly maintained.
5. Ensure that the participants are properly conditioned so that undue fatigue does not occur.
6. Establish a routine safety check of all equipment utilized.
7. Anticipate potential safety hazards and establish local rules when dangerous situations may arise.

If the teacher plans proper safety measures and develops an accident prevention and safety procedure unit, most accidents will be avoided and the child can develop without fear of injury (Fig. 4-5).

EVALUATION

Evaluation is a continuous and important part of any physical education program. If program progress toward meeting behavioral objectives of physical education is to be verified, it is necessary for the teacher first to determine the level and needs of the children participating in the program. (See Chapter 8.) In order to guide the children in the proper direction, the teacher should measure the physical performance stature of each child in the class.

Evaluation can be accomplished through a variety of techniques. Teacher observation, knowledge tests, motor development tests, and physical fitness measurements are used not only to aid in program development and improvement but also to interpret the program to children, parents, and the community. Through the use of behavioral objectives, test results, self-testing charts, and

peer evaluations, the children can follow the path that leads toward the accomplishment of stated favorable behavioral changes.

Evaluation should be used as a tool to improve the instructional program and to motivate children to achieve individual goals. Because man seeks goals by nature, he learns tasks best in an environment where objectives for learning are clearly presented. Care should be taken to avoid setting group standards too high, which may curtail individual progress. Emphasis should be placed on the advancement of each child toward individual aims. Establishing reasonable behavioral objectives on the basis of maturation and readiness levels provides the teacher with an ongoing method of program evaluation and allows the child to understand his goals (Fig. 4-6).

A sound evaluation program provides for a system of accountability to determine the degree to which program objectives are met. A behavioral objective is a specific course of action that is measurable and attainable. In the behavioral objective approach, praise is used in abundance as opposed to techniques of fear and punishment.

In this text, evaluation is offered in individual chapters, with suggested tests for each phase of physical education presented. The behavioral objectives listed in the game activities in Chapter 13 suggest measurable skills that will aid the teacher in developing a practical evaluation program.

IMPLEMENTATION OF THE LESSON

A well-planned and well-designed physical education curriculum is of little value unless the teacher is capable of translating the material into enjoyable program activities that are suited to the needs and abilities of the children in each developmental level. How does the teacher make use of the curriculum plan suggested for a specific grade level? The following procedure is presented to acquaint the teacher with the steps that should be followed in utilizing the yearly plan as a guide to the development of the daily lesson.

Fig. 4-6. Teacher evaluating student performance.

1. The teacher should refer to the yearly plan to determine what percentages and types of activities are recommended for the level involved. (See Chapter 5.) The teacher can then select the broad categories of activities and can project the actual number of days that the children should participate in each classification.

2. After the time factor in each category has been established, the teacher selects the activities that are appropriate for a specific grade level on the basis of the information presented in Chapter 5 in relation to seasonality, feasibility, and other factors.

3. The teacher can then develop activity unit plans within the yearly time block. The units of instruction will vary from single-day plans in level 1 to monthly or 6-week units for level 3. The unit or monthly plan should be more specific than the yearly plan and include the names of the games or skills to be offered. (See Chapter 5.)

4. The unit plan is then converted into detailed daily lesson plans that should include the objectives of the lesson, teacher and student procedures, class formations, space requirements, and equipment needed. (See Chapter 5.)

Within the unit plan there are two approaches to scheduling weekly activities. The first is the block plan in which the same activity is scheduled 5 days a week for a set period of time. A 4-week unit in soccer offered each day of the week allows for a concentrated effort in a single activity. Skills are learned quite well under this plan; however, it does not allow for variety, and if some students do not like the activity, a lack of interest and unfavorable attitudes toward physical education may be initiated.

The second approach to scheduling involves a finger-type plan in which the seasonal activity is offered 3 days a week with alternate programs on the other 2 days. A soccer unit under this plan would be offered on Monday, Wednesday, and Friday, and dance, volleyball, and other activities would be offered on Tuesday and Thursday. This plan allows for a greater variety of physical activities for participation during each week. In the lower levels in which daily self-contained units are complete, the finger program could involve movement exploration activities on Monday and Wednesday, rhythms on Tuesday, sports and games on Thursday, and stunts and self-testing activities on Friday.

Although the physical education teacher should determine which plan best meets the needs and interests of the students at the various program levels, the finger plan often allows for better utilization of facilities where space is limited.

Daily lesson presentations

A complete lesson in physical education will include five major parts: introduction, explanation, demonstration, participation, and evaluation.

Introduction. Introducing the lesson in a positive and interesting manner can make the difference between student enthusiasm and apathy toward the activity. A little research involving the origin of the game or dance will allow the teacher to set the stage for the day's lesson and will serve as a point of reference for the children involved. Visual aids in the form of posters or motion pictures presenting the activity in a stimulating and interesting setting with proficient players can motivate children to pursue the lesson with great enthusiasm. Whenever possible, the introduction should take place in the classroom and should not take time away from the physical education period.

Explanation. The explanation should include the actual specific directions for playing a game or learning a skill. The teacher should know the subject well and use terminology that is easily understood by the children involved. The explanation should be brief and to the point, allowing the children to become involved in the activity as soon as possible. If a complicated game or skill is being taught, the teacher should explain the activity in parts, providing practice periods between directions, until the complete activity is learned. The explanation can be enhanced by using visual aids or combining the explanation with the demonstration. Beginning teachers often spend too much time talking during this phase of the lesson and leave too little time for activity.

Demonstration. Demonstration, as is a picture, is worth a thousand words. The teacher who is well skilled and can demonstrate before the class has a definite advantage in the successful presentation of a lesson. Children may interpret the verbal explanation in a variety of ways, but the demonstration presents a visual explanation that is difficult to misunderstand. The teacher can present the demonstration in slow motion, progressing to actual game speed so that all phases of the skill can be easily seen. When the explanation and demonstration are combined, the time for activity is usually increased. Before demonstrating, the teacher must make sure that the skill performed is an accurate reproduction of what is to be learned. If he cannot execute the skill accurately, it is permissible for him to use one of the better students in the class to demonstrate. This allows the teacher to point out proper positioning and skill techniques to the class without being an actual participant.

The respect the teacher gains by virtue of demonstrating in a professional manner is well worth the time taken to develop personal skills.

Participation. This phase of the lesson should take the majority of time allotted for physical education. Children expect to participate during the activity period, and the teacher should prepare the lesson in such a manner that maximum amount of play experience is provided. The quicker children become involved in the activity, the less chance there is for problems to arise.

In the lower levels, participation usually involves playing a complete game. In the upper levels, the participation phase may be limited to lead-up skills or drills until such time that the class is ready to play the complete game. In order to alleviate boredom during the drill period, the teacher may substitute a modified game with fewer rules and skills to allow for some game competition during each period. Teachers can have fun creating their own games and often find new and successful approaches to learning an activity through competitive skill drills.

Evaluation. The evaluation period is the last phase of the daily lesson. This phase should take no more than 2 to 3 minutes out of the total period, but it can be one of the most valuable experiences of the day. During this time, the teacher is able to discuss with the class the successes or failures of the day's lesson and offer suggestions for the next day. A note of favorable recognition for a child's excellent play or a brief reprimand to a class that could improve its be-

havior is more meaningful when done immediately after the experience. Grouping the class briefly before returning to the classroom provides a cooling-off period and allows the teacher to check on injuries and make sure all equipment is returned.

The teacher of physical education is an important person faced with a great number of responsibilities. When he accepts his responsibilities with pride and enthusiasm, the experiences for all concerned are well worth the effort.

RECOMMENDED READINGS

Dauer, V. P.: Dynamic physical education for elementary school children, ed. 4, Minneapolis, 1971, Burgess Publishing Co.

Davis, C., and Wallis, E.: Toward better teaching in physical education, Englewood Cliffs, N. J., 1961, Prentice-Hall, Inc.

Fait, H. F.: Physical education for the elementary school child, ed. 2, Philadelphia, 1971, W. B. Saunders Co.

Mosston, M.: Teaching physical education, Columbus, Ohio, 1966, Charles E. Merrill Publishing Co.

Chapter 5

Organizing for physical education

Effective learning in physical education depends on the careful selection of the child's experiences in each grade level. Organizing these experiences to provide for a safe, healthy, and interesting developmental program of physical education will do much to ensure that the outcomes of physical education are in line with established objectives. Currently, there is a trend to employ full-time physical education teachers in the elementary schools; however, this trend is progressing at a slow pace because of limited financing in school districts throughout the country. Educational systems moving in this direction have recognized the value of a sound physical education program presented by trained specialists (Fig. 5-1). Another plan is to utilize a supervisor of physical education who serves many schools, charged with the responsibility of providing classroom teachers with current materials, methods, and techniques for conducting physical education.

Although the need for specialists in physical education is recognized by both teachers and administrators, most elementary schools are still organized on a self-contained basis. Under this plan, the classroom teacher has the full responsibility of organizing the physical education program as well as the many other subject areas offered

in the curriculum. Regardless of who has the responsibility for teaching physical education, the fact remains that all activities must be well planned and organized in order to meet the needs and interests of the elementary school child.

SELECTING PHYSICAL ACTIVITIES

Before discussing specific factors involved in the selection of physical activities, we will present a classification system to provide for the proper emphasis in selecting activities. There is no unanimity among members of the physical education profession regarding such a system. For the most part, the selection of a classification system appears to be the writer's prerogative depending on his particular approach to teaching physical education. In this text, physical education activities are listed under four categories: movement exploration, self-testing, rhythms and dance, and games and sports. The accompanying charts list examples of activities provided under each category and suggest percentages for each instructional level (Figs. 5-2, 5-3, and 5-4).

PLANNING THE PROGRAM

Teachers should begin planning for physical education by developing a yearly

Fig. 5-1. Physical education specialist individualizes instruction.

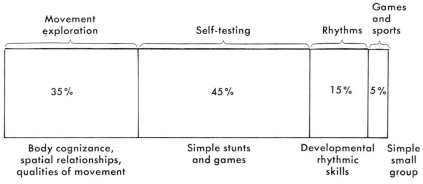

Movement exploration	Self-testing	Rhythms	Games and sports
35%	45%	15%	5%
Body cognizance, spatial relationships, qualities of movement	Simple stunts and games	Developmental rhythmic skills	Simple small group

Fig. 5-2. Level 1 activity percentage chart, ages 3-5.

Movement exploration	Self-testing	Rhythms	Games and sports
25%	30%	20%	25%
Sequential movement problem solving	Intermediate individuals and group stunts	Creative rhythm activities— singing games	Modified team games

Fig. 5-3. Level 2 activity percentage chart, ages 6-8.

Movement exploration	Self-testing	Rhythms	Games and sports
15%	25%	15%	45%
Advanced movement routines	Advanced stunts— pyramid building	Folk dance, square dance	Regular team games, carry-over skills

Fig. 5-4. Level 3 activity percentage chart, ages 9-12.

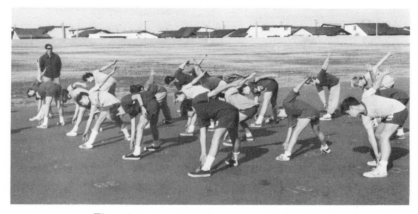

Fig. 5-5. Proper class size improves instruction.

plan based on the suggested percentages provided for specific developmental levels. This gives the teacher a point of reference from which to develop actual program activities. From this plan, the teacher should then develop monthly, weekly, and daily lessons based on the needs of a particular class. Sample plans for each developmental level are included in the lesson plan section. The factors of class size, activity variation, and seasonality should be considered during the selection and planning of the physical education program for each developmental level.

Class size

The size of the class determines to a large degree the amount of individual atten-

tion that can be given to the children involved. As a general rule, the class size should be commensurate with the developmental abilities and interests of the children. A regular class in physical education should have a maximum of 35 pupils, whereas a class of children with motor deficiencies should be limited to 20. The adequacy of facilities, achievement level of the pupils, and special motor problems are factors to be considered in determining class size (Fig. 5-5).

Activity variation

Physical education provides for a broad choice of activities. Teachers should be careful to include a wide variety of activities

when planning the program because the games played over and over each day, month, or year may not meet the needs and interests of all the students in the class. New activities should be presented, the proper amount of time being devoted to movement education, self-testing activities, rhythms and dance, and games and sports. Adequate time allowed for each of the categories requires careful planning to assure a program balance.

Seasonality

Proper attention given to fall, winter, spring, and even summer activities will aid in presenting a program that is conducive to development of an interest in physical education. In areas where seasonal climatic conditions affect participation in certain activities, the physical education program should be planned so that outdoor activities are offered during the best weather conditions. Teachers should also plan their program in line with national sport seasons; attempting to teach children softball skills during the fall does little to develop interest and enthusiasm when football and soccer are in season. Custom and feasibility should play a major part in the selection of activities based on seasonality.

MEETING THE OBJECTIVES OF PHYSICAL EDUCATION

Program activities should be selected in line with their contributions toward the general objectives of physical development, knowledge and understanding, and attitude and appreciation. Each activity considered should be reviewed in respect to its contribution to the developmental outcomes described in Chapter 1. Neglect of a review of this nature often allows for a limited approach to child development through physical activity. A review of the contributions of each activity toward the objectives of physical education will aid the teacher in providing a balanced program at all levels (Fig. 5-6).

Skills for leisure

Activities offered in the instructional program should be utilized in extra class hours and other leisure-time hours. Many activities are acceptable because of their immediate developmental value. However, there should be concern for teaching skills that can be used for maintaining good health and personal satisfaction in adult life. A strong foundation in movement patterns and elementary game skills can set the stage for learning and enjoyment in the more sophisti-

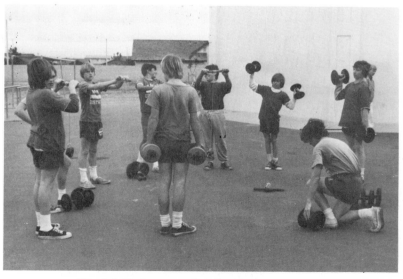

Fig. 5-6. Students meeting the physical objective.

Fig. 5-7. Student developing carry-over skills.

cated sport activities during the adult years (Fig. 5-7).

Feasibility

In selecting activities for the physical education program, the teacher should also consider the feasibility of the activity considered. Such things as adequate time requirements, the availability of proper facilities, and the confidence and ability of the instructor should all be considered before an activity is selected. Attempting to present activities when these three factors have not been properly provided for will usually result in a poor teaching-learning situation that can transform a normally safe and exciting activity into one that is hazardous and uninteresting to the children.

Identifiable needs

The teacher must identify the needs of the children at each developmental level if he is to plan effectively. This can be accomplished through personal observation by

Fig. 5-8. Child testing muscular strength.

the teacher and through a sound program of evaluation. After testing the students, teachers have the opportunity to take students from the point at which they find them to as far as they can go within their own individual and group capabilities. This manner of teaching allows each child to achieve a level of skill in physical education that is within his own individual potential. With the needs of the individuals and group so determined, the teacher will then be able to prescribe a developmental program that will have meaning and be within the capacities of the children involved (Fig. 5-8).

Program integration and transfer

The integration of physical education with other subjects in the school can do much to enhance the total education of the child. Social studies, language arts, music, art, mathematics, science, and industrial arts afford many opportunities for integration with physical education in the education of the child. A geography lesson can come alive as children participate in a native dance of the country being studied. Encouraging a child to write about or describe his favorite sport in an English class might well be the motivating factor necessary to achieve success. A project in a woodshop class can increase the physical education equipment inexpensively; balance boards, stilts, and jumping standards are practical items that can be constructed and used directly in the physical education program. There is no better subject area than that of physical education to discover how the human body functions. Children in a science class can better understand the values of exercise as they develop charts and graphs on which are recorded their own heart and respiration rates. Projects of this nature can develop into interesting discussions regarding growth and development and the maintenance of good health. Sports and games are ideal topics for the art lesson. Posters made by

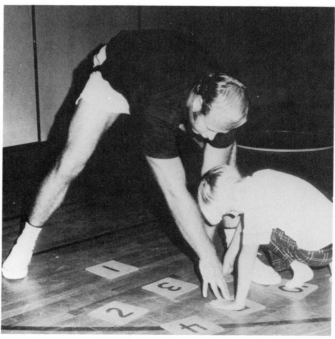

Fig. 5-9. Teacher integrating physical education activity with classroom subject.

children in an art class make wonderful displays on bulletin boards and often tell a story in a more meaningful way that children understand.

Teachers responsible for physical education should make every effort to integrate physical education with other school subjects whenever possible. Greater participation, interest, and enthusiasm can be generated when the child becomes physically and mentally involved in learning (Fig. 5-9).

Activity progression

In order for children to learn effectively, skills must be developed step by step, one forming a basis for the next. Children must have a good foundation before more advanced skills can be taught. Lessons should have continuity, showing a gradual progression from simple to more complex skills. Children must first be taught fundamental locomotor skills before they can succeed in

a game utilizing these requirements. Lead-up games comprising individual basic skills, such as around the world, in which the shooting skill required for basketball is developed, should be learned prior to participation in sophisticated official sports and games, such as basketball (Fig. 5-10). Part IV offers progression in a variety of activities and skills so that teachers can present them in a logical order in relation to degree of difficulty.

PROGRAMMING FOR EFFECTIVE TEACHING

In order to provide the most efficient learning situation, teachers of physical education should be familiar with various types of grouping techniques. Grouping pupils is essential in developing a good program of physical education; it provides for a sequential progression of experiences, permits students of equal ability to be together, allows for individual instruction, and provides leadership experience for many children.

Fig. 5-10. Lead-up activity to basketball.

For certain activities, the teacher might wish to work with the class as a whole, or in other situations, it might be more desirable to divide the class into smaller groups. The teacher might accomplish this by numbering the children from one to four, or whatever number of groups he wishes, and then combining the same numbers into groups. The class can also be divided by allowing the children to select their own team members, which is one method of equalizing competition. The squad system is a very desirable type of organization for the physical education period because it is a controlled yet free program that offers opportunities for child planning, child leadership, and child appraisal. However, because of the social immaturity of many children, it is necessary to develop a progressive system of squad selection to eliminate the placing of a heavy burden of responsibility on some children too early in their development. Some classes will be ready to achieve squad organization and will be able to bypass the first or the first and second progressions. It is the teacher's responsibility to determine the starting point on the basis of the maturity, readiness, and ability of the class.

The following system of squad organization is adapted from La Salle and has proved to be a successful method of class organization (Fig. 5-11).[107]

PROGRESSION 1

1. The teacher appoints squad leaders and selects squad members at 3- to 4-week intervals.
2. Squads are assigned to a leader; the leader and the group remain together during the physical education period.
3. During the activity period, the teacher may assign a familiar game on a daily basis; each squad leader is responsible for selecting his equipment.
4. The teacher assigns an activity space to each squad leader; the game and the equipment remain in the assigned location during the time devoted to play.
5. When all squads are ready to play, the teacher gives the signal to begin.
6. After adequate playing time has been allowed, the teacher gives the signal to stop. The children form a line in front of their squad leaders, with the leaders facing the squads, after which a signal to move to the next playing area is given by the teacher. The squad leaders lead their groups, in line, to the next activity, rotating in one direction only. Changes should

Fig. 5-11. Extended squad formation for warm-ups.

continue every 5 to 10 minutes depending on the difficulty of the game until each squad has participated in all activities planned. First-grade children are often not capable of any further squad progression.

PROGRESSION 2
1. The children elect squad leaders.
2. Each squad leader chooses his own squad members.
3. The teacher assigns the game and the play space as indicated in progression 1.
4. Each squad begins to play when ready.
5. At the teacher's signal, all squads rotate as indicated in progression 1.

PROGRESSION 3
1. The children elect squad leaders.
2. Each squad leader chooses his squad members.
3. Each squad leader selects his own game for the day, the choice of the activity being made in the classroom.
4. At the teacher's signal, the squads prepare to rotate as before. This time the squad leaders do not move with their group but act as leaders of the same games for each succeeding squad. Each squad moves informally rather than in a line to the next activity. The teacher may wish to appoint an assistant squad leader to aid in controlling the group, thereby affording additional opportunities for leadership.

PROGRESSION 4
1. Each child chooses the game he wishes to play by standing in front of the squad leader of that particular game and in the place where the game is to take place. If the squad is filled with the maximum number in each group, the leader sends the extra children to another group.
2. Each squad starts to play when the size limit has been reached.
3. At the teacher's signal to stop, each squad lines up in front of the squad leader.

4. At the signal for rotation, the children may go to any game they have not played that day and follow the same procedure as before.

PROGRESSION 5. All steps are similar to those in progression 4 except that a class leader is chosen at the time the other squad leaders are selected, and it is his responsibility to give the signal to stop playing, to change squads, or to aid in any way the class agrees on. In the primary grades, class leaders should be rotated on a daily basis to provide a greater number of opportunities for leadership and to eliminate the possibility of one child's being deprived of the opportunity to participate in the games.

The teacher may wish to experiment to determine the progression of squad organization for which the class is ready. Since the degree of maturity is generally observable, the teacher should be able to select the point at which the class is prepared to begin. It is possible that a class may be ready for one phase of a progression but may not be mature enough to use it in its entirety. In the upper grade levels, squads may be maintained for a longer period of time. Periods of 4 to 6 weeks are suggested as team games are introduced and longer units of instruction are necessary. In order to prevent the problem of having one child always selected last and to alleviate favoritism, the teacher and the squad leaders should meet away from the class so that the children will not know in which order they have been chosen. In grade levels in which the squads are made up of both boys and girls, the selection should be made by alternating a boy and then a girl. In order to be more fair, the direction of the choices by the squad leaders should be reversed after each round; for example, with four squads, number four would make the fifth choice and number one squad would make the eighth and ninth choices. A teacher effectively using the squad method can add much to the physical education experience. Squad leaders can help by maintaining control of their own team members and also can assist the teacher in a variety of routine procedures

during the period, such as checking out equipment, taking roll, and helping to plan the daily lesson. Sound squad organization should allow for maximum time utilization and child participation during the physical education period.

SELECTING STUDENT LEADERS

It is the role of the teachers to provide maximum opportunities for children to experience leadership; however, child leadership is not automatic but must be planned for and taught. Bookwalter aptly states that in developing pupil leadership, the following principles should be applied:

1. Duties must be mutually understood by teacher, leader, and pupils.
2. Full performance of duties must be expected.
3. Authority must accompany the responsibility of leadership.
4. The leader must be acceptable to the group.
5. The leader must be democratic, not autocratic.
6. The leader must guide by example rather than precept.
7. The leader must be positive (implementing) rather than negative (inhibiting) in approach.
8. Satisfactions rather than annoyances must ensue.
9. Creativity potential must be developed.
10. Slower individuals must be encouraged and developed.
11. Superior individuals must be encouraged to attain their capacities.
12. Alternate leadership and followership experiences should be provided.
13. Self-direction and self-expression of all must be promoted.
14. Socially sound standards of behavior must be inculcated.
15. Help in meeting individual needs more fully must be provided.*

Leadership experiences should be progressive in nature; teachers should assign small responsibilities that the child is capable of completing successfully prior to an assignment as an assistant or squad leader. Opportunities to report attendance, act as an assistant in group games or stunts, help the teacher record test scores, and perform other

*Bookwalter, K. W.: Physical education in the secondary schools, New York, 1964, The Center for Applied Research in Education, Inc.

assigned duties can help the child develop the ability to serve others and achieve self-realization compatible with the goals of physical education (Fig. 5-12).

Peer teaching

The use of more talented children in a class to lead and teach skills to their peer group can be an effective way of teaching physical education. Children are often motivated by the abilities of the better skilled boys and girls in the class, and their attention and interest are often increased through this approach to learning. The use of physically gifted students to aid the teacher in presenting a physical education lesson can allow for more individualized instruction and can provide greater opportunities for small-group participation. Peer teaching can be effectively utilized at all levels but should be supervised carefully to ensure that proper techniques in both skill and safety are provided (Fig. 5-13).

Cross-age teaching

Another method that has been successful in the elementary physical education program is that of utilizing the talents of students in the upper grades during the activity period. In this approach, students from a nearby high school or junior high school work under the supervision of an individual responsible for the physical education program. Many of these students indicate an interest in the teaching profession and welcome the opportunity to work with younger children. Such a cooperative venture between the schools involved provides an inservice approach to planning and presenting physical education activities. The supervisor of physical education first develops the master program and then assigns each student to a group of elementary school children. The students work with their assigned groups in developing a particular skill or game activity. The utilization of a large number of older students in the teaching-learning situation allows for much individual attention to the group involved and provides a close relationship between teacher and child (Fig. 5-14).

Fig. 5-12. Student leading class exercises.

Fig. 5-13. Peer teaching.

Fig. 5-14. High school student working with children.

Some schools using this plan are offering one period of physical education in the morning and one in the afternoon. One half of the class attends during the morning session and the remaining half of the children participate during the afternoon. One of the concomitant values of this approach is that the regular teacher has two periods during the day in which work can be accomplished with a class that is half the size of the normal enrollment. This allows the teacher to give more small-group and individual instruction in the classroom in the areas of reading and other subjects that could not be possible under the regular program.

The response to this approach to teaching physical education has been quite favorable, on the part of both the children and also the student aides acting as teachers of physical education. Each student aide has the opportunity to evaluate, plan, and participate with the children in his group. The possibilities for teaching physical education under this plan are unlimited, but the use of this technique depends heavily on the availability of high school or upper grade students. It should be mentioned that children from the upper elementary grades also have participated in this program with some degree of success.

USING VOLUNTEER PARENT GROUPS

Utilization of parents as aides during the physical education period also has been a successful approach, particularly in the primary grades. Interested parents can help the teacher to develop basic motor skills and self-testing activities after a brief in-service training program (Fig. 5-15). The following suggestions should aid in the development of a successful program:

1. Heterogeneous groups are usually more successful, since the less skilled students mimic the skill patterns of the better students.
2. The children should have readable name tags, and each group should have a color code to aid in class organization and control.

3. A list of sequential directions should be provided for the parents, stating specific skills to stress.
4. A ratio of no more than six children to each parent should be maintained.
5. A teacher should be in charge but free to circulate between stations to assist children and parents and offer positive reinforcement.

Some ideas for skill stations in which parents can help are as follows:

1. Obstacle course (old tires, cones, and boxes that may be worked in with permanent playground equipment)
2. Ball-handling skills (catching, throwing, bouncing, dribbling, and kicking)
3. Beanbags
4. Balance board
5. Walking beam
6. Jump rope
7. Stilts
8. Hula-Hoop

Many parents help in a variety of school programs; however, the use of parent aides in the physical education class is in its infancy.

ESTABLISHING CLASS ROUTINES

Effective organization of the physical education period involves the establishment of certain class routines. At the inception of each school year, the teacher should establish a procedure for beginning the physical education activity period. Such things as distribution of equipment, the move from the classroom to the gymnasium or playground, the type of formation to be used at the beginning of class, and the procedure to be followed at the end of the period should all be routine in nature. A good orientation to these routine procedures will allow the class to begin on time and in an orderly fashion, with the greatest amount of time being used for activity. Children should be taught which formations are to be used at the beginning and at the end of the period. These formations should be unvarying from day to day in order to eliminate any confusion as to what is expected. The formation selected might be a line, a circle, squads, or an

Fig. 5-15. Parents help children develop skills.

informal sitting position. If the routines are taught properly, the children will be able to go to the play area and return with little or no supervision. It is advantageous at the end of the activity period to meet the children in a group in order to give them opportunities to evaluate the day's lesson. Often this brief culminating activity is filled with teachable moments. It is also an excellent time for the teacher to make sure prior to returning to the classroom that no one is injured and to check on all equipment. Each teacher should develop procedures for collecting equipment, getting drinks, using the lavatory, and changing clothes, keeping the best interests of the children in mind for each individual situation.

Lesson planning

Adequate planning is necessary if the teacher is to present a sound physical education program in line with the goals and objectives discussed in Chapter 1. Teachers of physical education should have a yearly, monthly, weekly, and daily plan for activity. In developing the lesson plan, teachers must be aware of the objectives that the children are to achieve and what kinds of experiences will meet these objectives. The physical education program should be planned from kindergarten through the twelfth grade so that there are a variety of experiences that are not duplicated from year to year. Unless the teacher understands what has been learned prior to the grade level currently being

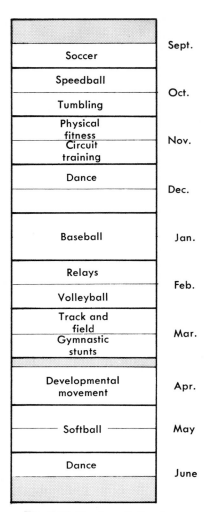

Soccer	Sept.
Speedball	
Tumbling	Oct.
Physical fitness	
Circuit training	Nov.
Dance	
	Dec.
Baseball	Jan.
Relays	
Volleyball	Feb.
Track and field	
Gymnastic stunts	Mar.
Developmental movement	Apr.
Softball	May
Dance	
	June

Fig. 5-16. Yearly activity plan.

taught and what is to come afterward, he will find effective planning increasingly difficult. From the yearly, monthly, or other time block plan, the teacher should be able to develop complete activity units within specific areas of instruction. We have included a sample yearly plan to demonstrate how broad planning relates to the areas of physical education (Fig. 5-16). The weekly plan sets the guidelines for what is to be offered to the students during this period of time (Fig. 5-17). This gives the teacher an opportunity to specifically view the program activities designed for the week. The daily plan is the most specific and provides the teacher with a guide for time allotment, teaching procedures, and suggested formations (Fig. 5-18). After each day's lesson, the teacher should evaluate the successes and failures of the class in order to determine the pace and direction for the following day. It is not always possible to determine that the activities suggested in the plan will be successful when put into practice; therefore, teachers should be flexible and be prepared to make changes in the daily plan of activities that might be more appropriate for successful learning within the abilities of the children.

Planning with children

Children should have every opportunity to help the teacher plan the physical education period. When children help develop

	Week No. 1	Week No. 2	Week No. 3	Week No. 4
Monday	Review kicking and catching skills	Practice under hand and overhand throw Play overtake ball	Practice fielding fly balls Play work-up	Softball tournament
Tuesday	Review rules Play base kickball	Practice base running Play beatball	Play work-up	Softball tournament
Wednesday	Review force-out rule Play base kickball	Practice batting skills Introduce work-up	Play work-up	Softball tournament
Thursday	Review double-play Play base kickball	Practice pitching skills Play work-up	Introduce softball Play softball	Softball tournament
Friday	Play base kickball	Practice fielding ground balls Play work-up	Play softball	Softball tournament

Fig. 5-17. Weekly activity plan.

routines, suggest needed practice for certain skills, and determine the best way to check out equipment, the program takes on a deeper meaning. Planning can be fun and children will have greater interest when involved in curriculum development. By selecting games and dances, building much needed equipment, and being involved in general overall planning, students can play a greater part in the educational process. Often the teacher finds children suggesting activities that integrate with other subject areas or have greater appeal than what was originally designed.

Formations

A modern physical education playground will have a variety of circles, straight lines, rectangles, and other figures painted on the activity surface. These permanent lines are helpful to the teacher in organizing the class and are of benefit to any physical education facility. In addition to this, specific formations are needed to provide adequate learning experiences. The following formations are suggested for use in teaching a variety of physical education activities.

Circle. One of the best ways to form a circle is to have the children take positions on a circular marking on the playground or gymnasium floor. If no markings are available, the teacher may take the hand of the first child in a straight line and walk around until he joins hands with the person at the end of the line, or the children may join

Name of game: *Nation Ball* Date: *Nov. 17th*

Behavorial objective: *To dodge, catch, & throw a ball accurately.*

Developmental goal: *Endurance, strategy, agility*

Space and equipment: *Rectangular court with center line*

Time allotment: *25 minutes*

Activities	Teacher procedure	Formations	Comments
2 minutes warm-up	*Have class leader give regular warm-up activities*	*Extended squad formation*	
5 minutes Practice throwing skills	*See that children throw ball properly in preparation for game; give individual help where needed.*	*Corner formation*	*Keep eye on target and follow through*
3 minutes Explain Nation Ball rules	*Keep explanation simple; place class in game situation as soon as possible.*	*Informal*	
12 minutes Play Nation Ball	*officiate game*		
3 minutes Review the lesson and cool down.	*Evaluate the play of the class and check equipment*	*Informal*	

Fig. 5-18. Daily lesson plan.

Fig. 5-19. Circle formation.

Fig. 5-20. Shuttle formation.

Fig. 5-21. Corner formation.

Fig. 5-22. Zigzag formation.

Fig. 5-23. Relay formation.

Fig. 5-24. Informal formation.

hands by themselves to form the circle. This formation is required in a variety of games of low organization, elementary dances, and warm-up exercises (Fig. 5-19).

Shuttle formation. The shuttle formation (Fig. 5-20) is excellent for practicing handoffs or passing-type skills. It can also be used for certain types of relays, since it allows children to execute a skill and return to their original positions after all have had a turn.

Corner formation. The corner formation (Fig. 5-21) is designed for throwing and catching skills. It also allows the teacher to rotate and instruct the different groups participating in the activity while maintaining a good supervisory position.

Zigzag formation. The zigzag formation (Fig. 5-22) can be used for throwing and kicking skills. It works best for small groups.

Opposing lines. This formation is used in many lead-up games and allows the class to be divided into two teams.

Relay formation. If the class is organized into squads, they are already in the relay formation (Fig. 5-23). Little or no movement should be necessary to begin a relay activity.

Informal formation. For creative activities or when no formal positioning is necessary, children are asked only to arrange themselves in a manner in which they cannot reach out and touch their neighbor (Fig. 5-24).

Use of the whistle

The whistle is an excellent piece of equipment for use in the physical education class; however, it should be used sparingly and must convey a specific meaning to the children. When the teacher blows the whistle, he should do it with authority, and it should indicate that all activities must stop, play equipment must be held, and all children must look in the direction of the teacher for further instructions. In the upper elementary grades, the whistle is used for officiating game activities. It should be noted that if whistles are provided by the school, there should be adequate means of sterilizing the mouthpieces.

MOTIVATIONAL AIDS

Each school should be well supplied with illustrated *booklets* of various sports activities. A reading table of these kinds of materials can be set up in the classroom in addition to the volumes in the library.

Bulletin boards can provide the children with an opportunity to collect pictures and drawings of in-season athletic performances. Photographs and articles from magazines and sports pages of newspapers can be used for this purpose. In addition to being used for displaying these materials, bulletin boards can be used for posting activity schedules, individual skill records, and self-testing charts. Materials can be arranged in an attractive, interesting, and colorful manner. Displays should be changed weekly so that children will be encouraged to look at the bulletin board.

Motion pictures and *slides* are excellent for introducing new activities to the class. Many companies provide a variety of filmstrips and cartridge movies for use in the instructional program (see Appendix II); however, some teachers prefer to make their own slides or movies of performances that often are more appropriate for specific situations. Video tape recordings can also be used for this purpose.

Tournaments

Tournaments are excellent motivational aids and stimulate the interest and enthusiasm of children in the upper elementary grades. They are more often thought of in the extraclass program; however, they can be a valuable part of the instructional program, particularly during the team sports units. The type of tournament selected depends on the amount of time available, the type of activity, and the number of teams or individuals involved. Teachers should select the tournament that best complements the class activity.

Elimination tournament. A single-elimination tournament is the easiest and quick-

est way to arrive at a winner (Fig. 5-25). It is best used when there are a large number of teams, limited facilities, and a short period of time to complete the tournament. If the number of teams or individuals entered equals a power of two, such as 2, 4, 8, 16, or 32, it is not necessary to have any byes, but if the number of teams or individuals does not equal a power of 2, then the next higher power of 2 must be selected to complete the first round. The number of byes is determined by taking the next higher power of 2 and subtracting the number of teams involved; for example, if 9 teams are competing, there will be 7 byes in the first round: the next higher power of 2 after 9 is 16, and subtracting 9 from 16 leaves 7.

Teams drawing byes are automatically placed in the second round.

Round robin tournament. This tournament has the advantage of offering maximum participation when time and facilities permit; it is the most satisfactory method of organization. The winner is the team that has the greatest number of wins after playing all the other teams. Numbers should be substituted for the names of teams or players to simplify the rotation in a round robin tournament. There will always be one less round than there are teams entered in the tournament; for example, six teams would yield five rounds. The number of the teams should be written in sequence in a counterclockwise direction as indicated in Fig. 5-26. Team number one should be held stationary while the rest of the teams are rotated one position in a counterclockwise direction for each round. At the end of five rounds, all teams will have had the opportunity to compete against one another. If the number of teams is uneven, add a bye and follow the same procedure as outlined previously. After the schedule is completed, team names may be substituted for the numbers.

Ladder or pyramid tournaments. Ladder tournaments provide continuous competition and are best used for individual or dual activities. The object is to climb to the top of the ladder or pyramid and remain in that position until the tournament is completed. The names of players or teams are listed separately on cards or tags and arranged on the rungs of the ladder by chance. One advantage of the ladder or pyramid tournament is that it takes little supervision, since the students usually arrange

Fig. 5-25. Elimination tournament.

Round 1	Round 2	Round 3	Round 4	Round 5
1-6	1-5	1-4	1-3	1-2
2-5	6-4	5-3	4-2	3-6
3-4	2-3	6-2	5-6	4-5

Fig. 5-26. Round robin tournament.

their own matches and report the results. In a ladder tournament a player may challenge only the first or second player immediately above his own name. If the higher player wins, they remain in their original positions, but if the challenger wins, they exchange positions on the ladder. Pyramid tournament players may challenge any team or individual on the row directly above them or in the same row directly to their left (Fig. 5-27).

Although there are many other types of tournaments, the ones just described are most commonly used in elementary schools.

FACILITIES

Physical education facilities should be well planned and aesthetically pleasing to the eye. Adequate facilities are important to the success of the physical education program and should place few limitations on the type of activities offered. Professional help should be solicited for the planning

Fig. 5-27. A, Ladder tournament. **B,** Pyramid tournament.

of new facilities; also the physical education teacher should be consulted for a description of the functional use of the area.

Outdoor facilities

The American Association for Health, Physical Education, and Recreation recommends that there be a minimum of 5 acres of land plus 1 additional acre for each 100 children in an elementary school. Part of the play area near the school buildings should be blacktop and of large enough size to accommodate basketball and volleyball courts with enough open space for games of low organization. The remaining area should be of natural or artificial turf with fields marked for football, soccer, and softball activities (Fig. 5-28). Lines burned in natural turf by an asphalt-base liquid will usually last the length of a sport season, eliminating continual marking.

Primary play area

A separate small playing area should be set aside for the younger children. Climbing apparatus, slides, sandboxes, and other selected equipment are placed in this area. Fencing off the area provides a safe play space and helps to prevent injury from activities participated in by older children. Fig. 5-29 is an example of an outdoor primary physical education facility.

Indoor facilities

Indoor facilities may range from the grade-level classroom or multipurpose room to the professionally designed gymnasium. It is more advantageous to have a separate gymnasium than a multipurpose cafetorium or combination auditorium-gymnasium. The indoor facility should be free from protruding objects and should have permanent floor markings painted in bright colors. Separate locker rooms with complete facilities for boys and girls should be located adjacent to the gymnasium. Adequate storage is necessary for proper maintenance of equipment and supplies. Specific designs of physical education facilities may be found in the following publications:

1. Planning areas and facilities for health, physical education, and recreation: Athletic Institute, Merchandise Mart, Chicago, Ill. 60654; and American Association for Health, Physical Education, and Recreation, 1201 Sixteeenth St., N. W., Washington, D. C., 20036.

2. Equipment and supplies for athletics, physical education, and recreation: Athletic Institute, Merchandise Mart, Chicago, Ill. 60654; and American Association for Health, Physical Education, and Recreation, 1201 Sixteenth St., N. W., Washington, D. C., 20036.

Fig. 5-28. Multipurpose play area.

Fig. 5-29. Primary play area.

3. School sight analysis and development: California State Department of Education, 721 Capitol Mall, Sacramento, Calif. 95814.
4. Facilities and space allocations for physical education: Outdoor teaching stations for elementary and intermediate public schools, Bulletin 40, 1967, Bureau of Health, Education, Physical Education, and Recreation and Bureau of School Planning, 721 Capitol Mall, Sacramento, Calif. 95814.

Equipment

The following equipment is recommended for indoor and outdoor facilities: Indoor equipment includes two three-speed record players, dance drum, climbing rope, jumping boxes, trampoline, basketball standards, volleyball standards and net, gym scooters, Stegel or similar piece of climbing apparatus, and gymnastic mats.

Outdoor equipment includes creative climbing and play apparatus, horizontal bars, horizontal ladders, balance beam, tetherball standard, basketball standards, volleyball standards, softball backboards, soccer goals, swings, free-form sandbox, track and field equipment, long-jump pit, high-jump pit and standards, and sensory-motor obstacle course.

Supplies

Enough supplies should be provided so that each child can participate without extensive waiting periods for a turn at the skill. If possible, each child should have a piece of equipment when a skill is being taught. Available supplies should include utility balls of all sizes, soccer balls, volleyballs, softballs, footballs, bats, basketballs, beanbags, measuring tapes, dance and rhythm records, long skipping ropes, individual skipping ropes, colored pinnies, whistles, stopwatches, Hula-Hoops, selected geometric shapes, stilts, and parachutes.

RECOMMENDED READINGS

Bucher, C. A.: Foundations of physical education, ed. 6, St. Louis, 1972, The C. V. Mosby Co.
Kirchner, G.: Physical education for elementary school children, ed. 2, Dubuque, Iowa, 1970, William C. Brown Co., Publishers.
LaPorte, W. R.: The physical education curriculum, ed. 6, Los Angeles, 1955, College Book Store.
Mosston, M.: Teaching physical education, Columbus, Ohio, 1966, Charles E. Merrill Publishing Co.
Rekstad, M. E., editor: Promising practices in elementary school physical education, Washington, D. C., 1969, American Association for Health, Physical Education, and Recreation.
Van Hagen, W., Dexter, G., and Williams, J. F.: Physical education in the elementary school, Sacramento, Calif., 1951, State Department of Education.

III

Instructional approaches

Part III provides the reader with current concepts about different instructional approaches to the physical education of children. It affords theoretical and practical information in the areas of movement education, basic motor development, motor fitness and exercise, and methods of modifying instruction in elementary physical education. Part III gives a basic rationale for including specific movement approaches in the well-integrated program of physical education.

Chapter 6

Movement education

Movement education was originated by Rudolf Von Laban in Germany and was brought to England and then to the United States, where it has become extremely popular. With its stress on free and individualized movement without the immediate control of the teacher, movement education represents a trend in physical education away from the highly structured type of program. Movement education is that aspect of physical education that is primarily concerned with multisensory awareness in contrast to the traditional kinesiological approach.

Movement education's current popularity reflects Western civilization's increasing struggle for individuality against the many dehumanizing forces found in a computerized society. Movement education allows for individual differences in maturation, readiness, and basic abilities. It fosters within the child creativity and at the same time a keen awareness of the body. Movement education is not a unique area, but a method of physical education designed to enhance the whole child. Through motoric exploration of an enriched environment, the child has the opportunity for optimum physical, mental, and emotional development. Through movement education the child may be enhanced as a learner and at the same time become skilled at handling

the body in a variety of situations (Fig. 6-1).

Broadly conceived, movement education encompasses many of the ideas that are currently innovative in contemporary education. Three of these concepts that can be directly related to movement education are decreased importance given to grade level, emphasis on individualized teaching, and emphasis on prescriptive teaching. (See Chapter 9.) Increasingly, schools are becoming more concerned with teaching children at their own particular levels in a given subject area, rather than emphasizing grade and age levels. Less emphasis is being placed on marks and more on personal achievement, self-analysis, and self-evaluation. Through analysis and evaluation, the teacher and student can mutually arrive at an educational prescription that will be appropriate for ultimate progress.

Movement education attempts to provide the child with the best conditions for individual growth. Consequently, the highly structured, ordered setting of traditional physical education is replaced by an atmosphere of informality. This is not to say that there is a lack of guidance but that the children are able to work on their own without constant teacher intervention. Ultimately, the child who has had the opportunity of being in a good movement education pro-

Fig. 6-1. Children solving movement problem.

gram will become aware of his own physical potential, will be able to perform uninhibited inventive movement, and will have experienced and learned a multitude of motor patterns, skills, and activities. Through movement progressions and sequences, the child becomes an efficient mover and develops a positive self-awareness that allows for personal pride and self-confidence.

SOLVING PROBLEMS IN MOVEMENT

Exploration and problem solving are innate in movement education. The teacher challenges the child with a movement problem to solve. This method is used instead of the traditional method of explanation by the teacher, demonstration by a child or teacher, execution of the skill by the class, and finally evaluation of the performance by the teacher.[121] Instruction is provided by the teacher in the form of concise and clearly stated problems. The teacher then allows the child to move in his own way without verbal guidance or cues. This allows the participant to gain insights while building movement patterns, one on another, that will eventually form a skill. Problems can be presented to the child by a verbal phrase, by an auditory

signal such as a whistle or bell, or by visual signals such as flash cards. Usually verbal challenges elicit the best response from the child. Challenges that start with words such as "can you," "how can," "what can," "show me," "show a," "how," and "be" provide the child with clear directions. Some examples are as follows: *Can you* find a better way to climb up the ladder? *How can* you move along the balance beam using both your arms and legs? *What can* you do to move faster over the hurdle? *Show me* how many ways you can move across the floor? *How* far can you throw a ball? *Be* as many different animals as you can. (See Chapter 10.) Movement problems to be solved by exploration can be organized from the following major areas: body awareness and spatial relationship, temporal awareness and rhythmic control, and motor skills in basic body management.

Body awareness and spatial relationships

The physical aspect of the self-concept, or how one views himself, is body awareness, or body image. It is more accurately defined by personality theorists as the perceptions, attitudes, and values that a per-

son holds of himself.[115] Body image is the assessment of the body from a spatial point of view. Barsch describes body awareness as the ability to answer the question, Who am I?[12] In essence, body awareness is the total of all external and internal impressions made on the individual.

From the time of conception, the human organism is structuring a personal system of awareness. The physical image is dependent on innumerable factors that produce the uniqueness of the individual. One can speculate that maturation of body awareness occurs on a continuum unfolding from birth to death. All the senses interplay in an intricate concert to form the awareness of the body in its spatial environment. As in the other factors of motor development, the awareness of the body matures in the head-to-foot and midline-outward directions.

The child constantly makes perceptual judgments through sight, hearing, touch, and movement that are matched and stored as an image of the body. The inner view of the self develops primarily through exploration, trial-and-error learning, and the perceptual feedback that occurs from movement. In the continual struggle to master the environment, the infant establishes a body awareness that serves as a base for all future perceptual responses and spatial relationships. O'Donnell states that "body image provides a basic construct, a point of reference, upon which future perceptual-motor skills develop and with which other perceptual-motor skills can be better understood."* Three elements are involved in body imagery: the integration of all external and internal sensory information, learning, and symbolic abstraction.[12]

Evaluation of body awareness. Accurate evaluation of how an individual views his physical makeup is extremely difficult. In recent years two approaches have been widely used to test body awareness: the draw a-figure test and tests of verbal command

*O'Donnell, P. A.: Motor and haptic learning, San Rafael, Calif., 1969, Dimensions Publishing Co.

Fig. 6-2. "Draw yourself," **A,** by a 9-year-old mentally retarded child, and, **B,** by a 9-year-old child of normal intelligence.

and mimicry. The Goodenough draw-a-person test is the most popular of pictorial tests in use today.[72] It was originally developed for a nonverbal demonstration of intelligence; however, since its inception it has increasingly been used as a reflection of how the drawer perceives himself. Such factors as detail, accuracy, size, distortions, omissions, part emphasis, placement, and perspective are scrutinized in an effort to judge the concept of the body (Fig. 6-2). One outstanding criticism of the draw-a-figure test is that a child with poor motor control may not be able to depict his true

inner feelings. Wold, in an attempt to remedy this problem, has developed an image test in which the child directs the examiner in drawing a figure.[169]

The second type of body awareness test now in vogue is the test of imitation of movement and verbal command. In the test of movement imitation, the child follows exactly the movements established by the examiner. Poor replication of movement or reversal of patterns may indicate difficulty in body awareness. Also the inability to follow verbal directions that is shown by inaccurate identification of body parts is thought by some to be an indication of faulty inner physical awareness.[96] As in the draw-a-person test, inaccurate imitation and identification of body parts after verbal commands do not necessarily indicate a distorted image but may be the result of a motor rather than a perceptual defect.

Body image disturbances. Much of our current knowledge of body awareness comes from the study of individuals who can be described as having mental, physical, or emotional disturbances. Since the inner awareness is firmly associated with the total functioning of the person, any disturbance of perception can alter movement and, conversely, can change how one perceives his body. For example, a degree of difficulty in any one or more of the following areas may distort one's conception of his body: inability to recognize or interpret perceptual stimuli, inability to organize ideas and actions, inability to deal with language formation, inability to develop concepts, and the inability to coordinate body movements with the environment.[115]

The spatial world can be perceived only with the body as a reference point. Objects in the environment are perceived in relation to the body's position. If the body awareness is unstable, then distortions of the spatial world can occur. Children who are unable to properly integrate their external and internal environments will often misjudge distances, overestimate or underestimate body sizes, and be unable to judge projectiles such as balls as to their size, position in space, or force.

Laterality and directionality. Closely associated with body image is the awareness of the two sides of the body known as laterality. The ability to project the inner lateral awareness to external space is called directionality.[169] At birth the neonate is bilateral and symmetrical in his neurological organization. Through sensory-motor, kinesthetic, and tactile stimulation by movement experimentation and exploration, the child becomes conscious of the two sides of his body. Further testing of the body allows for interaction between the two halves, and later a preference for one side occurs in selected activities. The outward expression of laterality has been termed directionality by Kephart.[95] The directional perceptions of left and right, up and down, and back and front are made with the body as the point of reference. If a person does not have a stable and accurate body awareness, his directional orientation may become confused.

The development of many cognitive activities in early childhood has been attributed to the development of body awareness. Directional orientation is particularly important in development of the language skills of reading and spelling. Until language has begun, the spatial world of the young child usually follows the law of object constancy.[169] In other words, objects remain the same whether or not they change spatial position or direction or are camouflaged. As stated in Chapter 3, the perceptual abilities of figure-ground discrimination, discrimination of like and unlike figures, and consistency in form regardless of changes in size are necessary for vision. Directionality must be added to these abilities before written or printed language can be understood. In most cases the 6-year-old child is expected to ascertain 62 symbols that vary as to their horizontal and vertical positions.[169] However, some children as the result of directional confusion find difficulty with such concepts as top and bottom of a paper or left and right or symbolic shapes such as d and p, b and p, or b and g. Many authorities attribute the directional confusion in children to

latency in body image development. Schilder says that "when knowledge of the body is incomplete and faulty, all actions for which this particular knowledge is necessary will be faulty too."*

Training for body awareness. Body awareness is a learned concept and must be planned for in the curriculum for young children. The child's world should contain as many opportunities as possible for gaining a heightened spatial awareness. Physical education activities such as trampoline jumping, balancing, crawling through objects, and traversing a challenging obstacle course have been found particularly to increase a child's body awareness. The enriched program challenges the child constantly to make postural adjustments and to correlate changes in direction and body location (Fig. 6-3).

*Kephart, N. C.: The slow learner in the classroom, Columbus, Ohio, 1960, Charles E. Merrill Publishing Co.

Temporal awareness and rhythmic control

Bateman defines temporal awareness as the "experience of duration,"[14] whereas Barsch describes it as the factor of "whenness."[12] A more precise definition is that given in the American College Dictionary: "the system of those relations which any event has to any other as past, present, or future; indefinite continuous duration regarded as that in which events succeed from one to another." Auxter describes time as being "'essential in coping with a series of temporal changes within an act itself. This is true in both the complex specific motor skills and also the more basic fundamental skills such as those involved with locomotion. Time is movement between two points."* Rhythm is a tempo, a uniform recurrence of beat, or measured movement.

*Auxter, D.: Developmental physical training for better motor functioning, experimental edition, Western Pennsylvania Special Education Regional Resource Center, 1969.

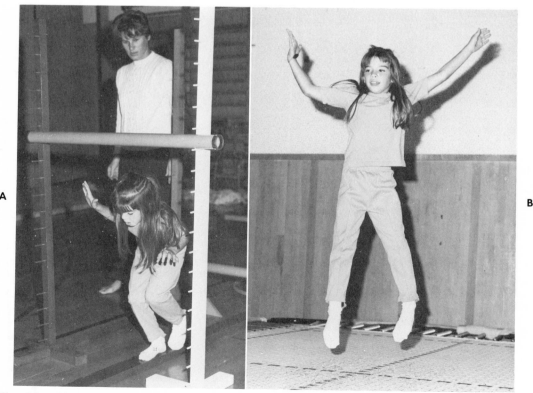

Fig. 6-3. Children gaining body awareness through obstacle course **(A)** and airborne activities **(B).**

Time, space, and rhythm are inseparable. A child's concept of time develops from a primitive subjective state to an outward objective universal state in adulthood.

Barsch divides the development of time into four domains: physiological, physical, milieu, and cognitive time. *Physiological time* consists of the varied periods of internal bodily processes such as heartbeat, respiration, sleep, and wakefulness. *Physical time* is night and day; clock time of seconds, minutes, and hours; calendar time of days, weeks, months, years, and seasons; and historical time of eras, eons, and ages. Physical time also refers to spatial estimates of distance and the concepts of here, far, there, now, then, fast, and slow. *Milieu time* refers to life periods of events such as infancy, early childhood, childhood, late childhood, adolescence, adulthood, and old age. Within each period are characteristic events such as speaking the first word, walking, going to school, driving the car, going steady, marrying, or having the first child. Barsch points out that *cognitive time* is the most complex of the four domains, involving the duration required for the perceptual process to take place, consisting of reaction time, recognition time, and memory.[12]

Table 2. Time schema

Time concepts, objective	Illustrative activities		
	Past	*Present*	*Future*
1. Terminology, definite	Yesterday, 1921, 10 years ago.	Noon, winter, today, this month.	Day after tomorrow, next Friday.
2. Terminology, indefinite	Many years ago when daddy was little.	Right now.	After a while, in a minute.
3. Spatial representation of time (measurement)	Time lines, calendars.	Clocks, calendars.	Calendar, time lines.
a. Fixed, equal	1 inch = 1,000 seconds, hours, or years.	Space between clock numerals = 5 minutes or 1 hour.	Same as past and present, except perhaps in science fiction.
b. Quantitative relationships	1 inch = 1 day; 7 inches = 1 week.	24 hours = 1 day.	
4. Relationships within eras	Which was invented first? What was happening in China in 1776?	What time is it in London?	Explain the twin problem in space travel.
5. Relationships among eras	Discuss speed of transportation in 1810-1820 compared to 2010-2020.	Relativity.	What can we do to prepare people for more leisure time in 1980?
Perception of time			
6. Estimation of duration	How long did it take to build a pyramid? How long is a second?	How fast did he run the 100-yard dash?	How long would it take to walk around the block?
7. Rhythm and sequence	Were those two rhythms the same or different? Digit repetition.	Dance to this beat. Reading, spelling.	Complete a rhythmic sequence.
Subjective time			
8. Awareness, control, and use of time	Recognition of apparent variations in lengths of elapsed time; e.g., each year seems shorter than the year before. Explain "Don't cry over spilled milk."	Punctuality.	Estimating and allotting time for completion of task. Long-term planning and goals.

From Bateman, B. D.: Temporal learning, San Rafael, Calif., 1968, Dimensions Publishing Co.

It is estimated that the acquisition of time concepts is progressive, sequential, and ongoing and is mature when a person is about 16 years of age. Bateman suggests a time schema (Table 2) illustrating some of the temporal skills and relationships acquired by adulthood.

Time and movement. Barsch describes time as movement between two points in space.[12] In order for a child to move efficiently and in a coordinated manner, there must be an accurate awareness of time. Temporal relationships and space are joined with a common bond. Coordinated movement requires an ability to judge the extent of neuromuscular system activation and to perceive time and distance factors associated with objects in space. Distance is a concept perceived as duration over time. If a child lacks accurate awareness of time, he may not have the ability to organize events or perceive subtle differences in speed. Inability to sustain a movement sequence will result in faulty motor performance. A child with this type of deficit will often find difficulty both in the classroom and on the playground. Chronic tardiness, inability to organize class assign-ments, and difficulty in playground activities may be indicative of problems in time and rhythm.

Rhythm. The major portion of the information on rhythm currently referred to has originated from the fields of psychology, physiology, physical education, and art. Time does not exclusively involve rhythm, but rhythm must involve time for its orderly application. Fee describes rhythm as that label given by man to those experiences resulting from the mind's effort to make sense out of the space-time-force phenomenon.[106] In essence, man is a rhythmic organism. Every cell, organ, and organ system functions in rhythmic patterns. H'Doubler defines rhythm as the controlling of force or the measure of energy that gives form to movement.[79] Barsch designates four fundamental aspects of rhythm that he labels as cosmic, biological, performance, and perceived rhythm. *Cosmic rhythm* refers to the universe and nature such as earth rotation, seasons, and day or night. *Biological rhythm* involves the physiological patterns functioning within each person, such as heart beat, respiration, and digestion. *Performance rhythm* refers to those

Fig. 6-4. Child learning a rhythmic pattern.

patterns of movement characteristic of each individual. *Perceived rhythm* consists of the awareness of cadences and ordered patterns that is both external, from the environment, and internal, from within the body.[12]

Rhythm is a necessary factor in the maintaining of gross and fine motor movements. In essence, efficiency in all motor responses implies a regular patterned sequencing of muscular contractions. Rhythmic movement also suggest a certain quality of motion. A person moving rhythmically is able to easily and gracefully cope with the intrinsic and extrinsic variables of space, time, and force. The rhythmic child is able to move smoothly and with regularity equally well in small and in large spaces, can move fast or slow, can engage in short bouts or sustained movement patterns, and is able to move lightly or heavily (Fig. 6-4). The dysrhythmic child is one who has difficulty in maintaining an order to a movement pattern. Disturbances in the ability to adequately cope with sequential motor patterns make performance in many activities difficult or impossible. Rhythm education in elementary schools is designed to reduce distortions through developing the accurate bodily perception of distance, duration, frequency, and intensity. (See Chapter 12.) Children should be provided with every opportunity to optimally develop their ability to perceive and reproduce synchronous motor responses.

Motor skills in basic body management

Movement education is generally concerned with basic movement skills leading to simple body management rather than with the more precise and accurate skills of highly coordinated games and athletics. Basic motor skills serve as a foundation for the more complex activities found in physical education. Although motor skills are for the most part learned, basic motor skills rely heavily on maturation and readiness. For the most part, "motor skill" is a relative term implying that an integration of the perceptual processes has occurred.[31] Basic motor skill development in this text

is concerned with body management and is separated into pattern areas. In a movement pattern the emphasis is on moving instead of on precision, in contrast to a fundamental motor skill.[71] For example, the fundamental skills of running and jumping fall into the large category of locomotor patterns.[165]

The movement education program in-includes basic motor skills that are presented to the child sequentially in a hierarchy of difficulty. The child progresses from very simple to more complex movements, each progression building a logical foundation for the next skill. Of extreme importance during preschool and primary years is skill efficiency in the gross motor

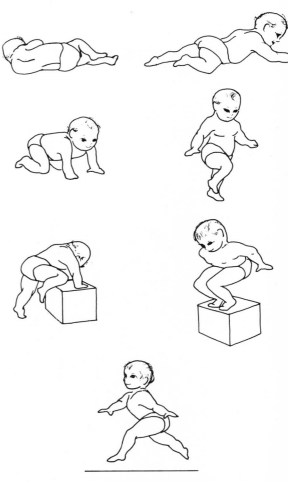

Fig. 6-5. Sequential development of locomotion.

patterns of locomotion, posture control, object control, and apparatus control.

Locomotion. This, as discussed further in Chapter 2, is one of man's greatest attainments. Mobility in the bipedal position frees the individual to explore and manipulate objects in the environment. Opportunities, therefore, should be afforded the young child to experience and to accomplish a variety of locomotor skills such as rolling, crawling, creeping, walking, climbing, hopping, skipping, galloping, jumping up, jumping down, running, and leaping (Fig. 6-5).

Posture and balance control. Posture control is associated with all movement and with every body position assumed. Postural control refers to the general area of good body mechanics and movement efficiency

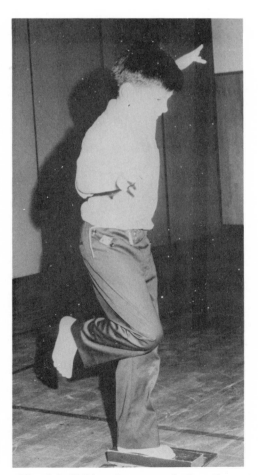

Fig. 6-6. Child testing postural adaptation.

that encompasses all the movements of locomotion, standing, twisting, sitting, reclining, bending, swinging, and stretching. In a discussion of human posture control, the elements of balance cannot be dismissed. Dynamic, static, and object balance are closely associated with the efficient use of the body (Fig. 6-6). The teacher challenges the child to solve movement problems that test postural adaption mechanisms involving the *vestibular apparatus* and *proprioceptors*.

Object and apparatus control. Of extreme importance to the developing child is the control of objects in the spatial environment. Control involves two main areas: manipulation of stationary objects and management of the kinetic energy produced by moving objects.[71, 109] To manipulate an object, the child must locate it by the visual and/or auditory sense and must accurately make contact with the object by reaching followed by identification through the tactile sense.[51] Dexterity and fine motor coordination are dependent on the ability to reach, grasp, and manipulate objects efficiently. Basic to the child's ability at play is his proficiency in controlling a variety of moving objects by striking, kicking, throwing, pulling, pushing, lifting, and carrying. Conversely, the child must learn to absorb kinetic energy of objects by catching, stopping, and holding. Through the movement education process a child is provided with many different types of objects that vary in texture, weight, shape, and size. Hula-Hoops, fleece balls, beanbags, deck tennis rings, and playground balls of assorted sizes are only a few of the play items that may be used by a child in learning to propel and receive objects. (See Chapter 11.) An object can be propelled by any part of the body such as the hand, foot, or head, or its inertia may be overcome or direction changed by hitting with a bat or racket. Variation in receipt of different objects can be explored by stopping them with different portions of the body or catching them with the hands, a wastebasket, a box, or a paper bag.

Basic to a child's motor skill develop-

ment is learning to manage the body when it is associated with different types of apparatus. Apparatus in this instance is defined as large, more or less stationary pieces of play equipment designed for motor development. Apparatus is distinguished from an object in that the participant performs on apparatus rather than with it. It should be noted, however, that apparatus can be natural, such as trees or rocks, or man-made, such as equipment commonly found on playgrounds. Motor development apparatus for the young child is generally categorized according to its primary function, namely, swinging, climbing, balancing, jumping, bouncing, crawling, turning, twisting, or traveling. Standard playground equipment such as horizontal ladders, teeter-totters, swings, merry-go-rounds, turning bars, balance bars, rings, slides, and swing ropes offer the child unlimited possibilities for motor development and imaginary play. The application of movement education to the use of apparatus assists the child in the further discovery of his potential.

Additional elements in movement education

Movement education has as one of its major goals exploration for increased awareness of and sensitivity to the body's internal and external environment. To heighten the child's awareness of movement, the teacher must present various concepts in the form of problems and challenges with which the child can experiment.

Forces. In order to control movement with his body, the child must apply force. Force is the amount of muscle strength that is exerted against a resistance. Implied in the concept of force is that there is enough muscular strength to start, accelerate, stop, and change the direction of a movement. Through strength the child is able to counteract forces directly affecting the body, particularly those of inertia and gravity (Fig. 6-7). Through motor education the child learns to use force efficiently. The teacher explains how muscles control the action of bones. The child ex-

plores force through various activities such as bouncing or striking a ball hard, normally, or softly. The teacher brings to the attention of the child the best way to apply force in pushing and pulling an object. The child learns the concepts of strong, weak, forceful, and gentle movement.

Continuity. Continuity of movement refers to changes in speed, direction, and pattern.[7] A complex skill contains the elements of rhythm, order, and direction. A movement patttern that flows is one in which the body or body part moves smoothly without an abrupt interruption (Fig. 6-8). Sensitivity to movement continuity in contrast to discontinuous movement develops when the child understands and can apply the concepts of slow versus fast, rhythmic versus arrhythmic, controlled versus uncontrolled, straight ahead versus angular, angular versus zigzag, and abrupt stop versus follow-through.

Weight. Weight refers to heaviness of an object and the amount of resistance that may be required to overcome it. Before a child can understand weight and its effect on movement, he must experiment with changes of the center of gravity, transferring the body weight in a variety of situations. The child tests his body weight distribution and equilibrium by performing activities at different levels (Fig. 6-9). The child is made aware of the body's center of gravity by performing tasks in low, medium, and high positions. The child may execute movements in the positions of reclining, standing on all fours, kneeling, standing flat-footed, and standing on tiptoes. He explores equilibrium and shifting of the center of gravity by performing the various patterns found in locomotion and apparatus activities. The child tests the losing and gaining of his balance in various static and dynamic positions. Rapid changes of body positions are made such as moving from lying on the back to standing and moving from standing to a four-point position. The logical outcome of exploration of weight and movement is proficiency in stunts and later in highly skilled gymnastics.

Creativity. Creativity is an integral part of movement education. In an atmosphere less structured than traditional physical education and in which decision making is primarily the responsibility of the child, creativity can flourish. A prerequisite to innovative movement is a sense of freedom, a positive self-concept, encouragement from the teacher, and willingness of the individual to explore, experiment, and test the spatial environment with all the physical attributes available to him (Fig. 6-10).

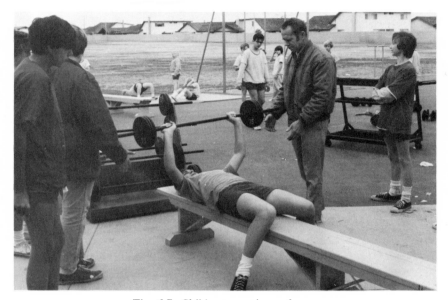

Fig. 6-7. Child overcoming a force.

Fig. 6-8. Children learning movement flow.

Fig. 6-9. Children testing concept of equilibrium: **A,** low position; **B,** medium position; and **C,** high position.

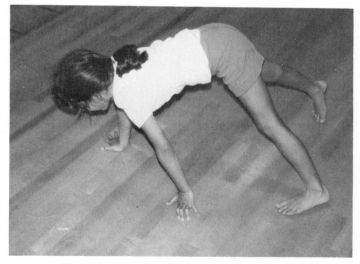

Fig. 6-10. Child experimenting with movement.

Through the movement process the child is helped to discover unique solutions to movement problems. Through movement education the child learns to plan and initiate a movement sequence. Movement education allows the individual to have self-confidence and no fear when asked to perform extemporaneously. The teacher can assist the child in creativity by challenging him to make his body into different shapes, such as flat, round, and straight, and to mimic animate and inanimate objects, such as animals, tables, and chairs.

Physical conditioning. Although physical conditioning exercises are not normally prescribed specifically in the primary years, physical conditioning is not neglected. In this discussion physical conditioning refers to muscular strength, muscular endurance, cardiorespiratory endurance, and joint flexibility. A well-conditioned child is able, generally speaking, to execute easily a wide variety of vigorous activities requiring strength and stamina. (See Chapter 8.)

Movement education encourages physical conditioning by "overloading" the performer. An overload is an excessive work load; in physical education it is used to produce a positive physiological change such as increased muscle power or the ability to continue in a prolonged activity. Overloading through the movement education approach can be accomplished by performing more repetitions of a task, increasing the speed of a task, statically holding a task position for increasing periods of time, or using progressively higher levels of resistance in a task.

ENHANCING THE LEARNING PROCESS

For the learner, the sensory-motor process can be enhanced by methods of teaching that employ sound motor learning principles. Although motor learning is for the most part an inexact science, many practical generalizations have been established that may be employed by the instructor. However, the principles discussed in this section must be considered only as suggestions for improving teaching methods and not as ends in themselves.

The learner

There are many factors that may enhance or adversely alter the learning abilities of the child. Maturation and individual developmental status definitely affect learning and motor skill. The very young child is best equipped to acquire motor skills in the same sequence in which myelinization of motor nerves occurs, that is, gross muscle control followed by fine muscle coordination. Upper-body management occurs before lower-limb management. Large-muscle activities such as running and jumping are mastered before the fine movements required in throwing.[125]

Motivation and interest are always factors in learning. Young children find it difficut to sustain the same activity over a long period of time; therefore, it is best to plan for program emphasis to encompass a great variety of activities. Children usually find that large-muscle exercises provide a pleasant satisfaction or a means of draining undirected energies. What is needed, however, is the proper direction for their excitement. Positive rewards found within the activity itself are much preferred to punishment or even rewards external to the activity. Ideally, the child should find the activity so interesting and exciting that he will play it for its own sake rather than for prizes, grades, or trophies. Skill objectives are more easily attainable when they are clearly stated by the teacher and, whenever possible, are agreed to or selected by the child in cooperation with the teacher.

Methods of teaching

Teaching has been called both an art and a science. (See Chapter 4.) We must concur with this. Teaching must be effective if learning is to take place; effective teaching requires that many interdependent factors occur simultaneously and in sequence with each other. The discrete variables of the teacher's knowledge of the subject, his knowledge of the learner, his knowledge of

personal strengths and weaknesses, and his knowledge of many techniques of communication are but a few factors in the storage of information.[150]

Instruction

Instruction is organized in terms of the sense mode that is used, that is, vision, audition, or kinesthesis. *Visual instruction* or guidance refers to teaching by demonstration, films, video tape, and the like. *Verbal teaching* uses primarily the auditory mode of perception for information input. (See Chapter 4.) Instruction through hearing is not considered particularly effective when complex motor responses are required. Motor guidance in teaching utilizes the kinesthetic sense, wherein the student feels the correct movement pattern or skill. It is generally agreed that not all children learn best through the same sense channels; therefore, the teacher should employ as many sensory modes as possible.[31, 101, 128, 150]

Knowledge of results

Of extreme importance in learning motor skills is the continuous feedback provided by the senses. A child can acquire greater progress in movement skills when he has immediate awareness of the outcome of his performance. The correctness of a motor act can be assisted directly in terms of scores as in basketball or base hits as in baseball or in terms of verbal description by the teacher. Instant playback of video tapes is an excellent method of acquiring immediate knowledge of performance. Children respond best when they are constantly aware of the results of their motor efforts. The astute teacher will provide the child with cues or signals that assist in the feedback process. Through proper cues the child becomes more alert as to what he sees, hears, and feels.

Practice

The way in which a skill is practiced is of the utmost importance for its mastery. Inappropriate practice habits can produce faulty perception and performance. There are many factors that affect the quality of practicing a movement task, for example, how motivated the learner is, whether he is maturationally ready to learn a new task, and whether he has a basic understanding of the objective to be accomplished. The teacher must provide opportunities for various types of practice, depending on the skill to be learned.

Massing of practice. Movement education programs vary considerably in intensity, ranging from a number of hours per day to a few minutes per week. Some motor development systems purport that the functional capacity of the brain can be altered positively by the constant stimulation resulting from the performance of developmental motor patterns.[41] However, movement education programs vary considerably in quality and in amount of external environmental stimulation required. Most programs claiming perceptual-motor learning as an outcome agree that the learner must have many sensory experiences in order to build a backlog for future responses.

The question for many teachers is how much information should be attempted in a single lesson. Should there be a massing of learning until a skill is mastered, or should there be a distribution of practice? Generally, it has been found that distributed practice is better for the learner and that shorter periods in time, intensity, and repetition allow more efficient learning to take place.[128] Authorities in motor learning generally agree that as a person becomes more proficient at a movement skill, increasingly longer periods of time can be spent at its practice. Consequently, younger children require more practices that are spaced closer together than those for older children, and skilled performers can effectively engage in longer practice periods than unskilled performers.[31, 101, 125, 128, 150]

Whole-part-whole method. Whole-part-whole method refers to learning skills in their entirety or learning parts that later are combined to form a complete skill. There are different approaches or combinations of the whole-part-whole concept such as whole

only, part only, part-whole, or whole-part-whole. Any or all of these methods may be utilized by a teacher, depending on the task to be learned and the individual characteristics of the learner. Simple motor tasks can generally be taught in their entirety, whereas more complex activities must be broken into their logical parts. A good teacher will identify and present to the child small whole skill patterns that help to make up the greater whole of the activity. For example, a child may be taught to jump rhythmically in place without a rope, which will later lead to the more difficult task of jumping a complete circling rope. Part learning is concerned with only a segment of a movement pattern of task and is tied to other sequents that will eventually form a complete skill. When a part has been learned well, the next part is attempted. If part learning is to be effective, more complex activities must be joined to one another in a logical sequence of events and in a time period in which the relationship of each part can be clearly understood by the learner. Skill parts learned without relationships often become disjointed and splintered. Ideally, the child sees the whole skill correctly executed, either through demonstration by the teacher or by film. The teacher using the whole-part-whole method continually reminds the child what the entire skill should look like and how the parts will eventually emerge as the completed skill.

Speed of movement. Research indicates that skills should be taught in the same manner in which the learner will ultimately perform them. In other words, the elements of the practice of skills should approximate as nearly as possible those of the actual performance. Slow motion practice provides little benefit in training for fast ballistic type movements. If accuracy is required for the successful completion of an activity, it must be considered from the beginning. Skills like basket shooting, kicking a ball, or hitting a golf ball include the elements of both speed and accuracy; consequently, each must be practiced as it will eventually be performed.

Specificity and transfer of training

A difficult area of study in motor learning is specificity and transfer of training. A number of researchers in motor learning have recently concluded that the learning of motor skills is highly specific for a particular task.[128] To illustrate, Fleishman in an analysis of the factors required in physical fitness, identifies the following specific attributes: (1) speed of change of direction, (2) gross body equilibrium, (3) balance with visual cues, (4) dynamic flexibility, (5) extent of flexibility, and (6) speed of limb movement. Research points out that from all factors studied, specific skills emerge.[31] With this in mind, the teacher must realize that each child brings to the class a multitude of individual skills that he can use in learning different motor tasks. However, a child's excelling in one activity does not mean that he will have an automatic ability in another.

Transfer of training implies that one learned task can be used to learn another task. The question is asked, If motor learning is specific to the task how may one skill enhance or perhaps hinder another?[101] Knapp terms a previously learned act that aids a new skill as positive transfer. Authorities tend to agree that there is specificity in motor ability and that some similarities can be transferred. For example, throwing a ball overhand is similar to the tennis service and the spike in volleyball. Underhand softball pitching can be compared to horseshoe pitching, an underhand serve in volleyball, or a badminton serve. Intrinsic factors such as adjustment of one's center of gravity or application of a specific force in pushing and pulling activities may be transferred from one activity to another. The teacher can improve the process of transfer by pointing out likenesses and dissimilarities between activities. This is particularly true when the child is engaged in tasks designed to assist in cognition. (See Chapter 7.)

RECOMMENDED READINGS

Chaney, C., and Kephart, N. C.: Motoric aids to perceptual training, Columbus, Ohio, 1968, Charles E. Merrill Publishing Co.
Cratty, B. J.: Movement behavior and motor

learning, ed. 2, Philadelphia, 1967, Lea & Febiger.

Engstrom, G., editor: The significance of the young child's motor development, Washington, D. C., 1971, National Association for the Education of Young Children.

Fisher, S., and Cleveland, S. E.: Body image and personality, ed. 2, New York, 1968, Dover Publications, Inc.

Frostig, M.: Movement education: theory and practice, Chicago, 1970, Follett Publishing Co.

Hackett, L. C., and Jenson, R. G.: A guide to movement exploration, Palo Alto, Calif., 1967, Peek Publications.

Kirchner, G., et al.: Introduction to movement education, Dubuque, Iowa, 1970, William C. Brown Co., Publishers.

Kirchner, G.: Physical education for elementary school children, ed. 2, Dubuque, Iowa, 1970, William C. Brown Co., Publishers.

Latchaw, M., and Egstrom, G.: Human movement, Englewood Cliffs, N. J., 1969, Prentice-Hall, Inc.

Mosston, M.: Teaching physical education, Columbus, Ohio, 1966, Charles E. Merrill Publishing Co.

Von Laban, R.: The mastery of movement, ed. 2, London, 1960, MacDonald & Evans Ltd.

Basic motor development

The basic motor learning program utilizes a developmental approach in helping children to reach their full physical and mental potential. It is very valuable as an introduction to physical education in early childhood and the primary school years. The basic motor development approach blends the physical and cognitive aspects of a child into a single entity, avoiding the mistake that is often made of treating the mind and the body as discrete entities. Through this approach the teacher has the opportunity to become more aware of the maturity and readiness levels of each individual child. Early identification of children who may have difficulty as physical performers and/or learners is also possible through this approach. Although the basic motor development program is most successful with young children, many of its offerings can be considered as prescriptive for older children who need remedial help.

The basic motor development program attempts, through a sequential task-learning process, to assist children in becoming more successful in managing their bodies in a wide variety of movement situations,[71] and at the same time it attempts to provide the child with movement experiences that are multisensory in nature. Through the basic motor learning process the child is given opportunities to accurately perceive and respond to a wide variety of external and internal stimuli. In essence, the basic motor development program strives to provide children with tasks that are appropriate for their particular maturation and readiness levels while at the same time stimulating integration of the nervous system in order that increasingly more complicated motor activities may be accomplished.

CREATING A PROGRAM

A basic motor development program must be thought of as an adjunct to, but not a replacement for, a good elementary physical education program. It has been very successfully used in programs for early childhood and for the primary grades.

The teacher

Schools vary on how they provide instruction in the basic motor program. In the self-contained type of classroom, the teacher teaches in this area. Other systems provide a specialist in physical education, whereas others engage aides, either on a voluntary or on a pay basis. Many elementary schools throughout the nation are enlisting parents to conduct their basic motor programs. In situations where aides or parents are used, teachers have the final responsibility of making sure that the program is initiated properly. (See Chapter 5.) An in-service training class is usually held in order to familiarize the aides with the proper procedures and safety precautions. (See Chapter 4.)

The individual assigned to this program as teacher must be highly enthusiastic and, above all, must become involved both physically and emotionally in the performance of the task. The teacher's dress must not hamper movements during class work. For example, a woman teacher who wears a dress and high heels will find demonstrating activities and assisting children in their performances to be very difficult.

Facilities and equipment

In most cases, facilities and equipment associated with the basic motor development program are simple and inexpensive. Most equipment can be improvised or constructed from common materials. Normally the program can be conducted in a classroom or in a limited space outdoors.

Evaluation of the child

Each child in a class should be given an initial evaluation before the program is begun. This evaluation reveals important information; it acts as a pretest that usually will be followed by a posttest indicating if progress has taken place. It also identifies children who may need special attention and provides a basis for emphasizing certain specific task areas. "Prescreening" and "postscreening" of the child are essential for determining individual progress. Information gained can be used to diagnostically determine sensory-motor deficits and to provide direction in programming. Children having basic motor deficits can prescriptively be given special remedial intervening activities. Pretesting and posttesting also give teachers a guide to their effectiveness in conducting the program.

Evaluation tools commonly used to determine basic motor effectiveness fall primarily into two categories: motor proficiency tests that attempt to determine motor maturity by definitive measurement and the survey types of tests that utilize observation for assessment. Both types of tests can be invaluable in elementary physical education.

The Oseretsky Test of Motor Proficiency and its adaptations represent attempts to objectively determine a child's motor age. They contain the movement elements of static balance, hand-eye coordination, dynamic balance, gross motor coordination, dexterity, speed of movement, and the ability to execute simultaneous movements such as that of walking and the rolling of thread on a spool at the same time.[46, 158]

The Basic Motor Ability Scale was developed as a preliminary screening instrument for 5- and 6-year-old children. Test items were selected on the basis of the particular motor factor they represented and the ease with which each item could be given by the teacher. However, in no way can the results of this test be considered definitive; it must be considered only as an indication of the child's motor ability in a given measurement area. The following motor factors were selected as providing valuable information for the teacher: (1) gross motor coordination, (2) dynamic balance, (3) explosive power, (4) movement imitation, (5) static balance, (6) dexterity, (7) arm movement speed, and (8) hand-eye coordination. (See Appendix II.)

In recent years many and varied surveys and observational tests have been developed to assist teachers in determining how their students motorically perform. In most instances, these instruments are based on the subjective opinion of the observer. In order for these tests to be more accurate tools, observations are often rated on a four- or five-point scale. The motor components that are commonly observed are relaxation, locomotion, balance, posture control, and body image. (See Appendix III.)

FUNDAMENTAL BASIC MOTOR TASK AREAS

Included in this chapter are the following activity categories that demonstrate fundamental basic motor task areas: reduction of muscular tension, locomotion, body awareness, functional posture control, management of objects in play, rhythm control, visual-motor control, and classroom motor skills.

All these task areas overlap one another; no task area is autonomous but

must rely on a multitude of cognitive and sensory-motor processes in order to be successful. The following information is designed to aid the teacher in organizing and carrying out a successful program. The tasks presented are designed not to splinter or segment the child's attention into the development of unrelated skills, but rather they are offered as a staircase to a higher order of motor expression.

Reduction of muscular tension

Consciously reducing muscular tension through willed relaxation is one of the most desirable motor abilities. The more difficult a motor skill is, the higher the requirement is for relaxing and contracting appropriate muscles. Children become familiar with their particular tension levels through a wide variety of movement exploration and play experiences.

The teacher and those who work with young children should assist them in becoming aware of how the body moves and the role muscles play in overcoming resistances. Children should learn the concept that movement is the result of tension and relaxation of opposing muscles. They must become aware that tension reduction is essential for recovering energy and proper coordination of opposing muscles, as well as for good mental and emotional health.[61, 140] A discussion on relaxation by the teacher and the class can reveal that the mind and body are inseparable so that worry or mental upset can result in muscular tension.

A teacher can assist children in becoming sensitive to tension and, at the same time, learning to reduce it through conscious control. One method that has proved extremely valuable to use is the modification of Jacobson's progressive relaxation technique.[87, 88] In Jacobson's method, the subject becomes increasingly aware of tensions throughout the body and learns to reduce them. A prerequisite to good body coordination and management is the ability to contract and relax muscles at will. Controlled tension and relaxation of opposing muscles allows for coordinated and efficient movement without undue fatigue. Muscular

tension is related directly to an individual's emotional state, so that the child who is anxious or psychologically upset will express the upset through muscular tension. Conscious reduction of tension provides the child with a better climate for muscular synchronization and emotional control.

The main physical education avenues to tension reduction are rhythmic movement, play that fatigues, stretching exercises, and the most beneficial and lasting means, conscious control by the use of imagery and the basic concepts of Jacobson.

Children can learn to identify the difference between tension and relaxation by engaging in purposeful muscular contractions and relaxations. The teacher can lead each child through a program designed to discover body tensions and ways to reduce them. A program in tension reduction for the elementary school child may progress as follows:

PHASE 1. While the children are resting on their backs, the teacher asks them questions such as "How stiff can you make your bodies?" or "Can you make them as stiff as a board?" or gives them directions such as "Keep your bodies stiff as long as you possibly can." The teacher may then have the children hold the stiff position about 30 seconds. During the stiff period, the teacher may ask, "Doesn't being stiff make you tired?" and then may say, "Now, class, I want you to become gradually less and less stiff until you feel like a limp rag." The teacher might then point out the fact that it feels better to be relaxed than to be tense. When the children have achieved the limp stage, the teacher can go around to them, lifting and dropping their arms to test their relaxed state. Phase 1 is a stepping-stone to understanding the concepts of tension and relaxation.

PHASE 2. This phase, in which bilateral control is learned, can be satisfactorily used with children who are at least developmentally 7 years of age and may be attempted after the individual has satisfactorily accomplished phase 1. The teacher may want to assist each child in learning to relax specific areas of the body. When teaching

the children to relax both legs or both arms, the teacher may start by having the class go through phase 1 and then may proceed to phase 2 by asking the children, "How stiff can you make just your legs, remembering to keep your arms limp?" As in phase 1, the teacher can test the relaxation by lifting the arms and letting them fall. When the class has accomplished the relaxation of both legs, the teacher should concentrate on both arms. (Through this procedure the teacher may recognize children who are unable to consciously relax and may, consequently, require a special remedial program.) When the class has learned the concept of relaxation, they will require less stiffness of the body to become aware of muscular tension.

PHASE 3. Unilateral control is accomplished when older children can progress to controlling the tension levels of one side of the body and then the other side. Phase 3 requires the ability to differentiate between the two halves of the body. Practice of phase 3 may assist a child who is having difficulty in laterality. The teacher may find going over phases 1 and 2 beneficial in properly preparing the class for learning phase 3. When the children's bodies are completely relaxed and limp, the teacher instructs them to tense the arm and leg on one side without tensing those on the opposite side. This is often a difficult skill for children who have problems with coordination. As in the first two phases, the teacher should test the level of relaxation attained by each child. One technique that tests the arousal level of the children when in their relaxed state is for the teacher to make a very loud noise; children who are not completely relaxed will be startled.

PHASE 4. Teachers may want to take the motor skill of relaxation to the point of specific control of individual body parts. Through phase 4, a child can become aware of areas of the body in which muscular tension may be very difficult to release; then he can concentrate on specific tense areas. The following chart is a suggested progession for this phase.

Action	Area where tension is felt
1. Curling right toes down.	Bottom of toes and foot.
2. Curling left toes down.	Bottom of toes and foot.
3. Curling right toes back.	Top of toes and foot.
4. Curling left toes back.	Top of toes and foot.
5. Pointing right foot down (not curling toes).	Bottom of foot, back of calves.
6. Pointing left foot down (not curling toes).	Bottom of foot, back of calves.
7. Curling right foot back (not curling toes).	Top of foot, top of leg.
8. Curling left foot back (not curling toes).	Top of foot, top of leg.
9. Extending right knee (straightening knee slightly).	Top of thigh.
10. Extending left knee (straightening knee slightly).	Top of thigh.
11. Flexing right knee (curling knee slightly).	Back of thigh.
12. Flexing left knee (curling knee slightly).	Back of thigh.
13. Rotating thighs outward.	Outer hip region.
14. Rotating thighs inward.	Inner hip region.
15. Squeezing buttocks together.	Buttocks region.
16. Tightening abdominal muscles.	Lower abdominal region.
17. Pressing back against floor.	Spinal region.
18. Pinching shoulder blades together.	Upper back and shoulders.
19. Pressing head against floor.	Back of neck.
20. Gripping right hand.	Hand and forearm.
21. Gripping left hand.	Hand and forearm.
22. Gripping right hand and curling wrist and elbow.	Front part of arm.
23. Gripping left hand and curling wrist and elbow.	Front part of arm.
24. Gripping right hand and curling it back, and flexing elbow.	Back part of arm.
25. Gripping left hand and curling it back, and flexing elbow.	Back part of arm.
26. Shrugging right shoulder.	Upper shoulder and side of neck.
27. Shrugging left shoulder.	Upper shoulder and side of neck.
28. Curling neck forward.	Front part of neck.

As previously discussed, the primary purpose of the guided relaxation session is to assist the child in becoming increasingly aware of body tension and letting these tensions "go" at will. Overt stiffening of the body should be less required as the child becomes more skillful. Although a reclining position is desirable, the child should be able to let go of tension in any position.

Many factors can be added to assist the teacher in conducting a successful program of relaxation, some of which are a room temperature of 76° F., comfortable loose-fitting clothes, and an exercise mat for each child. Additional factors beneficial to this program are breath control, imagery, and the use of sounds.

Controlled breathing helps the child to let go of body tensions, particularly in the early part of the relaxation session. The child is instructed to inhale slowly and deeply and then to exhale slowly. The teacher instructs the child to become limp as he exhales the air. As a state of relaxation occurs, breathing will automatically become progressively slower and more shallow.

Imagery should be encouraged by the teacher as part of the approach to tension reduction. Phrases like "melting like an ice cube on a hot day," "limp as a rag," "light as a cloud, "floating like a kite," "soft as a furry cat," and "heavy as a rock" may assist children in conceptualizing relaxation and tension. Often, the teacher must emphasize abstract imagery by concrete demonstrations. The children may more easily understand if the teacher gives contrasting imagery directions such as "Show me what a mechanical man looks like" and "Show me what a Raggedy Ann doll looks like or what a flag on a flagpole looks like when there is no wind."

Children should also become aware that sounds can produce tension and/or relaxation. Soft, slow music produces a soothing effect, or a metronome set at a slow cadence provides a relaxing setting for rhythmic movement; these can also serve as a background for the tension-reduction program. One should not discount the teacher's voice as an instrument for relaxing children. Voice qualities such as quiet, low, slow, and distinct tend to reduce classroom tension, whereas those qualities such as loud, high, rapid, and difficult to understand do not.

Locomotion

In the bipedal position, man is freed to explore and use implements. The basic motor program, particularly at the primary level, should include a large variety of locomotor activities that are sequenced and suited to individual maturational levels. Following is such a progression.

Rolling activities. These activities provide the child with opportunities to develop large-muscle control.

1. With the body fully extended, feet together, and arms at the side, the child rolls to the left for ten revolutions and back for ten revolutions. The child should be able to roll in both directions and in a straight line. To maintain a straight roll, the child must first lift and turn the head in the direction of the roll, next, lift and turn the shoulder and twist the trunk, and then lift the hips in the direction of the roll. He moves his legs in line with his hips.
2. With the body fully extended and arms overhead with hands clasped, the child rolls to the left for ten revolutions and then to the right for ten revolutions, maintaining the straight line.
3. The child makes himself as small as possible by grasping his knees in order to roll to the left and right like a ball.
4. Grasping onto the knees, the child rolls over the left shoulder and then the right shoulder. Successful rolling sequences can develop into basic tumbling stunt progressions. (See Chapter 11.)

Crawling activities. Crawling normally follows rolling in performance difficulty.

It offers the child opportunities for success in activities that are executed in a very stable position. Many motor factors that could lead to more complex skills can be acquired. As in all basic motor activities, each crawling sequence should be conducted with proper form.

1. The child crawls in a homologous fashion (moving the arms in unison and legs in unison).
2. He moves along the floor in a prone (face down) position, keeping the stomach close to the floor, and crawls in a cross-pattern movement.
3. He crawls in a homolateral fashion like a crocodile (moving the limbs on one side of the body in unison and then the limbs on the other side of the body in unison), or he wriggles like a snake.

Variations of crawling might be done like the maneuvers of a commando soldier: crawling on the back over and under obstacles, crawling on the stomach under obstacles, or crawling on a narrow board.

Creeping activities. In creeping, the child propels his body on his hands and knees. The well-skilled creeper can move easily and with control forward, backward, and sideward as well as turn in any direction.

1. The child moves along the floor on hands and knees using, consecutively, cross-pattern, homologous, and homolateral movements.
2. He creeps backward and/or to the left and then to the right.

Variations of creeping are the seal walk, crab walk, crawl around and under obstacles, crawl on a narrow beam, or walk with feet and hands (knees straight).

Bipedal activities. These include all activities that involve the upright posture, including ladder-climbing movements. (A hop is executed on one foot at a time, whereas a jump is done with two feet together.)

The child:

1. Executes cross-extension walking with bare feet on a variety of surfaces: cement, asphalt, grass, sand, dirt, puddles, soft mats, pebbles, and wood (Fig. 7-1).
2. Executes blindfolded cross-extension walking (Fig. 7-2).
3. Walks in a variety of directions, such as backward, sideward, obliquely, and in circles.
4. Walks in a variety of ways, such as on toes, on heels, with feet pointed out, and with feet pointed in (Fig. 7-3).
5. Hops on left foot and then on right foot.
6. Hops alternately on the left foot and then on the right foot.
7. Skips.
8. Gallops.
9. Jumps up off the ground.
10. Jumps over a line.
11. Steps from a 12-inch height.
12. Walks up stairs in cross pattern (Fig. 7-4).
13. Walks up a ramp in cross pattern.

Fig. 7-1. Child walking on soft surface.

Fig. 7-2. Child walking blindfolded.

Fig. 7-3. Children demonstrating different ways of walking: **A,** on toes; **B,** on heels.

Fig. 7-4. Child stepping up and stepping down in cross pattern.

Fig. 7-5. Children climbing ladder.

Fig. 7-6. Child running in cross pattern.

14. Walks down stairs in cross pattern.
15. Walks down a ramp in cross pattern.
16. Climbs a ladder in any manner (Fig. 7-5).
17. Climbs a ladder in cross-lateral pattern.
18. Broad jumps a distance.
19. Jumps from a height.
20. Jumps over a swinging rope.
21. Runs fast in cross pattern (Fig. 7-6).
22. Runs fast around obstacles.

Balance activities. These activities are essential in all human movement and involve the person's ability to maintain or

Fig. 7-7. Child in side-lying position.

Fig. 7-8. Child standing in two-point balance position.

control a desired body position while dynamically moving or while in a static position. An individual maintains and loses balance continually in most gross motor activities; the ability to maintain balance is developed through the body's losing and then regaining the balance position.

Static balance activities. Sequences are separated into two levels. Level 1 includes a sequence of static postures without the use of equipment. Level 2 is more difficult and uses various-sized balance boards. In both levels, balance posture is held for a minimum of 10 seconds.

LEVEL 1 TASK PROGRESSIONS:

The child:

1. Assumes side-lying position (Fig. 7-7).
2. Assumes three-point position (left knee off floor and then right knee off floor).
3. Assumes two-point position on left hand and right knee and then on right hand and left knee (Fig. 7-8).
4. Kneels upright on left knee, with arms crossed, and then on right knee, with arms crossed.
5. Squats with arms crossed (Fig. 7-9).

Fig. 7-9. Child squatting in balance position.

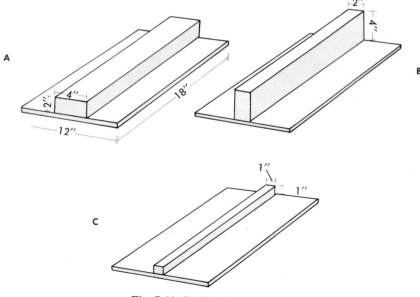

Fig. 7-10. Static balance board.

6. Stands, feet together, with hands on waist.
7. Stands, feet together, on tiptoes, with hands on waist.
8. Stands, heel to toe, left foot in front and then right foot in front, with hands on waist.
9. Stands on left foot and then on right foot, with arms crossed.
10. Stands on left foot and then on right foot, with arms crossed, blindfolded.

LEVEL 2 TASK PROGRESSIONS (balance board dimensions are indicated in Fig. 7-10).

The child:
1. Stands, heel to toe, with left foot forward and then with right foot forward, on the 4-inch surface.
2. Stands, heel to toe, with left foot forward and then with right foot forward, on the 1-inch surface.
3. Balances on right foot and then on left foot, with hands on waist, on the 4-inch surface.
4. Balances on right foot and then on left foot, with hands on waist, blindfolded, on the 4-inch surface (Fig. 7-11).
5. Balances on right foot and then on left foot, with hands on waist, on the 2-inch surface.
6. Balances on right foot and then on left foot, with hands on waist, blindfolded, on the 2-inch surface.
7. Balances on right foot and then on left foot, with hands on waist, on the 1-inch surface.
8. Balances on right foot and then on left foot, with hands on waist, blindfolded, on the 1-inch surface.

VARIATIONS OF STATIC BALANCE ACTIVITIES:

The child:
1. Balances statically while assuming different poses.

Fig. 7-11. Child maintaining static balance, blindfolded.

Fig. 7-12. Child balancing object with hand.

2. Plays catch while balancing.
3. While standing in one position, balances other objects, such as broomsticks on fingertips and beanbags on head (Fig. 7-12).
4. Plays "statue"—takes different positions and holds them.

Dynamic balance activities. As is static balance, dynamic balance is divided into two task areas: those that are conducted on the floor or ground and those that are done on the balance beam. Success in a specific task is determined when a child can slowly and deliberately perform for a minimum of ten steps on the balance beam. A dynamic balance task is not accomplished if the performer speeds up, stops, or wavers out of control before ten steps have been completed.

LEVEL 1 ACTIVITIES. All tasks must be conducted with hands on hips:

The child:

1. Walks forward in a 6-inch track.
2. Walks sideward (left and then right), foot to foot, in a 6-inch track.
3. Walks backward in a 6-inch track.
4. Walks, heel to toe, forward on a line.
5. Walks, heel to toe, sideward (left and then right) on a line.

LEVEL 2 ACTIVITIES (the balance beam, which is 10 feet long, is illustrated in Fig. 7-13):

The child:

1. Walks forward on the balance beam, heel to toe (Fig. 7-14).

2. Walks sideward on the balance beam to the left and then to the right, foot to foot.
3. Walks backward and then forward on the balance beam, heel to toe.
4. Walks forward on the balance beam, heel to toe, blindfolded.
5. Walks sideward on the balance beam to the right and then to the left, the following foot stepping over the leading foot.
6. Walks backward on the balance beam, heel to toe.
7. Walks sideward on the balance beam, blindfolded, and then backward, blindfolded.
8. Walks forward on the balance beam, stepping over obstacles of different heights (Fig. 7-15).

VARIATIONS OF DYNAMIC BALANCE ACTIVITIES:

The child:

1. Crawls on the balance beam.
2. Bounces ball while walking on the beam.
3. Catches and throws while walking on the beam.
4. Performs rebound activities on the balance beam.
5. Bounces on a pogo stick (Fig. 7-16).
6. Walks on stilts.
7. Skates with either roller skates or ice skates.
8. Rides a two-wheel bicycle.
9. Plays hopping games like hopscotch.

5"

Fig. 7-13. Balance beam.

10. Jumps rope.

11. Rides on a scooter board.

Rebound or airborne activities. Jumping from a surface or being projected upward provides children with a stimulating kinesthetic experience. While suspended in air, the body must make a multitude of neurophysiological adjustments in order to stabilize itself in space. Balance and gross muscle control are greatly enhanced through rebound and airborne activities.

The teacher should be aware of the number of factors essential to coordinated airborne activities, namely, balance, bilateral gross motor control, strength of jump, and jumping pace. Balance is important to good jumping, with the body following the position of the head. The child should be able to

Fig. 7-15. Child stepping over obstacles on balance beam.

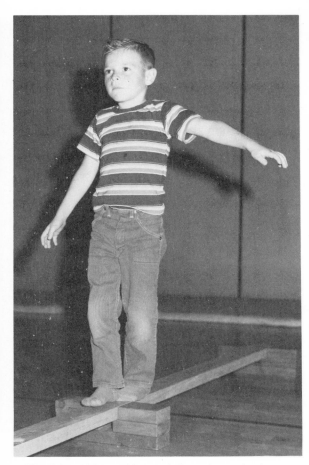

Fig. 7-14. Child walking on balance beam, heel to toe.

Fig. 7-16. Child bouncing on pogo stick.

change direction of his jump easily by shifting his body weight to the left or the right. Smooth jumping requires the coordinated use of both sides of the body. Arms should be level with each other, and feet should be parallel to the jumping surface. The child should be able to alter the height and speed of the jump on the teacher's command, in repetitive jumps. A child who displays stiffness and improper body control should be encouraged to participate in a wide variety of airborne jumping tasks.

PROGRESSIONS. Flexboards, tires, or springboards are used:

The child:

1. Jumps up and down with both feet.
2. Jumps up and down with the right foot and then with the left foot.
3. Jumps up and down, alternating feet.
4. Jumps up and down twice and then jumps with both feet, to the ground.
5. Jumps sideward to the right, to the ground, and then sideward to the left, to the ground.
6. Jumps backward to the ground.
7. Jumps and turns to the right one-fourth turn, one-half turn, three-fourths turn, and then a full turn.
8. Jumps and turns to the left one-fourth turn, one-half turn, three-fourths turn, and then a full turn.

VARIATIONS OF JUMPING ACTIVITIES:

The child:

1. Jumps and claps hands before landing.
2. Jumps and catches an object in the air.
3. Jumps over an obstacle.
4. Jumps and does a forward roll.
5. Jumps and throws an object.
6. Jumps on a trampoline, which is one of the devices for learning postural control. (See Chapter 11.)

Body awareness

Body awareness is extremely difficult to accurately assess. A person's total self-concept, including perception and values as well as attitudes, must be considered. Body awareness includes the awareness of body sidedness and of the relationship of the body to space. Tasks designed to assist children in developing their self-awareness can be divided into two broad categories: reflective and directive.

Reflective activities. Reflective body awareness tasks are designed to help the child accurately perceive and mimic the movement of another person. By performing reflective tasks, the child is able to learn accuracy in body positions, with immediate feedback provided by the teacher or peer. The teacher demonstrates the tasks in two ways: facing the child and facing a mirror with his back to the child. The child responds to the face-to-face task as he would while viewing himself in a mirror. When the teacher is facing away from the children, the child attempts to mimic the exact movements of the teacher. Reflective tasks are divided into two levels based on difficulty: level 1 involves activities that use either arms or legs, whereas level 2 involves arms and legs together in a task.

LEVEL 1 ACTIVITIES:

The child:

1. Raises both arms to a half side position.
2. Raises both arms to a three-fourths side position.
3. Raises both arms to a one-fourth side position.
4. Raises left arm to a three-fourths side position and right arm to a half side position (Fig. 7-17).
5. Raises right arm to a three-fourths side position and left arm to a one-fourth side position.
6. Raises right arm to a half side position and left arm to a three-fourths side position.
7. Raises left arm to a half side position and right arm to a three-fourths side position.
8. Extends right arm in front of face and raises left arm overhead.
9. Extends left arm in front of face and raises right arm overhead.
10. Spreads both feet to side.
11. Spreads right foot to side.

12. Spreads left foot to side.
13. Assumes a staggered position, with right foot forward and left foot back.
14. Assumes a staggered position, with left foot forward and right foot back.

LEVEL 2 ACTIVITIES:
The child:
1. Raises both arms to a half side position and spreads right foot to side (Fig. 7-18).
2. Raises both arms to a half side position and spreads left foot to side.

Fig. 7-17. Child performing reflective body awareness task, level 1.

Fig. 7-18. Child performing reflective body awareness task, level 2.

3. Raises both arms to a one-fourth side position and assumes a staggered position, with right foot forward and left foot back.

4. Raises right arm to a one-fourth side position, extends left arm overhead, and assumes a staggered position, with left foot forward and right foot back.

5. Extends both arms at shoulder level and spreads both feet.

VARIATIONS OF REFLECTIVE ACTIVITIES. Young children find mimicry exciting and fun. (See Simon says, p. 226.)

Directive activities. Body awareness tasks that are dependent on verbal directions are usually more difficult than are reflective tasks. Communication difficulties or misunderstandings may cause the child to be confused; therefore, directions must be simply stated. The teacher must not jump to conclusions when a child fails to respond properly to a verbal direction; however, repeated errors by the child may indicate a deficit in the area of body awareness or a difficulty in perceptual processing. Directive body awareness tasks are separated into two levels: level 1 is concerned with body planes, basic sidedness, and directionality; level 2 is primarily concerned with identification of specific body parts, body movements, and external objects as they relate to laterality and directionality.

LEVEL 1 ACTIVITIES:

Body planes

The child:

1. Touches the front of his body.
2. Touches the back of his body (Fig. 7-19).
3. Touches the side of his body.
4. Touches the top of his body.
5. Touches the bottom of his body.

Fig. 7-19. Child performing directive body awareness task, level 1, body plane.

Fig. 7-20. Child performing directive body awareness task, level 1, body part.

Body parts

The child:

1. Touches an arm (Fig. 7-20).
2. Touches a leg.
3. Touches a foot.
4. Touches an elbow.
5. Touches a knee.
6. Touches his face.
7. Touches his nose.
8. Touchs an ear.
9. Touches his mouth.
10. Touches an eye.

Body movements

The child:

1. Bends his body forward.
2. Bends his body backward (Fig. 7-21).
3. Bends his body sideward.
4. Bends his elbow.
5. Makes circling motion with either arm.

Laterality

The child:

1. Touches his left knee.
2. Touches his right foot.
3. Touches his left eye.
4. Touches his left elbow.
5. Touches his left shoulder.
6. Touches his right side against the wall.
7. Kneels on his left knee.
8. Holds any object in his right hand.
9. Steps up on any raised area with his right foot.

Directionality (two children face each other)

The child:

1. Touches partner's left hand.
2. Touches partner's right ear.
3. Touches partner's right shoulder.
4. Touches partner's left side.
5. Touches partner's right knee (Fig. 7-22).

Fig. 7-21. Child performing directive body awareness task, level 1, body movement.

Fig. 7-22. Child performing directive body awareness task, level 1, directionality.

6. Touches left side of desk or chair.
7. Touches right side of desk or chair.
 LEVEL 2 ACTIVITIES:

Body parts (more specific than in level 1)
The child:
1. Touches his shoulder.
2. Touches his thigh.
3. Touches his wrist.
4. Touches his upper arm.
5. Touches his forearm.
6. Touches his hand.
7. Touches his thumb.
8. Touches his little finger.

Body movements (more specific than in level 1)
The child:
1. Straightens his leg.
2. Bends one knee.
3. Makes a circling motion with one wrist.
4. Raises one arm overhead.
5. Bends fingers of one hand.
6. Straightens fingers of one hand.

Lateral awareness
The child:
1. Touches a beanbag or other object to his right side.
2. Touches object to his left knee.
3. Touches object to his left elbow.
4. Touches object to his right ear.
5. With right hand, touches his left foot.
6. With left hand, touches his right ear.
7. With left hand, touches his left shoulder.
8. With right hand, touches his left elbow.
9. With right hand, touches his left wrist.
10. With left hand, touches his right eye.

Directionality
The child:
1. With left hand, touches the right side of the chair.
2. With right hand, touches the left side of the chair.
3. With right hand, touches the right side of the chair.

4. Touches another child's right ear.
5. Touches another child's left knee.
6. Touches another child's left elbow.
7. Identifies on which foot another child is standing.
8. Identifies which hand another child has raised.
9. Stands so that his right side is against another child's left side.
10. Stands so that his left side is against another child's right side.

Functional posture control

The motor development approach for young children is concerned with the most efficient use of the body in supportive tasks such as standing, sitting, and various ways of overcoming resistance. The young child can become aware of the most efficient ways to use the body through a well-planned movement, problem-solving, and task-oriented program. Closely associated with static and dynamic balance, posture control is concerned with the execution of body positions that involves a minimum of energy demands. Good supportive posture is the relative arrangement of the body parts and body segments that provides the greatest mechanical efficiency, whereas poor supportive posture produces functional disharmony and mechanical inefficiency.

A child's posture is characteristically malleable and ever changing; consequently, it can be easily molded into good or bad posture. Restrictive postures that may be assumed by children for extended periods of time, such as sitting at a desk, are not conducive to the development of good posture. Children should experience a wide variety of large-muscle activities daily in order for postural efficiency to occur, for which these is a normal inclination.

Standing. Although children are seldom at ease when they stand statically in one position, the standing posture can provide valuable information for the teacher about how well each child is segmentally aligned. Ideally, each body segment is evenly balanced over the supporting segment below (Fig. 7-23). Children can discover their

own best standing posture by experimenting with the feel of contrasting positions.

To learn about the base of support, the children work in pairs with one child standing in back of the other with his hands placed on the other's shoulders. The teacher states the problem, after which the front child takes that position while the child in back pushes and pulls in an attempt to offset his partner (Fig. 7-24). Two contrasting positions are given by the teacher, and the child is asked to determine which one of the positions is the most stable. Following are examples of some contrasting positions:

The child:
1. Stands on toes or flat-footed.
2. Stands flat-footed, with feet together or separated.
3. Stands with knees straight or knees bent.
4. Stands with feet staggered or both feet even with each other.
5. Leans forward or stands straight.
6. Leans backward or stands straight.
7. Leans sideways or stands straight.

Each child is asked to test the following good and poor standing alignments by himself to see if he can feel the difference and decide which is better:

The child:
1. Stands with his head forward or balanced above the shoulders.
2. Stands with his shoulders forward or straight.
3. Stands with his back rounded or straight.
4. Stands with his hips forward with the abdomen relaxed or hips straight with the abdomen held firm.
5. Stands with his weight on the left foot with the left shoulder sagging or with his weight on both feet and shoulders even.

Sitting and rising. Because sitting and rising from a chair are so basic to everyday life, the teacher can use this element as a means of teaching proper body alignment.

Fig. 7-23. Segmental posture alignment.

Fig. 7-24. Children learning concept of body balance and posture.

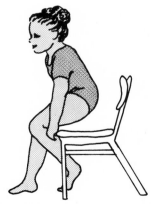

Fig. 7-25. Proper body alignment for sitting or rising.

He instructs the child to keep his head up and his back in good alignment when seating himself in a chair. The child places one foot behind so that it touches the front of the chair and simultaneously leans his trunk forward, lowers his body to the seat, and bends his knees (Fig. 7-25). Control comes from the quadriceps muscles, which extend the knee. To rise from the chair, the child leans forward slightly while the knee extensors straighten the legs.

Overcoming resistances. The supportive functions of lifting, carrying, pushing, and pulling are basic to a child as well as to the adult; consequently, they should be included early in a child's movement cur-riculum. Proper execution of these functions ensures a better application of mechanical forces, more efficiency of effort, and the prevention of muscle injury from strain.

When grasping a heavy object to lift it from a low level, the child must keep his feet flat on the floor, keep his back straight, and bend his knees (Fig. 7-26). To lift the heavy object, he straightens his knees while keeping his head, back, and hips in good alignment. To increase the mechanical advantages of the lift, he maintains the object close to the body.

A person should carry objects that are heavy with both arms close to the body.

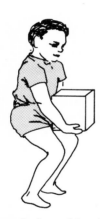

Fig. 7-26. Proper body position for lifting heavy object.

Fig. 7-27. Proper body position for carrying heavy object.

Fig. 7-28. Proper body position for pushing heavy object.

Fig. 7-29. Proper body position for pulling heavy object.

To increase force and decrease the chances of muscle strain, he should keep his body segments well aligned (Fig. 7-27). When carrying objects such as school books on one side of the body, he should make a special effort to keep the load close to his body and not to let the body sag; also frequent changes of the load from one side to the other will aid in preventing postural distortions.

The physical laws applied to pushing a heavy object require the pusher to push in line with or below his center of gravity (Fig. 7-28). To increase pushing power, he must keep his body well aligned, with one foot forward and one foot back and the hips slightly bent. The primary force comes from straightening the knees.

In pulling, in contrast to pushing, force is applied upward and forward. The body is inclined away from the heavy object, with the center of gravity in line with the force of the pull. One leg is forward and the other back, with the major force of the pull coming from the extension of the legs (Fig. 7-29).

The teacher can provide children with problems that will assist them in discovering the best methods for overcoming a resistance. The child should test the differences in the following contrasting ways of overcoming resistance:

The child:

1. Lifts a moderately heavy box without bending knees, and then bending knees.
2. Carries a box close to the hip and then away from the hip.
3. Pushes a heavy object at shoulder height and then at knee height at the center of gravity.
4. Pushes a heavy object with arms alone and then with the legs alone.
5. Pulls an object higher than, lower than, and in line with the center of gravity.

Management of objects in play

Dealing with objects in space is basic to successful game playing. The performer must be able to propel and/or receive objects efficiently if he is to play a wide variety of games and sports.[71] As do all motor skills, object control develops from a hierarchy of movement patterns and subskills that are built on each other to eventually emerge as a highly integrated motor act. Following are suggested steps leading to the individual movement skills of throwing, catching, kicking, and striking.

Throwing activities

Lead-up subskills

The child:

1. While seated, pushes a 9-inch playground ball with both hands to a receiver sitting 3 feet away.
2. While seated, pushes a 9-inch playground ball with both hands to a receiver sitting 6 feet away.
3. While seated, pushes a 9-inch playground ball with both hands to a receiver sitting 10 feet away.
4. While seated, pushes a 9-inch playground ball with his left hand to a receiver sitting 10 feet away.
5. While seated, pushes a 9-inch playground ball with his right hand to a receiver sitting 10 feet away.
6. While kneeling, bounces a ball straight into the hands of a receiver sitting 10 feet away.
7. While kneeling, bounces a ball with his right hand into the hands of a receiver sitting 10 feet away.
8. While kneeling, bounces a ball with his left hand into the hands of a receiver sitting 10 feet away.
9. While standing, throws a ball with both hands from an overhead position, straight to the receiver.
10. While standing, bounces a ball with the preferred hand to a receiver.
11. With opposite foot forward from throwing arm, throws a small ball to a receiver.

When the child can efficiently execute the last directive, the teacher should then teach him the mature way of throwing an overhand ball, as follows:

12. Preparatory movement (right-handed throw is described):
 a. Pivots by rotating his body to the right and shifting his weight to the right foot.
 b. Swings his throwing arm backward and upward and, from this position, is ready to execute an overhand throw.
13. Final sequence of throw:[165]
 a. Steps forward with his left foot in the direction of the throw, with his toes pointed in direction of the throw.
 b. Rotates his hips, trunk, and shoulders to the left while pulling his throwing arm back to the final position before starting the forward arm movement.
 c. Leads his right elbow forward horizontally, extends his forearm, and snaps his wrist just before releasing the ball.
 d. Executes the follow-through by continuing to move his arm in the direction of the throw until the muscular energy has been dissipated (Fig. 7-30).

Throwing skills
The child:
1. Plays catch with another person.

2. Throws balls or beanbags at a target.
3. Throws to a pitch-back device.
4. Throws, using a variation of projectiles, such as Hula-Hoops, beanbags, fluff balls, baseballs, soccer balls, and footballs.
5. Plays games like dodge ball.
6. Passes a football.
7. Learns different ways to project, such as underhand pitch, push pass, hook pass, and shot put, and becomes aware of the differences and similarities of the various techniques.

Catching activities
Lead-up skills. The learning ball should be partially deflated for ease of handling. The child:
1. While seated, traps a rolling 9-inch playground ball.
2. While seated, stops a rolling 9-inch playground ball with both hands.
3. While in a kneeling position, stops a rolling 9-inch playground ball.
4. First while kneeling and then while standing, handles a bouncing 9-inch playground ball. (Catching an aerial projectile requires the performer to overcome the fear of being hit in the face. The child with fear

Fig. 7-30. Mature overhand throw.

will have more success with a paper or cloth ball.)

5. Forms a scoop with his arms into which the leader throws the ball, first, from a distance of 3 feet and then from as far away as 10 feet.
6. Catches the ball, first, with arms and body, then just with the arms, and eventually just with the hands.
7. Uses gradually reduced sizes of balls.
8. Catches objects with either hand.

Catching skills
The child:
1. Plays catch.
2. Catches different types of objects, such as beanbags, Hula-Hoops, fluff balls, baseballs, and footballs.
3. Catches an object with a baseball glove or in a container such as a tin can, basket, or bag.

Kicking activities. Kicking or striking of an object with a foot emerges after the child is able to run.

Lead-up skills
The child:
1. Pushes or nudges a stationary large playground ball.
2. Kicks a stationary ball with either foot.
3. Kicks a stationary ball backward with inside, outside, and then bottom of foot.
4. Kicks a stationary ball to a target.
5. Kicks a stationary ball and makes it airborne.
6. While standing, kicks a ball rolled to him.
7. While walking, kicks a ball rolled to him.
8. While running, kicks a ball rolled to him.

Kicking skills
The child:
1. Plays kickball.
2. Plays games like soccer.
3. Kicks a soccer ball as he drops it from his hand.
4. Kicks a football.

Striking activities
Lead-up skills. The sequences described

are designed to lead to such activities as handball, tennis, golf, and baseball.

The child:
1. While sitting on the floor, hits a balloon with each hand, usually in an overhand movement.
2. While kneeling, hits a balloon in front of his body, at the side of his body, and overhead.
3. While standing, hits a balloon with a table tennis paddle or with a rolled-up newspaper.
4. With a table tennis paddle, hits a balloon in an overhand manner, with the same motion as in an overhand throw.
5. With a table tennis paddle, hits a balloon from a side position.
6. Holding a light plastic bat with both hands, hits balloon.
7. Holding a plastic bat with a correct batting grip, hits a large playground ball off a batting tee.
8. Bats a variety of airborne balls, such as fluff balls, tennis balls, 6-inch playground balls, softballs, and baseballs.
9. Using a plastic bat, hits a variety of objects on the ground.
10. Using a variety of implements, such as sticks, golf clubs, croquet mallets, and hockey sticks, hits a ball from the ground.

Striking skills
The child:
1. Bats off a tee for accuracy.
2. Bats off a tee for distance.
3. Plays base games.
4. Plays golf.
5. Plays hockey.
6. Plays croquet.
7. Plays table tennis.
8. Plays handball.
9. Plays paddle ball games.
10. Plays paddle tennis.

Rhythm control

Essential to a child's success at play and in the classroom is the ability to sense an external rhythm impression and to respond

Fig. 7-31. Children learning rhythm.

to it with precise movement. As discussed in Chapter 6, in all movement patterns, whether they are basic, as in locomotion, or complex, as in a gymnastic routine, or require large muscles or small muscles, rhythm control is necessary for efficient movement. The basic motor program should include progressive sequential tasks requiring the synchronization of specific body movements. In his program of metronomic pacing, Barsch suggests that a beginning cadence should be established at 48 beats per minute with drums, lummi sticks, or a metronome.[12] The number of beats per minute can be increased when the prescribed movement is performed easily and smoothly. Sequencing should progress from unilateral to bilateral to cross-lateral movements. For example, the children may be asked to blink to a cadence, first, one eye, then the other eye, and finally both eyes alternately (Fig. 7-31). The children can elect to engage in large-muscle rhythms and progress to the smaller muscles of the body.

Visual-motor control

Visual-motor coordination is necessary for achievement both inside and outside the classroom. As discussed in Chapter 2, the whole postural, transport, and manipulative system is dependent on the integrity of the visual process. In the primary grades, children must make many complex decisions daily that are based on information provided by the visual system. The teacher should offer each child a variety of challenges to encourage visual integration with the haptic sense.

Eye-hand coordination. Some suggestions for activities in eye-hand coordination are as follows:

The child:

1. Tracks a swinging ball with his eye.
2. Chases a flashlight beam.
3. Tracks moving objects with a flashlight.
4. Rolls a piece of paper into a ball with one hand.
5. Squeezes clay into various shapes.
6. Places clothespins around the edge of a tin can.
7. Sorts out nuts and bolts from a jar.
8. Cuts along a line with scissors.
9. Hits a balloon on a string as many times as possible.
10. Blows bubbles and breaks them with different fingers.
11. Traces pictures with chalk.
12. Plays a variety of target games.
13. Plays games like marbles, pickup sticks, and tiddlywinks.
14. Plays ball.

Eye-foot coordination. In order for a child to be able to play a variety of large-muscle games, he must have eye-foot coordination.

The child:

1. Steps on, over, and between objects, such as ladders or footprints.
2. Jumps on, over, and between objects; for example, he plays hopscotch, jumps rope, jumps on stilts, and jumps on tin cans.
3. Plays ball-kicking games.

Form-perception activities. The purpose of form-perception activities is to help the child in distinguishing basic geometric forms. The ability to distinguish such forms as circles, squares, and triangles leads directly to the development of the congnitive areas of reading, writing, and arithmetic.

The child:

1. Cuts out forms from different materials such as sandpaper and cardboard.
2. Draws, paints, or creates forms with different materials, such as clay, sandpaper, paper, water, and cornmeal.
3. Makes forms from materials such as felt, foam rubber, velvet, and wood.
4. Traces around a form with his eyes open and then with them closed.
5. Pastes forms on a board.
6. Draws forms.
7. Reproduces forms with his body.
8. Walks or runs around forms.

Blackboard and chalk activities. A planned program of blackboard activities can aid children in many of the motor areas required in the classroom, namely, eye-hand control, laterality, directionality, and simultaneous use of the various perceptual modes.

The child:

1. Draws geometric forms.
2. Picks a particular geometric form out of a group of forms (figure-ground discrimination) (Fig. 7-32).
3. Draws a continuous line within a narrow track crossing midline of body (Fig. 7-33).

Fig. 7-32. Child identifying geometric form.

4. Meets consecutive numbers with a line (Fig. 7-34).
5. Performs audiovisual-motor tasks as suggested by Klasen.[100]
6. Draws patterns with each hand independently.
7. Draws line patterns left to right, with both hands together.

Transfer game activities. Learning is best attained by most primary children, through gross motor activities and the kinesthetic sense. Transfer from outdoors to classroom is best acquired by the child when the teacher indicates similarities. Transfer activities are designed to be used in conjunction with the line marking suggested for the primary developmental playground (Fig. 7-35).[34]

Colored shapes and circles. The children use various means of locomotion such as hopping, skipping, walking, and running around the circle.

1. They stop when told to, on a designated object such as a triangle, square, circle, or half circle (as in musical chairs).

Fig. 7-33. Child controlling line within a track with the left hand.

Fig. 7-34. Child meeting numbers with a line.

2. They rotate around the circle with balls in hand, stop on a designated object, and execute a particular skill, such as bouncing the ball, turning around, or jumping up and down.

3. They rotate in various ways around the circle and stop on certain objects in relation to a color called in addition to the shape indicated.

4. In conjunction with the colored-shape circle, as the teacher calls out odd or even numbered children, they run to the large circle and find a particular object identified for their group. Any combination of shapes, colors, or numbered activities can be created and designed by the teacher.

Clock. The students learn how to tell time by standing on the numbers of the clock with arms extended. One additional student stands in the center of the clock and joins hands with the children of the various numbers to make the hands of the clock according to the time called by the teacher; for example, to indicate 3 o'clock, the person in the center joins hands with the child standing on the 12 and the child standing on the 3. The center child can also toss beanbags or bounce balls to the children on the numbers as different times are called. The clock circle can also be used for purposes of forming the class for games of low organization necessitating circular formation.

Successive-block hopscotch. In successive-block hopscotch the children either follow the numbers in consecutive order, changing directions as indicated by the outline, or play with a lagging object as in regular hopscotch beginning with a two-foot jump and continuing on through the pattern. A child makes an error when he steps on a line or does not follow consecutive order.

Twelve-square jumpscotch. In this game, the children begin by jumping on the num-

Fig. 7-35. Outdoor learning games.

ber 1 and then follow the numbers, attempting to turn in the air so that they can make the next jump in order without taking or making additional moves in the square. For another variation correlated with mathematics, the children add the numbers they are jumping on, proceeding as far as they can until they make an error.

Geometric circle. The geometric circle can be utilized in the same manner as the colored-shape circle; it is similar in design but has a greater variety of geometric figures. The children perform different learning tasks as they progress from one shape to another or from one color to another as designed by the teacher. They identify colors, squiggles, triangles, lines, hexagons, octagons, and other shapes to develop figure-ground relationships.

Question-mark hopscotch. Question-mark hopscotch is designed to be played in the same manner as regular hopscotch with the additional stress being that the children lean in one direction to make the turn in a continuous manner. The object is to progress all the way through the question mark and return to the dot without making an error. A lagging object can be used if so desired.

Alphabet grid. The alphabet grid can be correlated with the learning of letters and spelling lessons in the classroom. (See Fig. 5-28.) The children follow the alphabet grid in a consecutive manner or design their own games by spelling a variety of words. This is lead by the teacher or the student.

Typical hopscotch. The traditional hopscotch design can be used either by following the numbers consecutively or by using a lagging object. This design is the most commonly used hopscotch activity.

Hopscotch circles. Hopscotch circles are designed to develop laterality. The student begins on one end of the circle and hops with both feet if circles are side by side, selecting the dominant foot for the circle in the center and the other foot for the side of the circle, according to the design. The teacher may look for difficulties the children have in moving through the circles in the most efficient manner.

Jumpscotch court. The jumpscotch court is designed for children to jump with both feet consecutively from one number to the next. The object is to reach number 10 without making an error. The teacher can observe the students for efficiency in moving, body agility in turning, and knowledge of consecutive numbers.

Numeral grid. The numeral grid can be used in conjunction with a mathematics lesson. The child jumps into numbered squares called by the teacher or jumps consecutively, as in regular hopscotch.

Snail hopscotch. In snail hopscotch the child begins from the outside of the snail and jumps to the center, attempting to maintain balance while continuing along a pattern of smaller circular patterns. As the circle gets smaller, it is increasingly difficult to maintain balance and eliminate errors.

Classroom motor skills

It is generally agreed that learning behavior is developed and is expressed through motor responses. The language skills of reading, writing, and arithmetic depend to a great degree on the child's perceptual abilities, involving vision, audition, touch, and kinesthesis. Integration of these perceptual functions provides the basis for a child's cognitive and physical development. Physical education can provide many activities that may assist the child in the classroom. As in all education, some children learn easily through the auditory mode, whereas others are more visually oriented, and still others learn best by becoming physically involved with the material to be learned. It also should be noted that children with deficits in audition and/or visual perceptual modes use the haptic sense as their primary learning avenue.

Auditory skills. To successfully learn, children must have the ability to hear, discriminate or interpret, and respond in a meaningful way to sound. Children having difficulty in auditory-motor association may have difficulty in responding to instructions

given by the teacher or may fail to find success in activities so common to the primary grades.

To assist children in their auditory skills, a basic motor training program should be instituted that gives opportunities in motorically responding to sound, localizing where sound comes from, matching and discriminating sounds, and remembering sound.

Identification of sounds. The primary child should be able to name many different sounds. A lesson in naming sounds might include taking a walk around the school; while the children are listening for different sounds, the teacher might ask what sounds are different in different locations. In the classroom, a game may be played in which the children try to identify common sounds in the classroom, such as those of a chair moving, a pencil sharpener working, a window opening, or a door closing. Also, each child should be able to distinguish between sounds that are soft and loud, those that are slow and fast, and those that are first and last.

Localization of sound. Children can learn to localize sounds by closing their eyes and listening. There are numerous activity possibilities in helping a child localize sounds. The teacher might make various sounds around the room, and each time the children point, with their eyes closed, to the spot where the sound originated.

Following of a sequence of directions. Essential to a child's success in life is his ability to accurately follow directions. To follow directions, he must listen and remember a sequence of movements in their correct order. The teacher can give the class problems in following directions, progressing from the simple to the more complex. A simple direction might be, "Everyone stand up, and then everyone sit down," whereas a complex sequence would be, "Stand up, open the window, close the door, and then pick up these five pencils on the desk and sharpen them."

Imitation of rhythm and sound. Imitation of rhythm and specific sounds requires the ability to remember a sequence and to distinguish between subtle sounds. Moving the various body parts to a cadence (p. 205) and clapping, tapping, or striking the various percussion instruments common to the elementary schools, such as blocks, symbols, or sticks, are activities that enhance rhythmic responses. Children also like to add a rhythmic beat to names such as used in rhythms of the Orff-Schülwerk technique (p. 207).[127]

Imitation of sounds assists children in accurately hearing and responding. Making animal noises such as those of a dog barking, a crow crowing, and a kitten mewing is exciting to the young child. To enhance what is heard, the child can imitate the physical characteristics of the animal as well.

The ability to listen and to distinguish sounds is very important to a child's motor development. Such skills as imitation of rhythm, following of directions, game skills, and class motor activities require that the child hear and respond correctly.

Auditory activities:
1. The children identify sounds heard outdoors.
2. They identify sounds heard indoors.
3. With eyes closed, they identify sounds the teacher makes, such as pieces of sandpaper being rubbed together, glasses being hit together, a ball bouncing, bells ringing, and whistles being blown.
4. With eyes closed, they point to source of a sound such as a hand clap, finger snap, tongue flick, or ball bounce.
5. Using elementary musical instruments such as drums, sticks, bells, and triangles, children reproduce rhythm in marching activities.

• • •

The basic motor approach, although highly structured, is success oriented. Tasks should be selected by the teacher that the child can achieve even though they may take some effort. If any task is too difficult and failure is imminent, the teacher should introduce a less difficult task to the child. A good philosophy for the basic motor pro-

gram and for all physical education is that successes should be built on successes rather than on failures.

RECOMMENDED READINGS

Bateman, B. D.: Temporal learning, San Rafael, Calif., 1968, Dimensions Publishing Co.

Bayley, N.: The development of motor activities during the first three years, 1935, Society for Research in Child Development Monographs.

Cratty, B. J.: Active learning, games to enhance academic abilities, Englewood Cliffs, N. J., 1971, Prentice-Hall, Inc.

Glass, H.: Exploring movement, Freeport, N. Y., 1966, Educational Activities, Inc.

Godfrey, B. B., and Kephart, N. C.: Movement patterns and motor education, New York, 1969, Appleton-Century-Crofts.

Goodenough, F. L.: Measurement of intelligence by drawings, New York, 1926, Harcourt, Brace & World.

Mourouzis, A., et al.: Body management activities, Cedar Rapids, Iowa, 1970, Nissen Co.

O'Donnell, P. A.: Motor and haptic learning, San Rafael, Calif., 1969, Dimensions Publishing Co.

Oxendine, J. B.: Psychology of motor learning, New York, 1968, Appleton-Century-Crofts.

Singer, R. N.: Motor learning and human performance, New York, 1968, The Macmillan Co.

Wickstrom, R. L.: Fundamental motor patterns, Philadelphia, 1970, Lea & Febiger.

Wilson, J. A., and Robeck, M.: Kindergarten evaluation of learning potential, New York, 1967, McGraw-Hill Book Co.

Motor fitness and exercise

Elementary schools should be concerned with helping children to use their bodies efficiently. If a child has motor efficiency, he can use space to its best advantage and control the physical forces of equilibrium, inertia, and gravity to the fullest capacity.[31] In this chapter we will discuss the major areas of motor efficiency, motor fitness, flexibility, strength, stamina, balance and postural fitness, motor coordination, appraising motor fitness, and conducting a program of motor fitness.

MOTOR EFFICIENCY

In this chapter the expression *motor efficiency* has a mechanical connotation, referring to work output and the amount of energy expended. Human physiologists accept the fact that man's ability to take in and utilize oxygen through the cardiorespiratory system is currently the most valid measure of movement efficiency.[1] The human organism spends a lifetime building and refining an individual movement repertoire. The concern for motor efficiency in childhood has direct implications for health and well-being in later life.

Motor efficiency is concerned with five major factors that are interwoven to form a fabric of skilled movements: organic capability, normal growth and development, proficiency in the perceptual process, motor fitness, and motor educability (Fig. 8-1).

Efficiency in movement has been more specifically labeled as *motor fitness,* or the ability to perform a specific motor task.[31, 150] It is one factor in the larger area commonly called *total fitness.* Physical fitness is another of the many broad concepts that make up the state of total fitness; it includes organic health, physical abilities to meet emergencies, emotional and psychological stability, the ability to solve problems and make concrete decisions, attitudes and values that stimulate a zest for living, and finally, a moral and spiritual foundation that provides an ethical basis for behavior in our current culture.[56]

In *organic health* the organs and organ systems of the body are functioning properly. Also the organs have an inherent capacity to respond when stimulated by activity.

Growth and development is particularly important when imposed exercise demands exceed a child's limitations. Size, posture, and bone and muscle maturity play an extremely important role in how well a child performs a specific motor task.

Proficiency in the perceptual process, as discussed in Chapter 3, allows the child to interpret, store, and respond to internal and external stimuli. Without the ability to interpret or retrieve information, the child will often find many motor skills difficult to perform.

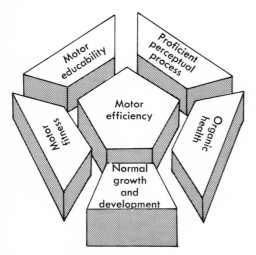

Fig. 8-1. Schema of motor efficiency.

MOTOR FITNESS

Motor fitness in general is that aspect of a child's physical capacity that allows for efficient performance of gross body activities. The basic movements of running, climbing, jumping, swinging, lifting, and the like require specific physical attributes that are common to all human beings, namely, joint flexibility, muscular strength, muscular endurance, cardiovascular-respiratory endurance, balance, and coordination.

Historical implications. Concern for motor fitness is as old as mankind. Historically it has meant the ability to survive in a hostile environment. Down through the ages the strong, agile person with great stamina could more easily fend off invaders, protecting himself and his family. History has shown that a physically fit and, more specifically, motorically fit populace is in a better position to withstand the rigors of abnormal stress such as those imposed by war and nature than is the less fit populace.

As automation increasingly provides man with opportunities for a sedentary existence, the need for exercise becomes increasingly more apparent. Each year more evidence comes to light that indicates that many diseases common in adulthood arise from a lifelong hypokinetic (inactive) existence.[103]

It is an accepted premise that many diseases stemming from or aggravated by obesity, hypertension, stomach ulcers, low-back syndromes and some cardiorespiratory conditions can be prevented or at least decreased in terms of incidence if a lifetime regime of reasonable exercise is maintained. Our society's low physical fitness level can be overcome by helping each child to understand the need for and the enjoyment of a well-balanced daily program of vigorous physical activity.

A positive attempt to overcome the low level of fitness of individuals in this nation came about as the result of important studies in the early 1950's showing that American children were inferior in their physical fitness to comparable European children. President Eisenhower in 1956 established a study commission on physical fitness.[103] From the work of this commission the Council on Youth Fitness was developed to promote physical fitness in Americans. The council since has played an important role in bringing to the citizenry important information on physical fitness.

Academic achievement. Authorities generally concur that there is not a dichotomy between the body and mind. A child's behavior is based on the interrelation of motor, emotional, social, and intellectual factors. This holistic point of view implies that enhancement of any one factor can positively affect the other factor or, on the other hand, adversely affect the other.[86] A review of studies and observations has been reported by Rogers that shows a positive relationship between motor traits and mental achievement.[56] There is little current evidence that intelligence and motor ability are positively correlated; however, evidence does point to the fact that a child's learning potential may be enhanced or diminished by the level of physical fitness.[56] In other words, children who are above average in their physical attributes such as size and strength also have a proportionately higher level of academic achievement in comparison to children with a lower level of motor fitness.

Fig. 8-2. Children enjoying movement.

Living optimally through exercise. The elementary school child should be instilled with the desire for proper exercise throughout a lifetime (Fig. 8-2). Numerous health factors are positively affected by the attainment of a high level of motor fitness, some of which are mental and emotional health, growth and development, prevention of injury, physical restoration, and the aging process.

Mental and emotional health. This can be positively affected through physical conditioning. Exercise is a desirable medium for emotional release. Pent-up emotions with high levels of abnormal muscular tension can be "drained off" through vigorous physical activity. Recuperative rest and sleep are promoted by the fatigue that comes from exercise, whereas mental and emotional health are benefited through the self-expression that emerges from engaging in motor activities. The child gains self-confidence and a positive self-concept when he can execute well a variety of body movement skills.[40] Good body control often parallels good emotional control.

Growth and development. They are influenced by physical activity. Growth, development, and movement are inextricably interwoven in a child's life. Without muscular activity the child is deprived of the stimulus to reach full maturity. This fact is apparent when children are bedridden or confined to limited movement. The inactive child is often small and frail in comparison to active children of the same age. An active childhood tends to increase lateral growth and results in stronger muscles, denser bony structure, and generally sturdier bodies with more normal weight.[50, 138]

Prevention of injury. This is aided by the motor fitness attributes of strength, joint flexibility, endurance, and movement skill. All these factors come into action when physical trauma is imminent. The active and well-conditioned child is able to withstand the extreme forces that are continually being applied to muscles and joints.[99] Exercise increases the stability of the most often injured joints, including ankle, knee, and shoulder, and a variety of vigorous activities increase the strength of both the muscles and the ligaments that support these joints.

Physical restoration. For the most part, physical restoration is the regaining of a functional level of physical conditioning after a major medical problem. After prolonged bed rest or injury to the body, a planned

program of rehabilitative exercises designed to restore full motor function may be required. Strength, flexibility, endurance, and skill development are all components necessary for physical restoration.

Physicians and therapists are well aware that muscles atrophy, or decrease in size, and that joints become rigid when movement ceases. Consequently, some muscular activity, including full range of joint movement, even though minimal, is encouraged at least once daily. Complete inactivity often compounds medical problems.

Aging. In all human beings aging is relative; it progresses at different rates for different individuals and also is variable in different cells, tissues, organs, and organ systems. The most outstanding factor of any individual over 30 years of age is the gradual decrease in his ability to return to a balance of function when his equilibrium has been disrupted. Research indicates that exercise plays a positive role in preventing or slowing down many of the deteriorations of aging.[24] There is little question that proper physical exercise carried out during a lifetime will significantly delay many aspects of the aging process. The specific elements of strength, flexibility, and endurance that are acquired in the elementary school years and maintained at a high level throughout life ensure a longer period of physical and mental productivity.

Flexibility

Flexibility is that aspect of motor fitness that indicates the range of movement that can be initiated in a joint. Although the term *flexibility* may be misleading, it includes joint flexion as well as extension and rotation. In other words, in a broad sense flexibility is the ability to move the body without encumbrances or restrictions. There is no single factor that enhances or detracts from body mobility; for example, any of the following conditions may alter joint range: (1) joint disease, (2) deviations in bony arrangement, (3) inextensibility of connective and/or muscle tissue, (4) muscle viscosity, or (5) inability to reciprocally relax opposing muscles.

At birth, in most instances, the human organism has the ability to move freely without restriction. One only has to hold an infant in one's arms or view an infant at play to realize just how potentially unrestricted the human body is. However, research points out that flexibility diminishes as the individual becomes older; this is attributed primarily to the type of activity habitually enjoyed rather than to a disease of tissue elasticity.[114] Extensibility of joint tissue is specific for the type of activity. This simply means that flexibility is restricted or enhanced depending on the demands of the imposed activity. Children who spend many waking hours in restricted sedentary postures conform to the position they are in habitually; therefore, to counteract this, a wide variety of large-muscle activities must be provided. There are two separate factors that come under the heading of flexibility: *extent flexibility,* the ability to flex or stretch the torso forward, backward, or sideward in a controlled manner, and *dynamic flexibility,* the ability to execute a number of quick stretching muscular contractions.[57]

Evaluation of flexibility. The teacher must consider flexibility to be unique for each individual child; however, there is a range that may be considered normal. Large deviations from this norm may require a remedial exercise program. For example, the Kraus-Weber test includes one item designed to measure the length of the back and hamstring muscles; the child stands with feet together and knees locked and attempts to slowly touch the floor with his fingertips (Fig. 8-3). Perhaps an even bet-

Fig. 8-3. Kraus-Weber test for low-back and hamstring flexibility.

ter means of evaluating a child's joint mobility is for the teacher to observe how supply and gracefully a child moves in a variety of gross motor activities. Does the child bend, twist, and stretch with ease, or is his movement mechanical, awkward, and inefficient?

Increasing flexibility. Abnormally short tissue around a joint can be lengthened by activities that encourage full range of movement and by the specific application of stretching exercises that are most beneficial and lasting when executed slowly and deliberately (Fig. 8-4). Slow and deliberate movements, in contrast to the ballistic-type stretching, serve to decrease the muscle tension in the opposing muscle group and allow for an increased range of movement, decreasing the possibility of strain.[126]

Strength

Strength is that factor of motor fitness that allows the child to overcome a resistance through muscular exertion. Gain in strength parallels the general gain in weight, height, and girth. There is a decided increase in strength between the ages of 3 and 6 years and again in the prepubescent period for both boys and girls. Girls have the greatest strength gains between 9 and 10 years of age, whereas boys gain most between ages 10 and 12 years. However, from birth and throughout life, boys are substantially stronger than girls.[50]

Strength factors. Three factors have been identified by researchers that are discrete and may or may not all be present in one person.[57] The first factor, *explosive strength,* is the ability to mobilize and expend a maximum amount of muscular energy in the execution of an explosive activity. The principle of explosive muscular strength is utilized in activities that employ speed and quick changes of direction, such as shuttle running, or activities in which the propelling of an object a great distance is important, such as baseball. The second factor is *static strength* (isometric strength), the ability to employ maximum muscular exertion, such as pushing, pulling, or lifting to overcome heavy resistance. Little, if any, muscle shortening occurs in static strength activities, whereas explosive strength activities involve muscle shortening. The third strength factor is *dynamic strength,* the ability of the muscle to exert repeated contractions over a sustained period of time (Fig. 8-5). Dynamic strength is otherwise called muscular endurance and will be discussed in more detail in the section on stamina.

Strength refers to the level at which a muscle can function in order to overcome stress imposed by a resistance. A child who is highly active and strong in comparison to his peers is able to more completely use his muscle fibers. This efficient use of muscle fibers comes as the result of employing more fully the neural

Fig. 8-4. Children increasing flexibility.

and biochemical properties available in the body. In most cases, the stronger individual has a greater mechanical advantage in the use of his muscles and is more able to find success in a variety of physical activities.

Overload principle. When muscles are forced to work progressively harder, the adaptation of increased strength occurs. Muscles can be overloaded or stressed by increasing the imposed activity's intensity, duration, and/or rate. Intensity can be increased by providing progressively more load or resistance to the contracting muscles. Duration can be increased by lengthening the time a muscle contraction can be maintained while keeping the resistance constant. Rate can be increased by progressively increasing the number of muscle contractions within a given period of time while keeping the load the same. Research points out that isotonic strength gain (muscle shortening) is best achieved when muscles are exposed to exercises that consist of between six and ten repetitions for three bouts (Fig. 8-6).[42, 83] On the other hand, isometric strength can develop when a muscle is maximally contracted or tensed by being shortened and the position held for 10 seconds.[54] *It should be noted that it may be dangerous*

Fig. 8-5. Child developing dynamic strength.

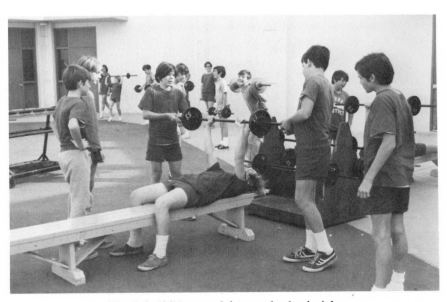

Fig. 8-6. Children applying overload principle.

for children to use isometric exercises extensively, primarily because the muscles of the growing child are often stronger than their bony attachments. Continued maximal isometric muscular contraction may produce an avulsion fracture caused by tendons actually tearing away from their attached area because of the force of contraction. It is becoming increasingly common for children when playing competitive sports that require hard throwing as Little League baseball, to develop various muscular and skeletal problems requiring medical attention.[99]

Stamina

Stamina is the capacity for engaging in sustained physical activity without undue fatigue. The ability to sustain movement depends on a number of distinctly interrelated factors, the most important of which are muscle endurance and cardiorespiratory efficiency.

Muscular endurance. This is the ability of a particular muscle or group of muscles to repeatedly contract. Researchers concur that strength and muscular endurance are interrelated; one cannot occur without the other.[113] Strength and endurance have been described as being on a continuum ranging from one single maximal contraction to repeated contractions against a constant resistance (Fig. 8-7).[54] Motor or physical fitness tests in reality are not testing pure strength but the ability of a particular muscle group to contract against a constant resistance.

Cardiorespiratory efficiency. This refers to the capacity of person's cardiorespiratory system to deliver oxygen to exercising muscles. If a person's heart, lungs, and vascular system are efficient, he will have the ability to engage in prolonged strenuous work without becoming overly tired and the capacity to recover quickly after fatiguing muscular activity (Fig. 8-8). The adequate delivery of oxygen to the tissues of the body is essential for the proper utilization of energy-producing food substances. The greater the amount of oxygen is that can be assimilated during physical activity, the longer the delay of fatigue will be.

Physiologically, the cardiorespiratory system of the elementary school child is as competent to deliver oxygen to exercising muscles as is that of the adult;[16] therefore, vigorous activities that place high-level demands on the heart and lungs should not

Fig. 8-7. Children developing muscle endurance against a constant resistance.

Fig. 8-8. Children developing cardiorespiratory efficiency.

be excluded from the physical education curriculum.[91] In fact, we believe it is essential that more demands be placed on the cardiorespiratory system of the elementary school child in the form of running or similar activities. Low-intensity activities that place little demand on the cardiorespiratory system of the child should be provided with an additional factor. For example, a low-intensity activity such as kick ball should be given a fitness factor of fast base running for 2 minutes, or a slow game of one-bounce volleyball might be given a fitness factor of running the out-of-bounds lines in between each game. Children's progress in cardiorespiratory fitness can be determined in terms of lower resting pulse rates and faster recovery time.[16]

Balance and postural fitness

Balance and postural fitness are inseparable; one cannot occur without the other. Position sense and the awareness of body alignment are essential to efficient movement and motor fitness. Posture is the relative arrangement of the various segments of the body. In good posture each body segment is well balanced in relation to other body segments. In essence, the head, trunk, pelvis, and lower limbs should be so aligned that the least amount of strain and energy

expenditure is produced. In faulty posture the mechanical performance of the body is inefficient because of an imbalance in opposing muscles.

As the child matures physiologically, the static and dynamic postural positions become automatic. Body alignment becomes a matter of unconscious self-regulation. Position awareness becomes the integration of visual cues, responses from the inner ear, and information given by tendon, joint, and muscle receptors. Misinformation or malfunction of any of these sense organs can result in faulty body alignment and inefficient use of the body. Therefore, all aspects of motor fitness are concerned with a balanced physical development.

Strength, flexibility, and muscular balance are essential to proper postural alignment. The increase of strength on one side of the body without an equal strengthening on the opposite side produces a postural distortion. Optimum joint flexibility is also needed for good posture. Children are usually very flexible, becoming less so as they become older. Excessive flexibility as well as abnormal tightness may adversely affect posture. Postural fitness, therefore, requires proper habitual use of the body as well as maintenance of a balance of strength and flexibility throughout the body.[93]

Motor coordination

Motor coordination is the ability to execute a skilled pattern of movement; it is specific for the particular skill performed and is not a general trait. If a person has good general coordination, he can achieve success in a wide variety of activities. In essence, the well-coordinated person has many specific motor abilities that provide success in numerous activities. The most important motor abilities are based on the interrelation of strength, flexibility, endurance, equilibrium, speed, and agility. Without a certain level of motor coordination, the child may be clumsy or awkward. Without the ability to integrate the neurophysiological processes properly, the child would find it difficult to learn new skills and im-

Fig. 8-9. Children developing eye-hand coordination.

possible to achieve competency in the important phases of physical education. Using different parts of the body in a sequence pattern to achieve a desired goal requires neuromuscular coordination. Some skilled acts require predominantly *eye-foot-hand coordination,* such as punting a football; other skills are mainly *eye-hand coordination,* such as the precision task of hitting the ball in a center jump in basketball (Fig. 8-9); and still others require *eye-foot coordination,* such as kicking a soccer ball.

Motor coordination develops in children along maturational lines with consistent improvement from birth to adolescence. Even during the rapid-growth period of pubescence, coordination steadily improves. The preschool child acquires movement experiences through exploration of the environs and through pretend play. During the primary years in school, the child discovers himself, exploring all kinds of movement with the emphasis on the development of personal motor coordination.[101] The child when he is 9 years old, having enjoyed the

free movement of the primary child, becomes increasingly concerned with more precise movement; when he is around 11 years of age, team competition and group interaction become very important.

APPRAISING MOTOR FITNESS

There are many tests that purport to measure specific factors inherent in motor fitness. Within many of these test batteries the elements of physical fitness are strength, muscular endurance, cardiorespiratory endurance, and the primary element of large-muscle agility. To properly represent motor fitness appraisal, we have included selected test items and norms from portions of the Oregon Motor Fitness Test (Tables 3 and 4) and the AAHPER Youth Fitness Test (Appendix IV).

Motor fitness test items

Flexed-arm hang (Fig. 8-10)

Factors measured: Strength and muscle endurance of hand grip and elbow flexors.

Age and sex: Boys and girls, kindergarten through grade 4.

Equipment: Adjustable horizontal bar or stall bar, stool to adjust subject to proper height, and stopwatch.

Regulations: The child grasps bar with overhand grip slightly outside the width of the shoulders and places his chin over the bar. Support is removed and he maintains chin above the bar and elbows flexed as long as possible.

Scoring: The stopwatch is started when the child is in a stable position and stopped when his chin touches the bar or falls below the bar. The length of time to nearest second is recorded.

Administrative hints: Pick a bar height that accommodates the majority of students. Each child gets one turn.

Floor push-up (Fig. 8-11)

Factors measured: Strength and muscle endurance of elbow extensors, shoulder, and chest.

Age and sex: Boys, ages 9 to 12 years.

Table 3. Motor fitness standards, Oregon Motor Fitness Test: rating norms for boys (grades 4 to 6)

Test items	Grade	Superior	Good	Fair	Poor	Inferior
Standing broad jump, (in inches)	4	69-up	62-68	52-61	42-51	12-41
Push-up	4	25-up	18-24	7-17	1-6	0
Sit-up	4	64-up	47-63	22-46	1-21	0
Standing broad jump (in inches)	5	73-up	62-72	56-65	46-55	16-45
Push-up	5	22-up	16-21	7-15	1-6	0
Sit-up	5	70-up	52-69	22-51	2-21	0-1
Standing broad jump (in inches)	6	77-up	70-76	59-69	49-58	18-48
Push-up	6	24-up	18-23	9-17	4-8	0-3
Sit-up	6	75-up	55-74	25-54	1-24	0

Adapted from The Operations Council, Oregon Board of Education, Salem, Oregon.

Table 4. Motor fitness standards, Oregon Motor Fitness Test: rating norms for girls (grades 4 to 6)

Test items	Grade	Superior	Good	Fair	Poor	Inferior
Hanging in arm-flexed position (in seconds)	4	30-up	20-29	5-19	1-4	0
Standing broad jump (in inches)	4	65-up	58-64	49-57	39-48	9-38
Crossed-arm curl-up	4	66-up	50-65	26-49	2-25	0-1
Hanging in arm-flexed position (in seconds)	5	31-up	22-30	10-21	2-9	0-1
Standing broad jump (in inches)	5	75-up	68-74	57-67	46-56	0-45
Crossed-arm curl-up	5	68-up	52-67	28-51	4-27	0-3
Hanging in arm-flexed position (in seconds)	6	37-up	27-36	12-26	1-11	0
Standing broad jump (in inches)	6	73-up	66-72	55-65	44-54	0-43
Crossed-arm curl-up	6	71-up	55-70	31-54	1-30	0

Adapted from The Operations Council, Oregon Board of Education, Salem, Oregon.

Fig. 8-10. Flexed arm hang.

Fig. 8-11. Push-up.

Equipment: Flat, hard surface.

Regulations: The boy assumes a face-lying position, with feet together resting on toes and with hands positioned slightly outside the width of the shoulders. He pushes his body upward, keeping back and legs straight with elbows fully extended. On the word "go," he lowers his body until his chest just touches the floor.

Scoring: One point is allowed for each time the boy fully extends his elbows. Movement must be continuous with the back and legs kept straight.

Pull-up (Fig. 8-12)

Factors measured: Strength and muscle endurance of hand grip, elbow flexors, and shoulder girdle.

Age and sex: Boys, ages 10 to 14 years.

Equipment: Horizontal bar or stall bar.

Regulations: The bar should be at a height at which the boy's legs can be fully extended. Using an overhand grip, the boy grasps the bar slightly outside the width of his shoulders. With his elbows fully extended in the hanging position, he pulls himself up until his chin is over the bar. This movement is continuously executed as many times as possible.

Scoring: One point is given each time the chin comes over the bar. No points are allowed if the body snaps or swings or if the legs are not kept fully extended.

Administrative hints: The boy can be kept from swinging by the counter's placing his arm at a point directly behind the boy's legs.

Knee-touch sit-up (Fig. 8-13)

Factors measured: Strength and muscle endurance of trunk flexion.

Age and sex: Boys, ages 9 to 12 years.

Equipment: Flat surface and a thin pad or rug to lie on.

Regulations: The boy lies on back, with hands clasped behind head, legs straight, and feet approximately 12 inches apart. His legs are held firmly in place by the counter. On the word "go," the boy touches his chin to his chest, curls his trunk upward, rotating to the right, and touches his left elbow to his right knee. He then lowers his trunk to the floor and repeats the sequence ex-

Fig. 8-12. Pull-up.

Fig. 8-13. Knee-touch sit-up.

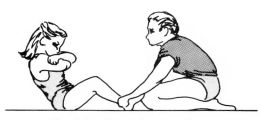

Fig. 8-14. Crossed-arm curl-up.

cept that he rotates to the left and touches his right elbow to his left knee. The boy may bend his knees slightly when executing this sit-up.

Scoring: One point is given each time an elbow touches a knee. Points are not given when movement is not continuous, the boy arches his back, or he bounces off the floor.

Crossed-arm curl-up (Fig. 8-14)

Factors measured: Strength and muscle endurance of trunk flexion.

Age and sex: Girls, ages 9 to 12 years.

Equipment: Flat surface and a thin pad or rug to lie on.

Regulations: The girl lies on her back in a hook lying position, with knees bent to about right angles, feet flat on floor, and arms folded across her chest. On the word "go," she curls her chin to her chest, rolls shoulders forward and curls trunk upward, coming to an erect sitting position. A partner holds the girl's feet in position.

Scoring: One point is given each time the girl comes to an erect sitting posture. Points are not given when movement fails to be continuous, girl arches back, or she bounces off floor.

Standing broad jump (Fig. 8-15)

Factor measured: Explosive strength of leg, thigh, and low back.

Age and sex: Boys and girls, ages 5 to 14 years.

Fig. 8-15. Standing broad jump.

Equipment: Flat floor surface, mat, or grassy area and tape measure.

Regulations: The child stands with feet comfortably separated and toes behind a take-off line. On the command "jump," he leaps with both feet simultaneously as far out as possible, landing on both feet. The greatest distance is achieved by extending both knees at the same time and swinging both arms forward.

Scoring: The best out of three trials is scored. Measurement is taken from the closest heel to the starting point. If the child is unable to maintain balance after the jump and falls back on his hands, measurement must be taken from that point.

Shuttle run

Factors measured: Agility and explosive strength.

Age and sex: Boys and girls, ages 5 to 14 years.

Equipment: Flat surface 40 feet long, two blocks of wood 2 inches by 2 inches by 4 inches, and stopwatch. Children should wear sneakers or run barefoot.

Regulations: Two lines are placed parallel to each other, 30 feet apart. Both blocks of wood are placed behind one line. At the word "go," the child runs to the blocks, picks one of them up, races back to the starting line, and places the block behind that line; then he races back to the second block of wood, picks it up, and returns it behind the starting line with the first block.

Scoring: The best time is recorded for two trials.

40- and 50-yard dash

Factors measured: Explosive strength and speed.

Age and sex: 40-yard dash for boys and girls, ages 5 to 9 years; 50-yard dash for boys and girls, ages 10 to 14 years.

Equipment: Outdoor grassy or dirt area and two stopwatches or

Regulations: one with a split-second hand. The runner stands behind a starting line; the timer stands at the finish line. On the command "get ready, get set, go," the stopwatch is started and the runner dashes the 40 or 50 yards.

Scoring: The time required to complete the run is recorded in seconds and tenths of seconds.

Administrative hints: To make the start more accurate, on the word "go," the timer can drop his hand in which he is holding a white handkerchief or rag.

Softball throw for distance (Fig. 8-16)

Factor measured: Explosive strength.

Age and sex: Boys and girls, ages 5 to 14 years.

Equipment: Playing field 100 yards long, tape measure, 12-inch softball, and metal or wooden spotting stakes.

Regulations: The participant throws as far as possible from a re-straining area that is indicated by two parallel lines 6 feet apart. The best distance of an overhand throw is marked with a stake.

Scoring: The greatest distance out of three throws is recorded.

400- and 600-yard run-walk

Factor measured: Cardiorespiratory endurance.

Age and sex: 400-yard run-walk for boys and girls, ages 5 to 9 years; 600-yard run-walk

Fig. 8-16. Softball throw for distance.

for boys and girls, ages 10 to 14 years.

Equipment: Marked running area and stopwatch.

Regulations: On the command "get ready, get set, go," the child runs or walks the prescribed distance. Time is called out as each child passes the finish line.

Scoring: A record is kept of the minutes and seconds required to finish the course.

CONDUCTING A PROGRAM OF MOTOR FITNESS

To have motor fitness is to be both physically fit and able to use the body in a coordinated manner. Ideally, the elementary school child should be able easily to meet the physical demands of daily life without undue fatigue and be able to successfully participate in a wide variety of large-muscle activities.

The intermediate child, who ranges from 9 to 12 years of age, should be provided with more specialized motor fitness activities than the primary child. Although in both levels there should be stress on the capacity for movement and energy expenditures, the intermediate period is the time when a lifelong desire for physical fitness can be established. The teacher concerned with a balanced activity program should make sure that developmental exercises are included in the daily regime.

The sound elementary school fitness program includes three major areas: a screening test for determining each child's status, a general developmental program, and a special remedial program for those individuals identified as being physically underdeveloped.

Developmental exercises

After administering a screening test, the teacher has some idea about each child's performance capacity; however, no typical state or national physical performance test can be considered as absolute in determining a child's work capacity. To do so would require specialized equipment not commonly available to the elementary school

program. Therefore, the screening tests described in this chapter are only indicators of a child's physical performance. Children who fall below the 25th percentile should be considered for a special remedial exercise program conducted as an adjunct to the regular physical activity program.

The following exercises and activities are presented according to the level of intensity and the body area most affected. Each exercise is assigned an intensity level of low, medium, or high that corresponds to the amount of energy expended or the amount of effort that must be put out for the accomplishment of the activity.

Exercises for conditioning arm and shoulder girdle

Wall push-away (Fig. 8-17)

Level: Low.
Purpose: Arm and shoulder strength and muscle endurance. This is a lead-up exercise to regular floor push-ups.
Equipment: Flat wall area.
Starting position: The child stands facing the wall, with his arms extended to the front at shoulder height and his feet a comfortable distance apart positioned about 2 feet from the wall.
Action: He places his hands on the wall a shoulder width apart and directs his body

Fig. 8-17. Wall push-away.

to the wall until his chest touches. After he touches the wall, he extends his arms and pushes his body away from the wall.
Count: He repeats the action until he can execute ten repetitions easily, at which time he is ready to progress to the knee push-ups.

Knee push-up (Fig. 8-18)

Level: Medium.
Purpose: Arm and shoulder strength and muscle endurance.
Equipment: Firm flat surface.
Starting position: The child extends his arms and places his hands on the floor just outside the width of his shoulders. He keeps his body straight from his head to his knees.
Action: While resting on his knees and hands, he lowers his body until his chest touches the floor and then returns to the extended-arm position.
Count: One knee push-up is counted each time the child returns his body to the extended-arm position. When the child can easily execute the knee push-ups ten times, he should progress to the regular push-up.

Push-up (Fig. 8-19)

Level: High.
Purpose: Arm and shoulder strength and muscle endurance.
Equipment: Firm flat surface.
Starting position: The child extends his arms and places his hands on the floor just outside the width of his shoulders. He keeps his body straight from head to heels.

Fig. 8-18. Knee push-up.

Action: While resting on his hands and toes, he lowers his body until his chest touches the floor and then returns to the extended-arm position.

Count: One push-up is counted each time the child returns his body to the extended-arm position.

Floor pull-up (Fig. 8-20)

Level: Low to medium.

Purpose: Arm, shoulder girdle, and upper body strength and muscle endurance. This is a lead-up exercise to the regular pull-up.

Equipment: Broomstick and a partner.

Starting position: The child lies on his back, extends his arms upward, and with his hands grasps the broomstick held by a partner who straddles the performer.

Action: While keeping his body straight, the child pulls his body upward until his chest touches the broomstick held by the partner and then slowly lets his body return to the beginning position.

Count: One floor pull-up is counted each time the child returns to the straight-arm position.

Pull-up (Fig. 8-21)

Level: High.

Purpose: Arm, shoulder girdle, and upper body strength and muscle endurance.

Equipment: Horizontal bar, ladder, or any piece of pipe that can be grasped easily and is high enough that the child can hang fully extended.

Action: Using the overhand grip, the child grasps the bar at shoulder width. From a fully extended arm position he pulls his body upward until he can place his chin over the bar and then returns in a controlled manner to the starting position.

Count: One pull-up is counted each each time the child pulls his chin over the bar.

Variation: A child not having enough strength to pull his chin over the bar may condition himself by jumping to a desired height and slowly lowering himself until his arms are in a straight hanging position.

Ladder travel

Level: Medium.

Purpose: Arm and shoulder girdle strength and muscle endurance.

Equipment: Horizontal ladder.

Starting position: The position depends on the method employed, but the child is usually positioned at one end of the ladder.

Action: The goal is for the child to reach the other end of the ladder using a variety of methods, such as grasping overhand each ladder rung, skipping one or two rungs, traveling hand to hand on one side of ladder, and alternating traveling using hands on both sides of the ladder.

Fig. 8-19. Push-up.

Fig. 8-20. Floor pull-up.

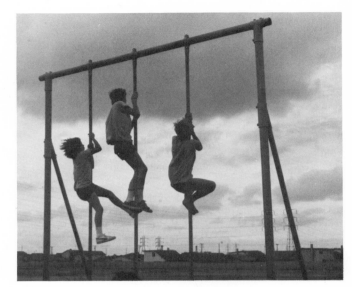

Fig. 8-21. Pull-up. **Fig. 8-22.** Pole climb.

Rope or pole climb (Fig. 8-22)

Level: High.
Purpose: Arm, shoulder girdle, and upper body strength and muscle endurance.
Equipment: Climbing rope 20 feet long and protection mat underneath rope.
Action: The extent to which the child exercises his arms and shoulders depends on how much he uses his legs and feet in the climb. The easiest method is the leg and foot break, in which the rope passes between the legs, around one leg, and over the instep of the foot. The other foot holds the rope in place over the instep. As the arms pull the body upward, the rope slides over the instep, and the pressure of the other foot provides a breaking action until the arms can recover for a new pull. A more difficult method is shinning up the rope. While the arms pull the body upward, the legs and feet, which are wrapped around the rope, push downward in assistance. One of the most difficult rope climbing techniques is with just the arms and without the aid of the legs.

Additional activities for conditioning arms and shoulder girdle include the crab walk (p. 181), wheelbarrow (p. 183), and caterpillar walk (p. 187).

Exercises for conditioning abdominal muscles

Abdominal curl (head and shoulder roll) (Fig. 8-23)

Level: Low.
Purpose: Upper abdominal muscle strength and endurance. This is a lead-up exercise to the sit-up.
Equipment: Exercise mat.
Starting position: The child lies on his back, with his knees bent and his arms at the side of his body.
Action: He lifts his head up until his chin touches his chest and then rolls both shoulders forward and returns to the starting position.

Abdominal curl with arms extended (Fig. 8-24)

Level: Low to medium.
Purpose: Upper abdominal muscle strength and endurance.

Fig. 8-23. Abdominal curl (head and shoulder roll).

Fig. 8-24. Abdominal curl with arms extended.

Fig. 8-25. Abdominal curl with arms folded across chest.

Fig. 8-26. Regular sit-up.

This is a lead-up exercise to the sit-up.

Equipment: Exercise mat.

Starting position: The child lies on his back, with his knees bent and his arms extended forward.

Action: He lifts his head up until his chin strikes his chest and then rolls his shoulders forward, lifting his upper back off the mat, until he achieves a sitting position.

Abdominal curl with arms folded across chest (Fig. 8-25)

Level: Medium.

Purpose: Upper abdominal muscle strength and endurance. This is a lead-up exercise to the sit-up.

Equipment: Exercise mat.

Starting position: The child lies on his back, with his knees bent and his arms folded across his chest.

Action: He lifts his head up until his chin touches his chest; then he rolls his shoulders forward and lifts his back from the mat to a full sitting position.

Abdominal curl (sit-up) with hands clasped behind neck (Fig. 8-26)

Level: High.

Purpose: Upper abdominal muscle strength and endurance.

Equipment: Exercise mat.

Starting position: The child lies on his back, with his knees bent and his hands clasped behind his neck.

Action: He lifts his head until his chin touches his chest, rolls his shoulders forward, points his elbows toward his bent knees, rolls his trunk to a full sit-up position, touching his elbows to his knees, and returns to the starting position by uncurling.

Count: One sit-up is counted each time the child comes to a full sit-up position.

Administrative hints: Proper execution of the abdominal curl is imperative. Arching the low back and snapping the head forward to provide impetus to the curl must be avoided to prevent injury.

Variations: A number of variations can be done that increase the difficulty and/or effectiveness of the abdominal curl:

1. The child performs a curl-up, alternately touching his right elbow to his left knee and his left elbow to his right knee.

Fig. 8-27. Curl-up on inclined board.

Fig. 8-28. Two-knee raise on inclined board.

Fig. 8-29. Hanging hip curl.

Fig. 8-30. Side abdominal curl.

2. He performs a curl-up and single-knee raise, alternately touching his right elbow to his raised left knee and his left elbow to his raised right knee.
3. He performs a curl-up on an inclined board (Fig. 8-27).
4. He performs a two-knee raise on an inclined board, bringing his knees to his chest, and returns to a fully extended position (Fig. 8-28).

Hanging hip curl (Fig. 8-29)

Level:	Medium to high.
Purpose:	Lower abdominal muscle strength and endurance.
Equipment:	Horizontal bar.
Starting position:	With his hands the child grasps the horizontal bar and keeps his feet together.
Action:	Keeping his arms straight, the child raises both bent knees and curls his lower trunk upward as far as possible, uncurling very slowly.
Count:	Each consecutive hip curl is counted as one.
Variations:	When the child is able to perform at least ten hip curls, he can derive increased benefits by alternating the curls, first to the left and then to the right. Added intensity can be provided later by having the child curl upward with his knees in an extended position.

Side abdominal curl (Fig. 8-30)

Level:	High.
Purpose:	Lateral abdominal muscle strength.
Equipment:	Exercise mat.
Starting position:	The child takes a side-lying position, with his legs straight and together and with his arms folded across his chest.
Action:	He raises his top leg to the side and at the same time curls his trunk sideward toward his raised leg.
Count:	Each consecutive side sit-up is counted as one.

Exercises for conditioning back

Straight-back raise (Fig. 8-31)

Level:	Low.
Purpose:	Back extensor strength.
Equipment:	None.
Starting position:	The child stands with legs comfortably spread and hands clasped behind his neck.
Action:	Keeping his back straight and his elbows even with his ears, he slowly bends from the waist to a right-angle position and returns slowly to a standing position.
Count:	One straight-back raise is counted each time the pupil returns to the straight standing position.

Upper-back lift (Fig. 8-32)

Level:	Medium to high.
Purpose:	Upper-back muscle strength.
Equipment:	Exercise mat and a pillow or rolled-up towel.
Starting position:	The child lies face down, with his feet together and his hands clasped behind his head. A pillow or rolled-up towel is placed under his pelvis.

Fig. 8-32. Upper-back lift.

Fig. 8-33. Lower-back lift.

Fig. 8-31. Straight-back raise.

Fig. 8-34. Front-lying hip raise.

Action: Keeping his back straight and his toes touching the floor, the child raises his chest about 2 inches off the floor.

Count: He holds the back lift position for about 10 seconds and then slowly returns to a relaxed position. He repeats the exercise three times.

Precaution: At no time should the child attempt to arch his back.

Lower-back lift (Fig. 8-33)

Level: Medium to high.
Purpose: Lower-back strength.
Equipment: Exercise mat and pillow or rolled-up towel.
Starting position: The child lies face down, with his feet together, legs straight, arms at side, and weight of body resting on his forehead. A pillow or rolled-up towel is placed under his pelvis.
Action: With his toes pointed backward and his legs straight, he lifts his legs about 4 inches from the mat.
Count: He holds the back lift for 10 seconds and then returns his legs to the mat. He repeats the exercise three times.
Precaution: The lower back should *not* be arched.

Front-lying hip raise (Fig. 8-34)

Level: Progressions for low to high intensity.

Purpose: Neck and back muscle strength.
Equipment: Exercise mat.
Starting position: The child lies on his back, with his knees bent, his feet flat on the floor, and his arms at his side.
Action: He lifts his hips, holds them in the raised position, and lowers them slowly to the floor.
Count: He holds his hips in a raised position for 10 seconds and then lowers them to the mat. He repeats the exercise three times.
Precaution: The child should avoid arching his back to the extent that weight is borne on the neck.

Additional activities for conditioning the trunk and back include the measuring worm (p. 180), Chinese get-up (p. 183), backward roll (p. 184), human ball (p. 185), and scooter (p. 187).

Exercises for conditioning legs and pelvic girdle

Jump and reach (Fig. 8-35)

Level: Low to medium.
Purpose: Leg strength and muscle endurance.
Equipment: Flat surface.
Starting position: The child stands with his arms at his side and his feet comfortably placed apart.

Fig. 8-35. Jump and reach. **Fig. 8-36.** Front lunge. **Fig. 8-37.** Half squat.

Action: Keeping his back straight, he bends his knees to right angles; swings his arms back, forward, and then upward; extends his knees forcibly and springs up until his feet leave the floor; and then returns to the standing position.

Count: One jump and reach is counted each time the child returns to a standing position. Ten consecutive jumps should be attempted.

Front lunge (Fig. 8-36)

Level: Low.

Purpose: Leg strength and muscle endurance.

Equipment: Flat surface.

Starting position: The child stands straight with hands on hips.

Action: He lunges with his left foot forward, shifting his weight forward and keeping his trunk straight, and then returns to the starting position and lunges with his right foot. The movement should be quick.

Count: Each lunge executed is counted as one.

Hop

Level: Low to medium.

Purpose: Lower-leg strength and muscle endurance.

Equipment: Flat surface.

Starting position: The child stands straight with his arms at his side.

Action: He hops on each foot a prescribed number of times.

Count: Each jump is counted as one.

Half squat (Fig. 8-37)

Level: High.

Purpose: Leg strength and muscle endurance.

Equipment: Flat surface.

Starting position: The child stands straight with feet spread comfortably and hands on hips.

Action: Keeping back straight, he squats and then returns to the standing position.

Count: One half squat is counted each time the child returns to the standing position.

General strength and agility exercises

Side-straddle hop (Fig. 8-38)

Level: Medium.

Purpose: Arm and leg conditioning, leg strength, and muscle endurance.

Equipment: None.

Starting position: The child stands erect, with his arms at his side and his feet together.

Action: He jumps, spreading his legs to the side at the same time that he brings his arms overhead.

Count: One side-straddle hop is counted each time the

Fig. 8-38. Side-straddle hop.

Fig. 8-39. Heel touch.

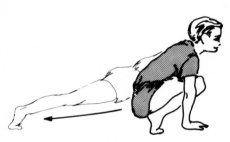

Fig. 8-40. Squat-thrust.

Fig. 8-41. Treadmill.

child returns to the erect standing position.

Stop and go

Level:	Low.
Purpose:	Ability to move and stop readily when a signal is given.
Equipment:	Whistle.
Starting position:	The children are informally scattered.
Action:	They run as fast as they can when the whistle is blown once and stop as fast as possible when it is blown twice.
Count:	There should be 10 to 20 stops and starts.

Heel touch (Fig. 8-39)

Level:	Low to medium.
Purpose:	Coordination and leg strength.

Equipment:	Whistle.
Starting position:	The child stands erect, with his hands at his side.
Action:	At the sound of the whistle, he jumps up and touches both heels with his fingers.
Count:	Each jump is counted as one.
Variations:	He can touch different parts of the legs. Heel touch may be a lead-up activity to a stick or short-rope jump. Holding the ends of a 16-inch rope with both hands, the child jumps over the rope without loosening either grip.

Squat-thrust (Fig. 8-40)

Level:	Medium to high.
Purpose:	Agility and general trunk and leg strength.
Equipment:	Exercise mat.
Starting position:	The child stands straight,

with his arms at his side and his feet together.

Action: He bends his knees and places his hands on the floor in a squat position, thrusts his feet and legs backward, assuming a push-up position, and then returns to a squat position and stands erect.

Count: One squat-thrust is counted each time the child resumes the standing position.

Variation: Push-ups may be added to the basic squat-thrust exercise.

Treadmill (Fig. 8-41)

Level: Medium to high.

Purpose: General strength and muscle endurance of trunk and legs.

Equipment: None.

Starting position: The child assumes the push-up position with one leg forward.

Action: He keeps his hands in place while alternately bringing one leg forward and extending the other leg in a running fashion.

Count: One treadmill exercise is counted each time the child brings his right leg forward.

Zigzag run

Level: Low.

Purpose: Agility.

Equipment: Any objects, such as chairs, that can be positioned to provide an obstacle course.

Starting position: The child stands erect at a starting line.

Action: At the word "go," he runs as fast as possible in a zigzag course around the obstacles.

Count: The time required to complete the course is recorded.

Exercises for cardiorespiratory endurance development

March

Level: Low to medium.

Purpose: Cardiorespiratory endurance and leg muscle endurance.

Equipment: Rhythmic device such as a metronome.

Starting position: The children stand in pairs, side by side. Each stands straight, with his arms at his side.

Action: At a moderately paced rhythmic beat (70 beats per minute), the children march shoulder to shoulder with their partners. At each beat, they lift one foot approximately 5 inches off the floor, first the left foot and then the right foot.

Progressions: The teacher can provide increased cardiorespiratory stress by speeding up the tempo, by having the children lift their legs higher, and by increasing the length of time of the march. The teacher might keep a record of how many steps the children perform per minute.

Run in place

Level: Medium to high.

Purpose: Cardiorespiratory endurance, leg strength, and muscle endurance.

Equipment: None.

Starting position: The child stands erect, with his arms flexed at his side.

Action: At the signal "go," he alternately lifts his left knee and then his right knee to a right-angle position, swinging his arms forcibly in opposition. The cadence can be varied to increase the exercise intensity.

Progressions: The teacher can provide a progression from medium to high cardiorespiratory stress by changing the tempo from 80 to 90 to 100 steps per minute. He can also vary the duration of the exercise.

Jog and run

Level: Low to high.

Purpose: Cardiorespiratory endurance, leg strength, and muscle endurance.

Equipment: Outdoor or indoor running area.

Starting position: The child stands erect with his feet staggered, one foot ahead of the other.

Action: At the signal "go," he walks, jogs, or runs a prescribed distance or length of time.

Progressions: Very low level: 150 yards in 1 minute (5 minutes, 750 yards).

Low level: 200 yards in 1 minute (5 minutes, 1000 yards).

Medium level: 250 yards in 1 minute (5 minutes, 1250 yards).

High level: 300 yards in 1 minute (5 minutes, 1500 yards).

Conditioning hints: The teacher can use this chart to roughly determine the cardiorespiratory level of each child as well as to devise a training program. He can initiate training progressions by increasing the distance covered and by increasing the movement time.

Bench step (Fig. 8-42)

Level: High.

Purpose: Cardiorespiratory endurance, leg strength, and muscle endurance.

Equipment: Bench 10 to 16 inches high.

Starting position: The child faces the bench, standing in an erect position with his feet together and his arms at his side.

Action: At a signal, he steps up on the bench, stands erect with both feet together, and then steps back down and returns to the starting position. Tempo and length of time are variable; 30 steps per minute for 5 minutes is considered a high-intensity exercise.

Fig. 8-42. Bench step.

Count: One bench step is counted each time the child steps down.

Interval sprint

Level: High.

Purpose: Cardiorespiratory endurance, leg strength, and muscle endurance.

Equipment: Running space and a whistle.

Starting position: The child stands erect, with one foot forward.

Action: The purpose of interval training is to increase the work capacity of the heart and lungs. This is accomplished by a series of sprints intermingled with recovery periods. The teacher can vary the program in any way feasible. Following is one type of interval program:

Day 1: all-out sprint 2 seconds, walk 25 seconds (5 repetitions).

Day 2: all-out sprint 3 seconds, walk 20 seconds (6 repetitions).

Day 3: all-out sprint 4 seconds, walk 20 seconds (6 repetitions).

Day 4: all-out sprint 5 seconds, walk 15 seconds (7 repetitions).

Day 5: all-out sprint 5 seconds, walk 15 seconds (8 repetitions).

Day 6: all-out sprint 6 seconds, walk 15 seconds (8 repetitions).

Day 7: all-out sprint 7 seconds, walk 10 seconds (8 repetitions).

Day 8: all-out sprint 8 seconds, walk 10 seconds (9 repetitions).

Day 9: all-out sprint 9 seconds, walk 10 seconds (9 repetitions).

Day 10: all-out sprint 10 seconds, walk 10 seconds (10 repetitions).

Circuit training

Circuit training is a technique of conditioning that can develop all the attributes of motor fitness. Morgan and Adamson developed this approach to provide children with opportunities and incentives no matter at what point on the continuum they start. These authors consider circuit training one of the most appropriate conditioning

methods available for use at the elementary school level. Little equipment is required, and an entire class can be conditioned in a very short period of time while at the same time each child can be performing on an individual basis.[119]

Establishing individual work load. On the first day of the circuit program, the teacher establishes the number of desired exercise stations. Normally there will be from six to eight stations. After determining the type of exercise to be initiated at each station, the teacher has the children go through the entire circuit, executing as many repetitions of each exercise as possible. The number of repetitions is recorded by the teacher. Each child's maximum number of repetitions is then reduced by one third. The next day, each child is given his particular number of exercise repetitions minus one third and instructed to go through the circuit three times, completing all exercises within a target time (usually between 15 and 30 minutes).

Class organization. If there are 30 children in the class and six stations have been selected, five children can be placed at each

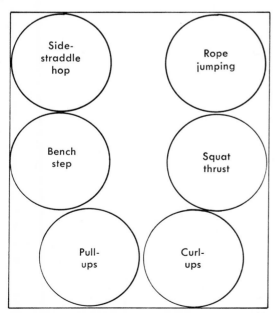

Fig. 8-43. Organization of stations for circuit training course.

station. In the beginning, if a target time of 30 minutes has been selected, each child would have 10 minutes to complete one circuit trip. A possible time distribution at each station could be 1 minute for completion of an individual exercise dosage plus 40 seconds for each child to record his progress and move to the next station.

Increasing the work load. The teacher can increase the work load by increasing the number of exercise repetitions, by decreasing the time in which to execute the repetitions, by increasing the difficulty of the exercise, by decreasing the rest time between stations, and by adding to the number of circuit trips that the children perform.

Exercise organization. Each station should have exercises that are designed to provide required strength, muscle endurance, cardiorespiratory endurance, and coordination. No muscle group should be exercised twice in a row. Fig. 8-43 illustrates a circuit organization.

Motivation. One advantage of the circuit program is that it helps to build a positive self-concept. One child's result is not compared to another's, but each child is encouraged to improve individually. If a teacher wants to motivate and increase the aspiration levels of the class, he can establish a predetermined performance level for a circuit, with accomplishment levels set at low, medium, and high. Each level may be distinguished by a color such as red, green, or gold or by an animal symbol such as a bear, tiger, or lion.

The fitness obstacle course

The obstacle course is one of the best devices to improve the child's fitness level. Like the circuit program, the obstacle course is separated into stations in which the performer executes a specific movement or series of movements. Unlike the circuit, the obstacle course is usually executed one time only and usually against a time factor.

The course can be made up of permanent fixtures established outdoors, or it can be made from available portable equipment

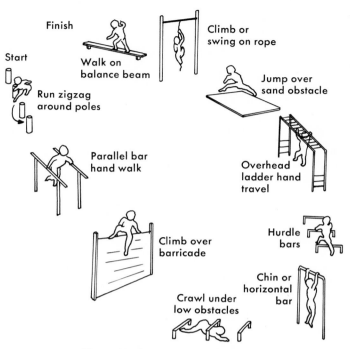

Fig. 8-44. Outdoor obstacle course.

and set up indoors. A typical commercial outdoor obstacle might contain the items indicated in Fig. 8-44.

Teaching exercises

Any program of physical conditioning should always be preceded by a program of warm-up and flexibility exercises. The warm-up includes body movements such as jogging or running in place designed to increase the circulation of blood to the deeper muscle tissue. It is generally accepted that a proper warm-up assists the efficiency of contracting muscles and at the same time prevents injuries that arise from overstraining the musculotendinous unit. Flexibility exercises, particularly those of the static stretch type, normally follow the warm-up regime. Stretching exercises performed at this time provide an additional factor of safety and increased function. The flexible joint is less likely to become injured when stressed from a high-level conditioning program.

Generally, each exercise has three ele-

ments: a *starting position,* the *exercise proper,* and the *finished aspect* of the exercise. To teach children exercises, the instructor must first organize the class into the most practical and expedient formations. Exercise formations can be roughly categorized into informal and formal. In the informal formation, the teacher instructs the class to take any spot on the floor, keeping an arm's length away from any other person. The formal type of class formation is generally conducted from squads or predetermined floor markings. To expedite formal exercise, schools will often paint spots, numbers, or letters on the floor that provide adequate room for exercises. In the squad method, children line up, one behind the other, usually in groups of about six. They face the front and move double arm's length to the right, make a right face again and move double arm's length to the right, and then make a half left face.

In teaching each exercise, the instructor calls out the name of the exercise, demonstrates it for the class, has the class execute

the exercise, and finally, evaluates how the class performed, pointing out errors that must be corrected. Each exercise should be performed to a cadence of four beats. The instructor and the class count, putting the number of the exercise at the beginning (1, 2, 3, 4; 2, 2, 3, 4; 3, 2, 3, 4; and so on) or at the end (1, 2, 3, 1; 1, 2, 3, 2; 1, 2, 3, 3; and so on) of each sequence.

Hints for proper exercise execution. Following is a list of suggestions for the instructor in conducting the conditioning program:

1. Conduct a proper warm-up before engaging in vigorous activities.
2. Avoid the forceful locking of the elbow and knee.
3. Be sure that each child knows why an exercise is given.
4. Avoid forceful deep knee bends.
5. Avoid straight leg raising from the back-lying position.

Understanding signs of overexertion. Any teacher working with children who are engaged in physical activities that produce stress must be aware of signs of overexertion. Children who respond adversely to physical activity that is reasonably given by the teacher must be referred to a physician. The following signs may indicate that the program is too intense or that a child is in need of medical assistance:

1. Excessive breathlessness apparent long after exercise is completed
2. Blue lips or nail beds that are not characteristic of a reaction to cold weather
3. Cold, clammy skin
4. Profound fatigue and poor recovery rate
5. Shakiness that is most apparent in hands more than 10 minutes after exercise
6. Muscle soreness lasting more than a day
7. Systemic complaints and problems such as headache, dizziness, fainting, sleeplessness, heart pounding, and stomach upset[80]

RECOMMENDED READINGS

Cooper, K. H.: The new aerobics, New York, 1970, Bantam Books, Inc.
Davis, E. C., and Logan, G. A.: Biophysical values of muscular activity, Dubuque, Iowa, 1961, William C. Brown Co., Publishers.
Falls, H. B., Wallis, E. L., and Logan, G. A.: Foundation of conditioning, New York, 1970, Academic Press, Inc.
Fleishman, E. A.: Examiner's manual for the basic fitness tests, Englewood Cliffs, N. J., 1964, Prentice-Hall, Inc.
Klafs, C. E., and Arnheim, D. D.: Modern principles of athletic training, ed. 3, St. Louis, 1973, The C. V. Mosby Co.
Kraus, H., and Roab, W.: Hypokinetic disease, Springfield, Ill., 1961, Charles C Thomas, Publisher.
Morgan, R. E., and Adamson, G. T.: Circuit training, London, 1958, G. Bell & Sons Ltd.
Olson, E. C.: Conditioning, Columbus, Ohio, 1968, Charles E. Merrill Publishing Co.
Staley, S. C., et al.: Exercise and fitness, Chicago, 1960, The Athletic Institute.

Chapter 9

Modifying instruction

Too often, physical educators have been guilty of lumping children into large groups without regard for individual capabilities or potential. Such groups are usually geared to the general class ability, so that the gifted or the less able children are thwarted in their efforts to succeed. Because physical education is important to people of all ability levels and ages, provisions should be made within each school to ensure that every child has an opportunity to engage in a good program. We believe that, ideally, all physical education should be adapted to individual needs rather than conducted on a mass basis; however, realistically, this may be feasible only for the exceptional individual. There are within every school and community exceptional children with very special requirements (Fig. 9-1). It has been estimated that over 12% of American school-age children are exceptional to some degree and require a modification of school practices or special services out of the ordinary in order for them to reach their maximum potential.[2] Exceptional children are those that are physically and mentally gifted as well as those that have physical, mental, and emotional handicaps.

INDIVIDUALIZATION OF INSTRUCTION

A number of teaching methods are currently being employed throughout the country that are designed to personalize teaching. Most of these methods have been successful with the special education and adapted physical education classes that have a limited number of students.

Modification of behavior

Out of the work of Skinner[151] and the influence of computer science have grown many current educational approaches that are designed to modify individual behavior through stimulus-response learning. Operant conditioning and positive reinforcement or variations of them are commonly employed to change behavior. Operant conditioning differs from classical conditioning in that a behavior produces the reinforcement rather than a simple involuntary reflex response as in Pavlov's salivating dog.[168] In this approach, particular target behavior is determined by the teacher, and an intervention program is instituted to alter that particular behavior. This is commonly known as behavior shaping. The target may be to acquire a simple behavior such as a habit of proper grooming or a more complex behavior such as overcoming a difficult reading problem or learning to perform a difficult sport skill. Positive reinforcement to initiate a specific behavioral response might be more adult attention, food, money, or permission to participate in a special activity. For children, reward can be any-

Fig. 9-1. Neurologically impaired children developing spatial awareness. (Photo courtesy Lyonel Avance and photography by Anita Delfs, Special Education Branch, Physical Education Project, Los Angeles City Schools.)

thing that brings pleasure, such as love or praise. Some basic rules for rewarding are as follows:

1. A new behavior that is being learned must have immediate reward.
2. In the later stages of learning a behavior, rewards can be given less often.
3. In the early period of learning a new behavior, rewards are given for accomplishment of less complicated tasks.
4. In the later period of learning a new behavior, rewards are given for increasingly larger accomplishments.
5. When a behavior is not rewarded, it will eventually become extinct.[129]

Prescriptive method

Prescriptive teaching is well suited to individualizing instruction in both the classroom and physical education settings. The following steps are taken in establishing and initiating an educational prescription:

1. The teacher selects an evaluation tool.
2. He evaluates the child.
3. He assesses the achievement test.
4. From the assessment, he determines an educational diagnosis.
5. From the diagnosis, he establishes a prescription of how to overcome a specific problem.
6. After establishing the prescription, he gives a prognosis as to when the problem will be overcome.

In most cases, the prescriptive teaching method is task oriented and utilizes operant conditioning methods; however, it is assumed that the teacher has a good diagnostic tool and that the teacher can accurately assess the test findings. This method individualizes instruction because it focuses attention on each child's personal strengths and weaknesses.

Contract method

The contract method takes the prescriptive method a step further by involving the child in the decision-making process. After assessing the child, the teacher establishes specific objectives or goals to be accomplished. Each goal is broken down

into logical task steps. Conferring with the teacher, the child contracts to work on specific task areas and agrees on the reinforcement that follows the accomplishment of each task.[84] The contract method has been found to be self-motivating and extremely valuable for children with low self-esteem.[9, 10]

Shifting of decision making

Education, in general, and physical education, in particular, have been guilty of not providing children with opportunities for making decisions. Physical education characteristically has been a field that has used the autocratic style of teaching with the major focus on the teacher as leader and the students as followers. However, the introduction of movement education has influenced some elementary schools to be more child centered.

Educators always ask how best to respond to the needs of children. There is no one best teaching method; children respond individually to various educational techniques. However, one commonality in education is that each child should develop a positive self-concept and become a mature, self-reliant person with a clear understanding of his abilities. This concept is particularly important to exceptional children with special requirements. Mosston indicates that before individualization can occur, a freeing process must take place that moves the student away from the teacher's dependency and toward independent thought and action.[121] The teacher can bring this about by gradually shifting decision making from himself to the student.

INDIVIDUAL PROGRAMS

Four programs within physical education are specifically oriented toward the individual and modifying instruction. They are the programs for the physically gifted, physical development programs, remedial programs, and modified games and sports programs. Movement education is also mentioned because it is a teaching method within physical education that encourages individualization.

Program for the physically gifted

Most schools and communities provide many opportunities for their physically gifted children through intramural and interscholastic sports. Intramural sports are usually offered by a school for children in grades 4 and up. Although designed for all children within a particular school, intramural sports provide the physically well coordinated child an opportunity to learn and perform at a level higher than he commonly engages in as part of the regular physical activities program. A school's intramural program should consist of a variety of games and sports that encourage a wide range of abilities such as locomotion, balance, agility, and hand-eye and foot-eye coordination as well as the elements of strength, endurance, and flexibility.

At the elementary school level, interscholastic sports, in which children perform against another school, are not widespread through the United States. However, community league, club, YMCA, and recreational department team competition is relatively common for the elementary school child. Such competition provides the athletically gifted child a chance to excel and the less gifted child a chance to be a part of a cohesive group. Some antagonists of the idea of elementary school children's competing consider it educationally, physiologically, and psychologically harmful. This point of view has never been substantiated by scientific research. Competitive athletics is neither good nor bad inherently; whether it is good or bad depends on the leadership and the direction in which the child is motivated.[52] The proponents of early athletic experience state that "engaging in athletic competition automatically instructs the participant in 'good sportsmanship'." This is not the case; sportsmanship, like any expression of attitudes and values, must be overtly planned for and taught to the performer by the team's leadership.

We consider it beneficial for the physically gifted child to have opportunities to excel at a sport; however, a number of dangers to the maturing child are inherent in his continually engaging in one sport

alone without regard to a variety of movement experiences. The athletically gifted child, as all children, must experience a wide variety of movement activities if he is to reach his full motoric potential. No one sport offers all that a child needs. Consequently, overemphasis of a sport must be avoided at all costs, to ensure that the gifted child has a well-rounded physical, mental, and emotional development.

Physical development program

Development is that aspect of human evolving that is continuous and ongoing until full maturity is reached. Schools commonly use the term "physical development program" to refer to a program dedicated to assisting children who are physically subfit. An increasing number of school districts are providing special opportunities for children to raise their level of motor fitness through an individualized program.

A primary goal of the physical educator is to develop, within all students, those physical attributes necessary for engaging in daily activities without undue fatigue and at the highest possible level of motor proficiency. Determining which children are physically underdeveloped is difficult for most teachers, mainly because there are so many factors that must be considered. The diagnosis of physical and motoric deficiencies is usually determined through tests that are designed to measure the immediate status of the child. Selected tests should also motivate the child to improve as well as measure progress after the child has engaged in a prescriptive motor fitness program for a period of time. (See Chapter 8.)

Since physical development programs are individual in nature, with each child having his own unique requirement, the fitness program should be created in cooperation with the child and the teacher. The role of the teacher is to interpret the test findings and provide valuable information about the best way to overcome specific deficiencies. However, program decisions should be made by the child and the teacher together in a cooperative venture. Ideally, a fitness program, besides amelio-

rating specific programs, will be motivating enough that the child will want to maintain a high degree of fitness throughout a lifetime. This can be accomplished best when the decisions are personally made or agreed to by the teacher and child rather than thrust on the child from some outside source. Following are some suggested steps in decision making in regard to overcoming subfitness:

1. The teacher selects and administers the test.
2. The teacher discusses the test with the child.
 a. The teacher identifies weak fitness areas.
 b. He suggests ways to overcome deficiencies.
3. The child and the teacher agree on ways to overcome deficiencies and the rewards to be earned.
4. The child and the teacher agree on the time to exercise each day.
5. The child keeps a personal progress record.
6. The child and the teacher agree when work load changes should be made.
7. Once the child reaches the fitness goals, the child and the teacher agree on the best ways to maintain and perhaps increase the child's level of fitness.

Remedial program

Remedial physical education in the context of this text refers to that aspect of physical education concerned with treating specific physical, mental, and emotional problems through prescribed movement activities. The problems of the children who receive remedial physical education range from minor problems to severe disabilities. A program of remedial physical education may be conducted as part of a regular school curriculum or may be an integral aspect of a special school dedicated to children with a specific handicap, such as mental retardation, orthopedic handicap, emotional disturbance, or the sensory deficits of blindness and deafness.

Primary objective. The primary objec-

tive of remedial physical education is to assist the child in achieving the full potential in mental, physical, emotional, and social maturity through a carefully planned and individualized program of physical education activities. The following opportunities should be afforded each child requiring special help:

1. To participate in a basic movement program (motor therapy) for children with motor handicaps
2. To ameliorate postural defects and appreciate good body mechanisms
3. To reach full organic potential within limitations
4. To become aware of means of protecting himself and preventing further aggravation of the problem
5. To develop desire and skill for engaging in leisure time games and sports
6. To develop an appreciation of his physical and mental capabilities

Program organization. The majority of schools or school districts have children requiring the modified physical education programs. At least 2% of the children in any school have medical problems so severe that they require a special class in physical education. There are a number of different ways in which a remedial physical education program (RPE) can be begun in a district. Ideally, each elementary school should have its specialists in physical education; however, in most instances this is too expensive. One plan that has had some success is the *itinerant plan,* in which one RPE teacher is responsible for approximately three schools. Each day, the itinerant teacher travels and conducts one or two special physical education classes in the schools under his jurisdiction. Another plan that has found moderate acceptance is the *center plan,* in which children are bussed to a center specially designed and equipped for therapeutic physical education. Whatever plan is employed, the success of any program is due to the teacher and the backing he receives from the school administration and the community.

Identification of participants. Children may be identified as eligible for a remedial class by one of a number of sources. The classroom teacher often initiates the referral of a child who may display signs of physical, mental, or emotional problems. The regular physical educator also refers children who, because of some problem, are not finding success in regular physical education. Other referrals come from physicians, nurses, and psychologists.

Advisory committee. Once a child's need for special adaptations in physical education has been identified, he is referred to an advisory committee. The advisory committee is composed of people from a number of different disciplines, the choice of which depends on the particular needs of the school and community. Commonly seen on such a committee are a physical educator, a medical representative (physician or nurse), a counselor, an administrator, a special education teacher, a parent, and perhaps a member from a community handicap organization. The committee members support the remedial physical education program by making themselves available for advice when special problems arise. They can be called on to assist in selecting the children who have the most need for such a program.[45]

Individualization of methods. A remedial program must be individualized in order to be successful. Normally, a remedial class has less than 20 students and often has aides to assist the instructor. The teacher's approach may be similar to that in the developmental program. A child requiring specialized exercises or activities should have his program placed on a card. Young children or those unable to record their own progress should dictate the information to a recorder. Program changes should be conducted by the child and teacher conferring with one another. If a child understands his particular problem and is reasonable in the understanding of his abilities, he should eventually be able to develop his own program without assistance.

Aides are extremely valuable in indi-

vidualizing programs for handicapped children. Paid aides, parent aides, and student aides provide a valuable service in freeing the teacher from many time-consuming chores, such as lifting children in and out of wheelchairs and putting on and removing braces, so that he has more time for individual instruction and class administration. If a teacher does not have delegated aides, the more capable children within the class can assist and thus gain personal reward and free the teacher for individual help.

Modification of activities. Extremely important to individualized instruction is the modification of physical education activities for children with special needs. In every physical education program, not just in special classes, provisions should be made to adapt games and sports. Some of the reasons for modifying activities are as follows:

1. Modifying activities gives opportunities to play games to children who otherwise would be unable to.
2. It provides possibilities for engaging in some form of active play in later life.
3. It provides a wholesome emotional release for children who may be confined.
4. It can be a therapeutic adjunct to a program of physical therapy.
5. It adds elements of fun to perhaps an otherwise monotonous existence.

Games and sports can be modified to meet personal requirements so that they are safe and at the same time developmentally sound. The innovative teacher can create many games that include competition and excitement for every performance level (Fig. 9-2). Generally, activities can be modified by changes in duration, speed, intensity, and space for performance. The teacher can modify activities as follows, when adapting them to children:

1. By decreasing the size of the playing area
2. By changing the size of the implements of the game
3. By increasing the number of players
4. By changing the rules

Fig. 9-2. Carom game can be enjoyed by all. (Photo courtesy Lyonel Avance, Special Education Branch, Physical Education Project, Los Angeles City Schools.)

5. By shortening the game time
6. By reducing the number of points in a game
7. By freely substituting the players
8. By changing the positions of the players readily

Modified games and sports program

The adapted concept in physical education of modifying games and sports is applicable to every level of ability and grade, although it is most often applied to children with special needs. It means that a teacher and the curriculum are flexible enough to accept all children as individuals and to make program modifications accordingly. The committee on Adapted Physical Education of the American Association for Health, Physical Education, and Recreation (AAHPER) defines adapted physical education as *"a diversified program of developmental activities, games, sports, and rhythms suited to the interests, capacities, and limitations of students with disabilities who may not safely or successfully engage in unrestricted participation in the vigorous activities of the general physical education program."* This statement implies that physical education should be available to all children no matter what physical, mental, or emotional problems they may have.

Movement education

Movement education induces the child to accept personal differences and to progress at his own rate. Through solving movement problems and analyzing himself, each child explores and discovers his own motor abilities. By increasing his sensory awareness, the child learns to solve complex movement problems involving the factors of space, force, and time.

SPECIAL CONCERNS

The elementary school teacher will be confronted with many children who require special considerations when engaging in physical activities. Children having special needs are often categorized as being impaired, disabled, or handicapped, but these terms are not synonomous or necessarily interchangeable. An *impairment* is an identifiable organic or functional condition that may be either permanent or temporary, such as the lack of a limb due to an amputation or a behavioral maladjustment. On the other hand, a *disability* is a restriction in the execution of a particular skill as the result of an impairment. Finally, a *handicap* is the psychological, emotional, or social effect of an impairment or disability. A handicapped person is one who views himself as being unable to overcome the obstacle of an impairment or disability.[156]

Motor disturbances

Motor disturbances can range anywhere from subtle movement difficulties to very obvious asynchronous movements. There are many causes, and the assessment of them is often difficult, requiring the assistance of a professional team of neurologists, pediatricians, psychologists, and educators. Children with moderate to severe cerebral dysfunction often are under the care of a physician and a physical therapist. However, less understood but more often seen are the children who display clumsiness.

The "clumsy child syndrome" is a catchall term for the lack of coordination of some children in the execution of certain motor tasks. This deficit may be attributed to heredity, central nervous system disorder resulting from disease or injury, perceptual-motor dysfunction, sensory impairment, and emotional problem; all these factors can contribute, in part or in combination, to a child's lack of coordination. Poor coordination may be manifested in large-muscle awkwardness in running, walking, or throwing or catching a ball or in the fine eye-hand coordination activities of playing with building blocks or writing. It should be noted that every child shows clumsiness in certain movements; however, the child who repeatedly displays problems in a number of motor tasks may require special help.

The child with motor difficulties is often a failure at play. He is relegated by his peer group to being chosen last and to

playing in the least desirable role or position in a game. This chain of failure events may be compounded and cause a feeling of inferiority and a fragile ego later in life. Intervention programs should be instituted as early as possible. There is good indication that basic motor development programs provided for young children with coordination difficulties can prevent them from having many of the problems when they are older.

Children with movement problems should be provided with as many opportunities as possible to engage in a wide variety of movement experiences (Fig. 9-3). An individualized program should be developed by the teacher that accentuates activities that will help to remedy a specific motor problem. Areas of remediation should be broken down into a logically sequenced set of tasks from simple to the more complex. For example, a child with

static balance difficulties might start with a task requiring that he stand with both feet together for 10 seconds and progress to a very difficult task of balancing with one foot on a 1-inch-wide board. After he has successfully completed a task, the child is given the positive reinforcement of praise or a more tangible reward such as points, food, or free activity time.

Learning impairments

Children with learning impairment fall into two major categories: those with normal intelligence who have a disability in some aspect of the learning process and those who have a general intellectual retardation. Each type of child must be considered educationally unique.

Educational disability. It has been estimated that almost 20% of children in the United States who are within the normal range of intelligence are educationally dis-

Fig. 9-3. Basketball shooting task for child with motor disturbances. (Photo courtesy Lyonel Avance, Special Education Branch, Physical Education Project, Los Angeles City Schools.)

abled.[53] These children have been variously called perceptually handicapped, neurologically handicapped, minimally brain-damaged, educationally handicapped, and dyslexic. Whatever the label, this problem is a disorder manifested primarily in the communication arts of reading and writing. Children who are educationally disabled may also be awkward and clumsy in small- or large-muscle activities, or conversely, they may be athletically gifted. Children with perceptual disorders may have difficulty in processing information in one or two perceptual channels such as vision and audition. (See Chapter 3.)

Mental deficiency. The American Association on Mental Deficiency (AAMD) refers to mental retardation as a subaverage general intellectual function occurring during the individual's developmental period and associated with an impairment in adaptive behavior.[2] The AAMD, using the Stanford-Binet test of intelligence, classifies mental capacity and retardation as follows:

Borderline retarded	70-84	IQ
Mildly retarded	55-69	IQ
Moderately retarded	35-54	IQ
Severely retarded	25-34	IQ
Profoundly retarded	0-24	IQ

An educational classification of mental retardation is as follows:

Slow learner	76-90	IQ
Educable mentally retarded	50-75	IQ
Trainable mentally retarded	25-49	IQ
Dependent mentally retarded	0-24	IQ

As does a person in any segment of the population, the mentally deficient child attempts to adapt to his environment; consequently, the most descriptive evaluation is that of how well the retarded child reflects appropriate behavior in meeting the demands of the particular culture. If the individual can adequately adjust to the responsibilities of the society, it is difficult to say that he is incompetent. In other words, it is very difficult to differentially diagnose the exact level at which a child is functioning, since the only criterion may be poor performance in school whereas maturation and social adjustment may be considered normal. Generally speaking, trainable mentally retarded children are unable to develop usable skills to achieve academically and are impaired in maturation and social adjustment. On the other hand, the educable mentally retarded child can achieve academically, but his performance is significantly below average for his age. In contrast to children who are classified as having learning disabilities, mentally retarded children are generally slow and have limited abilities.

Following is a list of some causes of mental deficiency in children:

Genetic irregularities
1. Inheritance that produces mental deficiency
2. Genetic disorders caused by factors such as overexposure to x-rays and infections
3. Errors in metabolism
4. Rh blood factor incompatibility

Adverse events during pregnancy
1. Infections (German measles)
2. Glandular dysfunctions
3. Toxic poisoning
4. Faulty nutrition

Adverse events at birth
1. Prolonged labor
2. Too rapid birth
3. Premature birth
4. Factors that reduce amount of oxygen transported to higher brain centers

Adverse events after birth
1. Childhood diseases such as whooping cough, chickenpox, measles, meningitis, scarlet fever, polio, and encephalitis
2. Glandular dysfunctions
3. Trauma

Adverse cultural and environmental events
1. Cultural deprivation
2. Serious emotional problems

Research points out that the mentally retarded child, besides being low in intelligence, may also be limited in his motor fitness, motor skills, and recreational skills.[47] He needs opportunities to experience a good physical education program. Increasing his

physical ability through motor activities may provide him with opportunities for enriched leisure time and perhaps even possibilities for employment.

Basic to all movement is motor fitness. Without an efficient fitness level, the retarded child characteristically has muscle hypotonicity (low muscle tone) and is flabby and unable to engage successfully in a wide variety of movement activities. If his motor fitness is increased, he will fatigue less, be less obese, become efficient in body mechanics, and be able to learn basic motor skills more readily.[78]

Because the retarded child matures and learns at a slower rate than the average child, he may be denied opportunities for learning basic movement skills such as running, jumping, climbing, throwing, catching, kicking, and striking. Therefore, he should learn basic motor skills before he attempts more advanced activities; the learning of basic movement skills is followed by the learning of rhythms and games of low organization, which lead in turn to the learning of the more advanced activities of dance, gymnastics, and sports. Many retarded persons, depending on their level of intelligence, with patient instruction, may be able to learn complex motor activities.

Essential to a fruitful life is the ability to perform recreational skills. For many retarded persons the enjoyable experiences of life are extremely limited; therefore, the physical education program should offer instruction in recreational and leisure time activities. Through these activities, retarded children can increase their physical capacity, social awareness, use of leisure time, and ultimately, their occupational potential. Following is a list of some techniques for teaching mentally retarded children motor skills:

1. Group the children according to interest rather than age.
2. Use small groups instead of large groups.
3. Choose games with few rules.
4. Limit competition with other children.
5. Include opportunities for immediate success in each activity.
6. Take part in the game.
7. Use exclusion from a game or a decrease in playing time as discipline.
8. Give opportunity for free play.
9. Closely supervise to recognize dangers.
10. Make explanation about activities short, concrete, to the point, and without abstraction.[69]

Emotional disturbances

Educators are becoming increasingly aware of children who are emotionally disturbed. Characteristically, these children are inflexible in their behavior and impaired in their ability to adjust to a changing environment. More specifically, these children often find difficulty in learning, getting along with other children, engaging in motor activities, and conducting themselves appropriately under normal social conditions.[2]

Emotional disturbance encompasses many personality and behavior traits that range from hyperactivity to hypokinesia and withdrawal. Some abnormal behavior characteristics that directly affect the learning process are hyperactivity, impulsiveness, disorganization, distractibility, figure-ground confusion, and perseveration; these are generally considered impulse disorders. Generally, a child with this set of behavior characteristics requires a highly structured and predictable environment.[37, 43] Following is a list of principles for the teacher who may be working with emotionally disturbed children with impulse disorders:

1. Remove distractions from the environment.
2. Overstimulate except in cases of hyperactivity.
3. Give concrete descriptions of rules and games.
4. Give manual guidance in learning basic skills.
5. Select tasks within each child's ability.
6. Give immediate reinforcement for an accomplished task.

Table 5. Emotional disturbances in children

Behavior disturbance	Characteristics	Intervention	Implications for physical education
Hyperactivity	Moves constantly; has high energy level; is usually aggressive; is unable to focus attention.	Decrease distractions; direct energy to one task.	Simplify rules of game; individualize instruction; pick play activities in which there are few distractions.
Impulsiveness	Exhibits unplanned, meaningless, and often inappropriate behavior.	Provide highly structured setting with no distractions; give concrete directions.	Provide activities that are distinct and maintain interest.
Disorganization	Exhibits random behavior; cannot listen; performs pointless activities; has untidy habits.	Provide highly structured setting with no outside distractions; pick short tasks with immediate reward.	Pick activities that require distinct sequencing, such as rhythms.
Distractibility	Cannot focus attention; is easily distracted by outside stimuli.	Structure the environment; decrease stimulation; use single-task approach.	Pick low-expectation activities; emphasize instruction with highly distinct aids, such as bright colors; provide individual instruction.
Figure-ground confusion	Cannot distinguish figure from background, visual and/or auditory.	Accentuate figure by decreasing background.	Play ball games against a plain, light background; give directions simply and concretely.
Catastrophic reaction	Has low frustration level; exhibits explosive behavior; has abnormal fears; overreacts to threatening situations.	Structure routine; use positive approach.	Keep games at low excitement level; prevent unexpected situations; teach rules concretely; keep distractions to a minimum.
Perseveration	Cannot shift attention; is locked into a specific behavior and automatic response.	Separate by physical means; provide distinctly different tasks.	Avoid activities that are too highly sequenced, such as bouncing a ball and marching; change activities often to create dissimilarity.

7. Avoid overengaging in the same activities.
8. Encourage the child in a positive self-concept at all times.

Physical education provides many opportunities for emotionally disturbed children to develop appropriate behavior. Through a well-planned program, they can acquire basic movement and game skills as well as learn to get along with other children. Personal constraint gained from encountering frustrations on the playground with other children may carry over to the classroom.

Following is a model of a planned intervention program for children with motor impairments:

I. Primary program: efficiency in movement
II. Secondary objectives
 A. General body management
 B. Object control
 C. Body control on apparatus
 D. Emotional control
III. A multisensory approach to movement: the acquisition of motor skills
IV. Primary developmental areas
 A. Gross motor development
 B. Fine motor development
 C. Perceptual-motor development
 D. Body image and spatial awareness
V. Admission evaluation in the areas of
 A. Balance

B. Gross body control
C. Hand-eye coordination
D. Dexterity
E. Simultaneous motor control
VI. Specific intervention task areas in
 A. Relaxation-tension recognition
 B. Locomotion
 C. Balance
 D. Movement exploration
 E. Rebounding
 F. Body awareness
 1. Directive
 2. Reflective
 G. Manipulation
 H. Play
 1. Throwing
 2. Catching
 3. Kicking
 4. Striking
 I. Posture control
 J. Motor fitness
 K. Classroom transfer activities
VII. Gaining emotional control by
 A. Behavioral modification through positive reinforcement
 B. Structuring the environment
 C. Gradual introduction of stress
 D. Planned social behavior
 E. Child counseling and family education*

Cardiac and respiratory problems

The elementary school teacher is often confronted with the problem of instructing children who have heart or respiratory problems. Over half a million children have heart disorders, the majority of which are attributed to rheumatic fever, which is caused by a hemolytic streptococcus infection. This infection within the bloodstream attacks the heart valves in some individuals. If the valves are affected, the heart may

*This program model was developed by the Institute for Sensory-Motor Development conducted at the California State University at Long Beach and was designed primarily for children who are considered awkward in their motor behavior, many of whom also have learning disabilities, emotional disturbances, and perceptual-motor impairments.

lose its pumping efficiency. In such cases, the child becomes less able to engage in physical activity; the extent to which he is able depends on the amount of damage. Second to rheumatic heart disease in incidence is the congenital malformation of the heart. Defective fetal development causes the malformation of the heart and/or blood vessels.

Graded exercise is generally considered good for children with heart defects if it is given in the proper amounts based on individual capacity. It is desirable that each child with a heart condition be classified by a physician as to his exercise level. Following is a classification system based on the child's ability to engage in physical activity:

Class A: The child needs no activity restriction.

Class B: He can conduct normal daily activity but cannot participate in competitive activities.

Class C: He is moderately restricted in his daily activity routine and is not allowed to participate in strenuous activities.

Class D: He is markedly restricted in all physical abilities.

Class E: He is confined to bed or chair.

Although the classifying of a child with a heart condition may assist a teacher in selecting correct activities, the best indicators are how the individual child reacts to activity. Contraindicated activities would be those that cause an accelerated pulse, shortness of breath, weakness or dizziness after exertion, undue fatigue, or a higher level of excitement.

Common to most schools throughout the country are children who have respiratory problems. The most prevalent lung condition is bronchial asthma. Asthma is the obstruction of the bronchial tubes that is caused by muscular spasm and an excess of fluid secreted from the mucous lining. Some of the factors causing asthma attacks are irritations from air contaminants or allergy-producing substances, and abnormal physical or mental stress. Like children with heart problems, those with lung problems must be

given graded activity programs based on individual requirements. Care must be taken so that an attack is not caused by overexertion or overexposure to extreme temperatures.

The teacher should adhere to the following rules in planning a program for children with heart or lung problems:

1. Avoid breath-holding activities.
2. Avoid causing breathlessness.
3. Reduce the speed of activities.
4. Reduce the number of activity repetitions.
5. Provide rest between exercise bouts.
6. Avoid high-level competition.

Most of the activities presented in this text can be specifically selected or modified to suit the needs of children with heart or lung problems. For example, if children are in class B and must avoid high-level competition, the teacher can select games for them to play, such as ball passing, nine court basketball, and steal the bacon.

Visual limitations

Children with visual limitations may be placed in special education programs or may be integrated into the regular classroom. In either case, the educational curriculum must be modified to meet their unique requirements.

Two educational classifications are used for children with visual defects: blind and partially sighted. Legally, the degree of blindness is determined by a test of visual acuity. The legally blind person is one who has a visual acuity of not more than 20-200 after correction; in other words, he can see 20 feet away what a person with normal sight can see 200 feet away. A legally partially sighted person is one who has a visual acuity of less than 20-70 after correction. A person who has a visual field of 20 degrees or less (tunnel vision) also may be deemed legally blind or partially sighted.

There are four basic causes of visual limitation: refractive error, structural defect, infectious disease, and imbalance in eye muscle function. About 50% of all visual defects are due to errors in refraction,

that is, the bending of light rays as they enter the eyes that results in the focusing of images on the retina.

Children with visual impairments often have developmental lags in all areas of classroom, social, and motor responses; consequently, the expectations of these children must not exceed their particular level. This is not to say that children with visual problems cannot reach their full mental and physical potential; it does mean, however, that special efforts must be made to help them arrive at their maximum level of achievement.

Physical activity is essential in providing visually limited children opportunities for adjusting to the demands of their environment. Only through the senses of feel, movement, and hearing can these children learn about their physical world. Accurate body awareness is particularly important to the blind child for acquiring a knowledge of his position in space. Before the blind child can be free to move around, he must have a sense of "whereness."[37]

Through physical education the lives of blind and partially sighted children can be enhanced socially, emotionally, and physically. Many games, sports, rhythmics, and stunts are available that require the use of the senses of audition, tactility, and kinesthesis. Activity adaptations can be made so that the sense that the blind child has most available is used. Through vocal guidance by a teacher or a classmate, he can enjoy many ball games and stunts. Many running activities are at the disposal of the visually limited child through the sense of feel and the guidance of a string or rope.

Lower-limb disabilities

It is not uncommon to find children with lower-limb disabilities integrated into regular classrooms or placed in special classes in a regular school setting. Such children may have defects such as lack of a limb due to amputation, congenital malformation, arthritis, and paralysis. Their mobility potential may vary from limited locomotion with braces on their legs or with crutches to

Fig. 9-4. Child with arm impairment performing a challenging task. (Photo courtesy Lyonel Avance, Special Education Branch, Physical Education Project, Los Angeles City Schools.)

permanent confinement in a wheelchair. Whatever their restrictions, these children should have physical activities adapted to their particular needs. As do all children, those with lower-limb defects need social opportunities, emotional outlets, a sense of accomplishment through play, as well as improvement of the motor fitness factors of strength, flexibility, and stamina.

The adapted program for children with lower-limb problems may be divided into the development of basic motor skills, stunts, games and sports, rhythmic skills, and motor fitness.[148] Because of their limited mobility, children with lower-limb disabilities should be given every opportunity for experiencing basic movement activities. Success at this level will provide self-confidence and a foundation for learning high-level activities.

Stunts, games, and sports can be suited to individual capabilities. Stunts can be executed that require little leg support, if any, such as tumbling, apparatus performance, and rope climbing. Many sports can be played from a wheelchair such as bowling, badminton, and basketball. Other games can be modified to be played by a child in a wheelchair, such as swinging-ball games like tetherball and target games, or to be played by a child on crutches, such as games like soccer or relays.

Motor fitness is of extreme importance to the child with limited movement. The development of arm and shoulder strength

and stamina is essential if the child is going to enjoy a full and productive life.

Upper-limb disabilities

As do children with lower-limb defects, those with upper-arm disabilities vary in their educational needs. Occasionally the teacher will have a child who, because of paralysis or congenital malformation, does not have full use of both arms (Fig. 9-4), although most frequently an affected child has single-arm involvement, such as that due to an amputation, with full use of the other arm. The latter children can engage in a full activities program with the major emphasis placed on posture control, balance, and motor fitness to counteract the asymmetry caused by having one affected arm.

RECOMMENDED READINGS

Bradfield, R. H., editor: Behavior modification, San Rafael, Calif., 1970, Dimensions Publishing Co.

Buell, C.: Physical education for blind children, Springfield, Ill., 1966, Charles C Thomas, Publisher.

Cratty, B. J.: Developmental games for physically handicapped children, Palo Alto, Calif. 1969, Peek Publications.

Cratty, B. J., and Sams, T. A.: The body-image of blind children, New York, 1968, American Foundation for the Blind.

Fait, H. F.: Special physical education, Philadelphia, 1972, W. B. Saunders Co.

Hayden, F. J.: Physical fitness for the retarded, Toronto, 1964, Metropolitan Toronto Association for Retarded Children.

Keeney, A. H., and Keeney, V. T., editors: Dyslexia: diagnosis and treatment of reading disorders, St. Louis, 1968, The C. V. Mosby Co.

Sequenced instructional programs in physical education for the handicapped, 1970, Los Angeles City Schools Special Education Branch Physical Education Project, Public Law 88-164, Title III.

IV

Activity progressions

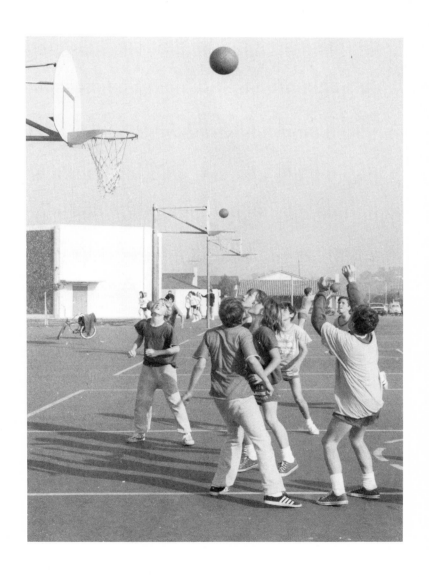

Part IV is concerned with the four major activity areas of movement exploration, stunts and self-testing, rhythms and dance, and games and sports. Activities within these areas are specifically chosen on the basis of their value to the child, and each area is presented in a progressive order, from the simple to the more complex. In order that the practitioner can account for each child's progress, behavioral objectives are given for each of the games and sports activities in three different levels. Because children vary considerably in their motor capabilities, we have chosen to present games and sports in three levels rather than by chronological ages. Level 1 represents low-organization activities; level 2, moderately organized games and sports lead-up activities; and level 3, highly organized activities.

Chapter 10

Movement exploration

Movement exploration is a technique used in teaching physical education, in which children solve problems by discovering how they can move in time and space. The teacher does not demonstrate the correct answer but allows each child to create his own response to problems such as "How can you move from your spot to your partner's, using your hands and feet?" and "Can you return to your spot using a different movement?" These problems are simple but act as a beginning in the development of movement exploration. The problems can become increasingly difficult and through auditory sequencing can develop the memory patterns as well as the movement activities of the children. In movement exploration activities the teacher has a greater opportunity to give individual help and to observe the child performing self-expressive activities. In movement exploration the children are able to progress within their own capabilities and at their own individual rate (Fig. 10-1). Since movement exploration activities are less formal than ones involved in the traditional games and sports approach, the teacher acts more as a guide in the learning experiences and the need for more formal demonstration is lessened. Although there is little chance for failure in this approach to physical activity, the teacher may offer suggestions from time to time that will al-low the child to improve on his particular problem solution. In the more advanced stages, children will be able to work with partners and small groups in arriving at a solution to the problem at hand.

Beginning teachers often find it difficult to take this more passive role that allows the child to discover his own capabilities and often have a tendency to give the solution themselves. It must be remembered that the objective of this approach to teaching physical education is to allow the child to use his cognitive powers and translate them into psychomotor activities rather than to mimic a skill presented by another.

A movement exploration program should include the following factors as illustrated in Fig. 10-2:

1. Body awareness—how the body can move
2. Space awareness—where the body can move
3. Quality of movement—how well the body can move

Each child experiments with and becomes involved in the variety of movements and positions his body is capable of executing (Fig. 10-3). He also discovers the amount of space it takes to execute a particular movement safely (Fig. 10-4). He must realize it takes more space to execute

Fig. 10-1. Children exploring space.

Fig. 10-2. Movement exploration model.

Fig. 10-3. Children exploring movement and position of body.

certain types of movement than others. After discovering how his body moves and where it can move throughout the activity area, the child discovers that the movements with better qualities are more efficient and effective in solving the problem.

The following are movement exploration problems. Depending on the needs of the children and the teacher's willingness to experiment, additional problems can be created and developed.

BODY AWARENESS
Parts of the body

1. Can you stand with your front toward me?
2. Can you show me your right arm?
3. Can you show me the top of your head?
4. Can you find your elbows?
5. Can you move your elbows?
6. Can you show me a different way to move your arms?

Fig. 10-4. Children exploring limited space.

Shapes

1. Can you make yourself into a ball?
2. Can you make yourself into a square?
3. Can you make yourself into a cork-screw?
4. How many ways can you make a triangle?
5. Can you make yourself look like a table?
6. Can you make yourself look like an elephant?

Locomotion

1. Can you go away from "home" and return on a signal?
2. Can you go away from "home" and return using another movement?
3. Can you cross the room by taking as many steps as possible?
4. Can you move across the room and move in a different way when the whistle blows?
5. Can you change direction and the way you move when I clap my hands?

SPACE AWARENESS
Levels

1. How low can you make yourself?
2. Can you get lower still?
3. How high can you get?
4. Can you raise your body from a low level to a high one?
5. Can you raise a part of your body?
6. Can you raise it another way?
7. Can you raise one part of your body and let another part fall?
8. Can you walk tall?

Individual space

1. Can you find a space and sit down?
2. How far can you reach without touching your neighbor?
3. How little space can you take up?
4. How much space can you take up?

Group space

For safety, the children should be trained to move among themselves without colliding; this is best accomplished by providing skills on a continuum.

1. Can you walk in one direction around the circle?
2. Can you change places with a neighbor while walking?
3. Can you slowly go to another spot without touching anyone?
4. Can you quickly go to another spot without touching anyone?
5. Can you move around the room using another movement and not touch anyone?

QUALITY OF MOVEMENT
Resistance—force

1. Can you walk very softly?
2. Can you show me a different way to move softly?
3. Can you make your feet heavy?
4. Can you show me how strong your hands can be?
5. How strong can your body be?
6. Can you show me another way to have a strong body?

Tempo—speed

1. How fast can you make your body go while staying in one place?
2. Can you swing your arms slowly?
3. Can you move to the right as slowly as possible?
4. How fast can you get back to home?
5. Can you make your shoulders do something fast?
6. Can you make them do something at a different speed?

Balance

1. Can you balance on one leg?
2. Can you balance on another part of your body?
3. Can you move while you are balancing?
4. Can you move in another direction?

Flow

Flow is continuous movement as opposed to erratic movement.

1. Can you move your body smoothly?
2. Can you make your body quiver?
3. Can you jerk one part of your body?
4. Can you move one part of your body smoothly?
5. Can you show me a smooth walk?
6. Can you show me a smooth run?
7. Can you walk or run smoothly another way?

Partners

1. Can you move across the room together?
2. Can you move a different way?
3. Can you move so that one partner is there first?
4. Can you stand up while holding hands with a partner?
5. Can you show me another way to stand up while touching your partner and not using your hands?

Working with props

Hula-Hoops

1. Can you climb in and out of your hoop?
2. Can you put one part of your body in the hoop and one part outside?

3. How high can you throw the hoop?

Rings, balls, and bags

1. How high can you throw the ring?
2. Can you throw it another way?
3. Can you catch it before it hits the ground?

Obstacles

1. How many ways can you go over the bar?
2. How many ways can you go under the chair?
3. How many ways can you go around the ball?
4. How many ways can you go through the hoop?

RECOMMENDED READINGS

Fait, H. F.: Physical education for the elementary school child, ed. 2, Philadelphia, 1971, W. B. Saunders Co.

Frostig, M.: Move, grow, learn (teacher's guide), Chicago, 1969, Follett Publishing Co.

Frostig, M.: Movement education: theory and practice, Chicago, 1970, Follett Publishing Co.

Glass, H.: Exploring movement, Freeport, N. Y., 1966, Educational Activities, Inc.

Latchaw, M., and Egstrom, G.: Human movement, Englewood Cliffs, N. J., 1969, Prentice-Hall, Inc.

Schurr, E.: Movement experiences for children, Des Moines, Iowa, 1967, Meredith Corporation.

Chapter 11

Stunts and self-testing

Stunts and self-testing activities are those forms of physical education in which the child tests his individual ability to accomplish movement skills. The satisfaction that he gains through the successful accomplishment of these skills is a strong motivating factor for lengthy practice. Growth in skill, flexibility, strength, and agility is the basis for participation in some of the more complex activities in group situations. One of the better ways of giving recognition to the child for accomplishing these activities is to have a self-testing chart from which he can receive recognition for each skill accomplished (Fig. 11-1). Although a child always seems to compare himself with other children in the class, he can also strive to accomplish as many of the stunts listed as possible within his own individual capabilities. When the teacher offers self-testing activities, it is best that he establish a variety of stations in order to provide activity for many children in the class. Care should be taken to offer activities that range from the simple to the complex so that all children can achieve success and be challenged to progress to the more difficult stunts.

STUNTS

Measuring worm. The child walks with his feet, up to his hands, keeping his hands on the floor; then he walks with his hands, away from his feet (Fig. 11-2). As a variation, he does it backward.

Frog hop. From a squatting position, he hops and lands on his hands first and then his feet (Fig. 11-3).

Rabbit jump. He assumes a bent-knee squat position, with his hands on the floor in front of and closer together than his feet. He leaps forward by pushing with his feet and bringing his feet forward on the floor outside his hands (Fig. 11-4).

Fig. 11-1. Self-testing chart.

180

Turk stand. He sits with his legs crossed and then stands without pushing with his hands (Fig. 11-5).

Knee stand. From the kneeling position with his toes out flat behind him, he jumps in one motion to a complete stand (Fig. 11-6).

Bouncing the ball. He jumps up and down from a squatting position while another child bounces him (Fig. 11-7).

Crab walk. Keeping his body straight and his head up, he walks forward on his hands and feet, with his back toward the floor (Fig. 11-8).

Wicket walk. He takes hold of both feet with his hands and walks forward, keeping his knees straight (Fig. 11-9).

Balance on one foot. He stands on one foot with his eyes closed for 30 seconds (Fig. 11-10).

Fig. 11-2. Measuring worm.

Fig. 11-3. Frog hop.

Fig. 11-4. Rabbit jump.

Fig. 11-5. Turk stand.

Fig. 11-6. Knee stand to standing position.

Fig. 11-7. Bouncing the ball.

Fig. 11-8. Crab walk.

Fig. 11-9. Wicket walk.

Fig. 11-10. Balance on one foot.

Fig. 11-11. Wheelbarrow.

Fig. 11-12. Chinese get-up.

Fig. 11-13. Heel knock.

Wheelbarrow. Keeping his body straight, he walks forward on his hands while his partner holds his thighs instead of his ankles to eliminate too much lateral motion (Fig. 11-11).

Chinese get-up. Two children sit back to back with their arms locked and push against each other to a standing position (Fig. 11-12).

Heel knock. The child jumps in the air, clicking his heels to the side (Fig 11-13).

Jump through arms. He curls his hips forward and tucks his knees and jumps through his arms (Fig. 11-14).

Human top. From a standing position, he jumps into the air and turns around, facing the opposite direction on landing (Fig. 11-15).

Swagger walk. He walks forward swing-ing his right foot around behind his left foot and as far forward as possible and placing it close beside the left foot. As he places his right foot flat on the floor, he lifts his left heel and bends his left knee. Then in like manner he swings his left foot around his right foot. He makes progress by alternating the action of his right foot and left foot in rhythm in a swaying motion (Fig. 11-16).

Corkscrew. He puts an object outside his left heel. He winds his right arm behind his right leg, in front of his left leg, and around to get the object (Fig. 11-17). He may raise his heels if necessary.

Mercury stand. He stands on either foot and bends his body forward until it is at right angles with the supporting leg, bending his free leg slightly upward from the knee

Fig. 11-14. Jump through arms.

Fig. 11-15. Human top.

Fig. 11-16. Swagger walk.

Fig. 11-17. Corkscrew.

Fig. 11-18. Mercury stand.

Fig. 11-19. Twister.

Fig. 11-20. Forward roll.

Fig. 11-21. Backward roll.

and holding his head up and his arms to the side horizontally. He holds this position for 5 seconds without wavering (Fig. 11-18).

Twister. Two children face each other, holding their right hands. One child lifts his left foot over their clasped hands at the same time that the other child lifts his right foot over their hands; then they turn back to back, keep on turning, lift their other leg over, and come back to the original position (Fig. 11-19).

Forward roll. The child squats, with his knees apart and his hands on the floor between his knees. Placing his weight on his hands and the back of his shoulders, he tucks his head so that the roll is on his shoulders (Fig. 11-20). His head does not need to touch the floor at all. He keeps the tucked position and returns to the standing position.

Backward roll. He assumes a squatting position. He places his hands at the sides of his head and, keeping his head tucked all the way over, he rolls his body over backward (Fig. 11-21).

Knee dip. He stands on one foot and grasps his other foot behind his back with the hand on the same side. He bends the knee of his supporting leg and touches it to the ground and stands again (Fig. 11-22).

Through the stick. He grasps a wand or rope with both hands behind his back,

Fig. 11-22. Knee dip.

Fig. 11-23. Through the stick.

Fig. 11-24. Single squat.

keeping his palms forward. He brings the stick over his head to a position in front of his body, keeping his arms straight and still grasping the stick. He lifts his right foot, swings it around his right arm and through his hands from the front over the stick. He crawls through the stick head first by raising the stick with his left hand over his head (Fig. 11-23). He then passes the stick down over his back. He lifts his left foot off the floor and steps backward through the stick. He may slide his hands along the stick but may not let go of it.

Fig. 11-25. Walrus walk.

Single squat. He stands on one leg, with his other leg out straight. Then he squats on the supporting leg and stands again (Fig. 11-24).

Walrus walk. He walks forward on his hands, dragging his feet and keeping his body straight (Fig. 11-25).

Jackknife. He stands with his feet slightly apart, his arms back of his body, and his elbows bent; and then he jumps, bending his trunk forward and touching his toes before returning to the standing position (Fig. 11-26).

Fig. 11-26. Jackknife.

Human ball. He sits with his knees bent close to his chest but separated and puts his arms down between his legs and around the outside of his shins and clasps his hands in front of his ankles. He may cross his feet if he desires. Then he rolls to the left side, over on his back, to the right side, and up to the sitting position again (Fig. 11-27).

Fig. 11-27. Human ball.

Fig. 11-28. Crane twist.

Fig. 11-29. Greet the toe.

Fig. 11-30. Jump the stick.

Fig. 11-31. Dwarf walk.

Fig. 11-32. Wind the clock.

Fig. 11-33. Caterpillar walk.

Fig. 11-34. Scooter.

Crane twist. A line is marked about 2 feet out from a wall. The child places the front of his head against the wall and, using his head as a pivot, turns his body around completely without moving his head from the wall and without stepping within the line (Fig. 11-28).

Greet the toe. Standing on one foot, he grasps his other foot in both hands and touches his toe to his forehead (Fig. 11-29).

Jump the stick. He holds a stick or rope in front of his body, with his palms facing him. He jumps and pulls the stick under his legs and then jumps back through to the starting position (Fig. 11-30).

Dwarf walk. He walks on his knees, holding his ankles in back. He keeps his weight well forward, throws his chest up, and keeps his back well arched (Fig. 11-31). He should do this only on a mat.

Wind the clock. He squats, bending his left knee and extending his right leg sideways. He puts his right hand on the floor between his knees and his left hand on the floor beside his left knee. Then he swings his right leg to the left, jumps over it with his right hand as it swings in front of his body and with his bent left knee as it swings to his left side, and brings it back to the starting place (Fig. 11-32).

Caterpillar walk. One child walks on his hands and places his feet on the back of a second child who is on all fours (Fig. 11-33). Then they walk forward, keeping in step with their hands and feet.

Scooter. Two children facing each other sit on each other's feet and join hands. They scoot forward as they bend their knees and one child lifts his partner about a foot off the floor (Fig. 11-34).

Simple pyramids using stunts learned

A variety of patterns and designs can result from combining stunts into simple pyramids. Children should be encouraged to create their own formations. In order to avoid injury, a child should not be allowed to bear the full weight of another child. The

fun of pyramid building should be in the variety of designs created rather than the height achieved. An excellent demonstration program can be developed when pyramids are performed to a count. A designated person counts as follows as the children form the pyramid as illustrated in Fig. 11-35:

1. All children stand side by side (*A*).
2. They move into a ready position for the pyramid (*B*).
3. They execute their stunts to form the pattern (*C*).
4. They return to the ready position (*D*).
5. They return to the standing position (*E*) ready to perform another pattern such as that illustrated in Fig. 11-36.

ROPE JUMPING

Learning how to jump rope is one of the most exciting and rewarding experiences for elementary school children. Developing skill in jumping both the long and the individual rope not only is fun but also is a great asset in improving the cardiorespiratory fitness of youth.

Rope is a relatively inexpensive item, and for a small expense, school districts can provide enough equipment for each child. Rope jumping is an excellent activity for the children to participate in, both in and out of school. Rhymes and activities performed in rope jumping provide endless hours of enjoyment (Fig. 11-37).

A 5-minute individual workout is an excellent way to develop cardiorespiratory fitness. The children should be encouraged to develop individual fitness routines of their own. Teachers may also establish speed records by asking questions such as "How many times can you jump in 30 seconds?" In order to enjoy the full benefits of rope jumping, children must learn the correct method of jumping and must achieve success as soon as possible. In learning to jump rope, beginners should try first the long-rope activity, in which the rope is turned by two persons.

Fig. 11-35. Building a simple pyramid using stunts learned.

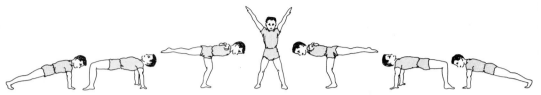

Fig. 11-36. Variation of a pyramid.

Fig. 11-37. Rope jumping is fun and develops physical fitness.

Long-rope jumping

Following is a progression for learning long-rope jumping that has proved to be successful with beginning students.

1. Without a rope, the child bends his knees and jumps straight up and down in place on the teacher's command to jump.

2. The child jumps in a 1-foot-square "magic box" drawn on the playground area with chalk. He must be able to jump in this magic box five times in rhythm before progressing to the jump with the rope. The teacher should insist that the child wait after each command to jump; he can use the verbal command "jump, wait, jump, wait" and so on (Fig. 11-38). Learn-

ing to jump without the rope eliminates the lateral movement often learned from jumping side to side over a low rope, which is detrimental to efficient rope jumping.

3. During this initial stage of learning how to jump straight up and straight down, the child should learn (a) to keep his feet together, (b) not to jump too high, (c) to land easily on the balls of his feet, (d) to stay in one place, (e) to maintain correct rhythm to the jump-wait beat, and (f) to flex his knees.

4. The child should learn how to be a good turner. He must use a full arm motion and not pull back on the rope, causing "high water" for the jumper.

Fig. 11-38. Jumping in magic box to commands:
A, jump and, **B,** wait.

A good turner must follow and stay even with the teacher.

5. The child should face the teacher and jump in the magic box drawn with chalk on the playground. He should watch the teacher and not the feet and should jump only when the teacher indicates by the jump-wait command (Fig. 11-39). Several practice calls of "jump" before the rope is actually turned will allow the teacher to see how fast the child reacts to the command. The teacher must adjust the speed of the call and the rope turn to the child's quickness or slowness of reaction time.

6. It is best to have no more than five beginners at one time using this technique. After a beginning practice period in which all have learned to jump, a heterogeneous group of children should jump together; this seems to speed the learning process, since the beginners pick up techniques from the more skilled students. The teacher should positively reinforce the learning of correct techniques of jumping rope by saying, for example, "How lightly you land on your feet," "Your knees are bent just right," or "What a fine turner you are; you stay right with me and hold the rope all the time."

7. After each child has had a turn at

Fig. 11-39. Successful learning involves watching the teacher, not the feet.

jumping, he should spend time turning the rope. However, in the beginning, a competent turner makes the teacher's job easier, and the rotation can be delayed until all have accomplished the skill.

8. The child learns jumping skills in the following progression: (a) he stands next to the rope and begins jumping; (b) he runs in while the rope is turning and jumps; (c) he runs in and out, jumping in between; (d) he runs in and out without jumping; (e) he runs around while jumping; (f) he touches the ground between jumps; (g) he jumps with a partner; (h) he changes places with a partner while jumping; (i) he pantomimes rhymes while jumping; (j) he runs in the back door and continues to jump; and (k) he performs double dutch (two ropes turning alternately in opposite directions).

It has been found that after a child jumps well when someone else is turning, it is easier for him to learn solo jumping, in which the additional skill of the hand coordination must be integrated with the jump. There are many different rhymes that children repeat as they jump rope. They encourage children to increase their jumping ability, maintain a regular tempo, and test individual progress in an enjoyable manner. Following are some of the favorites of elementary school children:

Lady, lady at the gate, eating cherries
 from a plate.
How many cherries did she eat? One,
 two, three, etc.

Johnny over the ocean, Johnny over the
 sea,
Johnny broke a bottle and blamed it on
 me.
I told ma and ma told pa, Johnny got a
 lickin' so ha, ha, ha!
How many lickin's did Johnny get? One,
 two, three, etc.

Down in the valley where the green
 grass grows,

There sat *(child's name)* as sweet as a
 rose.
She sang and she sang and she sang so
 sweet,
Along came *(child's name)* and kissed
 her on the cheek.
How many kisses did she get? One, two,
 three, etc.

Apples, peaches, peanut butter,
What's the initial of my true lover?
A, B, C, etc.

Gypsy, gypsy, please tell me
What my husband is going to be;
A rich man, a poor man, a beggar man,
 a thief,
A doctor, a lawyer, an Indian chief.

Verses that require that the child act out a stunt while jumping are more difficult, since while doing them, a child must either break rhythm or change the balancing position of his body. Some of these verses are as follows:

Mama, mama, I am sick,
Send for the doctor, quick, quick, quick.
Mama, mama, turn around,
Mama, mama, touch the ground
Mama, mama, are you through?
Mama, mama, spell your name.

Archie Bunker went to France,
To teach the children how to dance.
First the heel, then the toe,
Turn around, and out you go.

Teddy bear, teddy bear, turn around,
Teddy bear, teddy bear, touch the ground.
Teddy bear, teddy bear, show your shoe,
Teddy bear, teddy bear, that will do.
Teddy bear, teddy bear, go upstairs,
Teddy bear, teddy bear, say your prayers.
Teddy bear, teddy bear, turn out the light,
Teddy bear, teddy bear, say good night.

Not last night, but the night before,
Twenty-four robbers came knocking at
 my door.

I ran out *(child runs out)* and they ran in *(child comes in again)*
And hit me over the head with a rolling pin.
I asked them what they wanted, and this is what they said:
Spanish dancer do the splits, Spanish dancer give a high kick,
Spanish dancer turn around, Spanish dancer get out of town.

Individual rope jumping

The child can perform several modified activities of the regular jumping with the individual rope. The teacher can introduce a run with a skip, a jump backward, and other techniques to challenge the better students in the class. Caution should be taken not to progress so fast that the slow learners are discouraged. Jumping on one foot, jumping with alternate feet, and jumping with both feet together, combined with a variety of rope skills can develop into an excellent individual jump rope routine (Fig. 11-40).

Direction change. While jumping forward, the child brings his arms together as he brings them overhead and moves them to one side of his body. The rope is allowed to continue its arc while he makes a one-half turn with his body. At the completion of the turn, his arms are separated above his head as the backward turn is in progress. During the change, it is important that the jumper maintain the same rhythm throughout the stunt. The same procedure is followed in order to return to the forward jumping position.

Double jump. Increased speed and timing are essential in executing the double jump. At the completion of a single jump, the child begins to anticipate the double jump as the rope comes around, by increasing the speed of the rope and executing a higher jump. Many students will be able to master the double jump quite easily, and a few will progress to the triple jump, which is more difficult but can serve as an incentive to all.

Front cross. As the rope starts upward behind the child, he crosses his arms, making a loop to jump through. After completing the cross jump, he uncrosses his arms and makes the succeeding jump in the normal manner. A slightly higher jump is necessary for the successful accomplishment of this skill, since the rope becomes shorter as the arms are crossed.

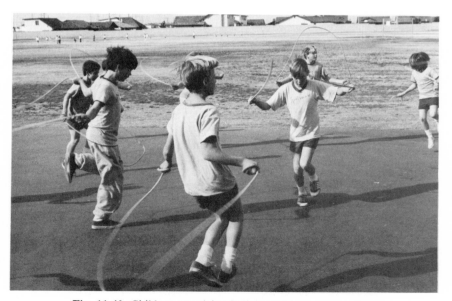

Fig. 11-40. Children practicing individual jump rope routines.

Jump rope routines. After the children have learned the individual rope skipping techniques, they may begin to develop their own routines. For example, a routine might include forward jumping, front cross, change to back jumping, return to front jumping, double jump forward, and front cross. Children can follow the leader and attempt to duplicate the jump rope routines as presented.

STILT ACTIVITIES
Tin can stilts

To feel secure while on a raised platform, a child can begin by standing on tin can stilts (Fig. 11-41). Once the child is able to stand straight without watching his feet and to walk with smooth strides, he may go on to tall wooden or metal stilts. Following is a progression for learning to walk on tin cans. The child:

1. Balances on the cans, holding the strings taut.
2. Balances on the cans, looking ahead, not at his feet.
3. Walks on the cans.
4. Walks on the cans, looking ahead, not at his feet, and standing tall.

Some suggestions for this activity are as follows. The child:

1. Uses cans with *both* ends intact to avoid collapse of the sides, which can result in a fall.
2. Strives for even, short steps close together.
3. Works on concrete or blacktop

Fig. 11-41. Child walking on tin can stilts.

Fig. 11-42. Stilt walking—first method.

rather than grass surfaces with tin can stilts because it is easier for him.

Wooden stilts

There are two ways of taking hold of the tall stilts. In the first method, a person holds the stilts 12 inches ahead of the child and a shoulder width apart. The child then grasps the stilts, with his palms facing inward in front of his body (Fig. 11-42). In the second method, the child stands directly between the stilts and places them behind his shoulders. He then grasps the stilts, with the palms of his hands facing forward (Fig. 11-43). With either method, the child mounts by placing one foot at a time on the footrests. The second position has proved

to be the easiest way for children to learn to balance when they go on their own because the shoulders act as an extra holding point.

When a child is learning, an adult or older child should station himself behind the beginner and hold the stilts while he mounts and walks. The helper can tap his foot on the back of the stilt that is to be moved next so that the child gets the left-right sequence. Once the child easily lifts and walks in rhythm, the helper can release his hold. From this point on, the child must practice mounting and working on his own.

Some suggestions for this activity are as follows. The child:

1. Stands as upright as possible, not looking at his feet.
2. Works on grass or a nonslip surface with the tall stilts.
3. Lifts his foot and hand at the same time, keeping pressure on the stilt with his foot.
4. Takes small steps, being careful not to get his feet too far apart.
5. When mounting on his own, positions the stilts and his hands first; next tips the stilts slightly backward and gently gets his feet up; then moves forward in a slightly rocking motion from side to side.

STEGEL ACTIVITIES

In recent years the German Stegel and similar apparatus have become popular in the United States, mainly because of their simplistic design and unlimited possibilities for a variety of movement skills (Fig. 11-44). The Stegel is particularly adaptable to the needs of young children, providing opportunities for movement exploration, imaginative play, and physical fitness activities.

The Stegel apparatus usually includes two sawhorselike supports, three wooden beams, an inclined wooden slide, and a ladder. All major parts are movable, so that different equipment combinations can be used, depending on the needs of the participants.

Fig. 11-43. Stilt walking—second method.

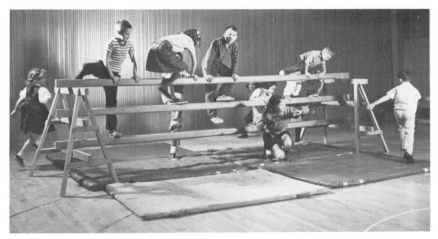

Fig. 11-44. Variations of Stegel climbing. (Courtesy Lind Climber Company, Evanston, Ill.)

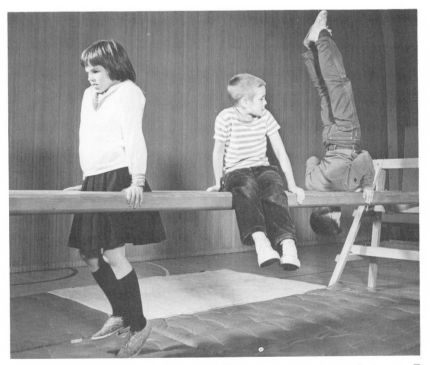

Fig. 11-45. Children developing skills on the Stegel. (Courtesy Lind Climber Company, Evanston, Ill.)

The Stegel apparatus lends itself to low-level basic motor skills and also to high-level stunts and physical fitness activities (Fig. 11-45).

Stunts and physical fitness activities

Parallel bar arrangement
1. Dip
2. Hand travel
3. Straddle seat
4. Push-up
5. Shoulder stand

Beams and ladders
1. Front vault
2. Squat vault
3. Straddle vault
4. Rear vault
5. Chin-up
6. Forward roll
7. Backward roll

Variations of stunts

1. Obstacle course, for which there are innumerable possible obstacles for children to overcome, such as running up the slide, walking the balance beam, crawling in and out of the rungs of a ladder, and jumping off the end of the horse to a mat
2. Partner activities such as passing while traveling on the beam or ladder and playing catch while balancing
3. Performance of stunts with the Hula-Hoop, such as arm circles, neck circles, body circles, and jumping through

TRAMPOLINE ACTIVITIES

Trampoline activities provide the child with a feeling of exhilaration and fun; however, they must be conducted with extreme caution. At all times a child must be physically supported when executing a new or difficult task and must be spotted from all points around the trampoline. When a child is on the trampoline, the teacher must be in direct

Lead-up to trampoline activities should progress from jumping up and down on a mat, to jumping from a height, to bouncing on a springboard. When a child is on the trampoline, the teacher must be in direct physical control or provide a minimum of two spotters on each side of the trampoline. Lead-up procedures to the standing trampoline jump are as follows. The child:

1. Performs a side roll on the trampoline bed.
2. Crawls around the edge of the trampoline bed.
3. Walks on the bed of the trampoline forward, sideward, and then backward.

When a child has a fear of bouncing himself, even with manual support, the following sequence should be instituted before more advanced skills are attempted:

a. The teacher bounces the child on his back while both are on the trampoline bed, the teacher straddling the child and holding his outstretched hands.
b. The teacher straddles the child and bounces him on the right side and then on the left side.
c. The teacher bounces the child on his stomach, being careful not to jerk the child's head.
d. The teacher bounces the child on his knees, supporting the child from either the front or the rear position. In the front position, the child and the teacher encircle each other with their arms. In the rear position, the teacher supports the child under his arms.
e. The teacher bounces the child in a standing posture, gradually relinquishing support, and takes a spotting position off the trampoline bed.

The child:

4. Executes the basic rebound jump with his feet comfortably spread to provide a stable base of support, his knees slightly bent, and his arms bent with his hands about waist level; performs the jump by extending his knees, bringing his feet together, and reaching upward with his hands (Fig. 11-46); and then returns to the starting position and repeats the re-

bounding action. To stop a jump, the child bends his knees and hips on making contact with the trampoline bed.

5. Performs the two-foot jump.
6. Performs the two-foot jump and stops at will.
7. Jumps with one foot forward, alternating first his left foot and then his right foot.
8. Jumps and moves to the right one-fourth turn, then one-half turn, three-fourths turn, and finally a full turn.
9. Jumps and moves to the left one-fourth turn, then one-half turn, three-fourths turn, and finally a full turn.

Basic trampoline stunts

When a child can easily rebound and make a full turn in the air in either direction,

he is ready for basic stunts, some of which are as follows:

Knee drop. The child, while airborne, bends both his knees so that his legs are at right angles to his thighs (Fig. 11-47). In this position, he lands on his knees on the trampoline bed, keeping his thighs and back straight, and then he rebounds to the fully extended posture. Before going on to more difficult stunts, he should be able to execute a knee drop at will. To increase the difficulty of the knee drop, he performs turns or twists while in the air in either direction. To facilitate the twist, he first turns his head and then twists his shoulders in the desired direction. When he is able to perform a full twist, he is ready to progress to the next stunt.

Seat drop. The child flexes his hips and extends his legs while airborne. In an ⌞ position, the performer lands on the bed (Fig. 11-48) and rebounds back to the upright position. To receive the most advantage from the spring of the trampoline bed, he must land with all parts of his legs and thighs contacting the bed at the same time. He must keep his back straight; however, he

Fig. 11-46. Basic trampoline jump.

Fig. 11-47. Knee drop on trampoline.

Fig. 11-48. Seat drop on trampoline.

Fig. 11-49. Back drop on trampoline.

can use his hands for balance and rebounding by placing them palms down next to his hips. Adding a midair twist to the seat drop increases its difficulty to a great extent. The half and full twist are common additions; in both, the child raises one arm over his head and at the same time brings his arm across his chest as he rebounds, simultaneously turning his head and rotating his hips in the direction of the twist. After completing the twist, he immediately plants his feet on the trampoline bed.

Front drop. The child rebounds from the trampoline bed, lifting his hips even with his head. While falling back to the bed, he straightens his body, raises his arms to shoulder level, and bends his elbows at right angles. He makes contact with the bed first with his abdomen. *He should take care that his back is not hyperextended.* If he makes contact properly, he will rebound straight up from the bed, and then he flexes his hips, bringing his feet toward the bed, and extends his back into the full upright posture.

Back drop. After springing into the air, the child flexes his hips, lifts his legs so that his feet are higher than his head, and then falls back, making contact with the bed on his upper back, keeping his head forward (Fig. 11-49). After making contact, he

snaps his legs forward to return his feet to the bed. He must take care to avoid landing on his neck; therefore, it might be best to progress into this stunt by starting from a squat position and then graduating to the full upright posture.

Development of a routine

Once the child has learned the four basic trampoline stunts, he can develop a routine. He may put the four together in any combination. He may add half and full twists to increase the difficulty of the routine. Mastery of the basic stunts usually leads to more difficult moves such as the forward flip (Fig. 11-50) and back flip followed by layouts combined with midair twists.

Variations of stunts

Besides being used for stunts, the trampoline may be used for a variety of cognitive as well as motor functions. The child:

1. Jumps and lands on specified spots on the trampoline bed. This activity may be used to challenge the child to solve unique movement problems, such as landing on specific spots that the teacher names. The spots may be letters or numbers so that

Fig. 11-50. Forward flip on trampoline.

the child must solve cognitive prob-
lems while jumping.
2. Jumps rope on the trampoline.
3. Catches various objects while on the
 trampoline.
4. Throws objects at a target while
 jumping on the trampoline.

PARACHUTE PLAY

Parachute play is a relatively new and
exciting activity for all levels of children in
the elementary physical education program.
The cloth part, or canopy, is all that is used,
and the strings must be removed or cut
away. An entire class can participate suc-
cessfully in continuous, vigorous activity at
one time. The children, evenly spaced apart,
grip the parachute firmly around the outside
and, on a given signal, raise it and make it
undulate or balloon high in the air. The
objective of parachute play is to improve
arm and shoulder strength, cardiorespiratory
endurance, and movement skills through
group cooperation and interaction.

For safety's sake, the following rules
must be established before play begins:
1. If at all possible, the children play
 on a grass area.
2. They are spaced at even intervals
 around the parachute. It is helpful to
 have a parachute with alternate
 colored panels.
3. The teacher establishes a loud signal
 to start and stop a stunt—a whistle
 is usually preferred.
4. The teacher demonstrates the meth-
 ods of holding the parachute—over-
 hand grip, underhand grip, and alter-
 nate overhand and underhand (one
 hand on the top and one hand on
 the bottom). If a firmer grip is de-
 sired, the children can roll the edge
 of the parachute two or three times
 toward the center.
5. The teacher limits beginning activity
 to 10 to 15 minutes so that the chil-
 dren's hands do not get sore.

To begin the activity, the children stand
an equal distance apart around the para-
chute and grip the edge.

Inflating the parachute

The children stretch the parachute tight
at waist level and then all together bring the
parachute edge to the ground (Fig. 11-51).
On the teacher's command "up," the chil-
dren should stretch high to complete the
inflating. At the whistle, the parachute should
be brought to the waist-level position.

Ballooning the parachute

The children inflate the parachute and
then take three steps toward the middle. As
the parachute starts to descend, the children
back out.

Variations of parachute play

Change of places. While the parachute
is ballooning, the teacher tells two children
to change places (Fig. 11-52).

Tag. While the parachute is ballooning,
the teacher tells a child to catch another
child.

Steal the bacon. The teacher places a
small object such as a beanbag under the
parachute in the center. The class is divided
into teams, each child having a number.
The children inflate the parachute, and when
it is at its highest point, the teacher calls a
number and the players with that number
from each team must attempt to grab the
beanbag and get back to their position with-
out being tagged by the other players with
the same number. One point is awarded for
a successful attempt. No point is awarded if
the parachute descends on the players.

Ball bounce. The class is divided into
two teams, which are placed on opposite
sides of the parachute. A ball or balls are
thrown into the center of the parachute
(Fig. 11-53). Each team attempts to bounce
the ball off the other team's side of the
parachute. The children may not use their
hands to keep the ball from leaving the
canopy. A team is awarded a point each
time they bounce a ball onto the ground on
their opponents' side.

CRAZY LEGS

Crazy legs is played on a heavy canvas
with rope handles around the outside. One

Fig. 11-51. Children inflating parachute.

Fig. 11-52. Children changing places in parachute play.

Fig. 11-53. Children bouncing ball on parachute.

Fig. 11-54. Children playing crazy legs. (Courtesy James W. Grimm, Supervisor of Health and Physical Education, Hamilton Board of Education, Hamilton, Ohio.)

Fig. 11-55. Children twirling Hula-Hoops.

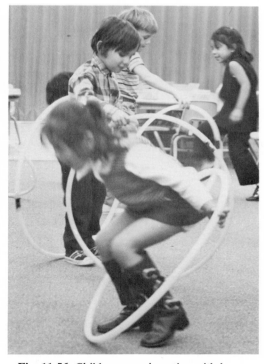

Fig. 11-56. Children experimenting with hoops.

child is chosen to stand in the center of the canvas while the others hold up the canvas (Fig. 11-54). It is an activity in which some of the same techniques required in parachute play and the trampoline are used. For the child in the middle, the game provides a moving platform for fun, space perception, and balance skills. For the children on the outside holding up the canvas, it offers heavy activity for strengthening the legs and upper body as well as the opportunities for strategy and teamwork.

The object of the game is for the person on the canvas to stay on his feet as long as possible. In order to make the task more difficult, the crazy-legs platform is moved up and down in a waving motion and rotated slowly and fast. The activity should be performed over a padded area to provide a safe environment.

HULA-HOOP ACTIVITIES

The Hula-Hoop can be used in a variety of ways. The child normally uses it to experience continuous motion, but he can also roll it along the ground and use it in solving problems while working alone or with a partner. When using it in continuous motion, the child must have a certain amount of rhythm, balance, and practice to be able to keep it circling smoothly and for any length of time. Music is fun and helpful for the child while he moves the hoop around his body (Fig. 11-55). Once he masters the trick, he can try new activities. The hoop is an excellent prop for creative movement. The teacher can challenge the child to attempt different movements with it (Fig. 11-56).

Continuous movement

The teacher can challenge the child to do continuous-movement tricks by asking the following questions:
1. Can you spin the hoop around your body?
2. Can you spin it around another part?
3. Can you make it move slower or faster?
4. Can you make it move higher on your body?

Rolling

The teacher can challenge the child to do rolling tricks with the following questions:
1. Can you roll your hoop and jump through it?
2. Can you spin it like a top?
3. Can you roll it away and have it come back by itself?

Partners

The teacher can challenge the child to do tricks with a partner with the following questions:
1. Can you roll it to your partner?
2. Can you help your partner crawl through, not letting the hoop touch the ground?
3. Can your partner jump through?

RECOMMENDED READINGS

Fait, H. G.: Physical education for the elementary school child, ed. 2, Philadelphia, 1971, W. B. Saunders Co.

Kirchner, G.: Physical education for elementary school children, ed. 2, Dubuque, Iowa, 1970, William C. Brown Co., Publishers.

Smalley, J.: Physical education activities for the elementary school, Palo Alto, Calif., 1963, National Press Books.

Van Hagen, W., Dexter, G., and Williams, J. F.: Physical education in the elementary school, Sacramento, Calif., 1951, State Department of Education.

Chapter 12

Rhythms and dance

Since primitive times, dance has played a major role in expressing the ideas and feelings of man in each civilization. Fertility rights, festive occasions, and preparation for war have all been expressed in some form of rhythmic activity. Today the many cultures throughout the world are recognized by the particular kind of dance activity associated with their culture or geographical area. Dancing usually expresses a joyous mood and is a pleasurable activity enjoyed by all.

To perform the creative movements or specific dance steps involved in a good rhythm program, the child needs to develop balance, coordination, poise, and self-confidence. Most children have a good sense of rhythm and enjoy moving their bodies to the beat of a drum or other types of musical accompaniment. However, the degree to which a child learns rhythmic coordination depends a great deal on the emphasis placed on the dance program in the elementary school. Some suggestions for developing rhythm in children are as follows:

1. They can duplicate the rhythm by clapping their hands, snapping their fingers, stamping their feet, or using other rhythm instruments (Fig. 12-1).
2. By using a drum or clapping their hands to slow or fast rhythms, the children can learn to step on every beat.
3. They can develop ball skills and rhythm by bouncing a ball to the beat. Additional skills of running around the ball, turning and catching the ball, and throwing the ball into the air can be combined with the rhythmic pattern described.
4. They can jump rope to a rhythmic beat.

Although it is desirable for the dance teacher to have the ability to play some type of musical instrument, it is not necessary for an effective lesson in rhythmic activities. There are many records available for each category of dance that offer satisfactory accompaniment during the lesson. In addition to this, percussion instruments can be made by the children that allow for greater involvement in the total rhythm program, such as rhythm sticks made from dowels, sandpaper blocks, and drums made from cans with drumheads from inner tubes. In most cases, materials for these instruments can be secured free of charge, and all children can participate in both construction and rhythmic activities.

In this text, dance is divided into the following sections:

1. Fundamental rhythms
2. Creative rhythms
3. Folk dances and singing games
4. Square dances

In each section the dances are arranged

in order of difficulty and are not necessarily offered for specific grade levels. The grade level at which a dance is taught depends to a great extent on the previous experiences of the children. Before presenting a dance, the elementary school teacher should assess each class to determine what movements they have learned.

FUNDAMENTAL RHYTHMS

Dance includes basic locomotor skills provided in various combinations and degrees of force. Most children come to school already knowing a variety of fundamental locomotor skills; however, in many cases the learning of these skills has been limited to uneven and nonrhythmic movements, and

Fig. 12-1. Children developing rhythm through finger snapping.

Fig. 12-2. Children marching to rhythm.

there is a definite need to develop smoothness and rhythm in the execution of these skills. The following eight basic locomotor patterns serve as the basis for many of the more sophisticated dance steps.

Walk. The walking step is an even rhythmic movement involving transferring of the weight from one foot to the other (Fig. 12-2). A rhythmic count or beat should be given to develop a smooth walking step.

Run. The running step is an even rhythmic movement similar to the walk except that the speed is increased and the weight is carried on the balls of the feet. In the running step, both feet are momentarily off the ground at the same time.

Hop. The hopping step is an even rhythmic movement that involves springing from the floor from one foot and landing on the same foot. The spring and landing are executed with the balls of the feet as in the running step.

Jump. The jumping step, an even rhythmic movement, is a spring from the floor with both feet, in which the toes are used for pushing off and landing.

Leap. The leaping step is an even rhythmic movement that is an extension of the run. It differs from the run in that the knee bend at the beginning and end of the movement is exaggerated. One foot is used for pushing off and the other for landing. During the leap, both feet are off the floor at the same time.

Skip. The skipping step, an uneven rhythmic movement, is a fast step-hop with the foot. After each step-hop, the foot is extended forward in preparation for the next step-hop by the oposite foot.

Gallop. The galloping step, an uneven rhythmic movement, is the transferring of weight from the lead foot to the closing foot. The same foot remains the lead foot throughout the sequence of steps.

Slide. The sliding step is an uneven rhythmic lateral movement, in which the same foot continues to lead as in the gallop. The weight is transferred from the lead foot to the back foot in a sliding manner.

Following is a list of records that can be used to learn the fundamental rhythm skills:

Walk Run	Folkraft album 20; RCA Victor album E-71, vol. 1
Hop	Childhood Rhythms, series I, nos. 101 and 102; Folkraft album 20 (fundamental steps and rhythms); RCA Victor album E-71, vol. 1 (rhythmic activities)
Jump	Folkraft album 20; RCA Victor album E-71, vol. 1
Leap	Childhood Rhythms, series V, nos. 501, 502, and 505
Skip	Childhood Rhythms, series II, nos. 202 and 205; Folkraft album 20; RCA Victor album E-71, vol. 1
Gallop	Childhood Rhythms, series III, nos. 302, 303, and 305; Folkraft album 20; RCA Victor album E-71, vol. 1
Slide	Folkraft album 20; RCA Victor album E-71, vol. 1

CREATIVE RHYTHMS

Elementary school children enjoy creating their own movement patterns to music. Discovering how the body moves and determining what kind of movements can best

Fig. 12-3. Children creating rhythmic movements.

describe an idea or feeling are enjoyable activities and develop rhythmic skills. Participation in creative activities is one of the major objectives of elementary physical education. Every child should be encouraged to discover how he moves and to understand his own physical capabilities and limitations. Through his imagination the child can describe in movement a variety of things in the world about him (Fig. 12-3).

In creative dance the teacher can present an idea and then allow the children to create movement patterns that express their feelings toward the idea. They may create a variety of rhythmic movement patterns in describing the wind, a flower, an animal, a mode of transportation, a feeling of joy or sadness, or a quality of strength or weakness. If all children are going to work on the same problem, the teacher often discusses it with the class as a whole, prior to beginning any activity. Positive reinforcement should be given at all times as the children attempt to solve the problem through creative movement. Recognition can be given to the most creative children in the class by allowing them to demonstrate their solutions to the problem. This often serves as a

motivating factor to the more reserved children in the group.

Another approach to creating movement feelings in children is to have them listen to music and then construct dance movements that express their feelings regarding the particular type of music. The music should be played first while the children just listen and begin to develop ideas as to how they will move to the rhythmic tones involved.

Another activity that can help to develop rhythm and the recognition of rhythm is the beating of a drum. Each child can discover the rhythm of his name by expressing each syllable with a corresponding drum beat. A child can also tell a story with the drum by increasing or decreasing the intensity or the tempo. He can learn to express ideas through variations of the rhythmic pattern and intensity of the drum beat. Children in the class also may listen and try to guess what story the child is telling. The drum can also be used for beating out rhythms that describe the various modes of locomotion used in dance activities.

A game that is often played in Orff-Schülwerk sessions is lock and key (Fig. 12-4). Lock and key is a game of recognition of

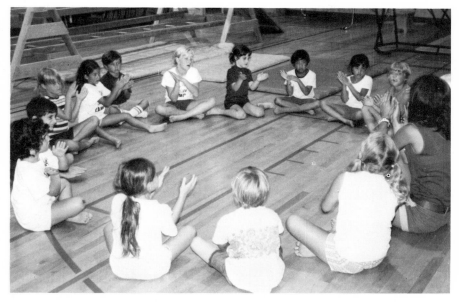

Fig. 12-4. Orff-Schülwerk session.

rhythmic patterns by either an individual or a group, using instruments made of materials such as metal, wood, and glass. The lock says, "Find the key, find the key," as he circles around the group searching for a key. "I'm a wooden lock. To open the lock you must do the same as me." The lock offers a rhythmic pattern. The key listens carefully and with encouragement attempts to duplicate the rhythm with the same implement. The lock then asks, "Did he open the lock?" The group responds by chanting, "He opened the lock, he opened the lock," or "No, try again, try again." In this kind of game not only does the individual have to be able to identify the rhythm and duplicate it in order to open the lock, but also the group must determine whether the rhythm repeated by the key was an accurate reproduction of the original rhythm. Intricate or simple patterns may be used, depending on the level of the group. Although some children temporarily fail, they will eventually succeed and receive peer admiration.

The creative rhythm lesson is based on movement exploration activities. Discovering which movement activity best fits the beat gives much enjoyment to the children and helps lessen the inhibitions often associated with creative movement. The teacher should allow children who are more timid to mimic others during the early stages of creative movement lessons. However, later on in creative movement activities, the teacher may select these individuals as the first to give their solution so that they receive proper peer recognition.

Following is a list of records that can be used to learn creative rhythm:

Animals	Childhood Rhythms, series V, no. 501, and series I, nos. 102 and 103; RCA Victor rhythm series 45-5007, vol. 2; MGM S-4264
Nature and creative rhythms	Columbia C-30769; Atlantic 68002; MGM S-4264

FOLK DANCES AND SINGING GAMES

Folk dances and singing games can provide understanding and appreciation of the people of different cultures of the world and are readily integrated with lessons in history and geography.

The nature of folk dances and the provision for changing of partners keep the reluctance to dance with a member of the opposite sex to a minimum. The children should not choose their partners for dance activities. Any technique in which partners are arranged ahead of time should be used to ensure that no one is selected last. Although holding hands is not a problem with children in the primary grades, children in the intermediate levels often are self-conscious and feel uneasy during dance activities. For the most part, the teacher should make little issue of this matter; if partners are changed often and if the teacher shows enthusiasm for the activity and presents dance in a positive manner, few problems will result.

Folk dances provide vigorous activity and involve a variety of intricate foot patterns. Individuals who become well skilled in these activities not only advance in their knowledge of the social graces but also increase their balance and coordination, all of which develop a favorable self-image. The following progression should be used for teaching folk dances:

1. The children listen to music.
2. The teacher demonstrates the dance step involved.
3. The children practice the dance step without the music.
4. They practice the step with the music.

The following dance formations are used in most dances (Fig. 12-5):

1. Square
2. Circle
3. Double circle
4. Double line

The following basic dance steps are used in the majority of dances in the elementary physical education program.

Step-point. The child performs the step-point by stepping on his left foot and pointing his right foot in front. He then repeats the motion, stepping to the right.

Step-hop. He performs the step-hop by

stepping on his left foot and hopping on the same foot. He then repeats the movement, stepping on the right foot.

Step-swing. He performs the step-swing by stepping on his left foot and swinging his right foot across in front of his left foot. He then repeats the motion, stepping on the right foot.

Bleking step. He performs the bleking step by taking a hop on his left foot and extending his right leg forward with the heel touching the floor. He then repeats the motion, hopping on his right foot with his left leg extended. He changes his left heel and right heel in a rhythmic pattern.

Balance step. He performs the balance step by stepping forward with his left foot

and closing with his right foot, rising to the balls of his feet. He can do the balance step in any direction.

Schottische step. He performs the schottische step by taking three running steps, beginning with the left foot, and then hopping on the left foot. He then repeats the motion, beginning with the right foot.

Polka step. He performs the polka step by stepping to the right and closing left to right and then stepping to the right again with a hold. He then repeats the motion, stepping first with the left foot.

Buzz step. He usually performs the buzz step with a partner. Keeping his weight on the inside foot, he pushes against the floor with the outside foot, as in riding a

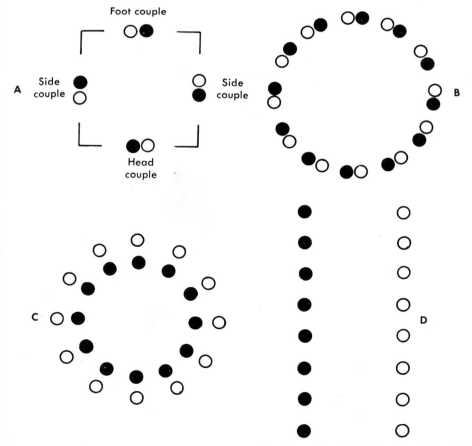

Fig. 12-5. Dance formations: **A,** square; **B,** circle; **C,** double circle; **D,** double line. The dark circle represents the boy, and the light circle, the girl.

scooter, and revolves around the pivot foot.

Grapevine step. He can do the grapevine step in either direction to the side. He crosses his right foot over in front of his left foot, takes a step on his left foot and brings his right foot behind his left foot, and then takes a step on his left foot.

Looby loo

Formation: The children form a single circle, facing in.
Music: Folkraft 1184; RCA Victor 45-5067 and 41-6153

Procedure: *During the singing of each verse, the children stand still and dramatize it. Then, after each verse, they sing the chorus, during which they join hands and slide, skip, run, or walk to the left or right:*

1. "I put my right hand in, I put my right hand out;
 I give my right hand a shake, shake, shake
 And turn myself about, Oh,"

Chorus:

"Here we go looby loo, here we go looby light.
Here we go looby loo, all on a Saturday night."

2. "I put my left hand in," etc.
3. "I put my two hands in," etc.
4. "I put my right foot in," etc.
5. "I put my left foot in," etc.
6. "I put my head 'way in," etc.
7. "I put my whole self in," etc.

Oats, peas, beans

Formation: The children form a single circle with one or more players in the center.
Music: Folkraft F-1182; RCA Victor 45-5067; Pioneer 3012.

Procedure: *All the children circle to the left or right, singing:*

"Oats, peas, beans and barley grow,
Oats, peas, beans and barley grow:
Can you or I or anyone know
How oats, peas, beans and barley grow?"

The child in the center is the farmer; he sows his seed, folds his arms, stamps his foot, claps his hands, and views his land. The children in the circle stand still and follow the actions of the farmer as they sing:

"Thus the farmer sows his seed,
Thus he stands and takes his ease:
He stamps his foot and claps his hands,
And turns around to view the land."

The children circle again and sing the next verse while the farmer chooses a partner. The partner should be chosen by the end of the verse:

"Waiting for a partner,
Waiting for a partner,
Open the ring and choose one in
While we all dance and sing."

All the children skip, the farmer and his wife going in the direction opposite to that taken by the circle players, as they sing:

"Now you're married, you must obey,
You must be true to all you say,
You must be kind, you must be good,
And keep your wife in kindling wood."

Did you ever see a lassie?

Formation: The children from a single circle, with their hands joined. The child who is "it" stands in the center of the circle.
Music: Folkraft 1183; RCA Victor 45-5066; Pioneer 3012.

Procedure: *All the children sing as they walk to the right in a circle:*

"Did you ever see a lassie [or laddie], a lassie, a lassie,
Did you ever see a lassie do this way and that?"

"It" thinks of some movement. All the children drop hands, face the center of the circle, and watch the leader's movement and imitate it, singing:

"Do this way and that way, do this way and that way,
Did you ever see a lassie do this way and that?"

The leader chooses someone to take his place, and the game is repeated.

The muffin man

Formation: The children stand in one large circle, with their hands joined.
Music: Folkraft F-1188; RCA Victor 45-5065.

Procedure: *The children skip to the left and sing:*

"Oh, have you seen the muffin man, the muffin man, the muffin man,
Oh, have you seen the muffin man, who lives in Drury Lane?"

One child stands in the center and looks for a partner from the big circle, as they sing:

"Oh, yes we've seen the muffin man, the muffin man, the muffin man,
Oh, yes we've seen the muffin man, who lives in Drury Lane."

The center child skips toward the chosen one and offers both hands. Then the two occupy the center and skip in a circle to the right, as the children sing:

"Two have seen the muffin man," etc.

These two then choose partners from the outside circle and all four join hands and circle to the right, as they all sing:

"Four have seen the muffin man," etc.

This procedure is followed until all are chosen. Then they sing:

"All have seen the muffin man," etc.

Hokey pokey

Formation: The children form a single circle and face the center. If couples are used, the lady stands to the right of her partner.
Music: MacGregor 699; Four Star 1505.

Procedure: *The children place their right foot forward into the circle and sing:*

"You put your right foot in."

They place their right foot back away from the circle and sing:

"You put your right foot out."

They shake their right foot toward the center of the circle and sing:

"You put your right foot in and you shake it all about."

They place their palms together above their head and rumba their hips and sing:

"You do the hokey pokey."

They shake their arms above their head and turn around and sing. If there are couples, the man turns the lady on his left once and a half with his right elbow and progresses one position clockwise:

"And you turn yourself around."

They clap their hands four times and sing:

"That's what it's all about."

They repeat these calls, substituting the following parts of the body: left foot, right arm, left arm, right elbow, head, whole self, and back side.

Then they raise their arms above their head and lower their arms and head in a bowing motion and sing:

"You do the hokey pokey
You do the hokey pokey."

They kneel on both knees and raise their arms above their head and lower their arms and head in a bowing motion and sing:

"You do the hokey pokey."

Then they slap the floor six times and sing:

"That's what it's all about."

London bridge

Formation: Two players with uplifted hands joined form an arch representing the bridge. A line of children pass under the bridge, each holding onto the waist of the person in front of him.
Music: RCA Victor E-87 and 45-5065; Decca 9-Du 9000 (45-73572).

Procedure: *The children pass under the bridge and sing, and on the word "lady," the guardians of the bridge lower their arms and catch the player directly underneath:*

"London Bridge is falling down, falling down, falling down,
London Bridge is falling down, my fair lady."

They continue singing as the bridge sways back and forth:

> "Take the key and lock her up, lock her up, lock her up,
> Take the key and lock her up, my fair lady."

All the children sing as the guardians of the bridge take the prisoner off to the side:

> "Off to prison she must go, she must go, she must go,
> Off to prison she must go, my fair lady."

They ask the prisoner whether he wants a bag of gold or a bag of diamonds, or they ask some equivalent question. The keepers have already privately agreed about which of the two objects they represent, and according to the prisoner's choice, they place him behind one of the two keepers. When all are caught, the side with the most players wins. A tug of war may be used to determine which side is the winner, once all players are caught.

Skip to my Lou

Formation: The children form a double circle, with the boys in the inside circle. Partners face to the right and join hands.

Music: Folkraft 1192; Pioneer 3003; Folk Dancers record MH 111.

Procedure: *All the children sing as the partners skip to the right around the circle:*

> "Flies in the buttermilk, skip to my Lou,
> Flies in the buttermilk, skip to my Lou,
> Flies in the buttermilk, skip to my Lou,
> Skip to my Lou, my darling."

The girls continue skipping while the boys stand and sing:

> "My partner's gone, what'll I do," etc.

The boys sing and skip around the inside circle, and the girls stand still:

> "I'll find another one, prettier than you," etc.

On "skip to my Lou, my darling," the boys take a partner nearest to them and repeat the dance with a new partner.

For variation, extra boys may be in the center of the circle. At the end of the third verse, they all try to get partners. The boys failing to get a partner go to the center and wait for a turn when the dance is repeated.

A-hunting we will go

Formation: The children form couples and stand in two lines, partners facing. There should be no more than six couples to a set.

Music: Folkraft 1191; RCA Victor 45-5064; Childhood Rhythms, series 7, no. 705.

Procedure: *All the children sing as the head couple joins both hands and slides down between the lines and back:*

> "A-hunting we will go, a-hunting we will go,
> We'll catch a fox, and put him in a box, and then we'll let him go."

All partners sing and join hands and skip around in a circle counterclockwise, following the head couple:

> *Chorus:*

> "Tra la, la, la, la, la, la," etc.

When the children who are the head couple reach the foot of the line, they form an arch by joining both hands, and all the other couples pass through. The second couple then becomes the head couple to repeat the dance. The dance is repeated until each couple has been head couple.

Chimes of Dunkirk

Formation: The children form a single circle, with boys and girls alternating. Partners face each other, with their hands on their own hips.

Music: RCA Victor LPM-1624, 45-6176, and 21618.

Procedure:

Measures 1-2: All the children stamp their feet (not too heavily) left, right, left.

Measures 3-4: They raise their arms overhead so that their face can be seen between their arms and bend their body sharply to the left and clap their hands over-

head and then to the right and clap, alternately. This represents the ringing of the town's bells.

Measures 5-7: The partners take each other's hands with their arms extended sideways. Starting with the left foot, they run in a small circle while turning their partners once around.

Measure 8: The children run forward on the last measure and secure new partners.

The dance is continued until the music ends.

Seven jumps

Formation: The children form one large single circle, with boys and girls alternating, and join hands. A number of smaller circles may be used.
Music: RCA Victor 21617, 41-6172, and LPM-1623; World of Fun M-108.

Procedure:

First jump

Measures 1-8: The children move in a circle to the right with step-hops, one to a measure (step on beat one and hop on beat two).

Measures 9-16: They all jump up high from the ground and come down with a stamp on both feet on the first beat of measure 9. Then they step-hop around the circle to the left.

Measure 17: They drop their hands and place them on their hips and bend the right knee upward.

Measure 18: They stamp their right foot to the ground on the first beat and join hands on the second beat.

Second jump

Measures 1-16: They repeat measures 1-16 of the first jump.

Measure 17: They all raise the right knee as before.

Measures 18-19: On the first beat, they stamp down right foot; on the second beat, lift left knee; on the third beat, stamp left foot; and on the fourth beat, join hands.

Third jump

Measures 1-17: They repeat measures 1-17 of the first and second jumps.

Measures 18-20: They all stamp right foot, lift left knee, stamp left foot, place right toe backward on the floor, kneel on left knee, and then stand and join hands (one action to each beat).

Fourth jump

Measures 1-17: They repeat measures 1-17 as before.

Measures 18-21: They stamp right foot, lift left knee, stamp left foot, place right toe backward, kneel on left knee, pause, kneel on right knee (both knees down), and on the last beat, stand and join hands.

Fifth jump

Measures 1-17: They all repeat measures 1-17.

Measures 18-22: They stamp right foot; lift left knee; stamp left foot; place right toe backward; kneel on left knee; pause; kneel on right knee; put right fist to cheek, raising elbow; put right elbow on the floor, with cheek resting on fist; and on the last beat, stand and join hands.

Sixth jump

Measures 1-17: They repeat measures 1-17.

Measures 18-23: They stamp right foot; lift left knee; stamp left foot; place right toe backward; kneel on left knee; pause; kneel on right knee; put right fist to cheek, raising elbow; put right elbow on the floor, with cheek resting on fist; put left fist to cheek, raising elbow; put left elbow on floor, with cheek resting on fist; and on the last beat, stand and join hands.

Seventh jump

Measures 1-17: They repeat measures 1-17.

Measures 18-24: They stamp right foot; lift left knee; stamp left foot; place right toe backward; kneel on left knee; pause; kneel on right knee; put right fist to cheek, raising elbow; put right elbow on the floor, with cheek resting on fist; put left fist to cheek, raising elbow; put left elbow on floor, with cheek resting on fist; push body forward; touch forehead to floor; and on the last beat, stand and join hands.

Bleking

Formation: The children form a single circle, and partners face each other and join both hands.

Music: RCA Victor LPM-1622 and 41-6169; Folkraft 1188; Pioneer 3016.

Procedure:

Measure 1: The children hop on left foot, place right heel forward, and extend right arm and then hop on right foot and extend left foot and arm (bleking step).

Measure 2: They repeat the step with three quick changes, hopping left, right, left.

Measures 3-8: They repeat measures 1 and 2 three times.

Measures 9-16: With hands joined and arms extended to the side at shoulder level, the partners turn in place with step-hops. The boy starts on his right foot, and the girl starts on her left foot. They move their arms up and down in windmill fashion.

Norwegian mountain march

Formation: The children form sets of three. Each set forms a triangle; for example, a boy in front holds the outside hands of two girls standing behind him, and the two girls join inside hands. The dance represents a guide pulling two others up and down a mountain.

Music: Folkraft 1177; RCA Victor 45-6173.

Procedure:

Measures 1-8: All the children take eight step-hops (or stamp-step-steps) forward, starting on the right foot, accenting the first beat of each measure.

Measures 9-10: The boy takes four step-hops backward under the arms of the two girls.

Measures 11-12: The girl on the right turns under the boy's left arm with four step-hops.

Measures 13-14: The girl on the left turns under the boy's right arm with four step-hops.

Measures 15-16: The boy turns under his own left arm with four step-hops. Then they all face forward.

They repeat measures 9-16.

Virginia reel

Formation: Six couples form two parallel lines, with the girls on the right and the boys on the left, facing each other.

Music: Folkraft 1249; RCA Victor 45-6180 and LPM-1623.

Procedure: *The children follow the instructions as they are given.*

"Forward and back":

Partners take four steps to the center, bow, and take four steps back to their places.

"Right hands around":

Partners meet, join right hands, swing around once, and return to their places.

"Left hands around":

They meet, join left hands, swing around once, and return to their places.

"Both hands around":

They meet, join both hands, swing around once, and return to their places.

"Do-si-do":

Partners walk forward, pass right shoulders, slide back to back, and walk backward to their places, passing left shoulders.

"Head couple down and back":

The children who are the head couple join both hands and slide down the set and back.

"Reel the set":

The children who are the head couple hook right elbows, turn around one and a half times, and then separate and go to the opposite line. The head boy turns the second girl around once with a left-elbow turn, and the head girl does the same with the second boy. Then the head couple meet in the center for a right-elbow turn and continue down the line, turning someone in the set with the left elbow and turning the partner with the right elbow, until they have reeled the entire set. On reaching the foot of the set, they swing halfway around so that the boy and girl are on the correct side, join hands, and slide back to their places.

"Cast off":

The lines face the front, and at the change of music, the head couple leads to the outside (boy to his left, girl to her right) and

marches to the foot of the set, the two lines following.

"Form the arch":

On reaching the foot of the set, the children who are the head couple join hands to form an arch. The other couples meet and skip under the arch and return to their places. The second couple then becomes the head couple for the next figure, and the original head couple becomes the foot couple. The dance continues until all have been head couple.

Road to the isles

Formation: Couples form a double circle facing counterclockwise in varsovienne position (p. 209).
Music: Imperial 1005.

Procedure: *The dance has two parts, the second of which uses the schottische step.*

Part 1

Measure 1: All the children point left toe forward slightly to the left and hold.

Measures 2-3: They take three steps, starting with the left foot, as follows: they place left foot slightly in back of the right foot on beat one, right foot to the right on beat two, and left foot forward in front of the right foot and hold on beats three and four.

Measure 4: They point right toe forward and slightly to the right and hold.

Measures 5-6: They take three steps, starting with the right foot, as follows: they place right foot slightly in back of the left foot on beat one, left foot to the left on beat two, and right foot forward in front of the left foot and hold on beats three and four.

Measure 7: They point left toe forward and hold.

Measure 8: They place left toe backward and hold.

Part 2

Measures 9-10: They all schottische forward slightly to the left, beginning with the left foot.

Measures 11-12: They schottische forward slightly to the right, beginning with the right foot. Then they hop on beat two of measure 12 and turn halfway to the right and face the opposite direction, keeping their hands joined.

Measures 13-14: They schottische, beginning with the left foot. Then they hop and turn halfway to the left and face the original direction.

Measures 15-16: They step in place right, left, right and hold.

Patty cake polka

Formation: The children form a double circle, with the boys in the inside circle. Partners face each other and join hands.
Music: MGM S-4473; Folkraft 1124.

Procedure:

Measures 1-2: The children perform the heel-and-toe twice, the boy starting with his left foot and the girl with her right foot.

Measures 3-4: They perform four slides counterclockwise.

Measures 5-8: They repeat measures 1-4 going clockwise, the boy starting with his right foot and the girl with her left foot.

Measure 9: They clap right hand with their partner three times.

Measure 10: They clap left hand with their partner three times.

Measure 11: They clap both hands with their partner three times.

Measure 12: They slap their own knees three times.

Measures 13-14: They swing their partner around once with their right elbow.

Measures 15-16: They walk to the left to a new partner.

They repeat the dance with a new partner.

Crested hen

Formation: The children form sets composed of a boy and two girls, with the boy in the middle, or a girl and two boys. The sets are scattered about the room.
Music: RCA Victor LPM-1624 and 45-6176.

Procedure:

Figure 1

Measures 1-8: The children in each set join hands in a circle. Starting with a stamp of

the foot, they move to their left, using a fast step-hop.

Measures 1-8 repeated: With a high jump, they reverse their direction and move to their right.

Figure 2

Throughout this figure, all the children perform the step-hop continuously. The girls release their hands from each other and dance on each side of the boy. They place their free hand on their hip.

Measures 9-10: The girl on the right step-hops under the arch formed by the boy and the girl on his left.

Measures 11-12: The boy then turns and step-hops under his own right arm.

Measures 13-14: The girl on the left step-hops under the arch made by the boy and the girl on his right.

Measures 15-16: The boy then turns under his own left arm.

They repeat measures 9-16 of figure 2.

Then the entire pattern is repeated as often as desired.

La raspa

Formation: The children form couples and face in opposite directions, left shoulder to left shoulder. The boy puts his left hand in the girl's right hand in front of her chest, and his right hand in the girl's left hand in front of his chest.

Music: RCA Victor LPM-1623, 20-3189, and LPM-1072; Imperial 12207; Monitor 82000.

Procedure:

Part 1

Measure 1: Both partners slide right foot forward and left foot back on beat one and slide left foot forward and right foot back on beat two.

Measure 2: They both slide right foot forward and left foot back on beat one and hold on beat two.

Measures 3-4: They repeat measures 1-2, sliding left foot forward first.

Measures 5-8: Keeping their hands joined, they turn toward their partner and face in the opposite direction, right shoulder to

right shoulder, and they repeat measures 1-4.

Measures 9-16: They repeat measures 1-8.

Part 2

Measures 1-4: With right elbows hooked and left hands held high, partners turn with eight running steps (two to a measure).

Measures 5-8: Reversing direction, with left elbows linked, the partners turn with eight running steps, clapping hands on measure 8.

Measures 9-12: Reversing direction again, the partners repeat the running steps. It is characteristic of this step to continue running without pause on changes of direction.

Heel-and-toe polka

Formation: Couples are arranged informally around the room. Partners stand side by side with their inside hands joined, with the girl on the right of her partner. The couples face to the right around the room.

Music: Folkraft 1166; MacGregor 4005 (45) and 400 (78).

Procedure:

Measures 1-2: The children perform the heel-and-toe and then step, slide, step, starting with the outside foot.

Measures 3-4: They perform the heel-and-toe and then step, slide, step, starting with the inside foot.

Measures 5-8: They repeat measures 1-4.

Measures 9-16: They perform eight polka steps around the room, the partners facing each other on one polka step and turning away on the next polka step, alternately.

Ace of diamonds

Formation: The children form a double circle, with the boys in the inside circle, and face their partners.

Music: Folkraft 1176; RCA Victor 41-6169 and LPM-1622.

Procedure:

Measures 1-8: The children clap their hands, stamp their right foot, and join their partner in a right-elbow swing for six skips.

Measures 9-16: They clap their hands, stamp

their left foot, and join their partner in a left-elbow swing for six skips.

Measures 17-24: They perform two change-steps: they hop on their left foot, placing the right foot forward, and then hop on their right foot, placing the left foot forward. They do four more change-steps rapidly. Then they repeat the two slow and four fast change-steps.

Measures 25-32: The partners do the polka step around the room side by side, facing each other and then turning away from each other, or in closed dance position.

Varsovienne

Formation: The children take the varsovienne position, with the boy slightly behind and to the left of the girl. The partners hold their hands high, right hand in right hand, left hand in left hand. The boy places his right arm behind the girl's shoulder. The waltz position may be used, with both partners moving sideward.
Music: Windsor 7516; Folkraft 1034; MacGregor CPM 10-398-3.

Procedure:
Part 1

Measures 1-4: Both partners start with the left foot and perform the steps as follows: they slide left foot to the left, close right foot to the left, raise left foot (swing foot out and in over supporting foot in a "cut step"); slide left foot to the left, close right foot to the left, and raise left foot; slide left foot to the left, close right foot to the left, and step with the left foot; and then turn and point right foot to the right side. They make a half turn on the last step.

Measures 5-8: They repeat measures 1-4, both moving to the right.

Part 2

Measures 9-10: Starting with the left foot raised to the left side, both partners make a half turn with the following steps: they swing left foot over the right supporting foot, slide it left, close right foot to the left, step with the left foot, and point right foot and hold.

Measures 11-12: They repeat measures 9-

10, starting with the right foot and moving back into position.

Measures 13-16: Then they repeat measures 9-12.

Cotton-eyed Joe

Formation: The children form a double circle, with the boys in the inside circle. They use the elbow grasp or social dancing position.
Music: RCA Victor LPM-1621 and EPA-4134.

Procedure:

Measure 1: The boy starts with his left foot and the girl with her right foot. They both take one heel-and-toe and three steps (the boy: left, right, left; the girl: right, left, right).

Measure 2: They repeat measure 1, the boy starting with the right foot and the girl starting with the left foot. (Many groups dance this step in the following manner: toe, toe, step together, step to side, and repeat to other side.)

Measures 3-4: Turning away from his partner, the boy to his left and the girl to her right, each takes four polka steps alone in a small circle. They end facing each other.

Measures 5-6: While facing each other, the partners take four push-steps counterclockwise and four back to place. The push-step is done as follows: the boy steps sideways on his left foot and then pushes away from the left foot with his right foot; then he takes another step sideways and gives a push with the right foot. The girl does the same, starting with her right foot.

Measures 7-8: In the elbow grasp or social dancing position, the partners take four polka steps in line of direction.

Rye waltz

Formation: Partners take the social dancing position or elbow grasp position.
Music: Folkraft 1103; Imperial 1044; MacGregor CPM 10-399-2; Decca DLA 1420 (25058).

Procedure:

Measure 1: The boy extends his left foot to the side and touches his toe to the floor

on beat one, brings his left foot just behind his right heel and touches the floor with his toe on beat two, touches his left toe to the side again on beat three, and touches his left toe in front of his right toe on beat four. The girl does the same step simultaneously, with the right foot.

Measure 2: The partners take four slides to the boy's left.

Measures 3-4: They repeat measures 1 and 2, the boy starting with the right foot and the girl with the left foot and sliding to the boy's right.

Measures 5-8: They repeat measures 1-4.

Measures 9-24: They waltz around the room, moving counterclockwise.

Little man in a fix

Formation: Two couples dancing together form a set. The boys hook left elbows, so that they will face in opposite directions. Their partners stand beside them. Each boys places his right arm around his partner's waist; each girl places her left hand on her partner's right shoulder and her right hand on her hip.

Music: RCA Victor 20449.

Procedure:

Measures 1-8: In the above position, the members of each set run forward in a circle, using small steps. The girls may have to lean backward if the tempo becomes too fast.

Measures 1-8, repeated: Without pausing in their run, the players begin to spread apart until the boys have their left hands joined and at the same time have their partner's left hand in their right hand. Simultaneously, the girls increase their speed and run under the boys' joined hands; then they turn left toward their partners, and the partners face each other. The girls extend their right hands, joining them above the boys' joined left hands, and they all run until the finish of measure 8.

Measures 9-10: Each boy takes the opposite girl's left hand in his right hand, and standing side by side, they dance the Tyroler waltz step, which is as follows: the boy begins with his left foot and the girl with her right foot, and doing the balance step, they

move away from each other for three beats and toward each other for three beats.

Measures 11-12: They repeat the Tyroler waltz step.

Measures 13-16: In the social dancing position, the couples perform four waltz steps, turning.

Measures 9-16, repeated: The players may waltz continuously if desired.

At the end of the figure, each couple seeks a new couple with whom to repeat the pattern. If there is an odd number of couples, one will be unable to find another to dance with, so that with each repetition there will be one "little man in a fix," who dances alone with his partner. There is no pause in the music as new lines of four children are organized.

SQUARE DANCES

Square dancing is native to the United States and fun for all ages. In square dancing, partners change often, and each individual has a chance to dance with many different partners. Square dancing is not difficult to teach and even a novice teacher can have fun calling some of the more simple dances. Although the teacher may use records with calls on them, it is easier for him to teach the dance when he makes the calls in relation to the children's learning speed in the activity. Some of the more simple square dances can be introduced as early as the first grade. Dances that involve some of the more sophisticated movements are usually more successful in the fourth and fifth grades (Fig. 12-6).

In teaching square dancing, it is best to have the students listen to the music and then walk through the dance in response to the verbal calls. If a record player is used, the tempo should be slowed until the children learn all movements thoroughly.

Forming the square

A square is composed of four couples, each couple standing on one side of the square, with the girl to the right side of her partner. Caution should be taken not to get the square too large. If the couples extend

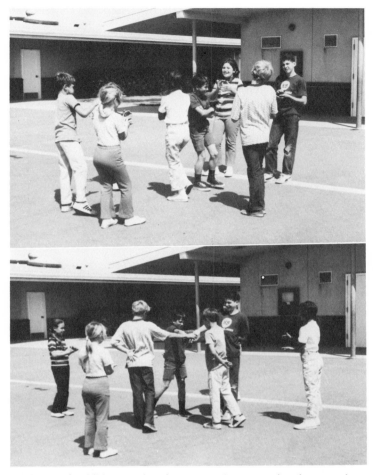

Fig. 12-6. Children performing square dances on the playground.

their outside arms, they will be able to maintain the approximate correct distance for the square. The head couple is the couple toward the music. The couple to the right of the head couple is couple number two, the couple directly opposite is couple number three, and the couple to the left of the head couple is couple number four. The original position of the couples is their home position. The boy's corner girl is the one to his left. The girl's corner boy is the one to her right. Couples one and three are the head couples. Couples two and four are the side couples. The couples standing directly opposite are the opposite couples.

Basic step. The basic step in beginning square dancing is a short walking step in which the weight is kept on the balls of the feet.

Balance step. In the balance step, partners face each other, take a step backward, join right hands and swing their right foot forward in a balancing action, and then return quickly to their original position.

Swing. Partners place their right sides together in a regular dance position and turn once in place, using the buzz step.

Grand right and left. Partners face each other and join right hands. Each person then advances forward to the next person, giving his left hand, and continues around the circle, alternating right and left hands, until he meets his original partner.

Promenade. Partners progress counter-

clockwise around the square, the boy holding his partner in the skating position.

Allemande left. The boy turns to his corner girl and joins his left hand to hers, and they move around each other and then return to their home positions.

Do-sa-do. Partners move forward, passing each other with their right shoulders and stepping sideward back to back. They fold their arms across their chest as they execute the move without turning around.

Elbow swing. Dancers hook right or left elbows with person indicated and swing around once.

Oh Johnny

Formation: Couples may dance in square formation or in one large single circle, facing the center. The latter formation makes it a good mixer.
Music: MacGregor 6525 and 007-3; Folkraft 1037; Imperial 1099-XR-239.

Procedure:

"Oh, you all join hands and circle the ring":

The children move clockwise in a circle.

"Stop where you are and give her a swing":

The boys swing their partners.

"Now swing that girl behind you":

The boys swing their corner girl.

"Go back home and swing your own if you have time":

The boys swing with their partners.

"Allemande left with your corner girl":

The boys do the allemande left with their corner girl.

"Do-sa 'round your own":

The children do-sa-do (sashay) around their partner.

"Now you all run away with your sweet corner maid":

The boys promenade counterclockwise with their corner lady to a new partner.

"Singing, oh, Johnny, oh, Johnny, oh!"

The teacher repeats the calls to the end of the recorded music.

Split the ring

Formation: Four couples dance as a set in the square formation.
Music: Decca Du-40080 and Du-720 (album).

Procedure:

"First couple out balance and swing
Down center and split the ring":

Couple one walks across the set and between (splits) couple three.

"Lady go right and the gent go left":

Girl one goes right and boy one goes left around the outside of the set, and then they go back home.

"Swing when you meet as you did before
Down the center and cast off four":

Couple one walks across the set. Boy one goes left between girl three and boy four. Girl one goes right between boy three and girl two. They walk outside the set and go back home.

"Swing your honey and she'll swing you
Down the center and cast off two":

Couple one moves forward to the center of the set. The boy goes left and between (splits) couple four. The girl goes right between (splits) couple two. They walk outside the set and go back home.

"Swing when you meet
Swing at the head and swing at the feet":

Couples one and three swing.

"Side four the same":

Couples two and four swing.

The teacher repeats the call for couples two, three, and four.

Hot time

Formation: Four couples dance as a set in the square formation.
Music: Folkraft F-1037; Imperial 1096;

Decca 9-28905; MacGregor
001-4 (album); Windsor 7115.

Procedure:

"First couple out, and circle four
around":

Couples one and two circle around.

"Pick up two, and circle six around":

*Boy one breaks the circle by unclasping his
left hand. They pick up couple three to
form a circle of six.*

"Pick up two, and circle eight around":

*Boy one breaks the circle again. They pick
up couple four, and the eight circle around.*

"There'll be a hot time in the old town
tonight.
Allemande left with the lady on the
left":

*The boys turn their corner girl with their
left hand.*

"Allemande right with the lady on the
right":

*The boys pass their partner on the inside of
the set and turn the right-hand ladies with
their right hand.*

"Allemande left with the lady on the
left":

*The boys pass their partner on the inside of
the set and turn their corner girl with their
left hand.*

"And grand right and left all around":

The partners swing.

"When you meet your partner, sashay
once around":

*The children either sashay or do the do-sa-
do around once with their partners.*

"Take her in your arms and swing her
'round and 'round.
Promenade around with the prettiest
girl in town.
There'll be a hot time in the old town
tonight."

*The teacher repeats the calls for couples
two, three, and four.*

Bird in the cage

Formation: Four couples dance as a set in the
square formation.
Music: Burns 895 and 896.

Procedure:

"First couple out, balance and swing,
Lead to the right, and form a ring
With four hands around.
Cage the bird with three hands 'round":

*Girl one steps into the center. Couple two
and boy one join hands and circle around
girl one.*

"Bird hops out, crow hops in":

*Boy one steps into the center as girl one
joins the circle with couple two.*

"Ring up three and you're gone again.
Crow hops out with a right-hand
cross":

*Boy one steps out between the two girls, and
all four form a right-hand star.*

"Then back with the left and don't get
lost":

*They reverse the direction, forming a left-
hand star.*

"Form a ring and make it go":

They join hands and form a circle.

"Lead to the next."

*The teacher may repeat the calls for couples
two, three, and four.*

Texas star

Formation: Four couples dance as a set in
the square formation.
Music: MacGregor 001-1 and 12-392.

Procedure:

"Ladies to the center and back to the
bar:"

*The girls walk to the center and then back
to their original positions.*

"Gents to the center with a right-hand
star
Right hands crossed":

*The boys form a right-hand star in the cen-
ter of the set by grasping the wrist of the*

boy in front while walking forward in a circle.

"Back with the left right where you are":

The boys reverse the direction, forming a left-hand star.

"Wink at your honey as you go by":

The boys pass by their own partners.

"Pick up the next gal on the fly":

The boys take the next lady to be their partner. The girls hook onto the boys' right elbow with their left arm, or the boys may place their right arm around the ladies' waist. They continue the star counterclockwise.

"The gents swing out, ladies swing in
 Form that Texas star again":

The boys break the star. The couples turn, moving counterclockwise, one and a half times. The girls then form a right-hand star in the center. The couples move in the star formation clockwise.

"Break in the center and everybody swing.
 Promenade all around that ring.
 Take your partner and promenade home."

The teacher repeats the calls three times until the ladies return to their original partners.

Sally Good'in

Formation: Four couples dance as a set in the square formation.
Music: World of Fun records M-117 and J80C-4415.

Procedure:
"First gent out and swing Sally Good'in":

Boy one swings the right-hand girl (Sally Good'in) around with his right hand.

"Now your taw":

Boy one swings his own partner around with his left hand.

"Swing the girl from Arkansas":

Boy one swings the opposite girl (Arkansas girl) around with his right hand.

"Then swing Sally Good'in":

Boy one again swings the right-hand girl around with his left hand.

"And then your taw":

Boy one swings his own partner around with his right hand.

"Now don't forget your old Grandma":

Boy one swings his corner girl (Grandma) around with his left hand.

"Home you go and everybody swing":

All the couples swing with a waist swing.

The teacher repeats the calls with boys one and two leading out simultaneously. He repeats them again, with boys one, two, and three leading out simultaneously. When he repeats them for the last time, all four boys lead out simultaneously.

The identity of the girls is the same for all boys; for example, Sally Good'in is the right-hand girl and Grandma is the corner girl. When more than one boy is called out, they reach the opposite girl (Arkansas lady) by following the boy on the left.

Arkansas traveler

Formation: Four couples dance as a set in the square formation.
Music: Burns 881 and 882; Decca Du 40080 and Du 720 (album).

Procedure:
"First four go forward and back":

Couples one and three go forward and back.

"Forward again in the same old track
 Swing your opposite right hand around":

Boy one swings girl three and boy three swings girl one, using a forearm grasp.

"Partners left and left hand around":

All the boys swing their partners.

"Corners right and right hand around":

All the boys swing their corner girls.

"Partners left and left hand around":

All the boys swing their partners.

"And promenade your corners":

The boys promenade with their new partners to the boy's home position.

The teacher repeats the calls for couples two and four, and then repeats them from the beginning until the girls are returned to their original positions.

Dive for the oyster

Formation: Four couples dance as a set in the square formation.
Music: RCA Victor 20592.

Procedure:

"First couple out to the couple on the right, and circle four":

Couple one walks to couple two, and they all join hands and circle around once to the left.

"Dive for the oyster, dive":

With both couples still holding hands, couple one dives under raised arms of couple two and steps back home.

"Dig for the clam, dig":

Couple two dives under the raised arms of couple one and returns home, all four children still holding hands.

"Dive right through and on to the next":

Couple one dives under raised arms of couple two and walks on to couple three, releasing couple two's hands.

Couple one performs the figure with couple three and then with couple four. After diving under couple four's arms, couple one returns home.

"All swing partners and promenade":

All the children swing their partners and promenade.

They repeat the dance until all couples have had a turn.

RECOMMENDED READINGS

Anderson, J., Elliott, M.D., and La Berge, J.: Play with a purpose, New York, 1966, Harper & Row, Publishers.

Dauer, V. P.: Dynamic physical education for elementary school children, ed. 4, Minneapolis, 1971, Burgess Publishing Co.

Harris, J. A., et al.: Dance a while, Minneapolis, 1964, Burgess Publishing Co.

Orff-Schülwerk: A means or an end? The School Music News (New York School Music Association), vol. 31, Jan. 1968.

Van Hagen, W., Dexter, G., and Williams, J. F.: Physical education in the elementary school, Sacramento, Calif., 1951, State Department of Education.

Chapter 13

Games and sports

Traditional games and sports are enjoyable activities in which all the children in the class can participate. In presenting game activities, the teacher should first read and clarify all the rules involved in the game being taught. If the game is complex, the teacher should next give a demonstration to show the children exactly how the game is to be played. After the demonstration, the children should actually participate in the activity. At the end of each game, the teacher should then take a few minutes to evaluate the play of the children and determine whether any changes in behavior or playing rules should be made.

In selecting the game to be played, the teacher must determine whether the activity suggested will challenge the children to develop new skills and at the same time must consider whether the skills involved in the game are too advanced and will hinder fun and willingness to participate. The maturity of the class is a strong factor in considering how many and what kind of team games will benefit the children. Games that place pressure on the children and strain their emotional control should not be presented at too early an age. The element of fun should not be overlooked, since it is uppermost in the children's mind rather than the skill development planned for by the teacher. Keeping rules to a minimum will increase participation and enable the children to more fully understand and enjoy the activities. The activities in this chapter are presented in a progressive order of difficulty, the responsibility being left to the teacher to determine the readiness of the class for certain games.

LEVEL 1 ACTIVITIES

Level 1 activities are designed to offer the child enjoyment in games that require beginning motor skills. Classroom games, tag games, relay games, games of low organization, and ball games that can be learned quickly allow children to receive maximum enjoyment in physical education.

Children at this level begin to develop the skills necessary to compete successfully in activities presented in level 2. The teacher should select a variety of activities on the basis of the needs of the children in the class. The behavioral objectives and developmental goals listed will aid the teacher in developing a well-rounded program.

Classroom games

7-up

Behavioral objective: To use strategy in deciding who to tap and self-restraint in keeping eyes closed.

Developmental goal: Patience, self-control, honesty, and auditory discrimination.

Space and equipment: Classroom.
 Number of players: 20-40.

Procedure: Seven children are chosen to be "it" and come to the front of the room while the rest of the children in the class remain seated. The teacher or a chosen leader says, "Heads down, fingers up." Those at their seats put their heads down on their arms on the desk and hold up the index finger on one hand. As soon as all the children have their eyes closed and their fingers up, the chosen seven go among the players; each taps one child's finger, which the child then lowers so that a duplicate tap will not occur. The tappers go to the front of the room and the leader says, "Heads up, 7-up." Each child who was tapped stands and gets a turn at guessing who tapped him. If he guesses correctly, he becomes a tapper and the original tapper goes to his seat. After a child has been a tapper three times and has not been replaced, a new tapper can be chosen. Children must keep their eyes closed until they hear the signal, "heads up." It is the responsibility of the leader to disqualify peekers.

Forty ways to get there

Behavioral objective: To devise original movement patterns.
Developmental goal: Creativity, memory, and originality.

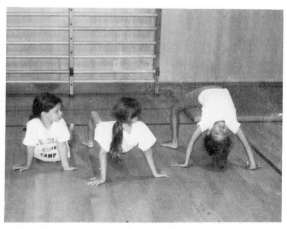

Fig. 13-1. Children playing the game forty ways to get there.

Space and equipment: Classroom.
 Number of players: Entire class.

Procedure: Each child is given a chance to move across the front of the room in any manner he wishes. Once a child has used a walk, hop, or any other movement, no one following may copy that movement. Any novel way of moving is acceptable (Fig. 13-1).

Charades

Behavioral objective: To interpret ideas in movements without using words.
Developmental goal: Imagination, team work, and cooperation.
Space and equipment: Classroom.
 Number of players: Entire class.

Procedure: The children are divided into small groups. Five or six groups are selected and allowed sufficient time to work out a charade together. A captain is elected for each group. The work or object that each group chooses to act out should have syllables to make it easier to act out. All dramatizations must be in pantomime. One group acts out its charade in front of the class. The captain of the group asks the class to guess the syllable or complete word. If the word has not been guessed within a certain time, the captain tells the class, and the next group takes its turn.

Good morning

Behavioral objective: To listen to a voice and correctly guess who the speaker is by his voice.
Developmental goal: Auditory discrimination and self-control.
Space and equipment: Classroom.
 Number of players: 5-40.

Procedure: The children sit at their desks. One child (John, for example) stands in the front of the room with his back toward the group. The teacher silently chooses another child (Jane, for example) to play the game. Jane approaches the standing child and says, "Good morning, John." Without turning his head, John guesses the name of the speaker. If he is unsuccessful, Jane re-

peats her salutation. If John is still unsuccessful, he returns to his seat, and Jane becomes the guesser. If John is successful, he remains the guesser, and a new player approaches and greets him. The children should not be allowed to disguise their voices in this game.

Humpty-Dumpty, strawberry pie

Behavioral objective: To find an object and give others a chance to find it.
Developmental goal: Figure-ground discrimination and self-control.
Space and equipment: Classroom.
Number of players: 5-40.

Procedure: All the children except one leave the room or remain seated and cover their eyes and ears and rest their forehead on the desk. One child hides a selected object some place within the room so that it is accessible to all but not too much in view. The children then return to the room or open their eyes, and they hunt for the object. As each child discovers the hiding place, he goes to his seat as quietly and inconspicuously as possible; when seated, and not before, he announces, "Humpty-Dumpty, strawberry pie!" Play continues until all have spotted the object or until the teacher calls off the hunt. The child who first discovered the object must retrieve it, and then he becomes the next player to hide it. In order to keep some children from being embarrassed at being last, the teacher should call off the hunt when three or four are still looking.

Hens and chickens

Behavioral objective: To listen for a sound and determine its source.
Developmental goal: Auditory perception and self-control.
Space and equipment: Classroom.
Number of players: Entire class.

Procedure: The children remain seated. One child is chosen to be the hen and goes to the cloakroom or hall. While the hen is out of the room, the teacher walks around the room and taps several children, who become chickens. All the children then place

their head on their desks, hiding their face in their arms. The hen comes in and moves about the room saying, "cluck, cluck." All the children keep their heads down, and the chickens answer, "peep, peep." The hen listens and taps any child on the head who he believes is a chicken. If the hen is correct, the chicken must sit up straight; if the hen is incorrect, the chicken continues to hide his head. After the hen has selected all the chickens, he or the teacher selects a new hen.

Find the moon rock

Behavioral objective: To find a hidden object through auditory discrimination.
Developmental goal: Auditory perception and figure-ground discrimination.
Space and equipment: Classroom.
Number of players: Entire class.

Procedure: The children decide on an object to be hidden. It should be a small object or pebble to represent the moon rock. The teacher chooses one player to be the astronaut and sends him out of the room while the class hides the moon rock. When the astronaut enters the room and approaches or moves away from the moon rock, the class may hum or clap, loudly or softly, depending on the position of the astronaut in relation to the moon rock. When the astronaut finds the moon rock, he chooses another astronaut.

Simon says

Behavioral objective: To listen for an oral command and follow it with an action.
Developmental goal: Auditory perception and honesty.
Space and equipment: Classroom.
Number of players: 6-30.

Procedure: A leader is chosen to stand in front of the children, who stand or sit, but preferably stand. The leader gives commands to jump, bow, turn right, and so on. If the command is preceded by the phrase "Simon says," it is to be obeyed by all the players. If the phrase "Simon says" is

omitted by the leader, the command is to be ignored. If a player fails to obey a command preceded by the phrase "Simon says" or obeys one not preceded by this phrase, he is eliminated. The last player to remain in the game is the winner. If the group is large, the last five or ten may be declared the winners.

Clothespin drop

Behavioral objective: To sight and to drop a clothespin into a bottle.
Developmental goal: Eye-hand coordination.
Space and equipment: Classroom or gymnasium.
Number of players: Entire class.

Procedure: Each row of children in the classroom is a team. A milk bottle is placed in front of each row. The children take turns standing erect above the bottle and dropping five clothespins, one at a time, into the bottle. One point is given for each clothespin that is dropped into the bottle. The row with the highest total wins.

Wastebasket ball

Behavioral objective: To throw accurately at a target.
Developmental goal: Eye-hand coordination.
Space and equipment: Classroom.
Number of players: Entire class.

Procedure: The game may be played by teams or classroom rows. A captain is selected to keep score on the blackboard, and a child is selected to return the ball. The teacher places the basket on a chair at the front of the room. He marks a line with chalk on the floor at least 5 yards from the basket. Each child takes a turn standing on this line and trying to throw the ball into the basket. Everyone is allowed three trials, with an additional trial for every ball thrown into the basket. One point is given for each ball successfully placed. After all the children have played, the captain announces the winning team or row.

Crumple and toss

Behavioral objective: To crumple and accurately throw a piece of newspaper.

Developmental goal: Fine muscle coordination and accuracy.
Space and equipment: Classroom or gymnasium.
Number of players: Entire class.

Procedure: The children form two lines facing wastebaskets, with the front player 6 to 10 feet from the basket. The first player in each line is given a piece of newspaper, which he must crumple with one hand. The player attempts to throw the crumpled paper into the basket. After the first child takes his turn, he goes to the back of the line, and the next player moves up to the front of the line and takes a turn. The team with the largest number of papers in the basket at the end of the game wins. A half sheet of newspaper works best for crumpling and throwing. The children should crumple the paper tightly enough that it goes where they aim it. The goal of this game should not necessarily be speed, but accuracy.

Numbers change

Behavioral objective: To listen for numbers and to execute a movement change quickly and safely.
Developmental goal: Decision making and quickness.
Space and equipment: Multipurpose play area or gymnasium.
Number of players: Entire class.

Procedure: The children sit in a circle, with the child who is "it" in the center. The children are numbered consecutively. "It" calls out two or more numbers, such as 3, 9, and 17. The children whose numbers are called must quickly jump up and exchange seats, during which time "it" tries to take one of the seats. The player left without a seat becomes "it" and calls out other numbers.

Tag games

Most tag games are best played in a limited marked area such as a basketball court.

Seat tag

Behavioral objective: To safely tag another child and to avoid being tagged in a limited area.

Developmental goal: Agility and coordination.
Space and equipment: Classroom.
 Number of players: Entire class.

Procedure: One child is "it," and another is a runner who "it" chases about the room. The other children remain seated. The runner may sit down with some other pupil, and that pupil then becomes "it" and must chase the one who was "it." If "it" tags the runner, the positions are reversed, the runner becoming "it."

Nose and toes tag

Behavioral objective: To tag and to avoid being tagged.
Developmental goal: Flexibility, agility, and endurance.
Space and equipment: Multipurpose play area.
 Number of players: Entire class.

Procedure: A child chosen to be "it" attempts to catch any one of the other children. One who is tagged becomes "it." As a child is tagged, he holds up his hand for a moment to show the others that he is "it." A player may escape being tagged by grasping his nose with one hand and the toes of one foot with his other hand. Each child should be allowed a maximum of three "safe" tags by grasping his nose and toes.

Skip tag

Behavioral objective: To overtake and tag another child while skipping.
Developmental goal: Coordination and endurance.
Space and equipment: Multipurpose play area.
 Number of players: 10-12.

Procedure: The children form a single circle and all face inward. A tagger is chosen and stands outside the circle. The tagger, while skipping around the outside of the circle, tags a circle player. The circle player skips after the tagger and tries to catch him. If the tagger reaches the vacant space left by the circle player, the circle player becomes the tagger, and the game continues. If the tagger is caught by the circle player, he remains the tagger. If the tagger is unable to take a circle player's space after two

tries, the teacher should change directions or select another tagger.

Simple tag

Behavioral objective: To overtake and tag another child and to avoid being tagged.
Developmental goal: Agility and endurance.
Space and equipment: Multipurpose play area.
 Number of players: Entire class.

Procedure: One child is chosen to be "it." All children are scattered within a designated play area. "It" tries to tag another player. When a player is tagged, he becomes "it," and the game continues. A player who is tagged may not tag back the person who tagged him.

Circle tag

Behavioral objective: To move safely in a clockwise circle and to tag the one in front.
Developmental goal: Endurance and directionality.
Space and equipment: Multipurpose play area.
 Number of players: 10-12.

Procedure: The children stand in a circle formation with about 6 feet between each player. On a signal, all the players run in a clockwise direction around the circle. Each player attempts to tag the one directly in front of him. When a player is tagged, he takes two steps toward the center of the circle and sits down until the last player is tagged. The last player left is the winner.

Top hat tag

Behavioral objective: To balance a beanbag while tagging and being tagged.
Developmental goal: Posture and balance.
Space and equipment: Multipurpose play area.
 Number of players: Entire class.

Procedure: The children are scattered within a designated area. One child is chosen to be "it" and another to be the runner. The runner and "it" place a beanbag on their head, and they do not use their hands to hold the beanbag. "It" chases the runner and tries to tag him. The runner may trans-

fer his beanbag to the head of any other player, who then becomes the runner. If the runner is tagged, he then becomes "it."

Commando tag

Behavioral objective: To devise ways of break-
ing out of the circle and
to avoid being tagged.
Developmental goal: Agility, cooperation, and
endurance.
Space and equipment: Multipurpose play area.
Number of players: 8-10 in each circle.

Procedure: The children form circles. One child is selected to be "it" and stands in the middle of the circle. The circle players join hands. On a signal, "it" tries to break through the circle by crawling under or over joined hands or by breaking the handholds of the players. If "it" breaks through, the two circle players who "it" breaks through chase him, and the one who tags him becomes "it."

Hook-on tag

Behavioral objective: To tag and to avoid being
tagged and to work to-
gether as a unit.
Developmental goal: Coordination, cooperation,
and endurance.
Space and equipment: Multipurpose play area.
Number of players: Groups of 2, 3, or 4.

Procedure: The children, one behind the other, grasp the waist of the one in front. The player in front of each line is called the engine, and the one in the rear is the caboose. One child is chosen to be "it." "It" tries to hook onto the caboose of any group. When he succeeds, the engine of that group becomes the new "it." There may be more than one "it" at the same time if the group is large.

Stoop tag

Behavioral objective: To tag and to avoid being
tagged.
Developmental goal: Endurance and flexibility.
Space and equipment: Multipurpose play area.
Number of players: 10-15.

Procedure: The children stand in an informal group within boundary lines. Chil-

dren are safe from "it" when stooping. No child may stoop more than twice while one child is "it."

Relay games

Obstacle relay

Behavioral objective: To successfully run in and
out of markers as quick-
ly as possible.
Developmental goal: Agility, endurance, self-
control, and team loyal-
ty.
Space and equipment: Classroom or multipurpose
play area, and chairs or
rubber cones.
Number of players: 6-8 on each team.

Procedure: The children line up in squad formation. Chairs or markers are placed 6 to 10 feet apart and directly in front of each team. The first player runs in and out around the chairs and back to the starting position and then taps the next team member. The relay is continued until the last player in each squad has had a turn.

Stunt relay

Behavioral objective: To run and touch a desig-
nated line, turn, and re-
member to do a stunt.
Developmental goal: Self-control and memory.
Space and equipment: Multipurpose play area.

Fig. 13-2. Child demonstrating seal walk.

Number of players: 6-8 on each team.

Procedure: The children stand in squad formation behind a starting line. A turning line is drawn about 30 to 40 feet away. On a signal, the first player runs to the turning line and on his way back performs a stunt designated by the teacher (Fig. 13-2). The teacher should select the stunt in relation to the abilities of the children involved.

Shuttle relay

Behavioral objective: To run across an area and tag a team member.
Developmental goal: Endurance and self-control.
Space and equipment: Multipurpose play area.
Number of players: 6-8 on each team.

Procedure: The children divide into teams, and each team divides in half. The team halves line up on either side of two restraining lines, spaced approximately 20 feet apart, in file formation. The first player runs across the designated area to the other half of his team and tags the right hand of the first player in line. The tagged player runs back to the opposite side and tags the next player in line, and so on, until all have had a turn. The teacher may substitute locomotor or ball skills for straight running.

Christmas relay

Behavioral objective: To complete a drawing, following specific directions in sequence.
Developmental goal: Team work and quickness.
Space and equipment: Classroom.
Number of players: 5 or 6 on each team.

Procedure: The children sit in rows, with an equal number of children in each row. Each row is numbered from front to rear, beginning with 1. Each player 1 is given a piece of chalk. On a signal, players 1 run to the blackboard and draw a base for a Christmas tree. They return to their seats and hand the chalk to players 2, who run forward and draw the tree standing in its base. Players 3 add six Christmas tree decorations; players 4 attach four candles; players 5 place a star at the top of their tree; and players 6 write under their tree,

"Merry Christmas!" (The sixth step may be omitted with younger children.) The team wins whose player 1 first has the chalk in his hand after all the team members have played.

Object-passing relay

Behavioral objective: To pass a beanbag along a line of players without dropping it.
Developmental goal: Eye-hand coordination and laterality.
Space and equipment: Multipurpose play area.
Number of players: 6-8 on each team.

Procedure: The children form teams, with no more than eight players to a team, and they stand side by side in squad formation. Each captain is given a beanbag. At a signal, the children pass the beanbag along the line as rapidly as possible to the foot of the line. The last player touches the beanbag to the floor and starts it back toward the beginning of the line. The bag may be passed in different ways, such as with the right hand, the left hand, or both hands. If a bag is dropped or is not passed according to the selected method, it must be returned to the captain to be restarted by him. The team wins whose captain first receives the returned beanbag.

Walk, run, or hop relay

Behavioral objective: To perform a designated motor skill quickly.
Developmental goal: Endurance and coordination.
Space and equipment: Multipurpose play area.
Number of players: 6-8 on each team.

Procedure: The children line up in teams. The teacher draws a turning line 20 to 40 feet away from the starting line, the distance depending on the age and ability of the children. The first player of each team performs any specified locomotor movement (run, walk, hop, lead, skip, slide, or gallop) to the turning line and back. When the first player returns, the next team member takes his turn. The relay is continued until each team member has had a turn.

Games of low organization

Stop and start

Behavioral objective: To listen for a direction given by a leader and to move in the direction he says.
Developmental goal: Directionality and auditory awareness.
Space and equipment: Classroom or multipurpose play area.
Number of players: 4-12.

Procedure: The children stand about the room or field and watch the leader. When the leader points in any direction, the children must move in that direction. When he blows the whistle, the children must stop and turn in order to watch him for the next direction. Children who fail to stop immediately or who fail to follow directions form a second group of players on the opposite side of the leader. The object of the game is to be the last player to remain in the original group.

Animal chase

Behavioral objective: To run at a specific signal and to tag or avoid being tagged.
Developmental goal: Auditory awareness, endurance, and strategy.
Space and equipment: Multipurpose play area.
Number of players: Any number.

Procedure: The children stand on a line facing the teacher. Together they choose five animal names. Each child is then given one of the animal names. A hunter is chosen, who stands in the middle of the playing area. When he calls the name of an animal, all children who have that name try to run to a line opposite them without being caught. If they are caught, they are put in the cage, which is an area marked off outside the end boundary line. The hunter continues to call the names until he has called all of them. He then counts the number he has caught and chooses someone to be the hunter who has never been one. The same animal names may be used, or new ones may be chosen.

Pussy wants a corner

Behavioral objective: To get into an empty circle.
Developmental goal: Alertness, quickness, and cooperation.
Space and equipment: Multipurpose play area with a number of circles —one less than the number of children.
Number of players: 10-15.

Procedure: Each child stands with at least one foot touching a circle. The child who is the pussy stands anywhere outside the circles. The pussy moves around the play area saying, "Pussy wants a corner." The other children try to change places without being noticed. If the pussy can get into an empty circle, the child who just left that circle becomes the pussy. Occasionally the leader calls, "Everyone change." At this call, everyone runs to a new circle, including the pussy, and the child left without a circle becomes the pussy.

Ringmaster

Behavioral objective: To imitate designated animals.
Developmental goal: Imagination and creative movement.
Space and equipment: Multipurpose play area.
Number of players: Entire class.

Procedure: The children stand in a circle, with one child in the center, who is the ringmaster. The ringmaster moves about the center of the circle pretending to crack his whip and calls out the names of various animals. The circle players then imitate the animals. If the ringmaster calls out, "All join the parade," the children may imitate any animal they wish. The ringmaster selects the child who best imitates the animal to be the next ringmaster.

Duck, duck, goose

Behavioral objective: To run around a circle without being tagged and to tag the runner.
Developmental goal: Auditory perception and quickness.
Space and equipment: Multipurpose play area.
Number of players: 15-30.

Procedure: The children form a circle and face the center. The child who is chosen to be "it" runs around the outside of the circle, touching children on the shoulder and calling, "duck, duck, duck, goose!" All those who are called ducks squat and remain in their places. The one who is called goose chases "it," and if "it" gets to the vacant place in the circle before the goose catches him, the goose becomes "it." If "it" is tagged before reaching the vacant place, he remains "it." "It" may say "duck" any number of times before he says "goose." All players stand again at the end of the chase.

Cut the cake

Behavioral objective: To run around a circle in the opposite direction of a neighbor.

Developmental goal: Directionality and quickness.

Space and equipment: Multipurpose play area.

Number of players: 6-12 in a group.

Procedure: The children form circles and face the center and join hands. The child who is chosen to be "it" is the knife and stands inside the circle. With both hands together he acts like he is cutting with a slicing motion just above the cake. When he taps the joined hands of two children hard in a cutting motion, these two children run in opposite directions around the circle. The two runners should stop when they meet and shake hands or perform some other stunt to avoid head-on collisions. The knife stands still and judges which one of the runners gets back to the place first. The winning runner is the next knife.

Fire engine

Behavioral objective: To listen for a specific number and to run quickly to a designated line.

Developmental goal: Auditory awareness, endurance, and quickness.

Space and equipment: Multipurpose play area.

Number of players: Any number.

Procedure: All the children stand on a line at the end of the playing area. They count off by fives. The first chief stands at the side of the court halfway between the end lines. He calls, "Fire! fire! station number *(1 to 5)*." The children whose number is called run to the opposite end line and back to the middle line. The first one back becomes the new fire chief, and the game continues.

Midnight

Behavioral objective: To listen for a specific word and to run to home before being tagged.

Developmental goal: Auditory awareness and fast reaction.

Space and equipment: Multipurpose play area.

Number of players: Entire class.

Procedure: The children stand in a single line side by side on a line called home. One child is chosen to be the old man and he stands, facing them, about 30 feet away. The children leave their home and, as they approach the old man, keep asking him, "What time is it?" He answers, "8 o'clock," "10 o'clock," or anytime, as it pleases him. He may tag the other children only at midnight; Therefore, if he replies with any time except midnight, they are safe. When he says "midnight," the children must run for their home. The old man chases them, trying to catch as many as possible. Any whom he catches must go back to his home and help him catch the others. The last child caught becomes the old man for the next game.

Fox and squirrels

Behavioral objective: To tag and to avoid being tagged.

Developmental goal: Endurance, agility, and sportsmanship.

Space and equipment: Multipurpose play area.

Number of players: Entire class.

Procedure: The children stand in groups of three; two face each other and join both hands, forming the tree, and the third child is the squirrel and stands inside the tree. Trees should be scattered around the playing area. One squirrel without a tree and one fox are chosen to start the game. The fox

attempts to catch the squirrel. To avoid being caught the squirrel may run inside a tree, forcing out the squirrel in that tree. If the fox catches the squirrel, they exchange roles. After several chases, the trees and squirrels should change places. The game should be repeated until each child has had a chance to be a squirrel.

Bear in the pit

Behavioral objective: To break through a circle.
Developmental goal: Strength, strategy, endurance, and agility.
Space and equipment: Multipurpose play area.
Number of players: 15-35.

Procedure: The children stand in a circle and face the center with their hands joined. One child is chosen to be the bear in the center of the pit (circle). He attempts to get out by diving under or over the other children's arms or between their legs or by breaking through. Once the bear is free, all the players chase him. The one who tags him becomes the next bear.

Squirrel in the trees

Behavioral objective: To run safely to a different area before another person.
Developmental goal: Auditory perception, agility, and speed.
Space and equipment: Multipurpose play area.
Number of players: Entire class.

Procedure: The children stand in groups of three; two face each other and join both hands, forming the tree, and the third child is the squirrel and stands inside the tree. The trees should be scattered around the playing area. There should be two or three extra squirrels. When the leader calls, "Change trees," all the squirrels run to new trees. The teacher may blow a whistle to signal a change. The squirrels left without a tree change places with children who are trees. All the children should have a turn being a squirrel.

Old Mother Witch

Behavioral objective: To listen for a signal and run safely to a desig-

nated area and to tag others.
Developmental goal: Quickness, auditory perception, and endurance.
Space and equipment: Multipurpose play area or grass with lines.
Number of players: Entire class.

Procedure: The children stand in a single line side by side. One child is chosen to be Old Mother Witch and stands in front of the line, facing away from the other children. The witch starts walking away, saying the following verse and acting it out:

"Old Mother Witch fell in a ditch,
Found a penny
And thought she was rich."

The children in line follow as close behind as they dare. When the witch finishes the verse, she turns around and says, "Whose children are you?" Someone from the line says any name he pleases, such as the Jones children or the Smith children. If three kinds of names are given, the witch repeats her verse and continues on a few steps and then turns around again and asks the same question. As soon as someone calls out, "the Old Witch's children," the witch chases them back to the starting line. One person should be chosen to say, "the Old Witch's children." Any children who are caught join the witch and help to catch the others.

Red light

Behavioral objective: To move across to a finish line without being caught.
Developmental goal: Auditory awareness and visual perception.
Space and equipment: Multipurpose play area.
Number of players: Any number.

Procedure: One player is chosen to be the leader and stands on the finish line. He counts very rapidly from one to ten while he has his back to the players and then quickly says the words "red light" and turns around. The players move across the area during the counting and must freeze on the words "red light." Any player who is caught moving after the words "red light" have been said must return to the starting position. After the leader has sent back all who were

caught, he turns his back and begins counting again. The players may move when his back is turned. Once he starts counting, he cannot turn around until he has called out the words "red light." The first player to reach the finish line wins and becomes the leader for the next game.

Fairies and brownies

Behavioral objective: To chase and tag others on a signal.
Developmental goal: Quickness, endurance, and auditory perception.
Space and equipment: Multipurpose play area.
Number of players: 13-30.

Procedure: The children are divided into two equal groups of fairies and brownies. Each group stands behind a line. The lines should be about 60 feet apart. The fairies turn their backs toward the brownies. A leader or lookout watches the game and gives the necessary signals. The brownies creep forward quietly. The fairies are not permitted to look over their shoulders while the brownies are approaching. When the lookout sees that the brownies are near enough for the fairies to tag players, he calls out, "Look out for the brownies!" The fairies then turn and chase the brownies, tagging as many brownies as possible before the brownies cross their safety line. All the brownies who are tagged become fairies and join that group. The game is repeated, with the brownies turning their backs. The winning side is the one having the greater number of players at the end of the available time period.

Crows and cranes

Behavioral objective: To chase and tag others on a given signal.
Developmental goal: Auditory perception and endurance.
Space and equipment: Multipurpose play area.
Number of players: 12-30.

Procedure: The children stand side by side in two single lines facing each other about 60 feet apart. The children in one line are crows, and those in the other are cranes. A child chosen to be the leader stands in the middle. The teams walk toward each other, and the leader calls out the word "cr-r-r-rows" or "cr-r-r-ranes," holding the word until the teams are close together. If the word is "cranes," the cranes run back to their line and the crows try to tag them. All who are tagged join the other side. The calls should be drawn out as long as possible, to add to the suspense and uncertainty of the game.

New Orleans

Behavioral objective: To act out an occupation and to guess it and then to chase and tag.
Developmental goal: Imagination, cooperation, and endurance.
Space and equipment: Multipurpose play area.
Number of players: 12-30.

Procedure: The children stand side by side in two single lines facing each other about 60 feet apart. Team 1 decides on some trade it will represent and approaches team 2, and the teams have the following dialogue:

Team 1	Team 2
Here we come.	Where from?
New Orleans.	What's your trade?
Lemonade.	Show us something if you're not afraid.

The members of team 1 act out motions illustrating their trades, and those of team 2 guess what it is. When someone from team 2 guesses what it is, the members of team 1 run for their goal and those of team 2 try to tag them. All those who are tagged go with team 2.

Red Rover

Behavioral objective: To tag others.
Developmental goal: Auditory perception, endurance, and agility.
Space and equipment: Multipurpose play area.
Number of players: Entire class.

Procedure: The teacher draws three parallel lines, each 20 feet apart. The children stand on one end line and face the center line. One player is chosen to be "it"

and stands on the center line. "It" says, "Red Rover, Red Rover, let Jim, Jane, Bill, and Sue [any four or five players] come over." The players who were called run to the opposite end line, and "it" attempts to tag as many as possible before they reach the line. The child who is "it" should be allowed to have three or four turns, and then another child should be chosen to be "it." The player who catches the most children wins the game.

Uncle Sam

Behavioral objective: To listen for a signal and to identify specific colors and to run to another side.
Developmental goal: Color identification, speed, and agility.
Space and equipment: Multipurpose play area.
Number of players: Entire class.

Procedure: The teacher draws two parallel lines 30 to 40 feet apart. The children stand along one line. The other line is called the river. One child is chosen to be Uncle Sam and stands in the center of the play area. The children standing behind the line call out, "Uncle Sam, may we cross your river?" Uncle Sam says, "Yes, if you have blue," or he can say any color. All children wearing that color must run to the opposite side. Uncle Sam tries to tag as many as he can before they cross the opposite end line. Those who are caught must help Uncle Sam. The last person to be caught wins the game.

Ball games

Galloping Lizzie

Behavioral objective: To pass a ball before being tagged and to tag a person who has a ball.
Developmental goal: Eye-hand coordination, quickness, and endurance.
Space and equipment: Multipurpose play area.
Number of players: 6-12.

Procedure: The children stand in a circle fairly close together and face the center. One child stands outside the circle. The ball

is given to a circle player. The ball is passed from player to player or is thrown across to an opposite player. The outside player tries to tag a circle player while the circle player has the ball in his hands. When the outside player is succesful in tagging a player, he changes places with him. If a circle player drops the ball, he becomes the tagger, the former tagger taking his place. More than one ball may be used to make tagging easier.

Leader and class

Behavioral objective: To throw and catch accurately.
Developmental goal: Eye-hand coordination.
Space and equipment: Multipurpose play area and playground ball.
Number of players: 4-40.

Procedure: The children divide into groups of four to six. The members of each group stand side by side in a line. One end of the line is designated the head, and the other, the foot. The member at the head of the line becomes the leader and faces his group, standing 8 to 10 feet in front of them (Fig. 13-3). The leader tosses a ball to each player in his group in turn, and each throws the ball back to him. If a player misses the ball, he goes to the foot of the line. If the leader misses a ball, he goes to the foot of the line and the next player at the head becomes the leader. If the ball goes around the group twice and the leader has not missed, he takes his place at the foot of the line, and the player at the head becomes the leader. In this game, volleyball, softball, football, or soccer skills can be used, according to the grade level and ability.

Center-base ball

Behavioral objective: To throw and catch a ball and to tag another person.
Developmental goal: Agility and strategy.
Space and equipment: Multipurpose play area and playground ball.
Number of players: 6-16.

Procedure: The children stand in a single circle and face the center. They should

Fig. 13-3. High school student teaching the game leader and class.

stand at least 4 feet away from each other. One child stands in the center holding a ball. The center player throws the ball to a circle player and leaves the circle immediately. The one to whom the ball was thrown must catch it, take it to the center, place it on the ground, and then chase the first player. The center player tries to return to the ball and touch it without being tagged. If the center player is tagged, he joins the circle players and the circle player becomes the thrower. If the center player succeeds in reaching the ball, he throws the ball again, as before.

Circle ball

Behavioral objective: To throw and catch a ball.
Developmental goal: Eye-hand coordination.
Space and equipment: Multipurpose play area and playground ball.
Number of players: 6-10 per circle.

Procedure: The children form circles. One child in each circle is chosen to be the leader and stands in the center of the circle. He tosses the ball to each circle player, who must toss it back. If the leader drops a well-tossed ball, the child who tossed it becomes the new leader. A different child should have a turn in the center after a complete

revolution has been made and the leader has not missed a ball, and each child should have a turn as leader.

Call ball

Behavioral objective: To throw a ball and to catch a ball on one bounce.
Developmental goal: Auditory perception and ball skills.
Space and equipment: Multipurpose play area.
Number of players: 6-10 per circle.

Procedure: The children form circles. One child is chosen to be "it" and stands in the center. He tosses the ball into the air and calls a player's name. The child whose name is called must run in and catch the ball before it bounces more than once (Fig. 13-4). If he is successful, he becomes "it." If he fails, the original "it" tosses the ball again. To make the game harder, the children can be required to catch the ball *before* it bounces. The children also may be given numbers or colors to which they must respond.

Wonder ball

Behavioral objective: To pass a ball quickly to another person.

Fig. 13-4. Children developing ball skills in call ball.

Developmental goal: Eye-hand coordination and quickness.
Space and equipment: Multipurpose play area and playground ball.
Number of players: 6-10 per circle.

Procedure: The children form circles. They pass the ball around the circle from person to person while they say the following verse:

"The wonder ball goes round and round,
To pass it quickly you are bound,
If you're the one to hold it last
You—are—OUT!"

The child holding the ball on the word "out" is eliminated from the game. The children should pass the ball quickly but avoid wild throwing.

Beanbag ring throw

Behavioral objective: To throw accurately at a target.
Developmental goal: Eye-hand coordination.
Space and equipment: Multipurpose play area and three beanbags per team.
Number of players: 4-40.

Procedure: The children divide into teams of four to six. The members of each team line up in squad formation behind that team's restraining line. At a signal, the captain of each team, while standing behind the restraining line, throws three beanbags in succession toward a circle. The distance between the restraining line and the circle can be varied according to the ability of the children. Any bag that touches the circumference of the circle cannot be counted in computing the score. After the score is recorded, the captain picks up the beanbags, carries them to the next player on his team, and then goes to the end of his squad. Play continues until all have had a chance to throw the bags. Speed is not as important as accuracy in throwing. One point is earned for each bag that lands completely within the circle. The team wins that has the highest score after all the players have had a chance to throw the bags. Each squad should keep its own total score, making sure that only the bags that landed completely in the circle are counted. Wastebaskets can be used, if enough are available, to make it easier to know which throws earn points.

Exchange dodge ball

Behavioral objective: To change places with another person without being hit by a ball.

Developmental goal: Auditory perception and agility.
Space and equipment: Multipurpose play area and playground ball.
Number of players: 12-20 in a group.

Procedure: The children divide into groups of 12 to 20. Each group forms a circle with one child who is chosen to be "it" in the center. The children number off by fours or fives so that there are three or four children who have the same number. The center player also has a number that he uses when he is not "it." The center player has a ball that he lays at his feet. He calls a number, and all the children with that number exchange places. The center player picks up the ball and tries to hit one of the children who are exchanging places. He remains "it" until he can hit one of the children below the waist.

LEVEL 2 ACTIVITIES

The activities in level 2 require intermediate skills and prepare the child for the more advanced games presented for the upper grades. Lead-up games that require specific skills serve as the foundation for team games and sports. The games in this section challenge the student's cognitive powers, since more advanced strategies are involved and team work and cooperation are necessary for successful performances. The child's motor abilities are tested, since the games involve a higher level of agility, balance, endurance, and eye-hand coordination.

In some cases, children in the lower grades will be ready for activities at this level. The teacher should determine the activity level on the basis of the needs and abilities of the children in the class.

Classroom games

Human checkers

Behavioral objective: To change positions from one side to another.
Developmental goal: Visual perception.
Space and equipment: Classroom and chairs.
Number of players: 6 on each team.

Procedure: Seven chairs are placed in a row. Three girls sit on the three chairs at

one end; three boys sit on the three chairs at the other end. The object is for the girls to move to the boys' chairs and the boys to move to the girls' chairs in 15 moves. Only one move can be made at one time. Moves are made by sliding into an open chair or "jumping" over one person. Players can move only toward opposite sides. For example: first move, the girl next to the spare chair moves to the spare chair; second move, the boy next to the spare chair jumps the girl who is now in the spare chair; and so on.

Spell and act

Behavioral objective: To spell correctly, substituting motions for certain letters.
Developmental goal: Memory and coordination.
Space and equipment: Classroom.
Number of players: Entire class.

Procedure: The game is played like a regular spelling match, with the following addition: The letters *a* and *t* must not be spoken but must be indicated by action as follows: *a*, by scratching right ear and raising left hand, and *t*, by scratching left ear and raising right hand. The actions for the letters *a* and *t* can be varied each time the game is played.

Tag games

Exchange tag

Behavioral objective: To tag another person and to avoid being tagged.
Developmental goal: Auditory perception and quickness.
Space and equipment: Multipurpose play area or classroom.
Number of players: 6-20.

Procedure: The children sit at their desks, or if the room is large enough, they stand in a circle. One child is selected to be the tagger. If the children do not know each other's names, they should each be given a number to remember. One child chosen to be the leader calls the names or numbers of two children. Those two try to exchange seats or places in the circle before the tagger can tag them. If the players are

not tagged before they reach the desired places, the leader calls new numbers. A player who is tagged becomes the tagger.

Link tag

Behavioral objective: To work as a team in tagging others.
Developmental goal: Cooperation and team work.
Space and equipment: Multipurpose play area.
Number of players: 8-20

Procedure: The children are scattered about the area. Two children are selected to be the taggers. They link hands and attempt to tag other players with a free hand. As players are tagged, they take their place between the two original taggers; the chain grows longer with each additional player tagged. Only the end players may tag. The players being chased may break the chain if they are pressed too closely. If they break the chain, the chain players must unite again before they may continue tagging. Tired runners who are not being chased may retire to the sideline to rest, remaining there until they are ready to reenter the game. The last two players tagged become the taggers for a new game.

Hot potato

Behavioral objective: To tag a person who is holding an object and to avoid being caught while holding an object.
Developmental goal: Visual perception and agility.
Space and equipment: Multipurpose play area and beanbag.
Number of players: Entire class.

Procedure: The children are scattered in a designated area. One child is selected to be the runner and is given the "hot potato." Another child is selected to be "it." To start the game, "it" begins to chase the runner with the hot potato. The runner may at any time give the hot potato to another player. If "it" tags the runner with the hot potato, the runner becomes "it." The new "it" must count to five before chasing anyone.

Spot tag

Behavioral objective: To move quickly to tag another person.
Developmental goal: Agility and endurance.
Space and equipment: Multipurpose play area.
Number of players: Entire class.

Procedure: One child is chosen to be "it." All the children are scattered within a designated play area. "It" tries to tag another player. When a player is tagged, he must place one hand on the spot where he was tagged and hold it there while attempting to tag another player.

Relay games

Locomotion relay

Behavioral objective: To move fast against an opponent in a competitive situation.
Developmental goal: Endurance and coordination.
Space and equipment: Multipurpose play area.
Number of players: 10-40.

Procedure: The children form squads of four to six players. The first player on each team runs forward and to the left around a marker, runs back, tags the right hand of the next player, and goes to the end of his team. The next player must wait behind the starting line and must not run until his right hand is tagged. When every player on a team has had a turn, the whole team sits down. The first team to sit in a straight line wins. A variety of locomotor skills and stunts can be incorporated into this game in their entirety or in combinations, such as the skip, hop, gallop, crawl, crab walk, wheelbarrow, and swagger walk. The distance for the relay should be in relation to the difficulty of the skill involved and the age level of the children.

Over and under relay

Behavioral objective: To pass an object to another person quickly and accurately.
Developmental goal: Coordination and team work.
Space and equipment: Multipurpose play area and playground ball or beanbags.

Number of players: 10-40.

Procedure: The children form squads of six to eight players. The first player on each squad passes the ball over his head with both hands to the next player, who passes it between his legs to the next player, who passes it over his head, and so on to the last player, who receives the ball and runs down the right-hand side of his team to the front. Then all the players move back one space from the starting line, and the relay continues, the first player always passing the ball over his head to the next player. The team that returns first to the starting position wins. When a team completes the relay, all the team members should sit down to make it easier to judge which team finishes first. For variation, the children can all pass the ball over their heads or all roll or pass the ball between their legs.

Dizzy Izzy relay

Behavioral objective: To run fast and to control the body with an added stress factor.
Developmental goal: Balance and endurance.
Space and equipment: Multipurpose play area and bats.
Number of players: 6 40.

Procedure: The children divide into teams, with no more than six to a team. The teams line up in squad formation behind a restraining line. Each captain is given a baseball bat. At a signal, each captain runs forward to a line 25 feet away and, when he is beyond line, places his bat in an upright position on the ground, places his forehead on the end, and in that position runs around the bat three times. He then runs back to his team and hands the bat to the second runner. Play continues until one team wins by being the first to have all its members complete their turns. Adequate space must be allowed between teams, since some children get dizzy and have difficulty running a straight line.

Carry and fetch relay

Behavioral objective: To run fast and to carry an object to a designated area.
Developmental goal: Endurance.
Space and equipment: Multipurpose play area and beanbags.
Number of players: 6-40.

Procedure: The children form teams of six to eight players and line up in squad formation in back of the starting line and opposite

Fig. 13-5. Children participating in jump rope relay.

a circle. Each team leader is given a bean-bag. At a signal, the team leader runs for-ward, places the beanbag in his circle, and runs back to the rear of his squad, tagging the first player in the row as he passes. The second player dashes forward, grabs the beanbag, and runs back and hands it to the third player as he passes. The third player returns the bag to the circle. Play continues until all the team members have run. A beanbag may not touch the circumference of a circle. The team wins whose captain first receives the beanbag from his last runner or is tagged by his last runner, provided that no beanbag during the race contacted the circumference of the circle.

Jump rope relay

Behavioral objective: To jump rope and to travel forward as fast as pos-sible.
Developmental goal: Endurance and coordina-tion.
Space and equipment: Multipurpose play area and jump ropes.
Number of players: 5-6 on each team.

Procedure: The children form teams and line up in squad formation behind a starting line, with the first player on each team hold-ing a jump rope. The teacher draws a turn-ing line about 20 feet away. On a signal, the first player jumps the rope to the turning line and back (Fig. 13-5). The relay continues until the last player in each squad has had his turn.

Rescue relay

Behavioral objective: To run quickly to a line and return with a part-ner.
Developmental goal: Endurance and coopera-tion.
Space and equipment: Multipurpose play area.
Number of players: 6-8 on each team.

Procedure: The children form teams and line up in squad formation behind a start-ing line. Each team captain stands opposite his team behind a second line drawn paral-lel 20 feet in front of the first line. On a signal, the captain runs to the first member

of his team, grasps his hand, and runs back with him to the turning line. The player whom the captain brought over returns and brings the next player back. The relay con-tinues until the last man has been rescued and brought over to the captain's line.

Intermediate games

Jump the brook

Behavioral objective: To successfully jump in-creasing distances.
Developmental goal: Leg strength and coordina-tion.
Space and equipment: Multipurpose play area.
Number of players: Entire class.

Procedure: Two lines are drawn about 2 feet apart at one end and 6 feet apart at the other end. The children stand in single file formation about 10 to 15 feet away from the lines, which represent the sides of a brook. Each child in turn runs forward and jumps across the brook and continues to jump in line, increasing the width each turn. The child jumping at the widest part without stepping in the brook is the winner. Failure is kept to a minimum, since each child picks his own width for the jump. The children should be encouraged to try to increase their jumps each time the game is played (Fig. 13-6).

Two deep

Behavioral objective: To tag a person and to avoid being tagged.
Developmental goal: Endurance and agility.
Space and equipment: Multipurpose play area.
Number of players: 10-30.

Procedure: The children form a single circle and face the center, standing an arm's length apart. One child is chosen to be the runner, and another, the chaser. The chaser tries to tag the runner, who tries to escape being tagged by running around the outside

Fig. 13-6. Jump the brook.

Fig. 13-7. Two deep.

of the circle *for a short distance* and then stopping in front of a circle player, where he is safe from the chaser. The runner plus the one in front of whom he has taken refuge make the circle two persons deep at that point; the player at the rear therefore becomes the runner (Fig. 13-7). If the runner is caught, he becomes the chaser and the chaser becomes the runner. If a chaser is unable to tag a runner, the teacher may change directions, making the chaser the runner and thus allowing him to become safe by being two deep.

Touchdown

Behavioral objective: To transport an object across an opposing team's goal line without being tagged.
Developmental goal: Strategy and cooperation.
Space and equipment: Multipurpose play area.
Number of players: 10-30.

Procedure: The children form teams. The teams stand in single lines on opposite goal lines and face each other. The members of one team go into a huddle and decide who will carry an object, such as a small rock, stick, or chalk, to the opposite goal line. Each child holds his hands as if he were carrying the object. On a signal, the members of the team with the object run toward the opposing team's goal line and the opponents run forward to tag them. When a child is tagged, he opens both hands to show whether or not he is carrying the object. If the child carrying the object can get to the

opponents' goal line without being tagged, he calls out the word "touchdown" and scores one point for his team, and his team gets another turn. If he is caught, the object is given to the other team, and play is repeated, with the members of the other team going into a huddle to decide how to get the object across the field.

Stealing sticks

Behavioral objective: To retrieve an object and to avoid being tagged.
Developmental goal: Agility, speed, and strategy.
Space and equipment: Multipurpose play area and sticks or beanbags.
Number of players: 6-20.

Procedure: The children divide into two equal teams. The team members stand in their own territory scattered between the center line and their own goal and face the opposing team's goal. Each team selects a captain, who may, if he wishes, appoint some of the players as runners and some as guards to protect their own goal. The guards may not stand closer than 12 feet to their own goal, but they may approach it if they are attempting to tag an opposing runner.

The object of the game is for members of a team to run to their opponents' goal and secure their opponents' sticks. Runners are allowed to take only one stick a trip. Players may be caught as soon as they have both feet in the enemy's territory. To escape being tagged, they may return to their own side of the center line as often as they desire. If caught, players are taken to their captors' prison and must stand there until rescued by someone from their own team. While prisoners, they may reach out toward the approaching runners but must keep both feet behind the prison lines. Runners may not take any sticks from their opponents' goal while any member of their team is in prison; the prisoners must be rescued first. If the runners reach prisoners without being tagged, prisoners and their rescuers return to their own side in safety. Runners may rescue only one prisoner each trip. Runners successful in reaching their opponents' goal, take a stick and return to their own side in

safety. The game is won by the team whose members first carry away all of their opponents' sticks.

Streets and alleys

Behavioral objective: To tag and to avoid being tagged.
Developmental goal: Auditory perception and agility.
Space and equipment: Multipurpose play area.
Number of players: 20-30.

Procedure: The children stand in four to six parallel lines, with an extended arm's distance in all directions. A runner and a chaser are chosen. The children all face the same direction and join hands with those on each side, forming streets between the rows. To form alleys, they drop hands, turn sideways, and grasp hands in the opposite direction. The chaser tries to tag the runner; they go up and down the streets but cannot break through or go under arms. The leader aids the runner by calling for streets or alleys at the proper time so that passage is blocked for the chaser. When the runner is caught, the chaser and the runner choose two other children to take their places.

Steal the bacon

Behavioral objective: To retrieve an object and to return home safely.
Developmental goal: Agility and strategy.
Space and equipment: Multipurpose play area and beanbag, eraser, or similar object.
Number of players: 10-30.

Procedure: The children form two teams and line up facing each other. The team members are numbered consecutively from 1 to 15. A beanbag or eraser is placed in the center between the two lines. The teacher calls a number, and the players with that number from opposing teams try to retrieve the "bacon" without being tagged by the opposing player. If player 2 from team A picks up the bacon first, player 2 from team B tries to tag him before he crosses his home line. A point is scored each time the bacon is retrieved safely. So that there is

more activity and participation, a number of games with smaller teams can be played simultaneously.

Treasure Island

Behavioral objective: To retrieve an object and to avoid being tagged.
Developmental goal: Agility and strategy.
Space and equipment: Multipurpose play area and beanbag, towel, ball, or other object.
Number of players: 8-20.

Procedure: The children form a circle. One child is chosen to be the pirate and stands in the center circle near the treasure (beanbag) while the rest of the children stand outside Treasure Island (the center circle). Players run onto the island at will to try to take the treasure and get off the island without being tagged by the pirate either before or after taking the treasure. If a player is tagged, he is eliminated from the game. The player who succeeds in getting the treasure off the island without being tagged becomes the pirate. The game starts again with those who were tagged rejoining the game.

Intermediate ball games

Ball passing

Behavioral objective: To pass and receive an object accurately.
Developmental goal: Eye-hand coordination, team work, and quickness.
Space and equipment: Multipurpose play area and balls or beanbags.
Number of players: 6-40.

Procedure: The children divide into two or more teams, depending on the number of children playing. Each team is given a name or number. The players of each team form a single circle and face the center. The teacher starts an object around the circle and then additional objects or balls until five or six are being passed. The game is played for a given number of minutes, with as many repetitions as desired. Those children who miss an object or ball must retrieve it and put it into play as soon as

possible. The player must call loudly the name or number of his team when he misses an object. Each time he drops or misses an object, it scores a point for his team, but he remains in the game. The team with the lowest score at the end of the playing time wins. The game is more exciting when the objects passed vary in size and type.

Team dodge ball

Behavioral objective: To hit a moving target with a ball.
Developmental goal: Agility and coordination.
Space and equipment: Multipurpose play area and playground ball.
Number of players: 10-30.

Procedure: The children form two teams. One team forms a circle, and the other team stands inside it. The children on the circle team attempt to hit players in the middle of the circle with the ball. Soft playground balls should be used rather than soft soccer balls. Only hits below the waist count. Play continues for a specified length of time (2 to 4 minutes), and then the teams change places. The team with the most players left in the circle wins. A variation can be played in which each player who is hit joins the circle as a thrower and the last remaining child is the winner.

Keep away

Behavioral objective: To throw a ball to a teammate and to keep the ball away from an opponent.
Developmental goal: Endurance and eye-hand coordination.
Space and equipment: Multipurpose play area and playground ball.
Number of players: 8-16.

Procedure: The children divide into two teams of equal size, and members of both teams scatter around the playing area. The teacher hands the ball to one player. On a signal, the players pass the ball, trying to give it to teammates and to keep it away from opponents. There is a limit of 5 seconds to how long players may hold the ball before passing it to another teammate, so

that one player cannot keep the ball out of play. There is no scoring. The object is to see which team has the ball when time is called.

Fouls: Tripping, pushing, holding, kicking, or any other outstanding roughness is a foul and results in the ball's being given to the opposite team. A player is eliminated from the game if his play continues to be rough.

Four square

Behavioral objective: To bounce a ball accurately into another square.
Developmental goal: Eye-hand coordination.
Space and equipment: Four-square markings and playground ball.
Number of players: 4.

Procedure: The four squares are labeled A, B, C, and D. One child stands inside each square, and the other children line up outside square D. The serve always starts from square A. The child serves the ball by dropping it and serving it underhanded on the bounce. The server can hit the ball to any one of the other three squares. If the serve hits a line, it is considered a foul. The player receiving the ball must keep it in play by striking it after it has bounced once in his square (Fig. 13-8). He directs it to another square with an underhand hit. Play continues until one player fails to return the ball or commits a foul. If a player in squares A, B, or C misses or commits a foul, he drops back a square and the player in the next square moves up. If the player in square D misses or commits a foul, he goes to the end of the waiting line and the player at the head of the waiting line moves into square D. The player in square A at the end of the period is declared the winner.

Fouls: The fouls are as follows:
1. The player hits the ball with the side of his arm or overhand.
2. The ball lands on a line between the squares.
3. The player steps in another square to play the ball.

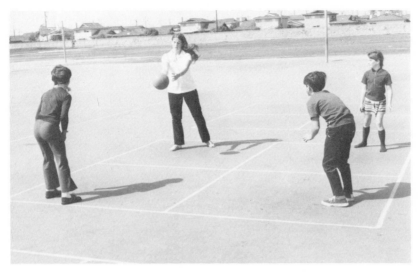

Fig. 13-8. Children playing four square.

4. He catches or carries a return volley.
5. He allows the ball to touch any part of his body except his hands.

Tetherball

Behavioral objective: To hit a moving target with the hand and to wind a ball around a pole.
Developmental goal: Eye-hand coordination.
Space and equipment: Tetherball court and tetherball.
Number of players: 2.

Procedure: One child stands on each side of the pole. The server puts the ball in play by standing in the service area, tossing the ball in the air, and hitting it in the direction he chooses. The opponent hits the ball back in the opposite direction. Each player tries to hit the ball so that the rope winds completely around the pole in the direction he has been hitting the ball and above the mark on the pole about 4 feet from the top (Fig. 13-9). Whenever a player commits a foul, his opponent receives a free hit. The free hit is taken like the serve, with the exception that the rope may not be unwound more than one-half turn before the hit is taken. The winner of the game serves to the next opponent.

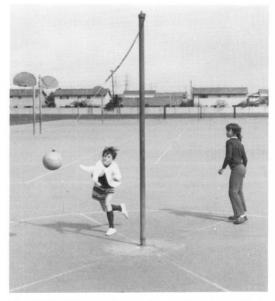

Fig. 13-9. Children developing eye-hand coordination through playing tetherball.

Fouls: The fouls are as follows:
1. The player hits the ball with any part of his body other than his hands or forearms.
2. He catches or holds the ball during play.
3. He touches the pole.
4. He hits the rope with his forearm or hand.
5. He throws the ball.
6. He winds the ball around the pole below the mark.
7. He steps into the neutral area around the pole.
8. He reaches into his opponent's court.

Battle ball

Behavioral objective: To kick a ball across an opposing team's goal line and to stop the ball from crossing one's own goal line.
Developmental goal: Coordination and team work.
Space and equipment: Multipurpose play area and soccer ball.
Number of players: 10-12 on each team.

Procedure: The teacher draws two parallel lines 20 feet apart. The children divide into two teams. One team stands on each line, and the players hold hands. Team 1 tries to kick the soccer ball across team 2's goal line, then team 2 tries to stop the ball and kick it back across team 1's goal line, and so on. When a team kicks the ball over the opposing team's line, it receives one point. If a player touches the ball with his hands, his team loses a point. If a player kicks the ball too high (over the heads of the other team), one point is deducted from his team's score. The team that first reaches a score decided on by the teacher wins the game.

Boundary ball

Behavioral objective: To throw a ball across an opposing team's goal line and to keep the ball from crossing one's own goal line.
Developmental goal: Catching and throwing skills.

Space and equipment: Multipurpose play area and playground balls.
Number of players: 8-16.

Procedure: The children divide into two teams. The players on each team occupy the area between their own goal line and the center line. The size of the court should be adjusted to the ability of the children. At a signal, the members of each team attempt to throw the ball so that it will bounce or roll across their opponents' goal line. The players try to prevent balls from crossing their own goal line. They may move about freely on their own side of the playing area but may not enter their opponents' territory. After the first throw, balls are thrown back and forth at will. Additional balls may be used to increase the activity. A player with the ball may not pass it to a teammate but must throw it himself. He may run with the ball to the center line before he throws it. After a goal is made, the ball is returned to the captain of the team that threw it and is put into play again.

Each ball that rolls or bounces over a goal line scores one point. Balls that cross a goal line on the fly or that pass outside the width of the goal line do not score. If a player steps on or across the center line, one point is given to his opponents. The team wins that has the higher number of points at the end of a specified time period.

Line dodge ball

Behavioral objective: To hit a moving target with a ball.
Developmental goal: Agility and throwing skill.
Space and equipment: Multipurpose play area and playground balls.
Number of players: 3-30.

Procedure: The teacher draws two parallel lines about 20 feet apart. Halfway between the lines, he draws a box about 4 feet square. One child is chosen to stand in the box. Half the children stand on one line, and half on the other line. The object of the game is to hit the player in the box at or below the waist with a ball. The center player may not step completely out of the box but may step out with one foot. When hit, the center player changes places with

Fig. 13-10. Captain ball court. Players inside the circles are forwards, and players outside the circles are guards.

the one who hit him. In order that each child may have an opportunity to throw, the ball should be started at one end of the line, and as it is returned from the other side, the next person in line should have a turn. Additional balls may be used to make the game more active.

Sports lead-up games

Captain ball

Behavioral objective: To develop passing and defensive skills as lead-up skills to basketball.
Developmental goal: Eye-hand coordination and team work.
Space and equipment: Basketball court and basketball.
Number of players: 24.

Procedure: The children divide into two teams and use pinnies or colored arm bands to distinguish the teams. Half the players of each team are forwards and the other half are guards. The forwards station themselves in the circles, and the guards stand near the forwards of the opposite side (Fig. 13-10). The ball is put into play in the center by the teacher, who tosses it to a guard of one team and thereafter to alternate teams if no score is made or to the team scored against when a point is scored. The guards try to get the ball and pass it to one of their forwards. The forwards try to pass it to their captain. One point is scored each time a successful pass is made from a forward to his captain. Forwards rotate one position clockwise, changing captain, and guards one position counterclockwise each time a point is scored or after every 3 minutes if no score

is made, so that the children have the chance to play in all positions on the court. The game is played in halves, with the guards and forwards changing places at the half.

Nine court basketball

Behavioral objective: To develop shooting, passing, and defensive skills as lead-up skills to basketball.
Developmental goal: Team work, sportsmanship, and eye-hand coordination.
Space and equipment: Basketball court and basketball.
Number of players: 18-30.

Procedure: The children divide into two teams and use pinnies or colored arm bands to distinguish the teams. They arrange themselves as indicated in Fig. 13-11. The teacher starts the game by tossing the ball to one of the players in the center and thereafter to alternate teams in the center if no score is made or to the team scored against when a point is scored. The center player attempts to pass the ball to his forwards (players closest to basket), who then attempt to shoot for a basket. Each basket that is made counts two points. The players rotate one court after each score or approximately every 2 to 3 minutes if no score is made.

Violations: The violations are as follows:
1. The player steps out of his own court.
2. He takes more than one step with the ball in his hand.
3. He bounces the ball more than once.

Fig. 13-11. Nine court basketball court. Opposing players are represented in each court area.

The penalty for a violation is that the ball is given to the opposite team out of bounds.

Fouls: Pushing, charging, tripping, and other rough play involving personal contact are personal fouls. The penalty for a foul is one free throw awarded to the team against whom the foul was made. The free throw is taken by the forward in the center court. If a forward is fouled in the act of shooting for a basket and misses the basket, two free throws are awarded. If the basket is made in spite of the foul, only one free throw is awarded.

Space ball

Behavioral objective: To throw a ball over the net out of the reach of an opponent and to catch a ball.
Developmental goal: Eye-hand coordination and agility.
Space and equipment: Volleyball court and volleyball.
Number of players: 10-15 on each team.

Procedure: The teacher lowers a volleyball net down to about 6 feet or strings a rope between two standards. The net height may be adjusted according to the skill level of the children. The children divide into two teams, and one team stands on each side of the net in a scattered formation. One team throws the ball over the net and the other team tries to catch it before it hits the ground and to return it over the net. When a team drops the ball or when a ball hits the court surface in bounds, the other team receives a point.

Bases on balls

Behavioral objective: To kick for distance and to run to bases.
Developmental goal: Eye-hand coordination and speed.
Space and equipment: Softball diamond and playground ball.
Number of players: 12-24.

Procedure: The children divide into two teams, and they are numbered consecutively on each team. Team A players stand behind the line connecting third and home bases, and player 1 goes to field balls within the diamond. Team B players line up behind the line connecting first and home bases, and player 1 stands behind home plate. The player at home base places the ball on the surface of home plate, and taking one step, he kicks the ball and immediately starts running around the bases. The runner tries to reach home base before the fielder returns to home plate with the ball. As soon as the fielder touches home plate with his foot or the ball while the ball is in his hand, the runner must stop where he is. The bases he has touched are recorded. His run is finished and he retires to the end position on his team. Player 2 on the kicking team then steps to home plate, and player 2 of the fielding team enters the diamond. When all members of the team have had a chance to kick the ball, the other team has its turn.

A ball that travels within the area outlined by home plate and first and third bases is a fair ball. If a fielder catches a fly ball, no score is made by the kicker, and new players from each team take their positions. A player is allowed a second kick if on the first try he fails to send the ball within the official boundaries. On a second failure, the player is retired to the end position on his team. The kicking team scores for each base reached before the fielder contacts home plate, as follows: one point for first base; two points for second base; three points for third base; and four points for home base. The team wins that has the highest number of points at the end of the playing period.

Kickball

Behavioral objective: To kick for distance and to run to bases.
Developmental goal: Eye-foot coordination, speed, and sportsmanship.
Space and equipment: Softball diamond and playground ball.
Number of players: 8-20.

Procedure: The children divide into two teams. One team stands behind the first base line, and each member takes his turn trying to kick the ball and run around the bases. The other team goes to the field, with a pitcher and catcher elected by the members (Fig. 13-12). After three members of the kicking team have been put out, the kicking team members go to the field and the fielding team members become the kickers. The game may be modified so that each team member has a chance to kick before the team goes to the field. The players rotate positions on the field so that all eventually have a chance to be pitchers and catchers.

The game is played according to softball rules, with the following exceptions:

1. The pitcher *rolls* the ball to the waiting kicker, who attempts to kick the ball into the field. To speed up play, each kicker may be allowed only one roll. If the player kicks the ball, he tries to run to first, second, third, and home bases before being tagged

or thrown out by the other team. He may not steal or play off bases while the pitcher has the ball in his hands in preparation for rolling it.

2. A base runner is out if he is tagged out or thrown out before reaching first, second, third, or home plate. He is tagged out if the ball is in the hands of the baseman or fielder when he tags the base runner. The runner is thrown out if the base is touched before the runner reaches it, either by the ball that is in the hands of a baseman or fielder or by some part of the body of a baseman or fielder who is holding the ball.

Each successful run to home plate scores one point. The team wins that has the higher score at the end of the time period.

Overtake ball

Behavioral objective: To run to bases quickly and to throw and catch accurately.
Developmental goal: Speed, accuracy, and eye-hand coordination.
Space and equipment: Double softball diamond and softball.
Number of players: 6-30.

Procedure: The children divide into six equal groups of base runners, pitchers, catchers, first basemen, second basemen, and third basemen. If, for example, there were 24 children in the class, there would be four in each group. Eight bases are placed around a diamond to form a double diamond (one base inside the other) (Fig. 13-13). On a signal, base runner 1 runs, using the inside diamond, to first base and continues on around until he arrives back at home plate. On the same signal, pitcher 1 throws the ball to catcher 1, who then throws it to first baseman 1, and so on, around the outside diamond. The object is for the runner to get home before the ball does. If the ball overtakes the runner at any base, he is out. After an out or a run is made by players 1, they all go to the end of their own line and players 2 continue the game. It is important for basemen to use the outside diamond for

Fig. 13-12. Kickball diamond.

Fig. 13-13. Overtake ball diamond.

throwing the ball in order to avoid hitting the runner with the ball. After all the players in each group have had their turn, each group rotates to a new position as shown in the diagram in Fig. 13-13 and as follows: Pitchers become catchers; catchers become base runners; base runners become first basemen; first basemen become second basemen; second basemen become third basemen; and third basemen become pitchers.

LEVEL 3 ACTIVITIES

Level 3 activities are team activities that require a high degree of skill. Successful performance in these activities is founded on the motor skills developed at the lower levels. Participation at this level should be limited to well-skilled chidren in order to provide fun and total involvement for all team members.

The games in level 3 can be organized for tournament play, and one class can challenge another class to play the games in league competition. Children who are not capable of successfully performing the skills

necessary in level 3 activities should be given individual help to improve their skills before they are selected as full-fledged team members.

Soccer activities

Circle soccer

Behavioral objective: To learn kicking skills as lead-up skills to soccer.
Developmental goal: Eye-foot coordination.
Space and equipment: Multipurpose play area and soccer ball.
Number of players: 20-30.

Procedure: The children divide into two teams and form a circle, each team making up half the circle. The members of each team try to kick the ball with the inside of the foot through the members of the other team and out of the circle. The players may block the ball with their body or legs or may trap it with their feet or knees, but they may not use their hands and arms. The ball should be momentarily stopped before it is kicked back across the circle. One point is given to a team when its members kick the

ball through the members of the other team, shoulder level or below. If a player kicks the ball beyond his own team's circle, one point is given to the opposing team. If a ball is kicked through the members of the defending team above shoulder level, one point is given to the defending team. The first team to reach ten points wins. The game also may be played for a specified time period.

Line soccer

Fig. 13-14. Line soccer field.

Behavioral objective: To develop skill in maneuvering around an opponent.
Developmental goal: Large-muscle development, eye-foot coordination, and agility.
Space and equipment: Multipurpose play area and soccer ball.
Number of players: 10 on a team.

Procedure: The children divide into teams, and the teams line up opposite each other as indicated in Fig. 13-14. On a signal, the runner at the right end of each line runs to the center and attempts to take possession of the ball in the center by pulling it back or to one side before dribbling it with his foot. He advances the ball by dribbling it up close to the opposing team's goal line in order to kick it through. The team members along the line defend their goal line, blocking the ball with any part of their body except their hands; they may use their hands and arms when they are held in contact with the body, but only to stop the ball, not to advance it. When the ball goes out over the sidelines, it is kicked in at the point where it left the field, by the nearest sideline guard of the team opposite the one that sent it out. A point is scored each time a runner kicks the ball through the opposing team's goal line. Even if the ball touches the body of a defending player, a point is scored. After each goal or on the teacher's command, the players rotate as follows: the runner becomes right guard, right guard becomes left guard, left guard moves into the space at the left end of the goal line, and all the players on the line

move one space to their right, that is, counterclockwise, or toward the position of the runner.

Fouls: The fouls are as follows:
1. The player touches the ball with his hands or arms above shoulder height.
2. He advances the ball with his hands or arms.
3. A line player or side guard plays in the center territory.
4. The player kicks the ball above shoulder height of his opponents. This is not a foul on a penalty kick, but no score is made. The players rotate, and the ball is put into play at the center.
5. The player pushes or holds another player or plays roughly.
6. On the initial play, he fails to pull the ball back or to one side and dribble it before kicking for a goal.
7. A line player or guard kicks the ball through the opposing team's goal line.
8. A runner dribbles the ball when taking a penalty kick.
9. An opposing runner crosses into the field of play before the ball reaches the goal line after a penalty kick.

The penalty for fouls is as follows: The runner on the opposing team is given a penalty kick from a mark 12 feet from the goal line. The free kick is a place kick, and the ball may not be dribbled. The runner of the offending team must go be-

hind his goal line and remain there until the ball reaches the goal line. If no score is made, the offending runner goes back into the field and the ball is put into play. If the runner of the offending team fails to stay behind his own goal line until the ball reaches the goal line and a goal is made, it is counted and the players rotate and the ball is put into play at the center as it is at the beginning of the game; if the runner fails to stay behind his line and the goal is missed, another penalty kick is awarded to the same player.

Alley soccer

Behavioral objective: To develop skill in maneuvering a ball around an opponent.

Developmental goal: Team work, sportsmanship, and eye-foot coordination.

Space and equipment: Alley soccer field and soccer ball.

Number of players: Two teams of 12 to 15 each.

Procedure: The children divide into two teams. Each team has three forwards. The field is divided into three long alleys, and each forward must stay inside his own alley at all times (Fig. 13-15). The other players on each team line up along the sidelines and the goal line of their own half of the field. No one may touch the ball with his arms or hands. One of the center players starts the game by kicking the ball ahead at an angle to one of his own forwards. They kick the ball to each other, trying to keep it away from their opponents, and move down the field. The forward who gets

Fig. 13-15. Alley soccer field.

control of the ball tries to kick it down the field and across the other team's goal line, below the heads of the players. If he kicks the ball across the goal line, the team scores a point. If the ball comes toward a player on the sidelines or goal line, he tries to keep the ball in play by kicking it to one of his forwards. If the ball goes over the sideline, it is brought inside and kicked by the nearest player on the team that did not send it out.

This game is an excellent lead-up activity to soccer, since the players are required to stay in their alleys and thus to keep their distance to receive a ball.

Fouls: The fouls are as follows:
1. The player touches the ball with his arms or hands.
2. He kicks the ball higher than a player's head.
3. A player other than a forward tries to score a goal.
4. The player pushes or trips another player or plays roughly.
5. He tries to block a free kick.
6. A forward steps outside his own alley.

When a foul is committed, a free kick is awarded to the opposing team.

Soccer

Behavioral objective: To execute the skills of kicking, dribbling, trapping, and passing in a game situation.

Developmental goal: Endurance and team work.

Space and equipment: Soccer field and soccer ball.

Number of players: Two teams of 11.

Procedure: The game of soccer involves the skills of running and kicking in which the ball is controlled by the foot. The ball may not be touched with the hands or arms. The ball is advanced toward the opposing team's goal with the foot, body, or head.

At the start of the game, the players are positioned as indicated in the diagram in Fig. 13-16. Each team consists of the goalie, right fullback, left fullback, right halfback, center halfback, left halfback, outside right

forward, inside right forward, center forward, inside left forward, and outside left forward. The forwards are primarily offensive players, and the halfbacks and fullbacks are primarily defensive players. It is decided which team will kick off. Then the center forward of the offensive, or kicking, team kicks the ball from the center circle toward a teammate. The ball must travel forward the length of its circumference. The opponents must remain outside the circle until the ball has been touched; then players on both teams may cross the center line and play the ball wherever it goes. They move the ball by dribbling it with the foot or passing it to another teammate. The team in possession of the ball tries to move it down the field and into the opposing team's goal. The defending players attempt to intercept the ball and reverse the direction of play.

Rules of play: Soccer rules discourage any unnecessary roughness. When unnecessary roughness takes place, the offending team is penalized; a free kick is given to the other team.

A penalty kick is awarded to the offensive team when a foul is committed in the penalty area by the defensive team. The penalty area is the largest rectangular zone around the goal (Fig. 13-16). The offensive team takes the penalty kick from the penalty mark while all the players except the goalie stand outside the penalty area.

A free kick is awarded to the opposing team for any fouls committed outside the penalty area. It is kicked from the spot of the foul. The opponents must remain at least 10 yards away until the ball is kicked.

Fig. 13-16. Soccer field.

If the ball is kicked over the sideline, it is put into play by the opposite team. A halfback usually puts the ball into play from the sideline by throwing the ball in with two hands overhead.

When the ball is kicked over the goal line but not through the goal by the offensive team, the goalie of the defensive team kicks the ball back into the game. The other team members must remain 10 yards away until the ball is kicked.

When the defensive team causes the ball to go over its own goal line, the offensive team gets a corner kick. This kick is taken by the outside forward from the corner of the field closest to the point where the ball went out of bounds.

Scoring: One point is awarded for each goal that is made. After a goal is scored, the team scored against kicks off.

Fouls: The fouls are as follows:
1. Carrying. The goalie takes more than two steps with the ball in his hands.
2. Handling. A player touches the ball with his hand or any part of his arm between the wrist and shoulder.
3. Pushing. A player moves an opponent away with his hands, arm, or body.

Privileges: The goalie has the following privileges:
1. He may pick up the ball with his hands.
2. He may punt the ball away from the goal line.
3. He may throw the ball away from his goal.
4. He may take only two steps with the ball.

The other players have the following privileges:
1. They may stop the ball with their feet.
2. They may dribble, pass, shoulder, or head the ball.
3. They may kick the ball to a teammate when trapped by an opponent.
4. They may stop the ball by blocking it with any part of the body except the hands or arms.

Speedball

Behavioral objective: To execute the skills of kicking, passing, dribbling, and trapping in a game situation.

Developmental goal: Eye-hand and eye-foot co-ordination, team work, sportsmanship, and endurance.

Space and equipment: Soccer field and soccer ball.

Number of players: 6-11 on a team.

Procedure: The children divide into teams as in soccer. One team is awarded the kickoff to start the game. The forwards of that team take their positions on the line with the ball, which is placed in the center of the field, or they may stand in any part of the field between the ball and their own restraining line, which is halfway between the center of the field and the goal. The backfield players of the team kicking off must be behind their own restraining line at the time of the kickoff. All players on the defending team must be behind their restraining line until the ball has been touched by the offensive team. The penalty for any infraction of these kickoff rules made by the attacking team is loss of the kickoff. If the foul is made by the defending team, the attacking team takes the kickoff over again 5 yards nearer the goal of the defending team.

The duty of the forwards is to attempt to move the ball into scoring position. The backs play a defensive game chiefly, attempting to secure the ball from the opposing forwards and pass it to their own forwards. The goalies protect their own goals. The forwards may not play behind their own restraining line. The backfield players may not advance beyond the opposing team's restraining line. The penalty for any infraction of the rules concerning playing zones is a free kick for any opponent on the restraining line where the foul occurred. During the free kick, the members of the offending team must be at least 5 yards away from the ball.

The ball must be played as in soccer unless it comes directly off the foot of a player, in which case the ball may be caught and played as in basketball. However, a ball bouncing up from the ground cannot be played with the hands. Only a ball kicked into the air may be caught and played as an aerial ball. A ball going over the sidelines or over the end lines and not between the goal posts (except on a touchdown) is kicked in by an opponent at the spot where the ball crossed the line. The players on the team that sent the ball out must be at least 5 yards away from the ball when it is kicked.

Scoring: A goal made as in soccer earns two points. A touchdown earns one point. A touchdown is a completed forward pass like in football and must be made from a player in the goal area to a player in the end zone. If a pass is not completed, is caught by an opponent, or is made by a player not in the goal area, the ruling is the same as for an out-of-bounds play, with no score. After a team scores, the team scored against kicks off.

Fouls: The fouls are as follows:
1. The player travels with the ball in his hands.
2. He holds the ball longer than 3 seconds.
3. He catches or touches the ball when it is not kicked into the air.

The penalty for fouls is as follows: Except for violation of the kickoff rule, the penalty for a foul is a free kick for the opponents. A free kick is a place kick taken on the spot where the foul occurred. The ball must be passed to another player within the field of play. It may be lofted to another player on the free kick to convert the play into an aerial play. A player may not loft the ball to himself on a free kick, nor may he score on a free kick. The players on the offending team must be at least 5 yards away from the ball when it is kicked.

Volleyball activity

Volleyball

Behavioral objective: To execute the skills of serving, receiving, pass-

ing, setting, and spiking in team play.

Developmental goal: Eye-hand coordination, strategy, and team work.

Space and equipment: Volleyball court and volleyball.

Number of players: 12-24.

Procedure: The children divide into two teams, and the teams stand on either side of a net. The player in the back right-hand corner on the serving team hits the ball from behind the back line over the net to the opposing team. If elementary school children do not have sufficient power to serve from the back line, the server may move up to an adjusted service line. The receiving team is allowed a maximum of three hits to return the ball. If the team members allow the ball to touch the ground, fail to return the ball over the net, hit the ball out of bounds, or catch, hold, push, or throw the ball, the serving team scores one point and the same person serves again. When the ball is returned to a server, it should be *rolled* under the net to avoid its being played. If the serving team members fail to get the serve over the net, hit the ball out of bounds, or catch, hold, push, or throw the ball, they score no point and the serve goes to the opposing team. When the service returns to the other team, this team rotates positions as shown in the diagrams in Fig. 13-17. The game may be played for a specified length of time or until one team reaches 15 points.

Basketball activities

Around the world

Behavioral objective: To develop the shooting skill as a lead-up skill to basketball.

Developmental goal: Individual skill development, eye-hand coordination, and object management.

Space and equipment: Basketball backboard and basketball.

Number of players: 3-5.

Procedure: The children stand behind the basket as indicated in Fig. 13-18. They take turns shooting the ball at the basket from each position shown in Fig. 13-18. After each shot, the waiting players retrieve the ball as the shooter moves to the next number. The player continues to shoot until he misses. When he takes his next turn, he begins at the spot where he last missed. The first player to succeed in scoring a basket from each position has traveled "around the world" and is declared the winner.

Twenty-one

Behavioral objective: To develop the shooting skill as a lead-up skill to basketball.

Developmental goal: Eye-hand coordination and object management.

Space and equipment: Basketball backboard and basketball.

Number of players: 3-5.

Procedure: This is a basket-shooting game.

For six players For nine players

Fig. 13-17. Volleyball rotations.

Fig. 13-18. Around the world.

The players take turns shooting. Each player takes a long shot and then a short shot. The long shot distance can be adjusted to the skill level of the children. The short shot should be taken from where the shooter catches the rebound. A player earns two points for a basket on a long shot and one point for a basket on a short shot. The player who gets 21 points first wins.

Basketball

Behavioral objective: To effectively execute the skills of dribbling, passing, and shooting in a competitive situation.
Developmental goal: Agility, endurance, and team work.
Space and equipment: Basketball court and basketball.
Number of players: 5 on a team.

Procedure: The children divide into two teams. Each team consists of two forwards, two guards, and a center. The forwards on the offensive team play near the opposing team's basket, the center plays in the center lane, and the guards play toward the center line. On the defensive team, the guards play near their own basket, the center plays in the center lane, and the forwards play toward the center line, ready to move toward the opposing team's basket. The game begins when the referee puts the ball into play by tossing it up between the two centers. Each center tries to tap it to one of his own teammates. The team who gets the ball passes or dribbles it among its players in an attempt to move it down the court toward the opposing team's goal (Fig. 13-19). Play continues until a basket is made or a foul is called. Any player may shoot for the basket. When a basket is made, the team scores two points. After each basket is made, the ball is given to one of the guards of the opposite team, who throws it in to a teammate, who moves it down the court in an attempt to score. When two or more opposing players have a firm hold on the ball with one or both hands, a held ball is called. The referee tosses the ball up between two of the opposing players involved as at the start of the game. A game consists of four 6-minute periods with 2 minutes between quarters and 10 minutes between halves.

Fouls: The breaking of a rule constitutes a foul if it is flagrant. The personal fouls

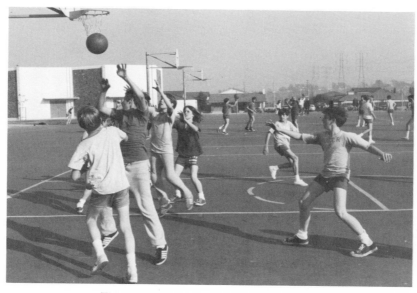

Fig. 13-19. Team competition in basketball.

are blocking, pushing, holding, tripping, or charging an opponent. Five personal fouls put a player out of the game. The penalty for a foul is a free throw for the opposite team; if a foul occurs while a player is shooting, two free throws are given to the player attempting the shot. A free throw that results in a basket counts one point.

Violations: The breaking of a rule constitutes a violation if it is of a lesser degree. Violations are stepping over the line on a free throw, throwing the ball out of bounds, taking steps with the ball, and beginning a second dribble before shooting or passing. A violation results in the ball's being given to the other team out of bounds.

Handball activity

One-wall handball

Behavioral objective: To execute serving and striking skills in a game situation.
Developmental goal: Eye-hand coordination and agility.
Space and equipment: Handball courts or building wall.
Number of players: 2-4.

Procedure: The children divide into teams, and two teams play each other. To begin the game, the serving team strikes the ball so that it hits anywhere on the front wall and then returns to the serving line.

Fig. 13-20. Children finishing 50-yard dash.

The receiving team may hit the ball on the fly or after it has bounced once. All the players must hit the ball with their hand. The players may not catch the ball and then hit it nor may they strike it with two hands simultaneously. Points are scored only by the serving team. The server continues to serve until he misses the ball. After each member of the team has lost his serve, the other team serves. The game may be played for a specified length of time or until one team reaches 21 points. Any building wall with a suitable playing surface may be used.

Sprinting activity

50-yard dash

Behavioral objective: To run fast on a signal.
Developmental goal: Large-muscle development, speed, coordination, and cardiorespiratory endurance.
Space and equipment: Running track or multipurpose play area.
Number of players: 1-30.

Procedure: Selected groups of children race each other until all of them have raced (Fig. 13-20). Then the teacher should match runners according to ability for subsequent races. It may motivate the children more for the teacher to use a stopwatch and keep time.

Football activities

Punt-pass-kick

Behavioral objective: To develop punting, passing, and kicking skills as lead-up skills to flag football.
Developmental goal: Eye-hand and eye-foot coordination, object management, and strategy.
Space and equipment: Football field and football.
Number of players: 2-30.

Procedure: The children divide into two teams and space themselves evenly on opposite ends of the field. The object of the game is to drive the opposing team back and to score by punting, passing, or kicking the ball over the opposing team's goal line and not having it caught. The game is begun by one

Fig. 13-21. Child learning football skills.

team kicking the ball from the 40-yard line. The ball is then played from the place where it is caught or first touched and by the person who catches or touches it. Passing the ball over the goal line counts one point, punting it over the goal line counts two points, and place kicking it over the goal line counts three points. This game is excellent for developing football skills (Fig. 13-21). To vary the game, the players can be given giant steps for catching a ball—five for a punt, three for a place kick, and one for a pass. The players may save these steps and take them at any time during the game. This modification adds suspense and activity to the game, since the players take the steps prior to a kick in a attempt to catch the opponents off guard and move closer to scoring territory.

Flag football

Behavioral objective: To execute passing, punting, running, receiving, and blocking skills in a game situation.
Developmental goal: Large-muscle coordination, team work, and strategy.
Space and equipment: Football field and football.
Number of players: Two teams of 7.

Procedure: Each team tries to retain possession of the ball and advance it across the opposing team's goal line. The game involves most of the basic skills, strategies, and elements of team play found in American football but eliminates the hazards of

Fig. 13-22. Child using football skills.

blocking and tackling. The offensive team may advance the ball forward by running, passing, or kicking (Fig. 13-22). The center must snap the ball backward to a teammate in the backfield before any other player may advance the ball beyond the line of scrimmage. The defensive team has the right to intercept passes and return kicks. Blocking of punts and recovering of fumbles are not allowed.

Formation: The game begins with a kickoff. The players of each team stand in their own half of the field with their backs toward their own goal until the ball is kicked. The players on each team are the left end, center, right end, left halfback, fullback, right halfback, and quarterback. The players of the receiving team may line up in any formation they wish, provided they form no group interference and are behind a line 20 yards away from where the ball is put into play. On scrimmage plays, the offensive team must have at least three players on the line of scrimmage and four or less players at least 1 yard behind the line of scrimmage when the ball is put into play. The defensive team is allowed to use any formation.

Rules of play: The game is started with a kickoff from any point on the 20-yard line. The ball may be place kicked or punted. It must travel at least 20 yards before it is in play. If the ball goes out of bounds between the goal lines without being in the possession and control of a player of the receiving team, it must be kicked over again.

The receiving team is allowed four downs, or tries, to advance the ball from the point of possession to, or beyond, the next first-down zone in the direction of the opposing team's goal. If in four downs this is not accomplished, the ball goes over to the opponents.

The offensive team may elect to kick the ball from the line of scrimmage rather than to run with it or pass it. This option is used by a team on the fourth down when they are not in scoring territory or on an earlier down as a surprise tactic.

If a kicked ball is muffed, fumbled, or touched, it is dead where it first touches the ground and is awarded to the receiving team at that spot.

Scoring: The scoring is the same as in football. A running play or forward pass play that results in the ball's being carried over the goal line is a touchdown and scores six points. The team scoring a touchdown may receive an additional point by successfully carrying or passing the ball across the goal line from the 3-yard line. After each touchdown is made, the team that scored kicks off. A safety occurs when the offensive team is tagged behind its own goal line. A safety scores 2 points. After a safety occurs, the ball is put into play by a place kick or punt from the 20-yard line by the team scored on.

Fouls and penalties: The fouls are tripping, clipping, tackling, leaving the ground with the feet when blocking or pulling the flag, rough play, and unsportsmanlike conduct. The team who is fouled is awarded 5 yards from the spot of the foul. The captain of the team who is fouled has the option of accepting or declining the yardage. His decision is governed by whether or not the yardage gained on the play is greater than that awarded because of the foul. It is also a foul for a player to be offside. Offside occurs when any part of a player is ahead of the nearest end of the ball when the ball is put into play. The play is not called back until the ball is dead. A 5-yard penalty is assessed against the offending team from the position of the snap. All fouls committed by the defensive team result in the down's becoming the first one for the opponents except for offside, in which case the down remains the same and a 5-yard penalty is assessed against the defensive team.

Playing terminology and rules:
Blocking. Any player on the offensive team may interpose his body between an opponent and the ball carrier. The player must have both feet on the ground while executing the block. He should hold his forearms against

his chest when he makes contact with a defensive player.

Defensive team. This is the team that does not have the ball.

Flags. The flags are 18 inches long and 2 inches wide. Two flags are worn by all players and are located on each side of the waist.

Forward pass. A forward pass is one made by the offensive team forward from any point behind the line of scrimmage. Any player of either team may receive or intercept a forward pass. Forward passes are allowed only on a scrimmage play. A forward pass caught by a player before the ball touches the ground is a completed pass. If a forward pass is not completed, the ball is put into play at the position of the previous down.

Fumble. Loss of possession of the ball after it has been received is a fumble. The ball is dead at the spot where it touches the ground and belongs to the team in possession of the ball when the fumble occurred.

Huddle. The huddle is the group of players gathered together to call offensive and defensive plays.

Line of scrimmage. This is an imaginary line extending across the field where the ball is to be put into play.

Offside. This is an infraction in which any part of a player's body is ahead of the near end of the ball when it is put into play.

Out of bounds. A ball is out of bounds when the ball carrier steps on or outside a sideline or when the ball hits the ground on or outside the sideline.

Running play. An attempt to carry the ball through or around the defensive team is a running play.

Safety. A safety is an action in which a player attempting to advance the ball is downed behind his own goal line with the ball in his possession. The team scored on puts the ball into play by a free kick at the 20-yard line.

Snap. A snap is the action of a center passing the ball between his legs to a player in the backfield.

Tackling. This is an action in which the flag of the ball carrier is pulled and thrown to

the ground. The ball is declared dead at the point where the flag was pulled. Pushing or striking the ball carrier is penalized as unnecessary roughness. The defensive player must make a direct attempt to pull the flag.

Touchback. A touchback is an action in which a player who receives a ball behind his own goal, with the impetus coming from the opponents, downs it in his own end zone. The ball is taken out to the 20-yard line, where the receiving team puts it into play.

Use of hands. Defensive players may use their hands to protect themselves from offensive blockers and to get to the player with the ball. The use of their hands is restricted to touching the shoulders and body of attacking blockers. Offensive players may not use their hands in blocking defensive players.

Softball activities

Long ball

Behavioral objective: To develop throwing, running, catching, and batting skills as lead-up skills to softball.

Developmental goal: Eye-hand coordination, object management, and team work.

Space and equipment: Softball diamond, bats, softball, and catcher's mask.

Number of players: 6-20.

Procedure: The children divide into two teams, and the members are numbered. Each team elects a pitcher, catcher and long baseman, or players may rotate to such positions with the change of innings; the remaining members of each team are fielders. The teams alternate as batters and fielders. A batting tee may be used instead of a pitcher for beginning players. Each member of the batting team tries to bat the ball and run to long base, which is a circle position 5 yards past first base. A batter must continue to bat until he contacts the ball with his bat. The contact may result in a foul tip, a foul ball, or a fair hit. The batter may not be put out on strikes. The instant a batter

contacts the ball, no matter how lightly and regardless of whether the ball is fair or foul, he must drop his bat and run to long base. If it is a fair hit, the base runners try to run back across the safety line before being put out by the fielding team; if it is a foul hit, the runners wait at long base until a succeeding batter makes a fair hit and then try to run to safety. The members of the fielding team move about as necessary, except for the long baseman, who remains near the long base. When runners are returning from long base, the fielders should go with them and be ready to receive a thrown ball so that they can tag out one or more runners before they can cross the safety line.

Foul ball: A ball that lands outside or behind one of the lines between home and first bases and home and third bases is a foul ball. When a batter hits a foul ball, if he reaches long base, he must remain there until a succeeding player of his team makes a fair hit.

Fair ball: A batted ball that lands inside the base lines is a fair ball. When a batter hits a fair ball, he should attempt to make a round trip to long base and back home across the safety line. At the same time, any players at long base should attempt to complete their run. To score a legal run, each runner must cross the safety line at some point between the two ends of the line without being tagged with the ball by a fielder who has it in his hand.

Outs: A team is out after each member has had a time at bat. Outs for individual players occur under the following conditions:
1. A fly ball hit by the player is caught.
2. A foul tip hit by the player is caught.
3. A runner is thrown out before reaching long base. Runners cannot be thrown out when trying to cross the safety line. They must be tagged with the ball by a fielder who has it in his hand.
4. A runner going to long base or returning to the safety line is tagged with the ball by a fielder who has it in his hand.
5. A runner at long base but not in contact with the base is tagged with the ball.
6. A batter throws his bat as he starts for long base.

Scoring: Each time a runner reaches long base and on a fair hit returns successfully over the safety line, one run is scored. The team wins that has the higher number of points at the conclusion of the playing period.

Work-up

Behavioral objective: To execute the skills of batting, throwing, pitching, catching, and running in a game situation.
Developmental goal: Eye-hand coordination, team work, and sportsmanship.
Space and equipment: Softball diamond, bats, and softball.
Number of players: 12-15.

Procedure: The children are numbered. Player 1 is the catcher; player 2, pitcher; player 3, first baseman; player 4, second baseman; and player 5, third baseman. Three players are batters, and the rest are fielders. The first batter hits a pitched ball and runs to first base or farther as in regular softball. The second batter then takes his turn at bat. Each batter continues at bat until he is put out as in softball; and then he takes the place of the last fielder, and all the players move up one position. A fielder who catches a fly ball may exchange places with the batter immediately. If all three batters are on the bases at one time, the first batter is put out and takes the last place in the field.

Softball

Behavioral objective: To execute the skills of throwing, catching, batting, and running in a game situation.
Developmental goal: Object management, sportsmanship, and eye-hand coordination.

Fig. 13-23. Children practicing batting and fielding skills for softball.

Space and equipment: Softball diamond, softball, bats, and catcher's mask.
Number of players: 18-20.

Procedure: The children divide into two teams—one at bat and one in the field (Fig. 13-23). The players on the fielding team take positions as indicated in Fig. 13-24. The members of the team at bat should stand or sit side by side behind the first-base line. No warm-up of the next batter is allowed unless a protected on-deck area is available. Play should not begin until the catcher has put on a protective mask. The pitcher throws the ball *underhand* to the batter, who tries to bat the ball and run to first base. The batter may take as many bases as he can safely, or he may stay at first and be advanced by the next batter. A runner may advance only one base on an overthrow at any base. No stealing or leading off bases is allowed. A run is scored when a runner successfully tags all three bases and home plate without being put out. After the team at bat makes three outs, the

Fig. 13-24. Softball field positions.

teams change sides. The game may be modified according to individual preferences, as follows:

1. Each batter is allowed only one to three pitches.
2. All the team members are permitted to bat before the sides are changed.
3. No fast pitching is allowed.
4. The batting team provides its own pitcher.

Outs: A runner is put out under the following conditions:

1. The ball the batter hit reaches first base before he does. (The runner does not have to be tagged.)
2. A fly ball hit by the batter is caught and held by a fielder.
3. The runner is tagged with the ball by a fielder when running to second, third, or home base.
4. The runner fails to return to the base he left before the ball does when a fly ball is caught.
5. The batter strikes and misses three times, or three strikes are called. Fouls count as strikes on the first two strikes.
6. For safety reasons, throwing of a bat constitutes an out for elementary-school children.

Forced out play: If there is a runner on first base, if there are runners on first and second bases, or if the bases are loaded, the runner must advance to the next base when the next batter hits a fair ball. If a fly ball is hit and caught, a runner advancing a base must return and tag the base he left before the ball is thrown to the base or he is out.

On a fair hit in a force play, the base may be tagged instead of the runner.

Nationball activity

Nationball

Behavioral objective: To dodge, catch, or throw, a ball accurately.
Developmental goal: Endurance, strategy, and agility.
Space and equipment: Rectangular court with a center line (volleyball court) and a playground ball.
Number of players: Entire class.

Procedure: The children divide into two equal teams. Each team chooses two goalies (usually the best dodgers and throwers). The players take positions as indicated in Fig. 13-25. The team 1 goalies throw the ball at the team 2 players in the center. If a team 2 player is hit, he must go out. The person who is hit has the next throw after he goes out. Players are out of the game only if they drop the ball or are hit. If a team 2 player catches the ball without dropping it, he may then turn and throw it at the team 1 players in the next square. The goalies may throw the ball to their own team members, who work the ball back and forth and have the privilege of throwing at the opposite team from the center. Once a person is hit without catching the ball, he is out and joins his goalie and assists in catching the ball and throwing it at the players on the opposite team. When one person is left on a team, the goalies may go in, usually one at a time. The last team to have all its players put out wins.

RECOMMENDED READINGS

Fait, H. F.: Physical education for the elementary school child, ed. 2, Philadelphia, 1971, W. B. Saunders Co.
Kirchner, G.: Physical education for elementary school children, ed. 2, Dubuque, Iowa, 1970, William C. Brown Co., Publishers.
Smalley, J.: Physical education activities for the elementary school, Palo Alto, Calif., 1963, National Press Books.
Van Hagen, W., Dexter, G., and Williams, J. F.: Physical education in the elementary school, Sacramento, Calif., 1951, State Department of Education.

Fig. 13-25. Nationball court.

References

1. Adams, W. C., and McCristal, K. J.: Foundations of physical activity, Champaign, Ill., 1968, Stipes Publishing Co.
2. Arnheim, D. D., Auxter, D., and Crowe, W. C.: Principles and methods of adapted physical education, ed. 2, St. Louis, 1973, The C. V. Mosby Co.
3. Arnheim, D. D.: Area I physical activity, general stretching. In Larson, L. A., editor: Encyclopedia of sport sciences and medicine, New York, 1971, The Macmillan Co.
4. Arnheim, D. D.: A clinician's guide to the Institute for Sensory Motor Development. Unpublished manual, Department of Men's Physical Education, California State College, Long Beach, 1970.
5. Arnheim, D. D.: Consultation report of motor development program. Unpublished, Lincoln School, Paramount School district, Paramount, Calif., 1971.
6. Astrand, P., and Rodahl, K.: Textbook of work physiology, New York, 1970, McGraw-Hill Book Co.
7. Auxter, D.: Developmental physical training for better motor functioning, experimental edition, Western Pennsylvania Special Education Regional Resource Center, 1969.
8. Ayres, J.: Patterns of perceptual-motor dysfunction in children: a factor analytic study, Perceptual and Motor Skills 20:335, 1965.
9. Bannatyne, A., and Bannatyne, M.: Motivation management materials, Miami, Fla., 1970, Kismet Publishing Co.
10. Bannatyne, A., and Bannatyne, M.: Home behavior management chart for children, Miami, Fla., 1971, Kismet Publishing Co.
11. Barsch, R. H.: Achieving perceptual motor efficiency, vol. 1, Seattle, 1967, Special Child Publications, Inc.
12. Barsch, R. H.: Enriching perception and cognition, vol. 2, Seattle, 1968, Special Child Publications, Inc.
13. Barsch, R. H.: The perceptual motor myth. Report from Workshop, Whittier Area Co-operative Special Education Program, Feb. 11, Whittier, Calif.
14. Bateman, B. D.: Temporal learning, San Rafael, Calif., 1968, Dimensions Publishing Co.
15. Bayley, N.: The development of motor activities during the first three years, 1935, Society for Research in Child Development Monographs.
16. Bookwalter, K. W.: Physical education in the secondary schools, New York, 1964, The Center for Applied Research in Education, Inc.
17. Bookwalter, K. W., and Vanderzswaag, H. J.: Foundations and principles of physical education, Philadelphia, 1969, W. B. Saunders Co.
18. Bradfield, R. H., editor: Behavior modification, San Rafael, Calif., 1970, Dimensions Publishing Co.
19. Braley, W., Konicke, G., and Leedy, C.: Daily sensorimotor training activities, Freeport, N. Y., 1968, Educational Activities, Inc.
20. Broer, M. R.: An introduction to kinesiology, Englewood Cliffs, N. J., 1968, Prentice-Hall, Inc.
21. Bucher, C. A.: Foundations of physical education, ed. 6, St. Louis, 1972, The C. V. Mosby Co.
22. Carr, D. B., et al.: Sequenced instructional programs in physical education for the handicapped, Los Angeles City Schools Special Education Branch, Physical Education Project, Public Law 88-164, Title III, Dec. 1970.
23. Chaney, C., and Kephart, N. C.: Motoric aids to perceptual training, Columbus, Ohio, 1968, Charles E. Merrill Publishing Co.
24. Clarke, H. H.: Muscular strength and endurance in man, Englewood Cliffs, N. J., 1966, Prentice-Hall, Inc.
25. Clarke, H. H.: Application of measurement

to health and physical education, Englewood Cliffs, N. J., 1967, Prentice-Hall, Inc.

26. Clarke, H. H., editor: The totality of man, Physical Fitness Research Digest, series 1, no. 2, Oct. 1971, Presidents' Council on Physical Fitness and Sports, Washington, D. C.

27. Committee on Aging: The health aspects of aging, Chicago, 1959, American Medical Association.

28. Cooper, K. H.: The new aerobics, New York, 1970, Bantam Books, Inc.

29. Cowell, C. C., and Schwelin, H. M.: Modern principles and methods in secondary school physical education, ed. 2, Boston, 1964, Allyn & Bacon, Inc.

30. Cratty, B. J.: Developmental sequences of perceptual-motor tasks, Freeport, N. Y., 1967, Educational Activities, Inc.

31. Cratty, B. J.: Movement behavior and motor learning, ed. 2, Philadelphia, 1967, Lea & Febiger.

32. Cratty, B. J.: Development games for physically handicapped children, Palo Alto, Calif., 1969, Peek Publications.

33. Cratty, B. J.: Perceptual motor and educational processes, Springfield, Ill., 1969, Charles C Thomas, Publisher.

34. Cratty, B. J.: Active learning, Englewood Cliffs, N. J., 1971, Prentice-Hall, Inc.

35. Cratty, B. J.: Human behavior, Wolfe City, Texas, 1971, The University Press.

36. Cratty, B. J., and Martin, Sister M. M. Perceptual-motor efficiency in children, Philadelphia, 1969, Lea & Febiger.

37. Cratty, B. J., and Sams, T. A.: The body-image of blind children, New York, 1968, American Foundation for the Blind.

38. Cureton, T. K., Jr., et al.: Physical fitness appraisal and guidance, St. Louis, 1947, The C. V. Mosby Co.

39. Davis, C., and Wallis, E.: Toward better teaching in physical education, Englewood Cliffs, N. J., 1961, Prentice-Hall, Inc.

40. Davis, E. C., and Logan, G. A.: Biophysical values of muscular activity, Dubuque, Iowa, 1961, William C. Brown Co., Publishers.

41. Delacato, C.: The diagnosis and treatment of speech and reading problems, Springfield, Ill., 1963, Charles C Thomas, Publisher.

42. Delorme, T. L., and Watkins, A. L.: Progressive resistance exercise, New York, 1951, Appleton-Century-Crofts.

43. Denhoff, E.: Cerebral palsy—the preschool years, Springfield, Ill., 1967, Charles C Thomas, Publisher.

44. De Santis, G. J., and Smith, L. V.: Physical education programmed activities for grades K-6, Columbus, Ohio, 1969, Charles E. Merrill Publishing Co.

45. Dexter, G.: Instruction of physically handicapped minors in remedial physical education, Sacramento, 1970, Bureau of Health, Education, Physical Education, Athletics and Recreation, California State Department of Education.

46. Doll, E. A., editor: The Oseretsky tests, Minneapolis, 1946, American Guidance Service, Inc.

47. Drowatzky, J. N.: Physical education for the mentally retarded, Philadelphia, 1971, Lea & Febiger.

48. Educational Policies Commission: The central purpose of education, Washington, D. C., 1961, National Education Association.

49. Engstrom, G., editor: The significance of the young child's motor development, Washington, D. C., 1971, National Association for the Education of Young Children.

50. Espenschade, A. S.: The contributions of physical activity to growth, Research Quarterly, American Association for Health, Physical Education, and Recreation **31**:351-364, 1960.

51. Espenschade, A. S., and Eckert, H.: Motor development, Columbus, Ohio, 1967, Charles E. Merrill Publishing Co.

52. Fait, H. F.: Physical education for the elementary school child, ed. 2, Philadelphia, 1971, W. B. Saunders Co.

53. Fait, H. F.: Special physical education, Philadelphia, 1972, W. B. Saunders Co.

54. Falls, H. B., Wallis, E. L., and Logan, G. A.: Foundations of conditioning, New York, 1970, Academic Press, Inc.

55. Fisher, S., and Cleveland, S. E.: Body image and personality, ed, 2, New York, 1968, Dover Publications, Inc.

56. Fitness Series No. 1, Washington, D. C., 1958, American Association for Health, Physical Education, and Recreation.

57. Fleishman, E. A.: Examiner's manual for the basic fitness tests, Englewood Cliffs, N. J., 1964, Prentice-Hall, Inc.

58. Fleishman, E. A., Thomas, P., and Munroe, P.: The dimensions of physical fitness—a factor analysis of speed, flexibility, balance and coordination tests. Technical report no. 3, The Office of Naval Research, Department of Industrial Administration, and Department of Psychology, Yale University, New Haven, Conn., Sept. 1961.

59. Florentino, M. R.: Reflex testing methods for evaluating CNS development, Springfield, Ill., 1963, Charles C Thomas, Publisher.

60. Foundations and practices in perceptual motor learning—a quest for understanding, Washintgon, D. C., 1971, American Association for Health, Physical Education, and Recreation.

61. Frederick, A. B.: Tension control, Journal of Health, Physical Education, and Recreation **38**:42-44, 78-80, Sept. 1967.

62. Frankenburg, W. K., and Dodds, J. B.: The Denver developmental screening test, Journal of Pediatrics **71**:181-191, 1967.

63. Frostig, M.: Movement education: theory and practice, Chicago, 1970, Follett Publishing Co.

64. Frostig, M., and Maslow, P.: Move, grow, learn, Chicago, 1969, Follett Publishing Co.

65. Frostig, M., et al.: The Marianne Frostig developmental tests of visual perception,

Palo Alto, Calif., 1964, Consulting Psychologists Press.

66. Gesell, A., and Amatruda, C. S.: Developmental diagnosis, New York, 1947, Harper & Brothers.

67. Gesell, A., et al.: The first five years of life, New York, 1940, Harper & Brothers.

68. Getman, G. H.: The visuomotor complex in the acquisition of learning skills. In Hellmuth, J., editor: Learning disorders, vol. 1, Seattle, 1965, Special Child Publications, Inc.

69. Gilmore, A. S., and Rich, T. A.: Mental retardation: a programmed manual for recreation leaders, Tampa, Fla., 1965, MacDonald Training Center Foundation—Research and Education.

70. Glass, H.: Exploring movement, Freeport, N. Y., 1966, Educational Activities, Inc.

71. Godfrey, B. B., and Kephart, N. C.: Movement patterns and motor education, New York, 1969, Appleton-Century-Crofts.

72. Goodenough, F. L.: Measurement of intelligence by drawings, New York, 1926, Harcourt, Brace & Co.

73. Guide for programs in recreation and physical education for the mentally retarded, Washington, D. C., 1968, American Association for Health, Physical Education, and Recreation, National Education Association.

74. Hackett, L. C., and Jenson, R. G.: A guide to movement exploration, Palo Alto, Calif., 1967, Peek Publications.

75. Halsey, E., and Porter, L.: Physical education for children, New York, 1958, Holt, Rinehart and Winston, Inc.

76. Harris, J. A., et al.: Dance a while, Minneapolis, 1964, Burgess Publishing Co.

77. Harvat, R. W.: Physical education for children with perceptual-motor learning disabilities, Columbus, Ohio, 1971, Charles E. Merrill Publishing Co.

78. Hayden, F. J.: Physical fitness for the retarded, Toronto, 1964, Metropolitan Toronto Association for Retarded Children.

79. H'Doubler, M. N.: Movement and rhythmic structures, Madison, Wis., 1946, Kramer Business Service.

80. Health problems revealed during physical activity, Journal of Health, Physical Education, and Recreation **36:**6, Sept. 1965.

81. Hebb, D.: Organization of behavior, New York, 1949, John Wiley & Sons, Inc.

82. Hetherington, C. W.: The school program in physical education, New York, 1922, World Book Co.

83. Hettinger, T.: Physiology of strength, Springfield, Ill., 1961, Charles C Thomas, Publisher.

84. Homme, L.: How to use contingency contracting in the classroom, Champaign, Ill., 1970, Research Press.

85. Hughes, J. G.: Synopsis of pediatrics, ed. 3, St. Louis, 1971, The C. V. Mosby Co.

86. Ismail, A. H., and Gruber, J. J.: Integrated development, Columbus, Ohio, 1967, Charles E. Merrill Publishing Co.

87. Jacobson, E.: Progressive relaxation, Chicago, 1938, University of Chicago Press.

88. Jacobson, E.: Self operation control, Philadelphia, 1964, J. B. Lippincott Co.

89. Jensen, C. R., and Schultz, G. W.: Applied kinesiology, New York, 1970, McGraw-Hill Book Co.

90. Johnson, D. J., and Myklebust, H. R.: Learning disabilities, New York, 1967, Grune & Stratton, Inc.

91. Karpovich, P. V., and Sinnings, W. E.: Physiology of muscular activity, Philadelphia, 1971, W. B. Saunders Co.

92. Keeney, A. H., and Keeney, V. T., editors: Dyslexia: diagnosis and treatment of reading disorders, St. Louis, 1968, The C. V. Mosby Co.

93. Kendall, H. O., and Kendall, F. P.: Developing and maintaining good posture, Journal of the American Physical Therapy Association **49:**319-336, April 1968.

94. Keogh, J.: Motor performance of elementary school children, Los Angeles, 1965, Department of Physical Education, University of California.

95. Kephart, N. C.: The slow learner in the classroom, Columbus, Ohio, 1960, Charles E. Merrill Publishing Co.

96. Kiphard, E. J.: Bewegungs—und Koordinations shwachen in Grundschulater, Stuttgart, W. Ger., 1970, Karl Hofman Schorndorf Verlag.

97. Kirchner, G.: Physical education for elementary school children, ed. 2, Dubuque, Iowa, 1970, William C. Brown, Co., Publishers.

98. Kirchner, G., et al.: Introduction to movement education, Dubuque, Iowa, 1970, William C. Brown, Co., Publishers.

99. Klafs, C. E., and Arnheim, D. D.: Modern principles of athletic training, ed. 3, St. Louis, 1973, The C. V. Mosby Co.

100. Klasen, E.: Audio-visuo motor training with pattern cards, Palo Alto, Calif., 1970, Peek Publications.

101. Knapp, B.: Skill in sports, London, 1963, Routledge & Kegan Paul Ltd.

102. Kraus, H., and Roab, W.: Hypokinetic disease, Springfield, Ill., 1961, Charles C Thomas, Publisher.

103. Kraus, H., et al.: Minimum muscular fitness tests in school children, Research Quarterly, American Association for Health, Physical Education, and Recreation **25:**178-188, May 1954.

104. Laban, R.: The mastery of movement, ed. 2, London, 1960, MacDonald & Evans Ltd.

105. LaPorte, W. R.: The physical education curriculum, ed. 6, Los Angeles, 1955, College Book Store.

106. Larson, L. A., editor: Encyclopedia of sport sciences and medicine, New York, 1971, The Macmillan Co.

107. La Salle, D.: Rhythms and dances, New York, 1926, A. S. Barnes & Co.

108. La Salle, D.: Guidance of children through

physical education, New York, 1946, A. S. Barnes & Co.

109. Latchaw, M., and Egstrom, G.: Human movement, Englewood Cliffs, N. J., 1969, Prentice-Hall, Inc.

110. Learning to move—moving to learn: movement exploration and discovery, Los Angeles City Schools Division of Instructional Planning and Services, Instructional Planning Branch publication no. EC-260, 1968.

111. Leaver, J., et al.: Manual of perceptual-motor activities, Mafex Associates, Inc., Johnstown, Pa.

112. Le Winn, E. B.: Human neurological organization, Springfield, Ill., 1969, Charles C Thomas, Publisher.

113. Lind, A. R. ,and McNicol, G. W.: Muscular factors which determine the cardiovascular responses to sustained and rhythmic exercise, Canadian Medical Association Journal 96: 707-713, 1967.

114. Logan, G. A.: Adapted physical education Dubuque, Iowa, 1972, William C. Brown Co., Publishers.

115. McAninch, M.: Body image as related to perceptual-cognitive motor disabilities. In Hellmuth, J., editor: Learning disorders, vol. 2, Seattle, 1966, Special Child Publications, Inc.

116. Mastropaolo, J. A., Director, Physiology of Exercise Laboratory, California State College, Long Beach: Consultation, 1972.

117. Mathews, D. K.: Beginning conditioning, Belmont, Calif., 1965, Wadsworth Publishing Co., Inc.

118. Montgomery, J., and McBurney, R. D.: Operant conditioning—token economy, Camarillo, Calif., 1970, Child Health and Human Development Center, Camarillo State Hospital.

119. Morgan, R. E., and Adamson, G. T.: Circuit training, London, 1958, G. Bell & Sons Ltd.

120. Mosston, M.: Developmental movement, Columbus, Ohio, 1965, Charles E. Merrill Publishing Co.

121. Mosston, M.: Teaching physical education, Columbus, Ohio, 1966, Charles E. Merrill Publishing Co.

122. Mourouzis, A.: Body management activities, Cedar Rapids, Iowa, 1970, Nissen Co.

123. Mueller, G. W., and Christaldi, J.: A practical program of remedial physical education, Philadelphia, 1966, Lea & Febiger.

124. Nixon, J. E.: Flanagan, L., and Frederickson, F. S.: An introduction to physical education, ed. 6, Philadelphia, 1964, W. B. Saunders Co.

125. O'Donnell, P. A.: Motor and haptic learning, San Rafael, Calif., 1969, Dimensions Publishing Co.

126. Olson, E. C.: Conditioning, Columbus, Ohio, 1968, Charles E. Merrill Publishing Co.

127. Orff-Schülwerk: A means or an end? The School Music News, New York School Music Association 31:5-8, Jan. 1968.

128. Oxendine, J. B.: Psychology of motor learning, New York, 1968, Appleton-Century-Crofts.

129. Patterson, G. R., and Gullion, M. E.: Living with children, Champaign, Ill., 1968, Research Press.

130. Perceptual-motor foundations: a multidisciplinary concern. Proceedings of the Perceptual-Motor Symposium sponsored by the Physical Education Division of American Association for Health, Physical Education, and Recreation, Washington, D. C., 1969.

131. Pestolesi, R. A.: Critical teaching behaviors affecting attitude development in physical education. Unpublished doctoral dissertation, University of Southern California Graduate School, Los Angeles, 1968.

132. Pestolesi, R. A.: Strategy and tactical play. In Hall, T. J., editor: The fundamentals of physical education, Pacific Palisades, Calif., 1969, Goodyear Publishing Co., Inc.

133. Petitelerc, G.: Body image and body awareness. In Arena, J. I., editor: Teaching through sensory-motor experiences, San Rafael, Calif., 1969, Academic Therapy Publications.

134. Physical Education Framework Committee: Physical education framework for California public schools (tentative), Sacramento, 1969, California State Department of Education.

135. Physical education handbook, Fullerton Elementary School District (kindergarten, first, second, and third grades).

136. Physical education in early childhood, Curriculum Bulletin 2a-8, Miami, Fla., 1969, Dade County Board of Public Instruction.

137. Piaget, J.: The origins of intelligence in children, New York, 1936, New York University Press.

138. Rarick, G. L.: Science and medicine of exercise and sports. In Johnson, W. R., editor: Exercise and growth, New York, 1960, Harper and Brothers.

139. Rasch, P. J., and Burke, R. K.: Kinesiology and applied anatomy, Philadelphia, 1967, Lea & Febiger.

140. Rathbone, J. L.: Relaxation, Philadelphia, 1969, Lea & Febiger.

141. Rekstad, M. E., editor: Promising practices in elementary school physical education, Washington, D. C., 1969, American Association for Health, Physical Education, and Recreation.

142. Roach, E. G., and Kephart, N. C.: The Purdue perceptual-motor survey, Columbus, Ohio, 1966, Charles E. Merrill Publishing Co.

143. Robb, M. D., et al., editors: Foundations and practices in perceptual motor learning, Washington, D. C., 1971, American Association for Health, Physical Education, and Recreation.

144. Schurr, E.: Movement experiences for children, Des Moines, Iowa, 1967, Meredith Corporation.

145. Scott, M. G.: Analysis of human motion, ed. 2, New York, 1963, Appleton-Century-Crofts.

146. Seefeldt, V.: Perceptual motor skills, Bloomington, Ind., 1970, Indiana University, Phi Epsilon Kappa Fraternity.

147. Sehon, E., et al.: Physical education methods for elementary schools, Philadelphia, 1953, W. B. Saunders Co.

148. Sequenced instructional programs in physical education for the handicapped, Los Angeles City Schools Special Education Branch, Physical Education Project, Public Law 88-164, Title III, 1970.

149. Sigerseth, P. O.: Physical activity: general flexibility. In Larson, L. A., editor: Encyclopedia of sport sciences and medicine, New York, 1971, The Macmillan Co.

150. Singer, R. N.: Motor learning and human performance, New York, 1968, The Macmillan Co.

151. Skinner, B. F.: Science and human behavior, New York, 1953, The Macmillan Co.

152. Smalley, J.: Physical education activities for the elementary school, Palo Alto, Calif., 1963, National Press Books.

153. Smith, H. M.: Implications for movement education experiences drawn from perceptual motor research, Journal of Health, Physical Education, and Recreation, National Education Association **41**:30-33, April 1970.

154. Smith, H. M.: Motor activity and perceptual development, Journal of Health, Physical Education, and Recreation, National Education Association **39**:28-33, Feb. 1968.

155. Staley, S. C., et al.: Exercise and fitness, Chicago, 1960, The Athletic Institute.

156. Stein, J.: A clarification of terms, Journal of Health, Physical Education, and Recreation, National Education Association **42**:63-68, Sept. 1971.

157. Stewart, M. A.: Hyperactive children, Scientific American **222**:94-99, April 1970.

158. Stott, D. H., Moyes, F. A., and Headridge, S. E.: Test of motor impairment, Centre for Educational Disabilities, University of Guelph, Guelph, Ont., Can.

159. Sweeney, R. T., editor: Selected readings in movement education, Reading, Mass., 1970, Addison-Wesley Publishing Co., Inc.

160. U. S. Bureau of Education Bulletin No. 35, Washington, D. C., 1918, Government Printing Office, pp. 5-10.

161. Valett, R. E.: The remediation of learning disabilities, Belmont, Calif., 1967, Fearon Publishers.

162. Van Hagen, W., Dexter, G., and Williams, J. F.: Physical education in the elementary school, Sacramento, Calif., 1951, State Department of Education.

163. Van Witsen, B.: Perceptual training activities handbook, Columbia University, New York, 1967, Teachers' College Press.

164. Wells, K. F.: Kinesiology, ed. 5, Philadelphia, 1971, W. B. Saunders Co.

165. Wickstrom, R. L.: Fundamental motor patterns, Philadelphia, 1970, Lea & Febiger.

166. Williams, J. F.: The principles of physical education, Philadelphia, 1964, W. B. Saunders Co.

167. Wilson, J. A., and Robeck, M.: Kindergarten evaluation of learning potential, New York, 1967, McGraw-Hill Book Co.

168. Wilson, J. A., and Robeck, M.: Psychological foundations of learning and teaching, New York, 1969, McGraw-Hill Book Co.

169. Wold, R. M., editor: Visual and perceptual aspects for the achieving and underachieving child, Seattle, 1969, Special Child Publications, Inc.

170. Zigmond, N. K., and Cicci, R.: Auditory learning, San Rafael, Calif., 1968, Dimensions Publishing Co.

Appendix I

Source material

SELECTED FILMS

Anyone Can. Rope skipping, ball handling, Stegel, and trampoline activities. Bradly Wright films, 309 N. Duane, San Gabriel, Calif. 91775. Color; 27 minutes; 1968; $240.00.

Bridges to Learning. Perceptual physical education program K-6. Palmer Films Inc., 611 Howard St., San Francisco, Calif. Color; 30 minutes; 1970; $250.00.

Creative Body Movements. Perceptual-motor and problem solving through movement activities K-3. Martin Moyer Productions, 900 Federal Ave., E. Seattle, Wash. 98102. Color; 11 minutes; 1969; $125.00.

Discovering Rhythm. Basic motor concepts related to rhythm. Universal Education and Visual Arts, 221 Park Ave. S., New York, N. Y. 10003. Color; 11 minutes; 1968; $120.00

Fun with Parachutes. Locomotor, game, and rhythmic activities. Educational Activities, Inc., Freeport, N. Y. 11520. Color; $135.00.

Innovations in Elementary Physical Education. Movement Activities K-6. Crown Films, 503 W. Indiana Ave., Box 890, Spokane, Wash. 99210. Color; 20 minutes.

Learning Through Movement. Creative expression from verbal and rhythmic cues. S and L Film Productions, 5126 Hartwick St., Los Angeles, Calif. 90041. Black and white; 32 minutes; 1966; $165.00.

Movement Exploration. Movement activities K-6. Documentary Films, 3217 Trout Gulch Rd., Aptos, Calif. 95003. Color; 20 minutes; $185.00.

Movement Exploration. Locomotor activities; Hula-Hoop, jump rope, and apparatus stations. Educational Activities, Inc., Freeport, N. Y. 11520. Color; $220.00.

Perk! Pop! Sprinkle! Visual perception with motoric responses K-3. Martin Moyer Productions, 900 Federal Ave., E. Seattle, Wash. 98102. Color; 11 minutes; 1969; $125.00.

Sensorimotor Training. Sensory-motor skills for preschool children. Valdhere Films, 3060 Val-leywood Dr., Kettering, Ohio. Color; 24 minutes; 1968; $135.00.

Sport Skills. Sport techniques for badminton, basketball, field hockey, football, golf, gymnastics, trampoline, ice hockey, volleyball, soccer, tennis, and track and field. The Athletic Institute, 705 Merchandise Mart, Chicago, Ill. 60654. Super 8 mm. loop cartridge films; $18.95 each.

What Am I. Discovering how the body moves K-3. Film Associates, 11559 Santa Monica Blvd., Los Angeles, Calif. 90025. Color; 11 minutes; 1968; $125.00.

EQUIPMENT AND MATERIAL SOURCES

Rhythm balls. AMF Voit catalog no. 672.

Physical activity charts. Balance beam skills, ball-handling skills, locomotor rhythms, striking skills, stunts, and tumbling. The Athletic Institute, 705 Merchandise Mart, Chicago, Ill. 60654.

Bulletin board charts. Football, basketball, baseball, gymnastics, soccer, golf, tennis, and volleyball. The General Tire and Rubber Company, Athletic Products Division, Jeannette, Pa. 15644.

Sensory-motor games and climbing apparatus. J. L. Hammatt Co., Physical Education Division, Hammatt Place, Braintree, Mass. 02184.

Table games. Gammatt and Sons, P.O. Box 2004, Anaheim, Calif. 92804.

Recreational games and nets. Catalog no. 971. Indian Head Recreational Products, Blue Mountain, Ala. 36201.

Mats, balance beams, net standards, and play-ground equipment. J. E. Gregory Co., W. 922 First Ave., Spokane, Wash. 99204.

Plastic sport equipment and recreational games. Cosom Safe-T-Play Products, 6030 Wayzata Blvd., Minneapolis, Minn. 55416.

Records, filmstrips, cassettes, and instructional media. Educational Activities, Inc., Freeport, N. Y. 11520.

Weight and exercise machines. Universal Athletic

Saler Company, 1328 N. Sierra Vista, Fresno, Calif. 93703.

Athletic equipment. Mats, apparatus, and lockers. Gymnastic Supply Company, 247 W. 6th St., San Pedro, Calif. 90733.

Sports equipment, nets, and gymnasium apparatus. J. Ayfro Corporation, 1 Bridge St., P. O. Box 50, Montville, Conn. 06353.

Safety mats for indoor-outdoor equipment. Mallott and Peterson-Guindy, 2412 Harrison St., San Francisco, Calif. 94116.

Incline mats, spot trainers, and creative shapes. Skill Development Equipment Company, 1340 N. Jefferson, Anaheim, Calif. 92806.

Gymnastic equipment, trampolines, and tumbling mats. AMF American Athletic Equipment Division, Box 111, Jefferson, Iowa 50129.

Customized and all-purpose gym mats. Resilite, P. O. Box 764, Sunburry Pa. 17801.

Field flags and obstacle markers. Flex-i-Flag Company, 2238 Buchanan St., N. E., Minneapolis, Minn. 55418.

Dance records and costumes. Pacific Dance Supplies, 1724 Taroval St., San Francisco, Calif. 94116.

Appendix II

The Basic Motor Ability Scale

BASIC MOTOR ABILITY TESTS
Circle jump*

Factors measured: The child's ability to maintain gross motor control and to retain balance and postural control throughout a vigorous twisting of the entire body.

Equipment: Line markings of a circle with a 3-foot diameter divided into eight separate parts (Fig. II-1, *A*).

*Adapted from Robert F. Adams and Louis J. Confessore, Department of Health and Physical Education, Dade County Public Schools, Miami, Fla.

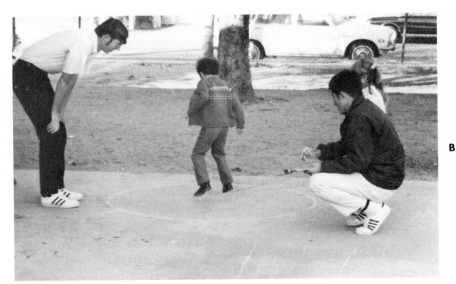

Fig. II-1. **A,** Circle jump marking. **B,** Circle jump test.

Regulations: The child stands in the center of the circle with feet comfortably spread apart and knees slightly bent. At a signal, he jumps in the air and attempts to twist around as far as possible (Fig. II-1, *B*). He repeats the test twice in both directions, and the best distance is recorded.

Scoring: The child is given the points nearest to the spot in which his trailing foot lands. Two points are added to the score when he maintains good balance on landing. Each direction is tested, with the results being added together to give a total score.

Beam walk

Factor measured: Mainly the child's ability to maintain dynamic balance.

Equipment: One board 2 inches by 4 inches and 10 feet long, raised 5 inches off the floor. Either two boards should be available or one board that is adaptable, so that the 2-inch surface and the 4-inch surface can be used separately.

Regulations: The child walks slowly and under control for ten steps forward heel to toe, ten steps backward heel to toe, and ten steps sideward foot to foot in each direction on the 2-inch and then on the 4-inch board surface.

Scoring: All steps are added together to make a total score. There is a maximum of 80 points.

Standing broad jump

Factor measured: The ability of the child to execute an explosive motor act.

Equipment: Tape measure or premeasured line marked off in inches.

Regulations: Standing with feet comfortably apart, the child swings his arms backward and bends his knees and then extends his knees and at the same time swings his arms forward and jumps as far as possible.

Scoring: The longest of three jumps is recorded. The distance is measured in inches from the point where the heel touches the floor nearest the point of takeoff.

Angels in the snow*

Factors measured: The child's ability to execute smooth bilateral, unilateral, and cross-lateral limb movements.

Equipment: Flat, smooth surface.

Regulations: Each child lies on his back with both arms at his side and feet together, separated from other children so that movement can be easily executed in all directions. The tester stands between two children at their feet and faces the children. The tester gives directions by touching his limb, as to which limb or limbs the children should move (Fig. II-2). For example, while touching his own left arm, he says to the children, "Move your arm on this side"; or while pointing to his leg, he says, "Move your leg on this side." The children move their limbs 8 to 12 times slowly at first and then gradually increase the tempo. All movements must be executed as smoothly as possible.

Scoring: There is a total of 15 points for the test. Each of the five movements receives a maximum value of three points—three points if the movements are accurate, are smooth, and can be done rapidly; two points if the movements are incon-

*Adapted from the Primary Motor Ability Test, Department of Health and Physical Education, Dade County Public Schools, Miami, Fla.

Fig. II-2. Testing angels in the snow.

sistent, that is, fast and then slow, range of limb movement is inconsistent, or action is not smooth; one point if the movement is very difficult for the child and there is general lack of limb control; and zero points if the child is unable to perform the movement.

One-foot balance stand

Factor measured: Ability of the child to maintain a static postural position with limited base of support.

Equipment: Two balance boards; two 2-inch-by-4-inch boards nailed to 12-inch-square bases, one nailed with the 2-inch side down (Fig. II-3, *A*) and the other with the 4-inch side down (Fig. II-3, *B*); and a stopwatch.

Regulations: The child stands on the balance board with the foot he prefers, with his hands on his hips (Fig. II-3, *C*).

At a signal, he takes a balance position on the board. He is tested on both widths with his eyes open and then with his eyes closed. The watch is stopped if the child removes a hand from his hip or if his raised foot touches the floor.

Scoring: Time in seconds is added together for the child's performances on both balance boards with his eyes open and with his eyes closed. Ten seconds is the maximum time for each performance, making a total of 40 seconds for the whole test.

Pegboard

Factors measured: Child's ability to manipulate small objects and to place them rapidly into holes.

Equipment: Pegboard and 30 pegs measuring $\frac{1}{16}$ inch in diameter and 1 inch long and a stopwatch.

Fig. II-3. A and **B**, Static balance test boards. **C**, Testing static balance.

Regulations: At a signal, the child rapidly picks up the pegs and places them one at a time into the pegboard holes. He places the pegs into any hole without regard for a pattern, in the time limit of 20 seconds per hand. The time for each hand is recorded separately.

Scoring: The number of pegs is counted for the performance with each hand.

Block transfer*

Factor measured: The speed of arm movement primarily; also manipulation and moving across the midline of the body.

Equipment: Twenty 1½-inch building blocks, commonly played with by very young children; two 9½-inch cigar boxes placed 30 inches apart; and a stopwatch.

Regulations: Twenty blocks are placed in one cigar box. The child stands between the two boxes and, on a signal, transfers as many blocks as

possible from one box to the other with, first, the left hand and then the right hand in 20 seconds for each hand.

Scoring: The number of blocks transferred with the left hand is added to the number for the right hand to form a total score.

Beanbag accuracy throw*

Factor measured: The child's eye-hand coordination.

Equipment: Five lines 6 inches long, spaced 3 feet apart and facing a wastebasket, and ten beanbags.

Regulations: After having two trials, the child attemps to throw two beanbags into the wastebasket from each of the five lines.

Scoring: Each beanbag successfully thrown into the basket scores two points; those hitting the basket but failing to enter it score one point.

*Adapted from Paul Sundstrom and Russell E. Orpet, Marianne Frostig Center of Educational Therapy, Los Angeles, Calif.

*Adapted from Jackson, R. D.: Measurements of achievement in fundamental skills of elementary school children, Research Quarterly **33:** 100-101, March 1962.

RECORD SHEET

Name_____Sex_____Tester_____

Motor factor	Test item	Score	Grade	Observations
Gross motor coordination	Circle jump			
Dynamic balance	Beam walk			
	Forward 4 inches			
	Backward 4 inches			
	Sideward left 4 inches			
	Sideward right 4 inches			
	Forward 2 inches			
	Backward 2 inches			
	Sideward left 2 inches			
	Sideward right 2 inches			
Explosive power	Standing broad jump			
Bilateral, unilateral and cross-lateral movement	Angels in the snow			
	Bilateral			
	Unilateral			
	Cross-lateral			
Static balance	One-foot balance			
	Eyes open, 4-inch board			
	Eyes closed, 4-inch board			
	Eyes open, 2-inch board			
	Eyes closed, 2-inch board			
Dexterity	Pegboard			
	Right hand			
	Left hand			
Arm speed	Block transfer			
	Right arm			
	Left arm			
Eye-hand coordination	Beanbag accuracy throw			

SCORING THE BASIC MOTOR ABILITY SCALE*

5 years of age

Grading	Gross motor coordination	Dynamic balance	Explosive power	Bilateral, unilateral, and cross-lateral movement	Static balance	Dexterity	Arm speed	Eye-hand coordination
Excellent	17+	70	45+	15	25+	20+	30+	15+
Good	15-16	65-69	38-44	11-14	23-24	18-19	25-29	14
Fair	10-14	35-64	13-37	7-10	10-22	9-17	17-24	6-13
Poor	9	34	12	6	9	8	16	6

6 years of age

Grading	Gross motor coordination	Dynamic balance	Explosive power	Bilateral, unilateral, and cross-lateral movement	Static balance	Dexterity	Arm speed	Eye-hand coordination
Excellent	19+	75	49	15	27+	23+	34+	17+
Good	16-18	70-74	42-48	11-14	18-26	19-22	31-33	16
Fair	12-15	40-69	25-41	6-10	13-17	11-18	18-30	8-15
Poor	11	39	24	5	12	10	17	7

*The Basic Motor Ability Scale battery was prepared by Dr. William A. Sinclair and Dr. Daniel D. Arnheim from a sample of 500 boys and 500 girls of primary age.

Appendix III

Movement observation survey

SELECTED CRITERIA FOR OBSERVATION

Relaxation

Factor measured: The ability of the child to let his arm become tensionless.

Equipment: Mat.

Regulations: While the child is in a supine (back-lying) position, the tester lifts the child's hand by the fingers off the mat (approximately 12 inches). The child relaxes his arm completely or as much as possible. The test is repeated three times.

Locomotion

Factor measured: The ability of the child to hop, or jump in place on one foot.

Equipment: Firm, flat surface.

Regulations: The child hops, first on one foot and then on the other, and then hops, alternating feet. He hops three times in each position.

Balance

Factor measured: The ability of the child to maintain a variety of static positions for 10 seconds on one foot.

Equipment: Firm, flat surface and stopwatch

Regulations: At a signal, the child takes a balance position and holds it for 10 seconds. He is allowed attempts at a position.

Posture control

Factor measured: The ability of the child to maintain proper postural control while airborne or rebounding.

Equipment: Any device that will spring the child into the air, such as an inner tube or a trampoline.

Regulations: The child springs up every time the tester claps his hands (in a rhythm of 40 beats per minute). The tester observes how well the child coordinates body parts and maintains a good balanced position.

Body image

Factor measured: The ability of the child to accurately, smoothly, and decisively imitate unilateral, bilateral, and cross-lateral movements.

Equipment: None.

Regulations: Standing and facing the tester, the child follows the movements of the tester exactly, as if he were looking into a mirror.

SENSORY-MOTOR OBSERVATION SURVEY SHEET

Name_____ Sex_____ Tester_____ Date_____

Motor task area	Specific task performance	Ratings (✓)					Comments
		1	2	3	4	5	
Relaxation	Let arm go limp 5—Arm falls completely limp						
	4—Arm falls with some tension						
	3—Arm falls with moderate tension						
	2—Arm falls stiffly						
	1—Arm is pulled down						
Locomotion	Hop 5—Hop easily done, alternating from one foot to the other						
	4—Hops not smooth						
	3—Cannot alternate feet						
	2—Can hop on one foot but not on the other						
	1—Unable to hop on one foot						
Balance	Static balance variations (held for 10 seconds) 5—Stork stands on each foot, hands over head (raised foot must touch opposite knee)						
	4—Stork stands on each foot, hands on hips						
	3—Stands on each foot, hands on hips						
	2—Stands on each foot, hands at side						
	1—Stands with feet together, on toes						
Posture control	Spring-O-Line, inner tube, or trampoline 5—Jumps are smooth and well co-ordinated						
	4—Feet are spread						
	3—Jumps stiffly						
	2—Emphasis on one side of body						
	1—Off balance, arms and legs moving at different times						
Body image	Movement mimicry 5—Imitates accurately, smoothly, and decisively						
	4—Imitates but not decisively						
	3—Imitates accurately but not smoothly and decisively						
	2—Imitates inaccurately						
	1—Unable to mimic						

Appendix IV

Standards for AAHPER
Youth Fitness Test and
Physical Fitness Profile*

AAHPER YOUTH FITNESS TEST

Boys or girls, K-4, flexed arm hang in seconds

	Age				
Percentile	5	6	7	8	9
100	80	95	105	113	122
95	37	40	43	45	49
90	29	32	35	38	42
85	24	27	29	32	34
80	20	22	24	26	28
75	18	20	21	23	24
70	16	18	19	21	22
65	14	16	17	19	20
60	12	13	14	16	17
55	10	11	12	14	15
50	8	9	10	11	12
45	7	8	9	10	11
40	6	7	8	9	10
35	5	6	7	8	9
30	4	5	6	7	8
25	3	4	5	6	7
20	2	3	4	5	6
15	1	2	3	4	5
10	1	1	2	2	3
5	1	1	1	1	1
0	0	0	0	0	0

*Standards for ages 5 through 9 modified from Educational Research Council of America Physical Education Program. Gabriel J. De Santis and Lester V. Smith. Cards 1357-1367. Copyright 1969 by Educational Research Council of America. Published by Charles E. Merrill Publishing Company, Columbus, Ohio. Standards for ages 10 through 14 from American Association for Health, Physical Education, and Recreation, Washington, D. C.

Girls, flexed arm hang in seconds

Percentile	Age				
	10	*11*	*12*	*13*	*14*
100	66	70	64	80	60
95	31	35	30	30	30
90	24	25	23	21	22
85	21	20	19	18	19
80	18	17	15	15	16
75	15	16	13	13	13
70	13	13	11	12	11
65	11	11	10	10	10
60	10	10	8	9	9
55	9	9	8	8	8
50	7	8	6	7	7
45	6	6	6	6	6
40	6	5	5	5	5
35	5	4	4	4	4
30	4	4	3	3	3
25	3	3	2	2	2
20	2	2	1	2	1
15	2	1	0	1	0
10	1	0	0	0	0
5	0	0	0	0	0
0	0	0	0	0	0

Boys, pull-ups

Percentile	Age				
	10	*11*	*12*	*13*	*14*
100	16	20	15	24	20
95	8	8	9	10	12
90	7	7	7	9	10
85	6	6	6	8	10
80	5	5	5	7	8
75	4	4	5	6	8
70	4	4	4	5	7
65	3	3	3	5	6
60	3	3	3	4	6
55	3	2	3	4	5
50	2	2	2	3	5
45	2	2	2	3	4
40	1	1	1	2	4
35	1	1	1	2	3
30	1	1	1	1	3
25	0	0	0	1	2
20	0	0	0	0	2
15	0	0	0	0	1
10	0	0	0	0	0
5	0	0	0	0	0
0	0	0	0	0	0

AAHPER PHYSICAL FITNESS PROFILE

Boys or girls, sit-ups

Percentile	Age 5	6	7	8	9
100	50	50	50	50	50
95	50	50	50	50	50
90	50	50	50	50	50
85	50	50	50	50	50
80	45	50	50	50	50
75	39	40	50	50	50
70	33	34	45	50	50
65	30	31	40	47	50
60	27	28	36	45	49
55	23	25	30	40	44
50	21	23	38	36	39
45	20	22	25	33	35
40	18	20	22	30	31
35	16	19	20	27	29
30	14	17	18	24	26
25	11	14	16	21	24
20	9	12	14	19	22
15	6	8	12	16	19
10	4	6	10	13	16
5	1	3	5	7	9
0	0	0	0	0	1

Boys and girls, sit-ups

Percentile	Boys Age 10	11	12	13	14	Girls Age 10	11	12	13	14
100	100	100	100	100	100	50	50	50	50	50
95	100	100	100	100	100	50	50	50	50	50
90	100	100	100	100	100	50	50	50	50	50
85	100	100	100	100	100	50	50	50	50	50
80	76	89	100	100	100	50	50	50	50	49
75	65	73	93	100	100	50	50	50	50	42
70	57	60	75	99	100	50	50	50	45	37
65	51	55	70	90	99	42	40	40	40	35
60	50	50	59	75	99	39	37	39	38	34
55	49	50	52	70	77	33	34	35	35	31
50	41	46	50	60	70	31	30	32	31	30
45	37	40	49	53	62	30	29	30	30	27
40	34	35	42	50	60	26	26	26	27	25
35	30	31	40	50	52	24	25	25	25	23
30	28	30	35	41	50	21	22	22	22	21
25	25	26	30	38	45	20	20	20	20	20
20	23	23	28	35	40	16	19	18	19	18
15	20	20	25	30	36	14	16	16	15	16
10	15	17	20	25	30	11	12	13	12	13
5	11	17	15	20	24	8	10	7	10	10
0	1	0	0	1	6	0	0	0	0	0

Boys or girls, standing broad jump in feet and inches

Percentile	Age				
	5	*6*	*7*	*8*	*9*
100	4'2"	4'8"	5'5"	5'11"	6'6"
95	3'10"	4'1"	4'8"	5'1"	5'6"
90	3'9"	4'	4'5"	4'10"	5'3"
85	3'8"	3'11"	4'3"	4'8"	5'
80	3'7"	3'10"	4'2"	4'6"	4'11"
75	3'6"	3'9"	4'0"	4'5"	4'10"
70	3'5"	3'8"	3'11"	4'3"	4'9"
65	3'4"	3'7"	3'10"	4'2"	4'8"
60	3'3"	3'6"	3'9"	4'1"	4'7"
55	3'2"	3'5"	3'8"	4'	4'6"
50	3'1"	3'4"	3'7"	3'11"	4'5"
45	3'	3'3"	3'6"	3'10"	4'4"
40	3'11"	3'2"	3'5"	3'9"	4'3"
35	2'10"	3'1"	3'4"	3'8"	4'2"
30	2'	3'	3'3"	3'7"	4'
25	2'8"	2'11"	3'2"	3'6"	3'10"
20	2'7"	2'10"	3'1"	3'5"	3'9"
15	2'6"	2'9"	3'	3'4"	3'7"
10	2'5"	2'8"	2'11"	3'3"	3'6"
5	2'2"	2'5"	2'8"	3'	3'4"
0	2'	2'2"	2'4"	2'6"	2'8"

Boys and girls, standing broad jump in feet and inches

Percentile	Boys Age					Girls Age				
	10	*11*	*12*	*13*	*14*	*10*	*11*	*12*	*13*	*14*
100	6'8"	10'	7'10"	8'9"	8'11"	7'10"	7'10"	8'2"	7'6"	7'4"
95	6'1"	6'3"	6'6"	7'2"	7'9"	5'8"	6'2"	6'3"	6'3"	6'4"
90	5'10"	6'	6'4"	6'11"	7'5"	5'6"	5'10"	6'	6'	6'2"
85	5'8"	5'10"	6'2"	6'9"	7'3"	5'4"	5'8"	5'9"	5'10"	6'
80	5'7"	5'9"	6'1"	6'7"	7'	5'2"	5'6"	5'8"	5'8"	5'10"
75	5'6"	5'7"	6'	6'5"	6'11"	5'1"	5'4"	5'6"	5'6"	5'9"
70	5'5"	5'6"	5'11"	6'3"	6'9"	5'	5'3"	5'5"	5'5"	5'7"
65	5'4"	5'6"	5'9"	6'1"	6'8"	5'	5'2"	5'4"	5'4"	5'6"
60	5'2"	5'4"	5'8"	6'	6'7"	4'10"	5'	5'2"	5'3"	5'5"
55	5'1"	5'3"	5'7"	5'11"	6'6"	4'9"	5'	5'1"	5'2"	5'4"
50	5'	5'2"	5'6"	5'10"	6'4"	4'7"	4'10"	5'	5'	5'3"
45	5'	5'1"	5'5"	5'9"	6'3"	4'6"	4'9"	5'11"	5'	5'1"
40	4'10"	5'	5'4"	5'7"	6'1"	4'5"	4'8"	4'9"	4'10"	5'
35	4'10"	4'11"	5'2"	5'6"	6'	4'4"	4'7"	4'8"	4'8"	5'
30	4'8"	5'10"	5'1"	5'5"	5'10"	4'3"	4'6"	4'7"	4'6"	4'9"
25	4'6"	4'8"	5'	5'3"	5'8"	4'2"	4'4"	4'5"	4'6"	4'8"
20	4'5"	4'7"	4'10"	5'2"	5'6"	4'	4'3"	4'4"	4'4"	4'6"
15	4'4"	4'5"	4'8"	5'	5'4"	3'11"	4'1"	4'2"	4'2"	4'3"
10	4'3"	4'2"	4'5"	4'9"	5'2"	3'9"	3'11"	4'	4'	4'1"
5	4'	4'	4'2"	4'5"	4'11"	3'6"	3'9"	3'8"	3'9"	3'10"
0	2'10"	1'8"	3'	2'9"	3'8"	2'8"	2'11"	2'11"	2'11"	3'

Boys or girls, shuttle run in seconds

Percentile	Age				
	5	*6*	*7*	*8*	*9*
100	11.1	10.9	10.3	10.1	9.9
95	11.6	11.1	10.5	10.3	10.1
90	12.5	12.2	11.6	11.2	10.8
85	12.7	12.5	11.8	11.5	11
80	12.9	12.6	12	11	11.2
75	13.1	12.8	12.2	11.9	11.4
70	13.2	12.9	12.3	12	11.5
65	13.4	13.2	12.5	12.2	11.7
60	13.5	13.3	13.7	13.3	11.8
55	13.7	13.5	12.9	12.5	12
50	13.9	13.7	13	12.6	12.1
45	14.1	13.9	13.2	12.8	12.2
40	14.3	14.1	13.3	13	12.3
35	14.4	14.2	13.4	13.1	12.4
30	14.5	14.3	13.5	13.2	12.5
25	14.7	14.5	13.7	13.4	12.7
20	14.8	14.6	13.8	13.5	12.8
15	15.2	15	14.3	13.8	13.1
10	15.5	15.3	14.6	14.1	13.4
5	16.5	16.1	15.5	14.8	14.2
0	17.5	17.1	16.3	15.6	14.9

Boys and girls, shuttle run in seconds

Percentile	Boys Age					Girls Age				
	10	*11*	*12*	*13*	*14*	*10*	*11*	*12*	*13*	*14*
100	9	9	8.5	8	8.3	8.5	8.8	9	8.3	9
95	10	10	9.8	9.5	9.3	10	10	10	10	10
90	10.2	10.1	10	9.8	9.5	10.5	10.2	10.2	10.2	10.3
85	10.4	10.3	10	9.9	9.6	10.8	10.6	10.5	10.5	10.4
80	10.5	10.4	10.2	10	9.8	11	10.9	10.8	10.6	10.5
75	10.7	10.5	10.3	10.1	9.9	11	11	10.9	10.8	10.6
70	10.8	10.7	10.5	10.2	9.9	11.1	11	11	11	10.8
65	10.9	10.8	10.6	10.3	10	11.4	11.2	11.2	11	10.9
60	11	10.9	10.7	10.4	10	11.5	11.4	11.3	11.1	11
55	11	11	10.9	10.5	10.2	11.8	11.6	11.5	11.3	11.1
50	11.2	11.1	11	10.6	10.2	11.9	11.7	11.6	11.4	11.3
45	11.4	11.2	11	10.8	10.3	12	11.8	11.8	11.6	11.4
40	11.5	11.3	11.1	10.9	10.5	12	12	11	11.8	11.5
35	11.6	11.4	11.3	11	10.5	12.1	12	12	12	11.7
30	11.8	11.6	11.5	11.1	10.7	12.4	12.1	12.1	12	12
25	12	11.8	11.6	11.3	10.9	12.6	12.4	12.3	12.2	12
20	12	12	11.9	11.5	11	12.8	12.6	12.5	12.5	12.3
15	12.2	12.1	12	11.8	11.2	13	13	12.9	13	12.6
10	12.6	12.4	12.4	12	11.5	13.1	13.4	13.2	13.3	13.1
5	13.1	13	13	12.5	12	14	14.1	13.9	14	13.9
0	15	20	22	16	16	16.6	18.5	19.8	18.5	17.6

Boys or girls, 40-yard dash in seconds

Percentile	Age				
	5	*6*	*7*	*8*	*9*
100	6.7	6.6	6.3	5.8	5.6
95	7.2	7.1	6.8	6.2	6.1
90	7.6	7.5	7.2	6.7	6.6
85	7.7	7.6	7.4	6.9	6.7
80	7.8	7.7	7.6	7	6.8
75	7.9	7.8	7.7	7.2	6.9
70	8	7.9	7.8	7.3	7
65	8.1	8	7.9	7.5	7.1
60	8.2	8.1	8	7.6	7.2
55	8.3	8.2	8.1	7.7	7.3
50	8.4	8.3	8.2	7.8	7.4
45	8.5	8.4	8.3	7.9	7.5
40	8.6	8.5	8.4	8	7.6
35	8.8	8.7	8.6	8.2	7.7
30	8.9	8.8	8.7	8.3	7.8
25	9.1	9	8.9	8.4	8
20	9.2	9.2	9	8.5	8.1
15	9.4	9.2	9.1	8.8	8.3
10	9.5	9.4	9.3	9.1	8.4
5	9.7	9.5	9.4	9.2	8.9
0	11.8	11.5	11	10.5	9.8

Boys and girls, 50-yard dash in seconds

Percentile	Boys Age					Girls Age				
	10	*11*	*12*	*13*	*14*	*10*	*11*	*12*	*13*	*14*
100	6	6	6	5.8	5.8	6	6	5.9	6	6
95	7	7	6.8	6.5	6.3	7	7	7	7	7
90	7.1	7.2	7	6.7	6.4	7.3	7.4	7.3	7.3	7.2
85	7.4	7.4	7	6.9	6.6	7.5	7.6	7.5	7.5	7.4
80	7.5	7.5	7.2	7	6.7	7.7	7.7	7.6	7.6	7.5
75	7.6	7.6	7.3	7	6.8	7.9	7.9	7.8	7.7	7.6
70	7.8	7.7	7.5	7.1	6.9	8	8	7.9	7.8	7.7
65	8	7.8	7.5	7.2	7	8.1	8	8	7.9	7.8
60	8	7.8	7.6	7.3	7	8.2	8.1	8	8	7.9
55	8.1	8	7.8	7.4	7	8.4	8.2	8.1	8	8
50	8.2	8	7.8	7.5	7.1	8.5	8.4	8.2	8.1	8
45	8.3	8	7.9	7.5	7.2	8.6	8.5	8.3	8.1	8.2
40	8.5	8.1	8	7.6	7.2	8.8	8.5	8.4	8.4	8.3
35	8.5	8.3	8	7.7	7.3	8.9	8.6	8.5	8.5	8.5
30	8.7	8.4	8.2	7.9	7.5	9	8.8	8.7	8.6	8.6
25	8.8	8.5	8.3	8	7.6	9	9	8.9	8.8	8.9
20	9	8.7	8.4	8	7.8	9.2	9	9	9	9
15	9.1	9	8.6	8.2	8	9.4	9.2	9.2	9.2	9.2
10	9.5	9.1	8.9	8.4	8.1	9.6	9.6	9.5	9.5	9.5
5	10	9.5	9.2	8.9	8.6	10	10	10	10.2	10.4
0	12	11.9	12	11.1	11.6	14	13	13	15.7	16

Boys or girls, softball throw in feet

	Age				
Percentile	5	6	7	8	9
100	64	78	95	120	142
95	47	58	75	88	104
90	42	47	62	76	96
85	39	43	47	72	88
80	37	40	53	68	81
75	35	37	49	63	78
70	31	34	46	60	74
65	28	30	44	55	69
60	26	28	42	51	65
55	25	27	39	48	60
50	24	26	36	45	56
45	22	24	33	42	52
40	20	22	31	40	49
35	18	20	28	37	45
30	16	18	26	35	42
25	15	17	24	32	39
20	14	16	22	29	37
15	12	14	20	26	33
10	11	13	19	24	30
5	8	10	13	19	25
0	5	8	9	10	17

Boys and girls, softball throw in feet

	Boys Age					Girls Age				
Percentile	10	11	12	13	14	10	11	12	13	14
100	175	205	207	245	246	167	141	159	150	146
95	138	151	165	195	208	84	95	103	111	114
90	127	141	156	183	195	76	86	102	103	100
85	122	136	150	175	187	71	81	90	95	103
80	118	129	145	168	181	69	77	85	90	95
75	114	126	141	163	176	65	74	80	86	90
70	109	121	136	157	172	60	71	76	82	87
65	105	119	133	152	168	57	66	74	79	84
60	102	115	129	147	165	54	64	70	75	80
55	98	113	124	142	160	52	62	67	73	78
50	96	111	120	140	155	50	59	64	70	75
45	93	108	119	135	150	48	57	61	68	72
40	91	105	115	131	146	46	55	59	65	70
35	89	101	112	128	141	45	52	57	63	68
30	84	98	110	125	138	42	50	54	60	65
25	81	94	106	120	133	40	46	50	.57	61
20	78	90	103	115	127	37	44	48	53	59
15	73	85	97	110	122	34	40	45	49	54
10	69	78	92	101	112	30	37	41	45	50
5	60	70	76	88	102	21	32	37	36	45
0	35	14	25	50	31	8	13	20	20	25

Boys or girls, 400-yard run-walk in minutes and seconds

Percentile	Age				
	5	6	7	8	9
100	1'49"	1'42"	1'35"	1'28"	1'22"
95	1'52"	1'45"	1'38"	1'33"	1'28"
90	1'55"	1'48"	1'43"	1'38"	1'31"
85	1'58"	1'53"	1'48"	1'41"	1'32"
80	2'	1'55"	1'49"	1'43"	1'34"
75	2'2"	1'56"	1'50"	1'45"	1'37"
70	2'3"	1'57"	1'52"	1'47"	1'38"
65	2'4"	1'59"	1'54"	1'48"	1'40"
60	2'6"	2'1"	1'55"	1'50"	1'41"
55	2'11"	2'5"	2'	1'51"	1'42"
50	2'15"	2'10"	2'1"	1'52"	1'44"
45	2'20"	2'11"	2'2"	1'54"	1'46"
40	2'21"	2'12"	2'4"	1'57"	1'49"
35	2'22"	2'14"	2'7"	1'59"	1'50"
30	2'24"	2'17"	2'9"	2'1"	1'54"
25	2'30"	2'19"	2'12"	2'3"	1'58"
20	2'32"	2'25"	2'16"	2'10"	2'8"
15	2'38"	2'29"	2'23"	2'19"	2'15"
10	2'42"	2'36"	2'32"	2'24"	2'19"
5	2'49"	2'45"	2'37"	2'30"	2'21"
0	3'5"	2'56"	2'48"	2'39"	2'30"

Boys and girls, 600-yard run-walk in minutes and seconds

Percentile	Boys Age					Girls Age				
	10	11	12	13	14	10	11	12	13	14
100	1'30"	1'27"	1'31"	1'29"	1'25"	1'42"	1'40"	1'39"	1'40"	1'45"
95	1'58"	1'59"	1'52"	1'46"	1'37"	2'5"	2'13"	2'14"	2'12"	2'9"
90	2'9"	2'3"	2'	1'50"	1'42"	2'15"	2'19"	2'20"	2'19"	2'18"
85	2'12"	2'18"	2'2"	1'53"	1'46"	2'20"	2'24"	2'24"	2'25"	2'22"
80	2'15"	2'11"	2'5"	1'55"	1'48"	2'26"	2'28"	2'27"	2'29"	2'25"
75	2'18"	2'14"	2'9"	1'59"	1'51"	2'30"	2'32"	2'31"	2'32"	2'30"
70	2'20"	2'16"	2'11"	2'1"	1'53"	2'34"	2'36"	2'35"	2'37"	2'34"
65	2'23"	2'19"	2'13"	2'3"	1'55"	2'37"	2'39"	2'39"	2'40"	2'37"
60	2'26"	2'21"	2'15"	2'5"	1'57"	2'41"	2'43"	2'42"	2'44"	2'41"
55	2'30"	2'24"	2'18"	2'7"	1'59"	2'45"	2'47"	2'45"	2'47"	2'44"
50	2'33"	2'27"	2'21"	2'10"	2'1"	2'48"	2'49"	2'49"	2'52"	2'46"
45	2'36"	2'30"	2'24"	2'12"	2'3"	2'50"	2'53"	2'53"	2'56"	2'51"
40	2'40"	2'33"	2'26"	2'15"	2'5"	2'55"	2'59"	2'58"	3'	2'55"
35	2'43"	2'36"	2'30"	2'17"	2'9"	2'59"	3'4"	3'3"	3'3"	3'
30	2'45"	2'39"	2'34"	2'22"	2'11"	3'3"	3'10"	3'7"	3'9"	3'6"
25	2'49"	2'42"	2'39"	2'25"	2'14"	3'8"	3'15"	3'11"	3'15"	3'12"
20	2'55"	2'48"	2'47"	2'30"	2'19"	3'13"	3'22"	3'18"	3'20"	3'19"
15	3'1"	2'55"	2'57"	2'35"	2'25"	3'18"	3'30"	3'24"	3'30"	3'30"
10	3'8"	3'9"	3'8"	2'45"	2'33"	3'27"	3'41"	3'40"	3'49"	3'48"
5	3'23"	3'30"	3'32"	3'3"	2'47"	3'45"	3'51"	4'	4'11"	4'8"
0	4'58"	5'6"	4'55"	5'14"	5'10"	4'47"	4'53"	5'10"	5'10"	5'50"

Index